PICASSO & MODERN BRITISH ART

Linklaters

'Picasso and Modern British Art'

at the Tate Britain

Wednesday 21 March 2012

We were delighted that you joined us.

Tate Publishing

PICASSO & MODERN BRITISH ART

EDITED BY

**James Beechey and
Chris Stephens**

WITH CONTRIBUTIONS FROM

James Beechey
Andrew Brighton
Christopher Green
Richard Humphreys
Helen Little
John Richardson
Chris Stephens

First published 2012 by order of the Tate Trustees
by Tate Publishing, a division of Tate Enterprises Ltd,
Millbank, London SW1P 4RG
www.tate.org.uk/publishing

on the occasion of the exhibition

PICASSO & MODERN BRITISH ART

Tate Britain, London
15 February – 15 July 2012

The Scottish National Gallery of Modern Art
4 August – 4 November 2012

A catalogue record for this book is available
from the British Library.

ISBN 978 1 85437 890 3

Distributed in the United States and Canada by
ABRAMS, New York
Library of Congress Control Number 2011940733

Designed by Philip Lewis
Colour reproduction by DL Imaging Ltd, London
Printed by Grafos SA, Barcelona

Measurements of artworks are given in centimetres,
height before width.

Works by Picasso are identified by their number in the
catalogue raisonné: Christian Zervos, *Pablo Picasso*,
33 vols, Paris 1932–78.

FRONT COVER Pablo Picasso, *Nude Woman in
a Red Armchair* 1932 (detail, no.60)
BACK COVER Duncan Grant, *The White Jug* 1914–18
(detail, no.15); Wyndham Lewis, *A Reading of Ovid
(Tyros)* 1920–1 (detail, no.20); Ben Nicholson, *1933
Musical Instruments* 1932–3 (detail, no.44); Henry
Moore, *Reclining Figure* 1936 (detail, no.85); Francis
Bacon, *Three Studies for Figures at the Base of a
Crucifixion* c.1944 (detail, no.98); Graham Sutherland,
Crucifixion 1946 (detail, no.112); David Hockney,
Harlequin 1980 (detail, no.130)
FRONTISPIECE Pablo Picasso, *Women of Algiers
(Version O)* 1955 (detail, no.120)
PAGE 6 Pablo and Olga Picasso outside the
Alhambra Theatre, Leicester Square, London 1919.

CONTENTS

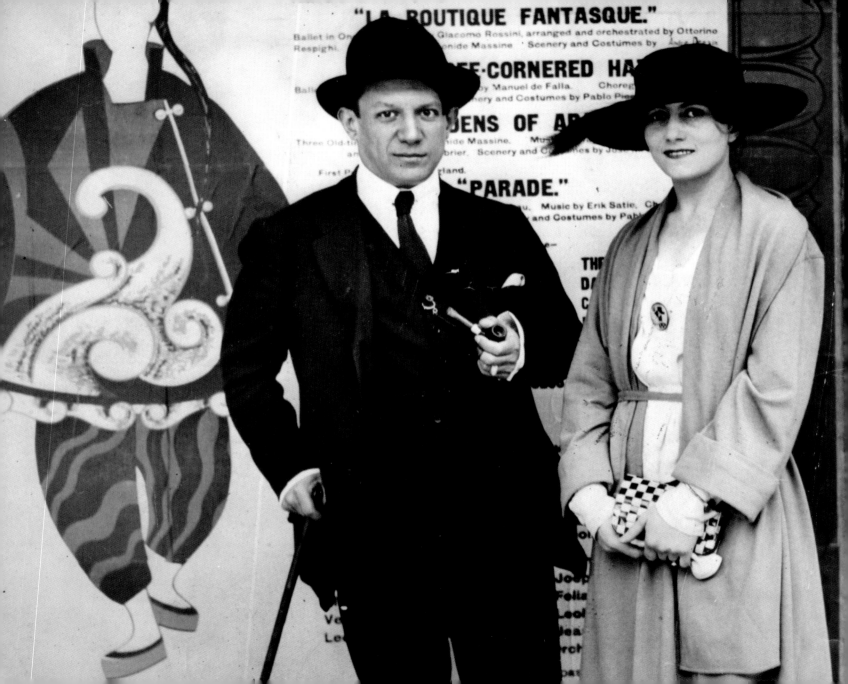

FOREWORD

If Britain was of little importance to Picasso, Picasso has been very important to British art. This exhibition, the first to explore his influence on the art of this country, makes this abundantly clear. It also shows, if more subtly, how that influence changed and grew, from being an acquired taste, to a cultural norm. The changing focus of the exhibition moves from pictures owned and seen by a small, cultivated elite, to works which form an integral part of our national understanding of modern visual culture. In many ways the discovery of Picasso in Britain might be effectively equated with the discovery of modern art and the gradual acceptance of another way of seeing.

The role of the artist in helping a larger audience understand Picasso and his importance is central to the story which this exhibition unfolds. Individual artists appreciated Picasso well before his significance was more widely understood. In this sense, artists act as the agents for other artists, helping them to infiltrate a broader consciousness. By confining itself to a relatively limited number of artists, rather than attempting to include the many who came under Picasso's influence, the exhibition helps us to appreciate more fully the work of those artists who have come to be seen as central to any story of Modern British Art, and to see how that story connects with that of Picasso.

In part then this show is museological, highlighting the role of the museum in shaping the visual culture of a community. And in part it is sociological, in demonstrating how an influence grows and changes, escaping a tiny world of privilege to achieve much wider purchase. But, and more importantly, this exhibition shows how art works, as one artist inspires another.

As we move from generation to generation, from Bloomsbury to Hockney, we move into the democratisation of contemporary art which continues to this day. Whereas in the pre- and inter-war period the work of Picasso could generally only be seen in small galleries and the houses of a select group of private collectors, by the postwar period he was permanently represented in the National Collections and shown, in depth, in the major retrospective mounted by the Arts Council at the Tate in 1960. The present exhibition not only implicitly traces the journeys which some of these works have made from the homes of British collectors, such as Douglas Cooper and Roland Penrose, into the major collections of Europe, but also follows a more local history, in succeeding Douglas Cooper's very last exhibition, *The Essential Cubism*, held here almost thirty years ago.

The exhibition has had a complicated genesis, existing first as an idea mooted by Richard Humphreys, developed with James Beechey – who had studied the British links with Picasso for some years – with whom it was taken forward by Robert Upstone. After Robert's departure from Tate Britain in 2010, Chris Stephens generously took on the role of lead curator. Throughout this time, the project has been ably supported by Helen Little and benefited from the advice of Professor Christopher Green. The make up of the catalogue reflects this genesis, but James Beechey and Chris Green have shaped its content overall. The recent Picasso conference at Tate Liverpool occasioned the paper from Andrew Brighton which is now included as an essay here. The Paul Mellon Centre for Studies in British Art was most generous and accommodating in its support of the catalogue.

A project like this, which draws on particular parallels, visually and historically, is dependent on very specific works. The fact that we have, by and large, been able to demonstrate these links, is due to the very great generosity of a large number of lenders, private and institutional, in this country and abroad.

The curatorial team is indebted to many colleagues, but none more so than John Richardson, who was generous with advice in every way. We are delighted to be able to include in this catalogue an interview which he kindly gave to Chris Stephens last autumn.

It is significant for Tate Britain that this is our first exhibition to tour to the Scottish National Gallery of Modern Art, and we are pleased that its curator there, Patrick Elliott, is also a contributor to the catalogue. It was important for Edinburgh that the exhibition be staged during the International Festival, and while we shall be sorry to see it leave us in London's Olympic summer, there is additional historical significance in taking Picasso to the Edinburgh Festival, and in underlining the scope of an influence which affected British art in general, and not only in London. The permanent collections of SNGMA, like those of Tate, are well positioned to show this broader context.

In 1960 the organisers of the Picasso exhibition, the Arts Council, thanked the Tate Gallery for making available their galleries 'at great inconvenience to themselves'. Fifty years later our institutional involvement has changed substantially, but the art has not. We might focus instead on the words of Roland Penrose, the exhibition's curator, who wrote of Picasso in the same catalogue, that 'no artist can afford to ignore him', because his art fulfils 'the intensification of feeling and the education of the spirit'.

PENELOPE CURTIS
DIRECTOR, TATE BRITAIN

EXHIBITION SUPPORT

We would like to thank our corporate sponsors JCA Group and RLM Finsbury for their generous support.

Our sincere thanks is extended to The Picasso and Modern British Art Supporters Group: Christopher Eykyn and Nicholas Maclean; The Paul Mellon Centre for Studies in British Art; Mr and Mrs Jürgen and Clarissa Pierburg; Sian and Matthew Westerman; and those donors who wish to remain anonymous. We are also grateful for the support of the Office for Cultural and Scientific Affairs, Embassy of Spain and The Spanish Tourist Office.

ACKNOWLEDGEMENTS

Modern British art is often a rather enclosed field. The experience of studying the works of leading British artists in relation to the art of Picasso has, therefore, offered new experiences for us and opened up new areas of knowledge. In charting this unfamiliar terrain we have benefited hugely from others' knowledge and experience and the generosity with which both have been shared. The whole concept of the exhibition, its shape and, for the most part, the selection is James Beechey's. We were fortunate to have Christopher Green as a consultant advisor to the project. He also selected the Ben Nicholson and Henry Moore sections of the exhibition, as Richard Humphreys did for Wyndham Lewis. We were delighted that in addition, Andrew Brighton also agreed to contribute a paper. We were especially delighted that John Richardson, author of the definitive biography of Picasso, agreed to give an interview for the catalogue. In addition to John himself, this unique insight into the human links between Picasso and Britain would have been impossible without the support of Rob Grover.

We are, of course, hugely indebted to those who so generously lend their precious works of art to an exhibition such as this. We especially appreciate the support we have received from Picasso's family and would like to thank Bernard Ruiz-Picasso for his advice and understanding, Claude Picasso, Maya Widmaier Picasso and Diana Widmaier Picasso. We must also thank Christine Pinault at the Picasso Administration and, for her support of several loans, Florence Half-Wrobel.

Many others have also contributed in many ways, large and small, helping trace individual works, preparing them for loan, negotiating on our behalf. As always, we have been helped by colleagues in the commercial sector and we are very grateful to Melanie Clore, Tobias Meyer, Oliver Barker, James Rawlin, Michael McCauley and Francis Christie at Sotheby's, Conor Jordan and Francis Outred at Christies, Kate Austin at Marlborough Fine Art, Ivor Braka, Rupert Burgess, Libby Howie, Simon Hucker at Jonathan Clark Fine Art, James McCrone, Sandra Poole, and Michelle Rosenfelt, all of whom helped pursue and secure loans. Colleagues in other institutions have been hugely supportive: Stephen Coppel at the British Museum, Christopher Riopelle at the National Gallery, Barnaby Wright at the Courtauld Institute, Maria Balshaw in Manchester, Frances Guy at The Hepworth Wakefield, Simon Martin at Pallant House, Ann Temkin, Anne Umland and Cora Rosevear at the Museum of Modern Art, New York, Pepé Serra at Museu Picasso Barcelona, Guillermo Solano at the Museo Thyssen-Bornemisza, Madrid, Sophie Krebbs at Musée d'Art Moderne de la Ville de Paris, and Anne Baldassari and her colleagues at the Musée Picasso, Paris.

We are extremely grateful to David Hockney for taking time to discuss at length the subject of Picasso and this exhibition specifically, and, from his extraordinary team, we would like to thank in particular Gregory Evans and Jean-Pierre Gonçalves de Lima.

For knowledgeable advice in all sorts of ways, we would like to acknowledge Dawn Ades, Lee Beard, Peter Brooker, Richard Calvocoressi, Lynette Cawthra and her team at the Working Class Movement Library, Salford, Tim Clark, Elizabeth Cowling, Paul Edwards, Anita Feldman, Michael Fitzgerald, Rachel Flynn, Matthew Gale, Andrzej Gasiorek, John Golding, Peter Goulds, Anna Gruetzner Robins, Christoph Grunenberg, Gary Haines at the Whitechapel Art Gallery, Madeleine Korn, Rebecca Lewin, Marco Livingstone, Dr. Enrique Mallen, Professor Director & Editor, Online Picasso Project, Marilyn McCully & Michael Raeburn, Tom Normand, Mary Moore, Lynda Morris, Michael Phipps, Alan Powers, Jane Pritchard, Ben Read, Elaine Rosenberg, Richard Shone, Ann Simpson, Alice Strang Lisa Tickner, Gary Tinterow, Sarah Turner, Anne Wagner, Sophia Wilson.

There is great excitement that Picasso's collaboration with the Russian Ballet in London in 1919 has prompted a collaboration between Tate Britain and the English National Ballet. We have greatly enjoyed working with their Artistic Director, Wayne Eagling, and his team and we are especially grateful to Louise Halliday whose enthusiasm has driven the project forward.

We are so pleased that this exhibition will travel to the Scottish National Gallery of Modern Art in time for the Edinburgh Festival. Patrick Elliott has been a wonderful, efficient, helpful and patient colleague to work with there and we are especially appreciative of his help with various things at the eleventh hour. We appreciate the work done on the exhibition by Bill Duff, Jacqueline Ridge and their teams and appreciate the faith shown by Simon Groom.

This catalogue has been designed by Philip Lewis, managed by Judith Severne and Alice Chasey successively, with the assistance of Beth Thomas, and the picture research was conducted by Miriam Perez and Deborah Metherell. We are hugely appreciative of the characteristic thoroughness and energy they have brought to the task. Finally, we would like to thank everybody across Tate who has supported each and every aspect of this project.

CHRIS STEPHENS
HELEN LITTLE

PICASSO AND BRITAIN

JAMES BEECHEY

Belonging to all movements, yet outside them all, and influencing all artists ... walks or runs the biggest artist of them all. Picasso. In Picasso is all the history of modern art, all its experiment, all its eclecticism, its exploration and use ... of all arts, where art exists.
GEOFFREY GRIGSON, 1934[1]

According to Roland Penrose – Picasso's foremost British advocate and his devoted Boswell – when the eighteen-year-old artist left Spain for the first time in the autumn of 1900, Paris, where he eventually settled four years later, was not his intended destination, 'but merely a halt on a journey that would take him farther north, to London'. The young Picasso had conceived an admiration for England, Penrose claimed, on account of his Anglophile father's taste for English furniture and clothes, his own interest in the work of the Pre-Raphaelites and Edward Coley Burne-Jones, and his fascination with the legend of the intrepid traveller Lady Hester Stanhope, who was, he believed, 'a woman of a type so different from any he had ever met, a woman who had conquered her own liberty and also the hearts of men, [that] he decided he must investigate the country which fostered women of this admirable breed'.[2]

However fanciful this notion may seem, it is certainly the case that Picasso knew about Britain, and certain aspects of British art, long before Britain or British artists had heard of him. Britain was, after all, then the most powerful nation in Europe. One of his most ambitious adolescent compositions, *Science and Charity* 1897 (fig.1) with which he hoped to launch his career in Madrid, appears to be derived from Luke Fildes's phenomenally popular Victorian morality painting *The Doctor* 1891 (fig.2), known through reproduction across Europe.[3] When Picasso moved to Barcelona in 1899, he found himself in a milieu engaged with British culture and keen to emulate English art nouveau in its own Catalan version of the movement, *modernisme*: the journal the *Studio* was widely circulated and *Joventut*, the *Modernista* magazine in which his first commissioned drawing was published, was modelled on the internationally admired *Yellow Book*, the British periodical whose art editor was Aubrey Beardsley. The inaugural issue of *Joventut* in 1900 carried a long, reverential essay on Beardsley, and Picasso's lifelong identification of himself with Harlequin may have been suggested by Beardsley's own adoption of Pierrot as his alter ego. Picasso was clearly familiar with posters by the Beggarstaff Brothers (William Nicholson and James Pryde), and copied their stylised simplifications and thick, heavy outlines in the advertisements and menu cards he designed for the café-cabaret Els Quatre Gats in Barcelona; in his pen and watercolour *Self-Portrait 'Yo'* 1900 (The Metropolitan Museum of Art, New York, Zervos XXI, 109)

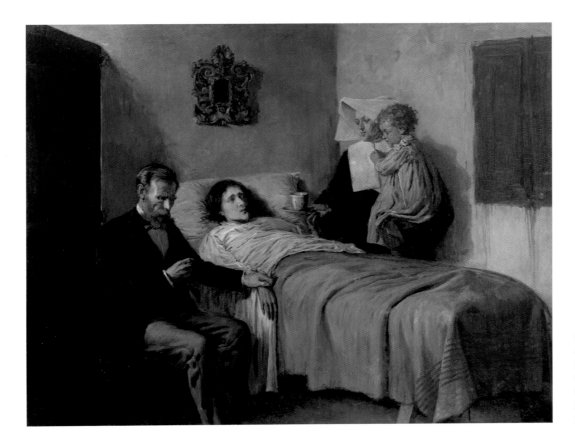

Fig.1
PABLO PICASSO
Science and Charity 1897
Oil on canvas
197 × 249.5
Museu Picasso, Barcelona
Zervos XXI, 56

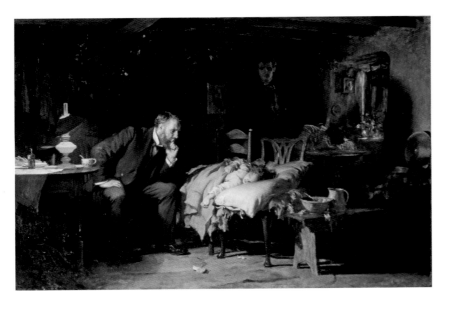

Fig.2
LUKE FILDES
The Doctor exh. 1891
Oil on canvas
166.4 × 241.9
Tate

he presents a romantically glamorous image of himself quite in contrast to the ironically artisanal self-portrait that Nicholson included in his 1889 lithograph *A was an Artist*, but one that relies on the same stylistic devices. *Joventut* also often used drawings by Dante Gabriel Rossetti and Burne-Jones to illustrate its stories, and Picasso later affirmed – to Duncan Grant, among others – the esteem in which he held Burne-Jones in particular: the wistful melancholy with which Burne-Jones imbued his female models in his work of the 1890s, his use of a reduced, almost monochrome palette, and his preference for such physical characteristics as a long neck, pallid complexion and drooping head (fig.3), all left an indelible mark on Picasso's early portraiture.[4]

In *fin-de-siècle* Barcelona and Paris the international cult of symbolism continued to exert a potent influence in the circles in which Picasso moved: the subtle tonalities and cool harmonies of James McNeill Whistler were much imitated and the humanitarian aestheticism of G.F. Watts was highly regarded. The pose of the bent, hunched figure plucking at his instrument in Picasso's *The Old Guitarist* 1903 (Art Institute of Chicago, Zervos I, 202) immediately

Fig.3
EDWARD COLEY
BURNE-JONES
Vespertina Quies 1893
Oil on canvas
107.9 × 62.2
Tate

act as a lightning-rod for such arguments for many years. Anti-Picassoism gained a lengthy currency in Britain and boasted some distinguished names in its camp. Well into the 1920s Walter Sickert was still mischievously maintaining that 'Picasso is certainly not a patch on Poulbot, or Genty, or Métivet, or Falke or Arnac, or Kern, or the amazing Laborde'.[7] But the most impassioned attacks came from the culturally conservative, who were opposed to modernism in all its forms. In a critique of contemporary art criticism in the wake of the reproduction in the *New Age* of Picasso's *Mandolin and Glass of Pernod*, 1911 (National Gallery, Prague. Zervos IIa, 259), the author G.K. Chesterton described the work as 'a piece of paper on which Mr. Picasso has had the misfortune to upset the ink and tried to dry it with his boots'.[8] Though as a fourteen-year old Evelyn Waugh published an essay 'In defence of Cubism', he would later sign off his letters with the brutal valediction 'Death to Picasso!', and wrote to the editor of the *Times* in 1945 that 'Senor Picasso's painting cannot be

recalls that of the wretched musician in Watts's celebrated *Hope* 1886 (fig.4) and the air of desolation that pervades Watts's later painting resurfaces throughout the similarly allegorical imagery of Picasso's Blue Period.[5] Picasso never learned to speak or read English, but that he knew early on the work of at least one British author in translation is evident from an inscription in the margin of an 1899 drawing of an embracing couple: 'Oscar Vilde – autor ingles este siglo'.[6]

Picasso did not become a name to conjure with in Britain until 1910, a decade after he supposedly set out for London. When Roger Fry showed pictures in his pioneering Post-Impressionist exhibitions in 1910 and 1912, the public laughed, critics sneered and cartoonists made irresistible fun of their weird distortions. In Britain, almost overnight Picasso became the most notorious symbol of modern art – and worse, foreign modern art – around whom centred all the controversies it ignited, and he would continue to

Fig.4
GEORGE FREDERIC WATTS
AND ASSISTANTS
Hope 1886
Oil on canvas
142.2 × 111.8
Tate

intelligently discussed in the terms used of the civilised masters … He can only be treated as crooners are treated by their devotees'.[9] Four years later Alfred Munnings, in his farewell address as its President, famously told the Royal Academy's annual banquet (and, via the BBC, the nation at large) that, when Winston Churchill had asked, 'Alfred, if you met Picasso coming down the street would you join me in kicking his … something, something?', he had heartily agreed that he would.[10]

Picasso's British adversaries may have had some of the best lines and delighted in conveying them to a largely receptive audience, but however noisy their interventions there were always others ready to combat them. One of the aims of this exhibition is to demonstrate that British engagement with Picasso has been longer-standing, wider and deeper than is generally acknowledged. Nor did British recognition of Picasso significantly lag behind his appreciation elsewhere, not least his homeland of France. Fry's *Second Post-Impressionist Exhibition* of 1912 was the first occasion on which Picasso and Henri Matisse were explicitly positioned as the twin animators of the modern movement, establishing a canonical duopoly that prevailed throughout the twentieth century – and which was reinforced in Britain by the joint exhibition of the two artists at the Victoria and Albert Museum in 1945–6 (later shown in Manchester and Glasgow), which included a small retrospective of Matisse's work while Picasso chose to send only a selection of wartime paintings. In his early endorsement of Picasso, Fry was joined by Clive Bell, whose assertion in 1920 that the artist's restless spirit would dominate his age was one of the earliest instances of a later commonplace.[11] Though Picasso was much more thoroughly exhibited in America than in Britain from an early date, it is possible that their advocacy bore its richest fruit in the United States, where Alfred H. Barr Jr. turned New York's Museum of Modern Art into the principal laboratory for Picasso studies.

There was no such institutional support for Picasso, or indeed modernism in general, in Britain before the Second World War. In 1917, the Tate Gallery, hitherto the national collection of British art, was given an additional role as the national collection of modern art. Though the directors did not truly embrace modernism for many years, Picasso's *Jars and Lemon* 1907 (no.2) was borrowed for the opening of the new Modern Foreign Galleries in 1926 and,

in December 1933, those galleries were rehung to present Frank Stoop's recent bequest that included two Picassos from 1905 and one of 1923 (nos.3, 4, 58). Nevertheless, the presentation of Picasso was left largely to the private sector. As well as his inclusion in group shows between 1910 and the First World War, a solo exhibition of Picasso's drawings was presented at the Stafford Gallery, London, in 1912. This was followed in 1921 by a significant exhibition of paintings, drawings and prints at the Leicester Galleries.

The Leicester Galleries exhibition was a commercial disaster and it was in the 1930s that Picasso's work became more widely accessible. With the encouragement of painter Ben Nicholson, the venerable Alex. Reid and Lefevre Gallery presented *Thirty Years of Pablo Picasso* in 1931, a major exhibition that anticipated the artist's first retrospective at Galerie Georges Petit in Paris the following year and which offered major paintings stretching from the Blue Period *La Vie* 1903 (Cleveland Museum of Art. Zervos I, 179) to recent Dinard paintings. Paris was easily reached and many British artists are likely to have made the trip to see the 1932 survey. In 1936 Picasso's principal Parisian dealer, Paul Rosenberg, opened a gallery in London with his brother-in-law, Jacques Helft. As well as a regular stock of work by Picasso, Rosenberg & Helft mounted two significant exhibitions: of 29 paintings from 1930–4, including some major pieces, in 1937 and, in 1939, of work from 1936–9. At the same time, Picasso's new and earlier work continued to be shown at the Leicester and Lefevre galleries, at Arthur Tooth & Son, and the gallery added to Zwemmer's bookshop in 1929. The Mayor Gallery reopened in Cork Street in 1933 with a new partner, Douglas Cooper, who would amass a collection of cubist paintings and drawings as well as handling many other works. Picasso was shown at Peggy Guggenheim's Guggenheim Jeune in London, and the London Gallery – which from 1938 became the home of English surrealism under the direction of Belgian surrealist E.L.T. Mesens and with the backing of Penrose – presented *Picasso in English Collections* in May 1939. Absent from that exhibition were the fourteen paintings and drawings that the collector Hugh Willoughby had lent as a small exhibition at the Tate Gallery in 1934 and at Cheltenham Museum and Art Gallery in 1935 and 1937.[12]

In Britain during the 1930s, Picasso was the touchstone for far-reaching discussions about abstract art that spread through the pages of journals such as *Axis* and

Circle. While Fry and Bell had positioned cubism as part of a formalist development in art, for Naum Gabo writing in *Circle* it represented a dangerous destructiveness which had forced Picasso to 'retreat' 'back to Ingres' and was contrasted with the positive constructiveness of the new abstraction.[13] Conversely, in the journal *Axis* and later the book *The Painter's Object*, both edited by Myfanwy Evans, Picasso offered a model of an avant-garde artist who retained subject matter rather than a non-representational abstraction. The second issue of *Axis* reproduced several *papier collés* of 1912–14 that had just been shown at the Galerie Pierre, Paris, alongside Evans's article 'Beginning with Picasso'. The very first issue had indeed begun with Picasso, his *The Studio* 1927–8 (The Museum of Modern Art, New York. Zervos VII, 142) being reproduced (as *Intérieure* 1928) on the first page (fig.10). It is revealing of the artist's modish status that Evans, in her editorial, warned that 'To paint circles and rectangles instead of heads and bodies because Picasso does is the worst kind of generalisation'.[14]

Later in the same decade Picasso was the focus of a heated debate between realists and surrealists concerning the validity of their contrasting approaches to aesthetic and political questions, conducted in the *Left Review*, the *London Bulletin* and within art schools and exhibiting societies. After the Second World War, he remained a crucial reference point in the equally intense clashes that took place over competing visions of realism, and by implication the relationship between art and politics.[15] Both before and during the 1938–9 British tour of *Guernica* and its preparatory studies, Britain was the battleground on which were fired the opening salvoes in an ongoing dispute regarding the effectiveness as propaganda of Picasso's great painting: on one side Anthony Blunt lamented its subjectivity, believing the only statement Picasso could make was 'an expression of the horror which it inspired in him: it is a mere nightmare picture, and nothing else' which he contrasted with the committed realism of Diego Rivera; on the other, Herbert Read hailed *Guernica* as 'the modern Calvary'.[16] The painting continued to dominate British ideas of Picasso: the catalogue of the Victoria and Albert Museum's presentation in 1945–6 of his wartime work opened with it and ended with the unfinished *Charnel House* 1945 (The Museum of Modern Art, New York. Zervos XIV, 76).

As the V&A exhibition indicates, by the end of the Second World War Picasso was indisputably established in Britain; in 1944 Michael Ayrton had complained that to criticise him was to invite hostility and, in January 1946, Patrick Heron could write of 'our position in the Picassian present'.[17] A series of exhibitions during the 1950s of both earlier and recent work, organised by the Arts Council and the Institute of Contemporary Arts (ICA), culminated in his immense retrospective at the Tate Gallery in 1960, for which nearly half a million visitors queued and which one reviewer declared unambiguously 'the exhibition of the century'.[18] Not all critics' enthusiasm was unreserved. Although responsible for the translation of Daniel Henry Kahnweiler's *The Sculptures of Picasso* (1949), David Sylvester originally held a negative view of Picasso's painting. By 1960 that had been revised but he nevertheless found the work at the Tate 'curiously inert' compared with that of Matisse and Pierre Bonnard on display downstairs. He identified in Picasso a tendency to isolate one aspect or another in each painting, causing them to lack the internal contradictions that he saw as essential to a great work of art.[19] Ironically, Sylvester went on to curate the first major exhibition in Britain of *Late Picasso*, at the Tate Gallery in 1988.[20] John Berger's 1965 polemic *The Success and Failure of Picasso* was provoked in part by the unprecedentedly favourable press that the 1960 Tate exhibition engendered, and has had an enduring impact long outlasting the Cold War context in which it was written.

Critics from Fry and Bell, via Read and Blunt to Berger and Sylvester have appreciably affected our ways of looking at Picasso. In the field of art history, John Golding's *Cubism: A History and an Analysis 1907–14* (1957) remains the definitive study of that movement and, more recently, Christopher Green and Elizabeth Cowling have made outstanding contributions to scholarship on the artist. Two figures who loom large in this exhibition, Douglas Cooper and his arch-rival Roland Penrose – the former always a reluctant Englishman – became intimately associated with the artist and his reputation, enjoying his cherished, if at times capricious, friendship, precious access to his studios and vital insights into his working practice and thoughts. Cooper significantly advanced knowledge and understanding not only of Picasso's cubism, around which he built his superlative collection of the artist's paintings, but also of his ceramics and his work for the theatre.[21] In

the 1930s Penrose was a key agent in aligning Picasso with the international surrealist movement, and three decades later he was responsible for revealing the artist's previously little-known sculpture to a wider audience, thereby setting in train a fundamental re-evaluation of his entire oeuvre.[22] Penrose's 1958 biography of Picasso, written with its subject's cautious co-operation, remains the starting point for all subsequent accounts of his life.[23] Of these, the monumental, on-going multi-volume *Life of Picasso* by Picasso's last close British friend, John Richardson, has given us the most convincing portrait yet of the artist, an achievement unlikely to be superseded.[24]

While British engagement with Picasso has operated at many levels, its most visible testimony comes in the responses of other artists to his work. As Grigson's comment at the head of this essay indicated, any artist with even modest avant-garde ambitions had to respond in some way to Picasso's innovations. This exhibition considers seven artists for whom Picasso's example acted as a vital stimulus and whose encounters with his art decisively affected their own practice: Duncan Grant, Wyndham Lewis, Ben Nicholson, Henry Moore, Francis Bacon, Graham Sutherland and David Hockney. Four or five of these – Grant, Nicholson, Moore, Sutherland and possibly Lewis – knew Picasso and were invited by him to his studio, and several exhibited alongside him in some of the seminal group shows of the last century, including the 1912 *Second Post-Impressionist Exhibition* and the 1936 *International Surrealist Exhibition*. All grasped opportunities whenever possible to see his work and study it at close quarters: in exhibitions in Britain – at commercial galleries, the Post-Impressionist exhibitions, the 1938–9 *Guernica* tour, the 1960 Tate retrospective; in the abundant, and often sumptuous, reproductions published in foreign magazines, such as *Cahiers d'Art*, *Minotaure* and *Documents*, available through outlets such as Zwemmer's bookshop; and on visits to France. Though references to Picasso in such journals as the *Burlington Magazine* and *The Studio* are surprisingly rare, books on the artist began to appear around 1922 and were also available through Zwemmer's. While they were initially in French, the first English translation came in 1924 and the first by an English author, Anthony Bertram, in 1930.[25]

Picasso's versatility allowed for a range of responses among these seven – and other – artists. Alert to the possibilities that his example opened up, each took different aspects of his art and synthesised them with other sources and points of reference: longer traditions, such as the primitivism that enriched Moore's art as directly as it had Picasso's; a wider modernism; and the artists' own distinctive styles and intentions. In looking at the impact of Picasso on these British artists we separate out one aspect of a complex aesthetic and intellectual matrix. This is not a question of influence as a passive acceptance but of study and appropriation as a conscious strategy in each artist's practice.[26] As with critics and historians, each makes their own Picasso, reshaping his reputation as they draw upon his precedent. Apart from Hockney, for whom Picasso remains a model of creative freedom and whose persistent investigations into his methods and ludic improvisations on his styles and imagery did not begin until after Picasso's death, all were looking at his work and grappling with its implications more or less contemporaneously with its creation. The focus here is on Picasso's impact at a specific, pivotal moment in each artist's development, generally lasting just a few years and rarely more than a decade. None of these was a slavish imitator of Picasso – and one, Lewis, was often a caustic critic – even when explicitly drawing on his sources to formulate a style or elaborate an image. In addition, the significance of an artist's engagement with Picasso's art changed with time: while Grant and Lewis may have turned to Picasso as an especially innovative contemporary, by the mid-twentieth century his work and influence was so ubiquitous it perhaps said more about an artist's position if they ignored Picasso's achievement than if they responded to it, Munnings's RA speech being a case in point.

Of course, it was not only this septet whose work was enriched by the lessons they took from Picasso. Augustus John was almost certainly the first British artist to meet Picasso when the Spaniard visited his Parisian studio. On a return visit, John found a common admiration for the idyllic imagery of Puvis de Chavannes and a parallel in the gypsy and circus scenes to his own fantasies of Romany life.[27] Similarly, the sculptor Jacob Epstein, and later Henri Gaudier-Brzeska, who migrated from France to Britain, shared Picasso's appreciation – and accumulation – of African and Oceanic objects. An associate of Gaudier's, J.D. Fergusson knew Picasso in Paris, where he moved in 1908, and as Art Editor reproduced as

Study 1905–6 the drawing *Peasants from Andorra, Gosol, summer 1906* (Art Institute of Chicago, Zervos VI, 780) in the first issue of the journal *Rhythm* in 1911.[28] They met again at Cap d'Antibes in 1924.

A generation later, for Christopher Wood the possibility of seeing Picasso was one of the lures of Paris, where he moved in March 1921, and he joined a circle that included Picasso, Jean Cocteau and Serge Diaghilev. Picasso came to his studio in February 1926 and pronounced favourably on his work, and when Wood produced a life-size self-portrait the following year he indicated his artistic allegiance by painting himself wearing a harlequin-patterned jersey. In his work, Picasso's influence might be discerned in the clear, limpid line of his drawings, the recurrence of Harlequin and circus imagery and, when working on a commission for Diaghilev, in a faux-naïve style that echoed Picasso's ballet designs.[29]

Wood's close associate Ben Nicholson visited Picasso with Barbara Hepworth in the spring of 1933 (see p.100).[30] While Nicholson recalled peering into the studio where 'all the pictures were painted red and blue and Barbara was wearing a red skirt and a blue blouse', Hepworth wrote she 'would never forget the afternoon light streaming over roofs and chimneypots through the window, on to a miraculous succession of large canvases which Picasso brought out to show us and from which emanated a blaze of energy in form and colour'.[31] The same year, Hepworth began to incorporate into her carvings incised profiles that echo similar details in Nicholson's paintings and relate to Picasso's classicising heads and, perhaps, his own use of profiles (fig.5). She soon abandoned such work for pure, unelaborated forms but resumed the use of Picasso's double profiles in a series of works in the late 1940s.

Unsurprisingly, a number of British surrealists had connections to Picasso, in particular Eileen Agar who shared a summer holiday with him, Dora Maar, Man Ray, Penrose and others in the south of France in 1937. Having already recycled several of Picasso's motifs in her earlier work, she used a photograph she took of the artist himself, sitting like a monumental piece of sculpture on the beach at Mougins, as the basis for one of her most impressive compositions.[32] Agar's friend, Paul Nash, made a series of reliefs using found pieces of wood that surely owed a debt to comparable objects produced by Picasso. Two other artists loosely affiliated to the movement, F.E. McWilliam and Ceri Richards, both candidly exploited Picasso's surrealist iconography in the 1930s: McWilliam in his biomorphic reconfigurations of the human form; Richards in various works, including a series of drawings, prompted by Picasso's illustrations to Honoré de Balzac's *Le chef-d'œuvre inconnu* published in 1931, of a sculptor in his studio contemplating his object.[33] Richards also made a small number of cubist-derived, three-dimensional relief constructions, which constitute his most distinctive contribution to British modernism, and stylistically Picasso remained his major point of reference through to the 1950s.

Fig. 5
BARBARA HEPWORTH
Sculpture with Profiles 1932
Alabaster
23 × 23.9 × 15
Tate

Immediately after the Second World War, the display at the Victoria and Albert Museum of Picasso's wartime paintings had a galvanising effect on a generation of young British artists, including John Minton, Robert Colquhoun, Robert MacBryde, Keith Vaughan and John Craxton. Some had known and absorbed Picasso's work, including *Guernica*, before the war. Picasso's influence had also been mediated through the work and reminiscences of Polish émigré Jankel Adler. Undoubtedly, Sutherland, who was himself a major influence especially on Craxton, would have encouraged an interest in Picasso and all of these artists were supported by Peter Watson, the proprietor of the journal *Horizon* whose collection of Parisian modernism included Picasso. Having read James Thrall Soby's *After Picasso* (1935), Minton had rushed to Paris in 1938, where he saw a revival of the Ballet Russes's *Three-Cornered Hat* and the French Neo-Romantics' adaptation of Picasso's style.[34] Later, however, his admiration became an obstacle to his art and fuel for his depression, and he spoke for others of his generation when he reportedly said, 'After Picasso and Matisse there is nothing more to be done'.[35]

British artists and audiences were not alone in their belief that no other artist had surpassed the supremacy of these two, first posited as leaders four decades earlier. What Picasso stood for was not, however, what everybody sought. Ayrton attacked him as someone who cannibalised other artists' work rather than really going back to nature.[36] Meanwhile, anticipating the post-war exhibitions of modern masters, it was not Picasso's exhibition that Hepworth looked forward to but Paul Klee's. In Patrick Heron's criticism of the late 1940s and early 1950s, Picasso is acknowledged as an artist of 'protean invention' who has the 'power of investing his creations with a hallucinatory poetry', but it is Georges Braque who is judged 'the greatest living painter' on account of 'the massive harmony and calm which formal profundity and technical certainty always bestow'.[37] For Heron – the inheritor of the formalism of Fry and Bell, as Clement Greenberg was in the USA – and others after the Second World War, the quietness of Klee and Braque was more welcome than the brash assertion of Picasso.

Because he kept so much of it hidden from view for so long, the sheer inventiveness of Picasso's sculpture and its full ramifications took longer than his paintings to register. In fact, his primary influence on sculpture was probably through the sculptural figures that peopled his paintings and drawings of the late 1920s. If his use of animal imagery and a metamorphic approach to the depiction of his subject matter had had a huge impact on Sutherland, it might also have done so on the sculptors that emerged in the late 1940s, such as Lynn Chadwick, Bernard Meadows and Eduardo Paolozzi. At the same time, Reg Butler's contemporaneous iron waifs could trace their lineage back to the skeletal figures forged by Picasso (in collaboration with Julio González) in the 1920s. Though photographs of his early constructed sculptures had been exhibited in London in 1913, Picasso's pioneering use of assemblage was not seen by a British audience until the 1960s.[38] It did feature, however, in Kahnweiler's book on the artist's three-dimensional work, which might have provided a source for the bricolage sculptures made by Peter Lanyon in the early 1950s.[39]

By the 1960s, Picasso was simply one part of a longer, wider and ongoing history of collage and assemblage. For Anthony Caro in particular, however, immersion in Picasso's work and its application to his own practice has been a leitmotif of his career – from the lumpy female figures and animals, some of them with specific sources in Picasso's art, that he modelled in plaster and clay in the 1950s, via the abstract welded-metal sculptures of the 1960s, which had their origins in cubist collage, and the series of linear, cage-like structures made at Emma Lake in Saskatchewan, Canada, in the 1970s, with their unmistakable provenance in Picasso's filigreed sculpture of the late 1920s, to more recent pieces such as the colossal *Last Judgement* 1995–9, an indictment of human cruelty in war that carries inevitable allusions to *Guernica*.[40]

By the 1960s, Picasso's extraordinary status was so well established that for an artist to draw upon his precedent would signify little. A lacuna in the appreciation of his art was, however, around the late paintings. Picasso's startling inclusion in the Royal Academy's 1981 exhibition *A New Spirit in Painting*, alongside Lucian Freud, Frank Auerbach, Howard Hodgkin, Malcolm Morley and others, reflected a change in attitude and opened the eyes of many to the extraordinary raw vitality of his late work and its relevance for the resurgence of figurative expressionism then current in British painting. By this period, much of Picasso's *oeuvre* was sufficiently embedded in the popular imagination to invite its easy appropriation as an identifiable shorthand for

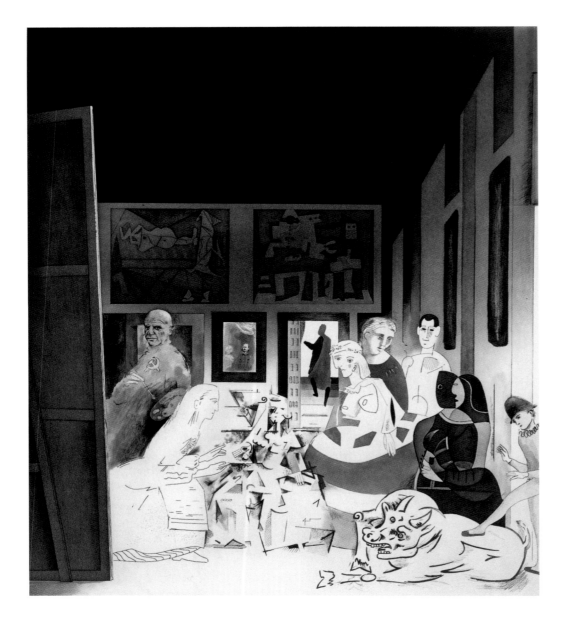

Fig.6
RICHARD HAMILTON
Picasso's meninas 1973
Etching on paper
57 × 49
Tate

wide-ranging aesthetic and political concerns. *Guernica*, for instance, has provided a model for anti-war art, from the work of Peter De Francia in the 1950s through Colin Self's denunciations of Cold War politics in the 1960s, to Goshka Macuga's installation with a tapestry replica of the mural as a centrepiece at the Whitechapel Gallery in 2009, conflating the mural's historic association with the gallery and the controversial removal of the tapestry from the United Nations during a debate about the invasion of Iraq in 2003. In other hands, some of Picasso's most memorable images have become vehicles for the sort of postmodern visual irony in which the artist himself so delighted: in addition to Hockney's numerous appropriations, these include Richard Hamilton's version of *Las Meninas* (fig.6), in which each of the characters is depicted in one of Picasso's distinctive styles, and Patrick Caulfield's wittily subversive commentary on the confrontational nature of *Les Demoiselles d'Avignon*, in his *Les Demoiselles d'Avignon vues de derrière* 1999, in which he reverses Picasso's composition so that the women are seen from the rear.

In 1942, Jankel Adler remarked that 'Picasso the greatest innovator of the twentieth century has knocked on the door of every painter's studio in the world'; such was his reputation that the same has continued to be true.[41]

Several of those who championed the artists featured in this exhibition were also among the most prominent sponsors and collectors in Britain of Picasso's work. Two of the earliest, Fry and Bell, were unstinting in their support of Grant and, for a while, of Lewis too; the paintings by Picasso owned by both critics (nos.2 and 8) acted as powerful catalysts for Grant especially. Nicholson's patrons included H.S. (Jim) Ede, who as a young curator at the Tate in the 1920s made contact with Picasso and strove to get his work shown in the Gallery, and also supplied Nicholson and Barbara Hepworth with an introduction to the artist in 1933, and Herbert Read, a vocal campaigner on Picasso's behalf in the critical disputes of the 1930s. It was on the walls of Michael Sadler's home in Leeds that Moore – like Read – must first have seen in the flesh paintings by Picasso; and it was through Penrose, a longstanding associate, that Moore met Picasso. Sadler was the first person outside Bacon's immediate circle to buy one of his paintings, the ethereal 1933 *Crucifixion* (no.89); the illustration of this work in Read's study of modern art, *Art Now* (1933), and Sadler's consequent purchase of it were both facilitated by Douglas Cooper, then a partner in the Mayor Gallery. After the Second World War Cooper took up Sutherland, whom he promoted as the 'only significant English artist since Constable and Turner' and the only one of his compatriots to merit a European reputation.[42] Later, Cooper and Hockney enjoyed a warm friendship, though they disagreed profoundly in their reaction to Picasso's late work, for which Hockney was an early enthusiast. Even over several generations, the British art world remains a small one.

Picasso's diversity allowed for a range of tastes. Fry, Bell and Sadler were in the vanguard of his British collectors, to be followed especially by Cooper and Penrose: while the latter acquired important examples of his cubist and surrealist work at a time when these still provoked hostility among less specialist audiences, Cooper built a collection that documented the development of cubism in the work of Georges Braque, Juan Gris and Fernand Léger as well

as Picasso. Like Soames Forsyte, the central character in John Galsworthy's *Forsyte Saga* (1906–21) who buys two Picasso paintings shortly after the First World War, most of those who bought the artist's pictures between the wars favoured the more easily legible output of his Blue and Rose periods.[43] Many, such as Samuel Courtauld (no.50), Frank Hindley Smith (no.47) and William McInnes (no.49), purchased just a single example to supplement their already extensive collections of impressionist and post-impressionist art. If this says something about conservative tastes, it also indicates the status that Picasso had attained as an artist whose name should be on a discerning collector's stock list. Only in the mid-1930s, when galleries in London started to arrange regular exhibitions devoted to Picasso, was a market cultivated for his more recent work, its dissonant character by then less of a barrier to its commercial appeal. By the end of that decade a number of exceptional pieces were in British hands although, in a period of economic downturn, British collectors of Picasso – as of other art – were not sufficiently numerous to compare with the Americans. At various times between the wars a number of major paintings were with London dealers but failed to find British buyers and so travelled abroad, including *La Vie* 1903 (Cleveland Museum of Art, Zervos I, 179), *Harlequin* 1918 (Harvard Art Museum, Zervos III, 159), *Two Seated Nude Women* 1920 (Kunstsammlung Nordrhein-Westfalen, Düsseldorf, Zervos IV, 217), *The Three Musicians* 1921 (Philadelphia Museum of Art, Zervos VI, 332), *Girl Before a Mirror* 1932 (The Museum of Modern Art, New York, Zervos VIII, 379) and *The Studio* 1934 (Indiana University Art Museum, Zervos VIII, 239).[44] This may reflect aesthetic taste but is equally revealing of economic disparity. Of the two most prolific British collectors of Picasso, while Cooper's neurotic Anglophobia ensured that none of his collection ended up in Britain, Penrose disposed of several choice paintings to subsidise the activities of the ICA. Penrose secured *The Three Dancers*, which Picasso regarded as his second great masterpiece after *Les Desmoiselles d'Avignon*, for the Tate Gallery in 1965 and, fortunately, some of the outstanding works still in his possession at his death have subsequently made their way into both the Tate and the Scottish National Gallery of Modern Art, Edinburgh.

THE PICASSOS OF BRITISH CRITICISM c.1910–c.1945

CHRISTOPHER GREEN

In January 1914, London saw what may have been the very first public showing anywhere of Picasso's cubist constructions. Photographs of a selection of them were included in an exhibition put together by Roger Fry at the Alpine Club Gallery.[1] '"Sculpture" devised by M. Picasso by means of egg boxes and other *debris*,' the *Athenaeum* reported tersely (fig.7).[2] It is telling, however, that collage and construction, the developments now conventionally considered most important of all in Picasso's pre-1914 cubism, are almost entirely ignored by Fry the critic, even though, as an artist, he used collage briefly in 1914–15.[3]

For Fry and his younger friend Clive Bell, who was as much an irritant as an ally, Picasso's cubism stood for an art of aesthetic 'purity' dedicated to 'design' as a unifying discipline. The fragmentary fragility of collage and construction was not an obvious comfortable fit with such a view of cubism. R.H. Wilenski, who emerged as a critic in the 1920s, did not like the critical stance of either Fry or Bell, but his idea of cubism was equally 'pure' and cohesive. In a later summing up of cubism, however, he was able to devote a perceptive passage to Picasso's and Braque's collages – he called them 'card dances' – but only by writing of them, anticipating Clement Greenberg, as a logical development of flat planar cubism; only by taking them to be a development dedicated to the unification of the disparate, produced without any relish whatsoever for the debris of the modern world.[4]

Of British writers on Picasso and cubism, Wyndham Lewis alone was responsive to the challenge that the material 'reality' of Picasso's constructions presented to the notion of modern art as aesthetically 'pure' and reassuringly cohesive. Only Lewis could echo the wide-eyed admiration shown in Paris by Guillaume Apollinaire and André Salmon for Picasso's brazen denial of painting.[5] 'Picasso,' he writes, 'has come out of the canvas and has commenced to build up his shadows against reality. "Reality" is to the artist what "Truth" is to the philosopher.' Lewis fears for these 'wayward little objects': 'You feel the glue will come unstuck.'[6] As always, Lewis is the irrepressible exception. I have started with Fry's, Bell's and Wilenski's evasion of the disruptive materiality of cubist collage and construction, because a central theme in this essay will be the need, repeatedly found in English critical responses to Picasso, especially between 1910 and 1945, for a Picasso who could be thought of as resolving contradictions, creating new,

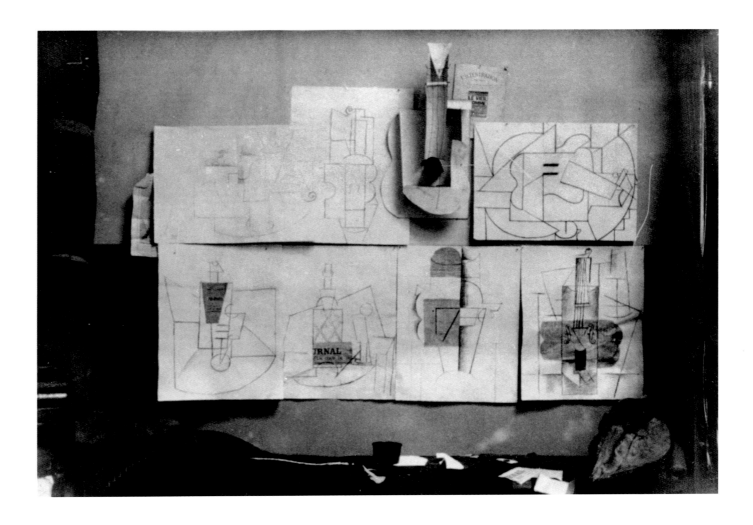

unified aesthetic experiences, even after he became aligned with surrealism, rather than the Picasso who has come to be thought of as aggressively, transgressively, 'a sum of destructions'.[7]

British displays of Picasso routinely met with outrage, but British outrage will not concern me here. My subject is the positive attempts by British writers to ask what Picasso could mean for them and for what they thought of as 'modern art' in Britain and the world. I shall be concerned above all with British responses to Picasso's art of surrealism and abstract art's emergence as a new, changing, contemporary phenomenon, which is to say in the period before the consolidation of Picasso the historical figure. That historical Picasso began to emerge in 'balanced' assessments in the 1930s, reaching a first comprehensive summing up with Alfred H. Barr Jr.'s exhibition and accompanying monograph *Picasso: Forty*

Years of his Art, at The Museum of Modern Art, New York, in 1939.[8] Its emergence was confirmed and a historical Picasso was codified in Britain in the 1950s, notably with Roland Penrose's biography, published in 1958, and the ICA exhibitions that were its prelude. But in 1930s Europe, Britain and North America, caught up in the excitement of surrealism and 'abstract art' emergenceas a worldwide vanguard, braced by the shocks that accompanied the fall into world war, Picasso and his work remained urgently contemporary. Throughout that decade critics who wrote for 'modern art' were still compelled to respond to him as a positive, innovatory force, not merely a historical fact.

In his recent piece on 'Interwar Picasso Criticism', Charles F.B. Miller leaves out British criticism altogether. One can see why. The Picasso that is the centre of his brilliant unwrapping of European critical writing on the artist is the Picasso we recognise now as proto-postmodern.

Fig. 7
Photograph of a construction by Pablo Picasso on the wall of his studio at 242 Boulevard Raspail, Paris, November–December 1912. This was shown at the Grafton Gallery in 1914.
Musée Picasso, Paris

This is the heterological, transgressive, 'black magic' trickster who, in Paris, jolted André Breton, Michel Leiris and Georges Bataille into eloquent action.[9] The Picassos of British criticism before the late 1940s do not amount to such a Picasso; these British Picassos were always simply 'modern'. Even without Eurostar, the distance between London and Paris was not great then, but the distance between Parisian writing and British writing on Picasso, at their most radical, was great.

The first major impact made by Picasso in Britain was in 1912 when, with Matisse, he was made the centrepiece of Roger Fry's *Second Post-Impressionist Exhibition*.[10] By 1914, with the publication of Wyndham Lewis's *Blast*, no radical art faction in Britain or indeed Europe could fail to take account of Picasso. Lewis could accept the challenge of Picasso's collages and constructions because, like Apollinaire and Salmon in Paris, he welcomed their sheer ugliness. 'Today,' he declared, artists are drawn 'to anything particularly hideous or banal, as a thing not to be missed'.[11] It would, however, be Fry's Picasso, the Picasso who with Matisse had taken painting back to 'the laws of design', to an art capable of stimulating what he called the 'unity emotion', who would dominate positive British writing on the artist all the way to 1930.[12] This Picasso was introduced by Fry in his 'Apologia' for the *Second Post-Impressionist Exhibition* published in the *Nation* in November 1912. Fry makes a point of dismissing the 'exaggerated' claims for the 'destructive and negative aspect' of Picasso's and Matisse's art, dwelling instead on its affirmation of 'the paramount importance of design' over 'the demand for mere imitation and likeness'. It was they, Matisse and Picasso, who would build a constructive art on the foundation laid by Paul Cézanne, leading the way back to 'the older and longer and more universal tradition'.[13] For Lewis, this was a route that led to a depressing end: 'a monotonous paradise.'[14]

Fry's certainties in his 'Apologia' did not allow a nicely resolved image of the artist. Picasso's impact was too immediate and too thrilling for that. Against much that would happen to their joint critical reputations in Britain for more than a decade, Fry opposes an intellectual, methodical Matisse to a spontaneous Picasso driven by 'sensibility'. For him, Picasso's turn towards abstraction – evident, he would have insisted, in, for instance, *Head of a Man* 1912 (no.6), one of the most recent Picassos in the 1912

exhibition – showed him impulsively resisting the fatal lure of his mimetic gifts, not consciously addressing 'abstract, intellectual problems of design'. Fry fixes on Picasso's restlessness, his 'continual experimenting', the summary, unfinished character of his work, where new ideas are rarely 'completely realised', before another arrives.[15]

Clive Bell enjoyed, it seems, taking a rise out of his friend Roger. After a war in which both doggedly resisted the gung-ho belligerence of Europe on a collective killing spree, in 1920 he followed up Fry's pairing of Picasso and Matisse as the modernist heirs to Cézanne with his own assessment of them.[16] Revealing something of his taste for refined pleasures, he wrote of their names going together like Fortnum and Mason, but he reversed Fry's opposition of their artistic personalities, to write of a Matisse driven by his 'extraordinary sensibility' and a Picasso who is inventive certainly but who is 'essentially intellectual', explaining: 'He invents conceptually and develops his inventions analytically.'[17]

In the summer of 1919, Fry, Bell and their milieu had had the opportunity to socialise with Picasso in London, during the months leading up to the London season of Diaghilev's Ballets Russes. In the early 1920s, Bell in particular, but also Fry, made a point of visiting the artist when they were in Paris. As his familiarity to the Bloomsbury critics increased, Picasso became, as is abundantly clear in Bell's 1920 piece, increasingly a model for emulation, not a shock to be absorbed. He was well on the way to becoming a 'great contemporary', even if not quite yet a historical figure. Given his established status, his art could freely be used as an endorsement of desirable routes into the future. Fry did not change his mind about Picasso's unpredictable impulsiveness, but his view especially of his cubism as 'design' tended to support rather than to detract from Bell's view of him as an intellectual, as the 'animator' of those who were drawn to 'theory' (Bell called them the 'doctrinaires').[18] It was this 'intellectual' Picasso, inventor of cubism, leader also of a return to classical forms of representation, who prevailed in positive British responses to his art through the 1920s. This Picasso was consistent above all with an idea of his work that utterly denied the destabilising uncertainties and contradictions so irresistible in much of his cubist work from 1909 into the 1920s, and already evident in *Head of a Man*.

Looking back from the end of the 1920s over his own role in the development of a theory of modernism, Fry characterised that theory altogether as 'the architectural theory'.[19] It was, however, Fry's adversary Wilenski who was most influential in disseminating in Britain in the later 1920s the metaphor of 'architecture' for all that was most 'modern' in new art, including the art of Picasso. He did so in a much read book, *The Modern Movement in Art*, first published in 1927. Wilenski's argument with Bloomsbury – he targets Bell more than Fry – is with the frankly elitist idea that the new 'architectural' art is to be identified by its power to induce aesthetic ecstasy in people of special sensitivity; rare individuals, an idea easily reduced to comical absurdity.[20] For him, this new architectural art is consistent with the secularisation of art, its retreat from the passions released by religion. The Modern Movement for him has nothing to do with anything that could be called ecstasy, but is produced by heightened, expanded but fundamentally *normal* perceptions and invites comparably *normal* responses.[21] Yet, on what was essential to the works capable of this heightened normality (if normality can be heightened), he, like Bell and Fry, insists on integration, unity, even if he ignores the possibility of a 'unity emotion'. The new 'idea of art' is 'the idea of architecture as the typical art'. The modern artist, like the architect, 'synthesizes and creates; he experiences proportion, balance, line, recession and so on, he co-ordinates and organizes his experience'. He works not with 'fragments' but with 'wholes'. Moreover, like Bell and Fry, Wilenski sees the 'Modern Movement' as a continuation of tradition: 'It is simply the idea which lies behind all the so-called classical art of the last five centuries.'[22] For Wilenski, the art of the Picasso he inserts into his *Modern Movement in Art* 'is supremely impersonal … It is magnificently classical'.[23]

Wilenski recognises the role played by Picasso's 'period of austere "abstract" architectural experiment' (cubism), but he was writing from the vantage point of 1926 and his attention is above all on the classicising representational painting of the previous eight or nine years.[24] He writes of him setting himself 'the problem of building a classical art that would recapture the peculiar serenity of Greek architectural sculpture', creating works that are 'the purest symbols of formal order that the art of modern times has anywhere produced'. His influence, he adds, has been 'enormous'.[25]

As early as 1916, Fry had been aware of Picasso's Ingrist drawings and the question mark they placed over what he too thought of as the 'abstract' experiment of cubism.[26] Like Wilenski (and Bell), he did not think of this move into classical representation as any kind of retreat, but rather as an advance. It acted as an endorsement of Fry's own growing conviction that the abstract design principles derived from cubism need not turn artists away from representation. It is worth adding that a constructive return to representation that accepted but set aside the perceived abstract extremism of cubism was, from 1919, also dominant in middle-of-the-road modernist criticism in France, in the writing of Louis Vauxcelles and of André Lhote, for instance.[27] Consensus cross-Channel criticism was well on the way to accepting the 'monotonous paradise' Lewis had feared in 1914: well-behaved art to welcome a postwar return to normality.

Fry's criticism became increasingly concerned in particular – from the publication of his anthology *Vision and Design* (London 1921) onwards – with his determination to resolve the contradiction between 'form' and what he had earlier rejected as 'anecdote' or 'literature'. What he saw as the abstraction of cubism became, for him, a fatal limitation. In his 1926 anthology *Transformations*, he brought out what he thought of as formal qualities in the way Rembrandt, for instance, told Bible stories; he wrote somewhat bafflingly of 'pyschological volumes'. By the 1930s he was speaking of 'operatic' and 'symphonic' paintings that fused the visually aesthetic and the literary.[28] It is certainly possible that Picasso's classicising styles of the early 1920s had a role in this turn. When Fry visited him in 1921, he was pleased to see 'vast pink nudes in boxes'.[29] A year later, after another visit, he wrote to Vanessa Bell of 'wonderful little pictures of nudes by the sea-shore in egg tempera'.[30] One work his description indicates he had seen on this visit together with the closely related *Family by the Sea* (figs.8 and 9), actively invites mythic narratives to be imagined; it has an explicit 'literary' dimension.

By the time Fry was developing his 'operatic' and 'symphonic' categories for such painting at the end of the 1920s, Picasso's cubism had become, for him, a salutary failure. In his 'Apologia' of 1912, Fry had brought out what he felt was the 'musical quality' of the cubist work, and that remained an important factor in his analyses of the

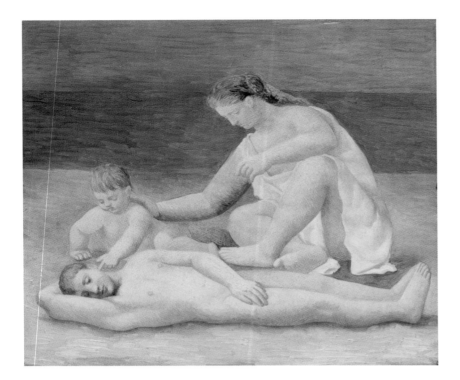

Fig. 8
PABLO PICASSO
Family by the Sea 1922
Oil on wood
17.6 × 20.2
Musée Picasso, Paris
Not in Zervos

1920s. His lecture notes early in the decade show that he continued to use a slide of the 1912 *Head of a Man* to bring out the 'new melodies' played 'in the various plastic rhythms suggested by objects' in Picasso's cubism, but by 1931 he was intent on bringing out also the limitations of a kind of painting which, as he saw it, by virtually erasing its subject matter, ended with 'almost no appeal except by its formal arrangement', and, most serious of all, which did without depth. [31] Earlier, in 1927, he confessed to an audience in Bangor that arrangements of planes confined by this restrictive flatness could not move him.[32]

There is no hint anywhere in Fry's writings, and nor is there in Wilenski's, that he was aware of the ironic, parodic aspect of Picasso's classicising 1920s work; the subversive potential of its often grotesque bodily exaggerations (no.77) , or the unsettling suggestiveness of such a painting as *Family by the Sea*. Wyndham Lewis, predictably perhaps, does show that something disturbing could be seen even from a British vantage point in Picasso's apparently reassuring return to representation. Towards the end of the 1920s, he writes of Picasso's enjoyment of the 'colossal', and adds: 'But if you compare one of Picasso's giantesses …

with a giant from the Sistine Ceiling, you will find that the Picasso figure is a beautifully executed, imposing doll.'[33] He writes of these figures almost as resembling clockwork dolls, as Sigmund Freud would write of the uncanny in the dead-alive character of automatons.[34]

By 1927, Picasso's move into the surrealist milieu around Breton was well under way, and so was the shift in his work towards an eroticised kind of figuration that confused genitalia with facial and bodily features (no.77). This was not a move that Fry, Bell and Wilenski could accept positively, given their commitment to the aesthetic and the 'architectural'. To accept the significance of the literary subject-matter was not, for Fry, ever to accept the significance in art of the erotic. His resistance was unshakable. In 1924, he published a comprehensive rejection of the claims of psychoanalysis to offer any purchase on art in his pamphlet *The Artist and Psychoanalysis*.[35] Earlier that year, privately in a letter to the poet Robert Bridges, he utterly dismissed the idea that sex could have any part in 'aesthetic apprehension'. For him, 'the preoccupation with the female nude' in painting has absolutely nothing to do with 'sexual feeling. It is simply that the plasticity of the female figure

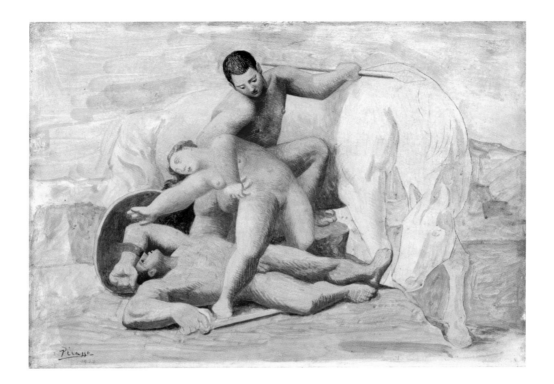

Fig.9
PABLO PICASSO
The Rape 1920
Tempera on wood
23.8 × 32.6
Museum of Modern Art,
New York.
The Philip L Goodwin
Collection, Zervos IV, 109

is peculiarly adapted to pictorial design; much more so, on account of its greater simplicity, than the male'.[36] The sexual undercurrents in a Picasso work such as *Family by the Sea* were simply unavailable to him; he had no time for the tumescent monuments of the turn of the 1920s and 1930s (no.77), nor for anything surrealist.[37]

But Fry's pamphlet, *The Artist and Psychoanalysis*, did not go unchallenged. Perhaps the most telling attack came from an emerging writer in 1924, then employed at the Victoria and Albert Museum and building a reputation as a poet and literary critic. This was Herbert Read, who by 1936 would call himself a surrealist. For Read, there was no doubt: Freud was right to see in the artist a neurotic (not the controlling designer extolled by Fry), and there was no reason why the aesthetic and the symbolic could not be experienced together.[38] From 1930, Read was to lead a fundamental shift in the direction of British art critical writing, which opened the way to new British Picassos, very different from those of Fry, Bell or Wilenski.

There was more shared ground between Fry, Bell and Read than between Read, Lewis and Wilenski. Read, like the Bloomsbury group, separated the artist as a special individual from society as a whole, and isolated what he thought of as the aesthetic impulse from every other human impulse, practical, religious or metaphysical. In *The Meaning of Art*, his 1931 anthology of art criticism mostly published in the *Listener*, he writes of expecting of the artist 'a distinguished sensibility … a unique and private vision of the world'.[39] He follows this up in his book *Art Now* (1933), his opening salvo on the side of the young British vanguard of the 1930s, by giving them a lot to live up to: 'People forget that the artist (if he deserves the name) has the acutest sense of us all; and he can only be true to himself and to his function if he expresses that acuteness to the final edge.'[40] The year after this declaration, Read contributed a piece on Picasso to an anthology, *Great Contemporaries*, and described cubism (which, like Fry, he saw as logically leading to 'complete abstraction') as above all a paradigmatic affirmation of the separation of the 'aesthetic' from what he calls 'the ideological', by which he means the 'moral or sociological'.[41] The idea that art expressed a distinct aesthetic impulse remained fundamental to his thinking, though the gap he was to open up with Fry and Bloomsbury is indicated by his readiness by 1937 to parallel the

'aesthetic' with 'the sexual impulse' – unthinkable for Fry.[42] Moreover, if the impulse behind modern art was unchanged, the new art still, for him, marked an epochal break, away from anything that could be called 'tradition'; he retained from before 1914 a wish for a Nietzschean rupture with all 'traditions'.[43] It is no surprise that one of Fry's last reviews was a no-holds-barred attack on *Art Now*, provoked in part by Read's insistence on a complete break with the past. It ended with the dismissal of Read's application of psychoanalysis to current art, with its fixation on dream imagery, and its inevitable recourse, as Fry put it, to the 'deadly monotony' of sex.[44] Tradition and monotony went together for Lewis; sex and monotony went together for Fry.

There is something more generous and confident about the acceptance of a more heterogenous 'modern art' in the writing of Read and the new British critics of the 1930s. It follows in part from a shared feeling that the defensive justifications of the previous decade centred on the question of representation were no longer needed: the argument between 'form' and 'representation' had been won by neither side, and had simply been overtaken by events. A marker of this new confidence concerning the question of representation is found in the first number of a new, self-consciously 'modern' art magazine, *Axis*, which appeared in January 1935. It opened with a piece by its young editor Myfanwy Evans, 'Dead or Alive', opposite a reproduction of Picasso's late cubist canvas, *The Studio* 1927–8 (Museum of Modern Art, New York, Zervos VII, 142) (fig.10). Evans's point was that this Picasso signposted neither representation nor abstraction, and that both were valid, since all that mattered was 'the internal truth of art'.[45] The year 1935 would see Evans and the painter John Piper move in together at Fawley Bottom, near Henley, and it was Piper writing in *Axis* in 1936 (to which Read, incidentally, was a contributor) who put his finger on a new way to think of Picasso. Piper's Picasso carries echoes of the impulsive, unpredictable Picasso introduced by Fry's 1912 'Apologia', but is unmistakably opposed to the theory-driven Picasso, leader of the modern 'school', made much of by Bell in 1920. 'Picasso,' wrote Piper, 'is a bad member of a school, either pupil or master'; even as a cubist 'he was a poor quality schoolmaster'; he was 'a bad Surrealist' and in sum was 'a shocking manifesto follower'.[46] The sheer heterogeneity of Picasso's work from the mid-1920s on had demanded

a different kind of response, one open to its plurality. In his first piece on Picasso, in 1930, Read had shown some hesitation in accepting Picasso's heteroclite production, but by 1933, in *Art Now*, he is prepared to underline the sheer range of his production positively by including his work in every one of the four strongly contrasting blocks of illustrations. The contributors to *Axis* had no difficulty in accepting his example on both sides of what had become the accepted central opposition within vanguard art: abstract art and surrealism.[47] Certainly as far as Picasso was concerned, the form-versus-representation question seemed long ago answered: it was a non-issue.

Picasso the cubist forerunner of International-Style abstract art and its more or less abstract fellow-travellers (such as Piper in the mid-1930s) was little different from the cubist Picasso of Fry's, Bell's and Wilenski's criticism; it was the surrealist Picasso that made possible a distinctly new British Picasso. To some extent this happened as one aspect of the absorption of the British vanguard into international surrealism brokered by Breton and Paul Eluard after contact had been made from London by Roland Penrose and the teenage surrealist poet David Gascoyne. Picasso himself, however, aided the process by the stress he placed on the spontaneous and the involuntary as quoted by Christian Zervos in *Cahiers d'Art* in 1932, even though he did not use the surrealist term 'automatism'. Read was quick to pick up on Picasso's famous remark to Zervos: 'each time that I undertake a picture I have the sensation of throwing myself into the void.'[48] Picasso became for him the type of intuitive artist who puts on canvas 'the sudden apparitions that force themselves on me'.[49] And Zervos's own emphasis on the anxiety that accompanies the act of creation for Picasso also fits well with Read's earlier acceptance of Freud's linkage of art to neurosis.[50]

Read's Picasso, therefore, was all but automatist before Gascoyne's *Short Survey of Surrealism* was published in 1936 and the *International Surrealist Exhibition* opened in the New Burlington Galleries in London the same year.[51] His Picasso was automatist because Read had already removed the requirement for conscious direction from his idea of the way artists produced art before he made his own move towards surrealism and became the card-carrying surrealist he was between 1936 and 1939. By 1933 Read's theory of artistic creation, as he outlined it in *Art Now*, had proposed the idea of the artist projecting symbols from

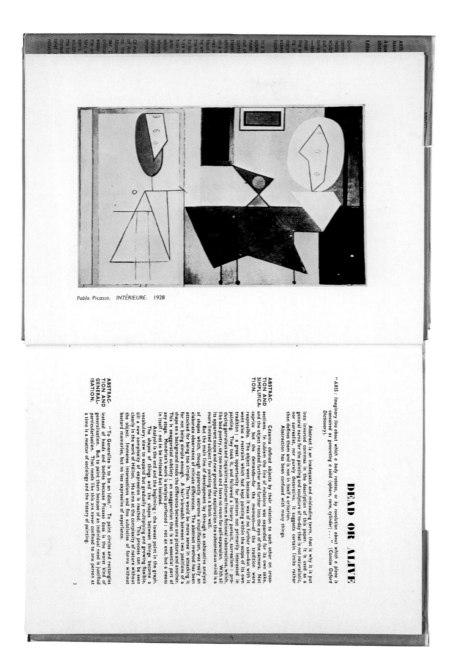

Fig.10
The Studio 1927–8, reproduced
as 'Interior 1928' in *Axis* no.1,
January 1935

the unconscious. He wrote of a new kind of non-geometric abstraction, represented by Picasso's more recent work (no. 77): the painting of 'symbolic form'.[52] He was ready with such a theory to take on board Freud's so-called late topography, in which he mapped the relationship, as he had come to understand it, between 'ego', 'id' and 'super ego' and this he achieves rather reductively in 1937 in *Art and Society*. 'The ego,' he writes there, 'gives form and physical harmony to what issues forceful but amorphous and perhaps terrifying from the id', only afterwards being adapted by the 'super-ego' to 'the ideological tendencies and aspirations of religion, morality and social idealism'.[53]

By 1937, therefore, Read, with the support of the surrealist group around Penrose and Gascoyne and the backing of Breton himself, had laid the groundwork for the dissemination in Britain of a surrealist Picasso open to psychoanalytic readings. This Picasso, however, was still the Picasso who had invented and developed cubism, and who as a graphic artist was still producing classic realist work. Read had acknowledged as much in *Art Now*.[54] The heterogeneity of Picasso's production contained within itself internal inconsistencies carried to a point that could, in the 1930s, seem to be conflicts between diametrically opposed forces. For Geoffrey Grigson, writing in the first issue of *Axis*, the geometric abstraction that Evans associated with Picasso's cubism led 'to inevitable death'. Yet what he called Picasso's biomorphism (which he aligned with the work of Henry Moore and Joan Miró, among others) was the way forward to a living art.[55] Picasso the artist stood for the dead and the live, together. That artists were subject to conflict, however, became in the 1930s for critics – and artists (among them Moore) – something distinctly positive; and Picasso became the type of such an artist. Read made of it a general principle in his Introduction to the book *Surrealism* (1936), which he edited: 'One might go so far as to say that the personality without contradictions is incapable of creating a work of art.'[56]

What is striking, however, in British critical responses to Picasso from the mid-1930s is a determination to find in his art, not conflict as destabilising tension, but conflict resolved into another, stronger kind of unity. Piper's contribution to issue 1 of *Axis* in 1935 was a review of the fourteen paintings and drawings by Picasso from Hugh Willoughby's collection, which were on show briefly at the Tate Gallery in 1934. He takes up a memorable metaphor of

Wyndham Lewis's for the opposition between the controlled and the uncontrolled; the contrast between 'some highly organised visual entity – a tiger, say', and 'a dark red splash upon a whitewashed wall'.' For Piper, Picasso was both an inventor of 'Classical form' and could be called a 'Romantic'. 'After all, a tiger as a visual entity may quite reasonably be considered a red splash in perfect control.'[57]

When Penrose reviewed Gascoyne's survey of Surrealism a year later, he was careful to quote Breton on the importance of channelling the 'forces' in 'the depths of our mind … in order to submit them later, if necessary, to the control of reason'.[58] The conscious and the unconscious had to operate together.

Piper's use of the terms 'Romantic' and 'Classical' is telling, since from the critical writings of Fry and Bell onward they were terms that were consistently applied to tie down opposed aspects of 'the Modern Movement', and to tie down the protean Picasso too. For Bell, he is 'classical', for Wilenski (surprisingly) he is 'romantic', and for Piper he is both. These terms, used as the markers of fundamental cultural antitheses, were central to Read's thinking throughout the interwar period and beyond. It was in the 1930s that Read's highly developed dialectical understanding of art in all its forms was given its initial shape.[59] Alongside the romantic/classical antithesis, during the 1920s Read developed from his absorption of the writings of T.E. Hulme and Wilhelm Worringer a supplementary pair of opposites: geometric and organic, or vital.[60] To oversimplify perhaps: the geometric pitched the enduring constancy of form against the chaos of a threatening world; the organic or vital tended to 'naturalism' from a position of control over a tamed world. Picasso, of course, could be both geometric (cubist) and organic (biomorphic). Dialectics had been central to Bretonian surrealism from the later 1920s, a dialectic whose core antithesis was between conscious and unconscious, dream and reality. The primary message of Breton's second Surrealist Manifesto in 1929 was that there existed a point where dream and reality are unified, where the antithesis is resolved in synthesis – the Hegelian sublation – a point, as Charles Miller stresses, reached (theoretically) in Picasso's merger of fantasy and reality.[61]

That was certainly the case as far as Read's Picasso was concerned. His 1934 essay itemises 'heads incomprehensibly interlocked or dislocated', 'gigantic sculptural figures built up with misshapen bones', 'forms foetal and nightmarish, actual and vital', and asserts: 'Such works of art cannot be rationally explained without some theory of the unconscious origin of such imagery.' But he also insists on 'the purely aesthetic qualities in the paintings'.[62] In *Art and Society*, three years later, now immersed in surrealism he entrusts to the Freudian 'ego', as we have seen, the role of giving 'form and harmony' to the terrifying images thrown up from the 'id'. And when he identifies 'conflict' within the personality as a necessity for creativity, he does so after claiming with absolute certainty: 'The contradictions of the personality are resolved in the work of art: that is one of the first principles of Surrealism.'[63] Indeed, for Read it was a first principle of art in general and of genius too. Early in *Art and Society* he sums up his dialectical theory of art: 'Art is what has become the fashion to call a dialectical activity; it confronts one thesis, say that of reason, with its antithesis, say that of imagination, and evolves a new unity or synthesis in which the contradictions are reconciled.'[64] Already in 1933, Read had found the mark of genius in the capacity of Picasso and Henry Moore to create unities in their fusions of abstraction and what he called then 'superrealism'.[65]

Across the period of Picasso's most forceful entrances into British culture, the resolution of contradiction – unity – remained, then, essential to the formation of the critics' Picassos and indeed to modernism altogether, as it was accepted in Britain. Even the post-surrealist Picasso of the 1930s was a figure who stood primarily for integration, psychological as well as aesthetic. Read quotes Freud: 'The real enjoyment of a work of art is due to the ease it gives to certain psychic anxieties.'[66] Picasso was something special, but his art brought balance. There is a further final point to make: these British Picassos were only rarely political. The political Picasso, of course, was introduced to Britain with, above all, the showing of *Guernica* at the *Paris International Exhibition* of 1937 and its British tour in 1938–9. One writer in particular reacted to this powerful political intervention as to be judged above all politically, the young Anthony Blunt, who had become a regular contributor to the *Listener* and the *Spectator*. Blunt was at this point a Communist fellow-traveller whose writing was driven by Marxist dialectics and, as I have shown elsewhere, in 1938 would set up a new dialectical antithesis: Picasso against Diego Rivera, though without holding out any hope for a

synthesis.[67] For him, the surrealist Picasso he first became aware of when Picasso's *Minotauromachy* etching of 1935 (no.63) was shown at Zwemmer's in London, was trapped in an internalised art devoted to 'nightmare' compulsions, of merely private not public significance; while Rivera had used the disciplines of cubism as the foundation for developing an optimistic, monumental public art.[68] *Guernica*, for Blunt, was 'a mere nightmare picture, and nothing else'.[69]

Read and Penrose responded directly to Blunt's dismissal of Picasso, and did so in a way revealing of their own difficulties in accepting this new, overtly political Picasso. Their reaction came in letters to the *Spectator* following a brutally negative piece by Blunt centred on Picasso's 1937 suite of etchings, *The Dream and Lie of Franco* (no.100–101), which included his remark on the 'nightmare' of *Guernica*, and the observation: 'the rest of the world will at most see and shudder and pass by.'[70] Both Read and Penrose made the argument for seeing the etchings and the painting not as simply propaganda, but as 'universal' in their meaning. Penrose, in particular, countered Blunt's 'private nightmare' charge by insisting on the capacity of the 'private' to communicate across humanity. For him, the 'personal' could be 'universal'.[71] He touched here on a theme that had been a key feature of Read's writing for years: the possibility that the images or 'symbolic forms' dredged from the unconscious derived their force in art from making contact with a 'collective unconscious'. The Read who so indelibly marked British criticism in the 1930s was already well on the way to what would become, after 1945, a deep commitment to the Jungian archetype, with its ground in a collective unconscious.[72]

It was Read who put comprehensively and uncompromisingly the case for art as being above any propaganda mission, even one aimed against fascism. He did so in *Art and Society*, as he came to terms with the Marxist certainties of Bretonian surrealism. The book is written as a polemic aimed above all against the late 1930s convergence of art and politics: both the ruthless totalitarian control of art in the Soviet Union and the Germany of the Third Reich, and the use of art for propaganda purposes by the alliance between Communists and Socialists of the Popular Front in the West. Read's position was unequivocal: art was 'an autonomous activity, influenced like all our activities by the material conditions of existence, but as a mode of knowledge at once its own reality and its own end'. It was the product of the 'aesthetic impulse', like the 'sexual impulse', and must not be made 'subordinate merely to a political doctrine'.[73]

Both Read and Penrose would be instrumental in the formation of Picasso-the-historical-figure, which in the 1950s would take over from Picasso-the-critical-force. The Picassos that survived from the critical writing of the 1930s would continue to have purchase on opinions. These Picassos, it is worth emphasising, besides standing aside from politics (something that continued to be possible even with Picasso being a Communist Party member), were not the Picasso who, for instance, would help draw Francis Bacon towards a 'realism of the imagination' open to horror.[74] As Dawn Ades has demonstrated, the periodical *Documents* edited by Georges Bataille in 1929–30, including no doubt its special Picasso number, was one stimulus for Bacon.[75] But Bataille's Picasso, which has so indelibly marked our 'Surrealist' Picasso – that excessive, cruel, erotic, morbid, 'informe', transgressive, Bacon-like Picasso – was neither the Picasso of Piper, Evans, Read nor Penrose, let alone that of Fry, Bell or Wilenski. Fifty years later, our Picassos, like the Picassos of radical French criticism in the 1930s, are very different from theirs.

THE POLITICS OF PICASSO IN COLD WAR BRITAIN

ANDREW BRIGHTON

By the 'Establishment' I do not mean only the centres of official power – though they are certainly part of it – but rather the whole matrix of official and social relations within which power is exercised.
HENRY FAIRLIE, *Spectator*, 23 September 1955

Every action, in the middle of the twentieth century, presupposes and involves an adoption of an attitude with regard to the Soviet enterprise.
RAYMOND ARON, *The Opium of the Intellectuals*, London 1957

The world's returning to normal – or is it?

In December 1945 a Picasso-Matisse exhibition opened in London at the Victoria and Albert Museum. But for war damage, it would have been at the Tate Gallery. It was a foreign intrusion. The British Council administered the tour of the show, but it was a gift from the French Government for Britain's role in the Liberation. It was the first major exhibition in Britain of modernist art in a public museum.

'That we can hold art shows again is a sign that the world's returning to normal – or is it?' ran the commentary to a British Paramount newsreel.[1] For a month, Picasso's work provoked crossed pens in the correspondence columns of the *Times*. D.S. McColl, a former Keeper and Trustee of the Tate Gallery, and Professor Thomas Bodkin, Director of the Barber Institute of Fine Arts, Birmingham, co-signed an early contribution: the 'invasion' of the V&A by 'two contemporary foreign painters of highly disputable merit' was unjustified, and schoolchildren at least should be barred from this 'crazy guying of humanity'.[2] The *Church Times* observed that the British Council had performed the astonishing feat of 'setting the whole of the population of England arguing about aesthetics'.[3] This was not true; the media had performed the feat. From newsreels to newspapers, from journals of opinion to popular weeklies the response to the exhibition made Picasso a standard-bearer and a target. He stood for modern foreign art and its British brigade of initiates. A few years later, Wyndham Lewis estimated the British initiates to number no more than five or six thousand.[4] Nevertheless, in London in 1945 there was in private hands a concentration of European modernist art of high quality and importance due to Nazism and the commitment of a few dealers and collectors, in particular Roland Penrose and Douglas Cooper.

Fifteen years later, something had changed. In July 1960, a major Picasso retrospective opened at the Tate Gallery. It was organised by the Arts Council of Great Britain (ACGB) and financed from its Government grant. It was possible because leaders of the modernist brigade were empowered by the state; they had become one of the constituencies of the Establishment. The *Times* published no fulminating letters. Even in the popular dailies, Picasso's work received

respectful attention. The exhibition had near to half a million visitors, twice as many per day as attended the V&A show. It made a substantial profit.

The results of searching for Picasso's name in the indices of those fifteen years reveals his contested status. At stake was more than what should hang on the walls of public galleries. Picasso as the breaker of traditional pictorial norms connoted a concept of modernity, a modernity that challenged the hierarchies, norms and ethos predominant in the Establishment. One fact, however, complicates the story: Picasso's membership of the Communist Party (CP). His significance figures in another terrain, the politics of the CP and the Cold War. This essay sketches some incidents in the reception of Picasso within both Cold War politics and the politics of Picasso's status.

The Party's Dilemma and the Incipient New Left

On 7 October 1944, three days after the event, the *Daily Worker* reported on an inside page, 'Pablo Picasso, the famous artist and ardent anti-Fascist, has joined the French Communist Party'.[5] News in the *Worker* was always late because it came via Moscow, or so went the standing joke. Picasso's membership was a dilemma for the Party. His status as an artist was constituted by his pre-eminent contribution to modernist art. In the opening address at the Soviet Writers' Congress held in Moscow in 1934, which established Socialist Realism as the theoretical core of Communist Party aesthetics, Andrey Zhdanov denounced Modernism as 'absorbed in pessimism, doubt in the morrow, eulogy of darkness', an anti-humanist symptom of a dying culture.[6] Zhdanov was speaking as Secretary of the Central Committee of the Communist Party of Soviet Union (CPSU). While continuing at the top of the Central Committee Zhdanov had a number of other roles including Director of Cultural Policy from 1946 until his death in 1948. In his particularly crass version of Socialist Realism art must be accessible and progressive; it must be both comprehensible to the workers and represent life in USSR under leadership of the CPSU and that of its allies and claimed antecedents as moral, positive and heroic. The *Worker* report mentioned *Guernica* as evidence

of Picasso's 'humanism' and anti-fascism but otherwise said nothing about his art.

No other British newspaper reported the event. Picasso's Communism was not news. Stalin was still Uncle Joe, a fighting ally. The subservience to Moscow of the national communist parties was veiled by Stalin's policy of 'broad alliances'. The Cold War was three years away. They reported, however, the anti-Picasso riot by Beaux Arts students at the Salon d'Automne a few days later. Giving Picasso's wartime work the starring role as an emblem of cultural resistance was peculiarly French, as was the riot. The notion that modern art could matter that much and in that way was as foreign to Britain as eating snails.

Our Time was an arts monthly owned by a group of intellectuals within the Communist Party of Great Britain (CPGB). They submitted to Party discipline but *Our Time* was not a Party publication. In 1944 Edgell Rickword replaced a workerist editor, against the wishes of the Zhdanovian Emile Burns, the chair of the CPGB Culture Group. Incomprehensibility to the workers was a regular disciplining criticism of the Party's own intellectuals. Rickword's first issue as editor of *Our Time* was in November, the month after Picasso's enlistment. He gave it fulsome coverage. The cover reproduced the 5 October front page of *L'Humanité,* the daily paper of the French Communist Party (PCF) with its photograph of Picasso at PCF headquarters joining the Party. 'An historic scene' headed the lead editorial (fig.11).

In France the separation of the people and intellectuals was carried to extremes; Gustave Courbet breached the separation at the time of the Commune. Now 'a greater painter than Courbet' honoured and was honoured by French democracy. It was a 'tribute to the Communist leadership in the struggle for national freedom'. For all its Party polemic, the assertion of Picasso as a greater artist than Courbet departed from the Soviet insistence on accessible socialist realism; Courbet was claimed as a heroic forefather. The editorial implied a non-Zhdanovian view of modernism.[7]

Our Time's review of the V&A exhibition a year later was by the artist and non-Party member Julian Trevelyan. He did not take the cultural horizons of the proletariat as a criterion. In a language that may have to be 'learnt before it can be understood', Picasso is a 'destroyer of outgrown aesthetic concepts, and of over precious standards of taste'.

Fig.11
A report on Picasso joining the French Communist Party from *L'Humanité*, reproduced on the cover of *Our Time*, November 1944
The Marx Memorial Library

A second article surveyed the press reception of the exhibition. It compared the general method of attack on Picasso in the popular dailies with Nazi invective against intellectuals and modern art. It instanced the *Daily Mail,* which reproduced a Picasso alongside one of the doodles scribbled by Hermann Goering during his Nuremberg trial; the caption read, 'Which is Art?'[8]

In the CPGB publication the *Modern Quarterly* in 1946 Derek Kartun, the Paris correspondent of the *Daily Worker,*

expounded what was emerging as the formula to cover the contradiction of 'the great artist' whose work was neither realist nor comprehensible to the masses. Picasso is 'the greatest living artist' with a 'strong intellectual and emotional link to the forward march of the common people'. His work reflects the agony and horror of our times but his paintings give little or no inspiration to the working class. Unlike the great artists of the past, his art is out of touch with the profound movement changing

history. Artists are caught up ideologically and financially in the bourgeois art world, which ruins their judgement with its 'insatiable appetite for the grotesque, the new and the clever'. Art suffers from forty years of 'barren experimentalism with form'.[9]

As the Cold War hardened the Party line, Rickword was bullied into resigning his editorship of *Our Time* in 1946, primarily by Emile Burns, and the journal ceased publication in 1949. E.P. Thompson was to observe that Rickword and the *Our Time* circle exhibited a 'premature revisionism' long before the Party fractures of 1956.[10]

Horizon, the Establishment and Evelyn Waugh

The November 1944 issue of *Horizon* mentioned that Picasso had joined the Communists in a report on the literary situation in France. Edited by Cyril Connolly, *Horizon: A Review of Literature and Art*, ran from 1939 to 1949. Its outlook was international and Picasso a feature in its cultural landscape. In 1946 Connolly listed some 'major indications of a civilized community': along with 'a passionate curiosity about art' went no capital punishment; no censorship; no discrimination against colour, race, class or creed; laws on homosexuality, divorce and abortion based on 'intelligent humanism'.[11] Connolly's desiderata were the mores of the Keynesians in the generation of upper-middle class, public-school reared, Oxbridge graduates entering the postwar Establishment as civil servants, politicians, journalists and academics. By the end of the 1970s they had campaigned and legislated to make Connolly's indicators a social reality.

One of the Bloomsbury group, Maynard Keynes owned work by Cézanne, Braque and Picasso. Not to respect art was not just philistine; it was to align yourself with the forces of stupidity. Keynes had argued in the wake of the Versailles Peace Treaty that the world was being ruined by stupidity rather than wickedness, 'a doctrine with obvious appeal to the clever', observed his biographer Robert Skidelsky.[12] A corollary had been built into the foundations of English modernism by Roger Fry. Conventional 'pseudo-art' was the sentimental merchandise of the ignorant plutocracy whereas he attributed intelligence to modernism's cognoscenti in

such phrases as: 'Intelligent first patrons ... intelligent writers on art recognise ... established amongst the intelligent.'[13] Keynes was the architect and his influence in Whitehall decisive in the creation of a new body within the matrix of public art institutions. Established in 1946, the ACBG gave powers of patronage to 'intelligent' opinion.

In 1945 Connolly saluted the election of Labour as giving 'us a Government of reasonable people, people like ourselves who are "we", not "they" and who are unlikely ... to use the word "intellectual" as an insult'.[14] In a letter to Philip Larkin from Oxford in 1946, Kingsley Amis picked up modern art as a sign of grace in the communion of the intelligent. 'I've discovered the way to my tutor's heart – he likes all those shags like Pickarso ... so I say things like "blue period" and "delicate colour sense" instead of "Saga like" and "piling on images".'[15]

When, in January 1946, Connolly attacked the enemies of *Horizon*, he characterised them as 'full of hate of other countries, you talk of Frogs, and Yanks and Wogs, and write to *The Times* against Picasso'.[16] This suggests an enemy in mind, his friend Evelyn Waugh, who wrote in his epistle to the *Times*:

> Señor Picasso's paintings cannot be intelligently discussed in the terms used of the civilized masters. The question to be asked of his work is that asked by the devotees of a crooner, 'did he send you? ... Modern art, whether it is Nazi oratory, band leadership, or painting, aims at mesmeric trick and achieves total success or total failure ... people who fall victims to Señor Picasso are not posers. They are genuinely 'sent' ... But let us not confuse it with the sober and elevating happiness which we derive from the great masters.[17]

This is not just vicarious ridicule; in British aestheticism from Walter Pater to the Bloomsbury group momentary aesthetic ravishment was prized and described in terms redolent of orgasmic pleasure.

Noel Annan in *Our Age: The Generation that Made Post-War Britain* (1991) lists Waugh as one of the deviants of his generation; 'he went against the grain of decent opinion'.[18] What separated Waugh, says Annan, was his Augustinian Catholicism. It enabled him to give the tacit mores of traditionalism a theological spine. For an Augustinian, the avoidance of ruinously wicked acts is a gift of God's

grace, not cleverness. To Waugh, the promise of collective redemption by 'intelligent humanism' and good government was a heretic delusion of modernity, and modernist art gave no glimpse of grace.

Beleaguered Centres: The Royal Academy and the Tate Gallery

In 1953 the Royal Academy mounted an exhibition of the School of Paris. Picasso denied permission for any of his work to be included, because of comments made in a speech by Alfred Munnings. In 1943, Munnings was elected President of the RA, the dominant institution of contemporary art in Britain. After the Picasso-Matisse exhibition in 1945 he held a dinner for the anti-Picasso contributors to the *Times*.

In 1949 the BBC Home Service broadcast to the nation the speeches from the first Royal Academy Dinner since the war. In his ribald oration Munnings reported that he and Winston Churchill had agreed that they wished to kick Picasso up the backside. The all-male assembly of members and their distinguished guests were much amused. He made no mention of Picasso's politics. However, it was a political speech. Munnings spoke for art embedded in a style of life, against art embedded in a deracinated discourse. He identified his enemies and his friends. Among the enemies were, 'highbrows, experts who think they know more about Art than the men who paint the pictures, they see so many pictures their judgement becomes blunt ... That reminds me of Anthony Blunt ... telling people that Reynolds was not as good as Picasso. What an extraordinary thing for a man to say.'[19] As his friends, Munnings claimed not only Churchill; 'I am right I have the Lord Mayor on my side and all the Aldermen and all the City Companies ... the Master of the Mercers' Company – Lord Selbourne – and I am sure he is with me'.

Churchill and Selbourne were aristocrats. Munnings was a painter of the pastimes of the landed: the horse, the hunt and the racetrack. Their names invoked the ethos of his rural boyhood when country and Country were aligned in the hegemony of the aristocracy. By 1949 their power, wealth and lifestyle were severely reduced, their authority

obsolescent.[20] It was not landed income and aristocratic status that gave Churchill and Selbourne places at the Royal Academy Dinner. It was their careers as soldiers and politicians and then, in Selbourne's case, into the City and directorships. He joined the financial plutocracy to which the Lord Mayor of London, an accountant, the Aldermen and members of City Companies belonged. Nevertheless Munnings was probably right; they did not signal their wealth by collecting modernist art.

Munnings received sacks of letters and telegrams and popular press support for his speech. The Royal Academy was to retain its audience and patrons among the great and good. Subsequent RA presidents aimed after-dinner jocosities at Picasso. Its members continued to paint as if cubism had never happened, some with seriousness and distinction. In practice, the RA was more latitudinal than Munnings' bigotry suggests. Its heterodox membership had no shared aesthetic ideology to defend. Rather, it aimed, in the defensive words of Walter Lamb, its Secretary, 'at preserving and developing a healthy tradition which keeps in touch with the perception and interests of normal people'. Its audience were the 'general public ... of normal sense and intelligence'.[21] In modernism it was facing an economy based on an initiate public and the abnormal value of a few artists, not the heterodox many.[22] For its adherents including its historians, modernism was an ethical cause. Its value was asserted in an account of aesthetic authenticity wrenched by an international canon of artists from the jejune norms of the plutocracy's bourgeois 'perception and interests'. In the 1950s it was expedient as well as principled for British modernist artists to refuse invitations to become RA members.

John Rothenstein, the Director of the Tate Gallery, was one of the more reflective critics of modernism but still subjected to Munnings's visceral abuse, sometimes laced with anti-Semitism. Writing in 1952, Rothenstein described Picasso's influence as destructive. The impact of cubism was part of a 'catastrophic' disintegration. Art had lost inspiring subjects and discipline, and had abandoned visual experience for an unfettered expression of personality. For Rothenstein, English modern art was of more interest than the French, as it combined French inventions with the 'traditional subjects of European art'.[23] This view, Douglas Cooper and others charged, caused Rothenstein

to make an inadequate collection of European modernist art at the Tate. There were no cubist works in its collection until 1949. That year, under pressure from the Tate's trustees led by Graham Sutherland, Rothenstein went to Paris and with Douglas Cooper's guidance, bought two Picasso paintings, *Bust of a Woman* 1909 (no.54) and *Seated Nude* 1909–10 (Tate N05904, Zervos IIa, 201).

However, in the opinion of its critics, under Rothenstein the Tate continued to be scandalously tardy in its purchases of foreign modern art. Rothenstein nurtured the idea of an indigenous British tradition. As did Kenneth Clark both in his writings and by his powers of patronage as the chair of a number of public arts bodies including the ACGB. However, this conception of, in reality, an English Art with its equivocal attitude to Modernism was to sink into irrelevance in the Atlanticist discourse of the emerging generation of 'experts' who were to run the public institutions of art.

launched what was called, using a phrase from Lenin and which rapidly entered the lexicon of CPGB, the 'Battle of Ideas'. Picasso was amongst the distinguished intellectuals whose much-cited names gave moral authority to the 'Peace Campaign'. And he provided the many versions of the Dove of Peace which became the campaign's brand image. He produced one for the Second Congress at Sheffield which the *New Statesman* described as looking as if it had been dragged backwards through an iron curtain. Rather than a Dove of Peace it was a 'Muscovy Duck'.[24] (fig.12)

Why were some overseas delegates barred? In expectation of a Third World War, the peace movement was officially assessed as a tool of Soviet subversion. It was, in a phrase coined by the then Labour Party foreign affairs adviser Denis Healey, 'A Trojan Dove'. The government decided to 'cripple' the Congress by administrative

The Trojan Dove

'What can I have done that they should have let me through'? This was Picasso's question to Roland Penrose when he arrived alone at London's Victoria Station in November 1950. He had set out from Paris as a member of a party of fifty-two delegates to the Second World Peace Congress in Sheffield. On landing at Dover, all but Picasso were denied entry. Why?

First, why was he there? The end of Stalin's policy of broad alliances was announced by Zhdanov at the inaugural meeting of Cominform (Communist Information Bureau) in 1947 which re-imposed a rigorous Moscow party line. Zhdanov declared the world was divided between war-hungry capitalism and peace-loving socialism. His speech

Fig.12
Poster for the Second World Peace Congress,
Sheffield, 13–19 November 1950
Lithograph
80 × 57
Collection Adrian Dannatt, New York

measures. These included leaving the organisers in uncertainty as to how the policy of *persona non grata* would be applied to bar overseas attendees.[25] The night before the opening day, presented with the enforced absence of 285 of the 745 overseas delegates, the Congress was cancelled and relocated to Warsaw.

Why was Picasso admitted? As the Cabinet refused to ban the Congress, the Foreign Office sought to 'reduce it to a fiasco'.[26] Prime Minister Clement Attlee's speechwriter had advocated 'making a laughing stock of some of the persons on whom the organisers will rely for prestige: a judicious mixture, in fact, of serious exposure and of ridicule'. Picasso was an apt target; already the object of media derision, his status as an artist was thought to have no political influence. Questioned in the House of

Commons about the 'tricks' used to stultify the Congress, the Home Secretary, Chuter Ede, said his selection of certain foreign delegates for exclusion was 'merely to separate the shepherds and the dogs from the sheep'. He remarked of Picasso, he 'is of no political interest. I invite anyone who doubts my word on that to read the profile that was written of him in last Sunday's *Observer*'.[27]

The unattributed *Observer* 'Profile' was probably a piece of Government-planted spin. It traduced rather than exposed Picasso. Picasso is profoundly muddled, it proposed, a decoy for the Kremlin, which, since his conversion, had ceased to call him bourgeois and decadent but still did not exhibit his work. The article accused him of passivity during both the Spanish Civil War and the Occupation of France, of having a 'peculiar mind', and

Fig. 13
Roland Penrose at 11A Hornton Street, London, in the early 1950s. In the background is Picasso's **Young Girl with a Mandolin** (top left) and **Still Life** (centre)
Roland Penrose Estate

of showing 'childish enjoyment in the fruits of fame and wealth'. It did assert, 'he is a great artist'. Then undermined its assertion. The future will see him as highly subjective, a distressed victim of a distressed time about whom a lot of nonsense was talked and written.[28]

Picasso never returned to Britain. He did, however, give work to be used as graphics or to raise money for the causes of 'intelligent' opinion in this country and internationally. Through Penrose's agency, he regularly gave pieces to raise money for the Institute of Contemporary Arts. There are letters of appeal and/ or thanks in the Picasso Archive from a variety of British organisations. These included not only communist front organisations like the British Soviet Friendship Society, but also the National Campaign for the Abolition of Capital Punishment, Amnesty International and the Anti-Apartheid Movement.[29]

The Communist Party opposed the unilateralist Campaign for Nuclear Disarmament until 1960. The CND symbol, designed by Gerald Holtom in 1958, became an international symbol for the peace movement. It carried no connotation of Muscovy Duck.

Zhdanov's Gift and Discarding

Zhdanov's gift to modernism was to freight it with import. The strictures of Soviet socialist realism made modernism a banner and art criticism an engagement in the 'Battle of Ideas'. For instance, when David Sylvester, a man of the non-Communist Left, reviewed the *Twentieth Century Masterpieces* exhibition at the Tate Gallery in 1952, he knew what side he was on. As he explained, the exhibition was organised by the Congress for Cultural Freedom. It had been part of a thirty-day arts festival in Paris. It was in effect an exhibition of the modernist canon including Picasso. The press release made the politics of the exhibition explicit; the exhibition 'could not have been created nor [would it have been] allowed by such totalitarian regimes as Nazi Germany or present day Soviet Union'.[30] Sylvester does not report this claim. What he probably did not know was that the festival and the CCF were funded by the CIA.

The politics of Sylvester's text lay in the explication of his judgements. He confined his review to 'picking

winners' and the winner was Picasso's *Young Girl with a Mandolin* of 1910 (Museum of Modern Art, New York, Zervos II, 235). It belonged to Roland Penrose. (fig.13) 'To reconcile opposites is one of the highest functions of art ... it is astringently architectural, yet tenderly and sensuously human ... it is above all serene, with a serenity that does not soothe but elevates.' He justifies his judgement by describing how its visual character constitutes an aesthetic experience of a high order. He posits art's autonomy and modernism as the art of our time. However, Sylvester's terms of praise, 'human', 'serene', 'elevates', carry a moral connotation. There may be an additional politics going on. The review appeared in the politically right-wing Catholic monthly, the *Tablet*.[31] It is as if he were finding in Picasso what Waugh had found absent.

Sylvester was for many years a contributor to the *New Statesman*, the house journal of 'intelligent' opinion. Until his death, Maynard Keynes had been chair of the *New Statesman* Board. In 1950 Malcolm Muggeridge said that the *New Statesman*'s proposition was that 'to be intelligent is to be Left'.[32] Picasso had long been advocated in its pages by, among others, Clive Bell and, postwar, by Patrick Heron. However, its dominant voice on art in the 1950s was John Berger. A non-Party Communist, he attributed nihilism to much modernist art, seeing it as the expression of the moral chaos of capitalism. Berger tended to accuse its adherents of fashion following, bad faith or venality. In 1954, he offered an argument that rescued Picasso's art for communist politics by sophisticating the stipulations of socialist realism. He asked why Picasso was the most famous artist in the world, and answered that it was because Picasso offered hope in the morrow. It was not the individual works that made Picasso socially progressive; it was his 'personal spirit'. In a period of confusion when human and cultural values had disintegrated, Picasso showed 'that within the confusion, out of the debris, new ideas, new values, new ways of looking at the world can and will develop ... It is the present existence of that spirit that we celebrate'.[33]

In 1956, the Communist Party of Great Britain fractured in the wake of Khrushchev's revelations and the invasion of Hungary. It lost a third of its members including many of its leading intellectuals. Ex-Party members were amongst the founders of *Universities and Left Review*. The first edition in 1957 included 'Commitment in art criticism'

by the non-Party Marxist artist, Peter De Francia. He considered 'the great achievements of our time – Cubism, the work of Léger, Guttuso and Kokoschka, and the over-riding importance of Picasso.' In the context of the 'Battle of Ideas' this was a coded assertion of a Western Marxism un-beholden to what De Francia called the 'mechanical criticism' of the Marxist countries. Since he was eighteen De Francia had been reading the theoretical writings of Antonio Gramsci who until his imprisonment in 1926 had been head of the Italian Communist Party. In the early 1950s Gramsci's sophisticated Marxism was such a threat to the Zhdanovian Marxism of the CPGB that it blocked party member Hamish Henderson from publishing trans-lations of Gramsci's seminal *Prison Notebooks*.[34] De-coded, De Francia's essay advocated a sans-Zhdanov Marxist recasting of Modernism as part of an intellectual assault on bourgeois cultural hegemony. For many Marxist intel-lectuals pre-1956 art mattered that much and in that way. In England, wrote De Francia, 'the idea that intellectual movements could carry weight, be heard, produce the fundamental changes in outlook, vision, and liberty in society' is rejected. But 'this must be done'.[35] However, amongst the editors of that first edition of *Universities and Left Review* was a founding figure of Cultural Studies, Stuart Hall. In the subsequent advance of the New Left into the academic establishment, the idea of great art, art itself and eventually Picasso were brought in for questioning and charged with ideological vices and complicity in hegemonic culture.

The Politics of Picasso and the Arts Council of Great Britain

In the 1950s Picasso was the foreign artist most exhibited by the ACGB even after the Sheffield Congress had advertised his Communism. Why was a Government-funded body allowed to give such prominence to a Communist during the height of the Cold War?

Two examples give some indication of attitudes in official circles. The Government commissioned an Independent Enquiry into Overseas Information Services, chaired by Lord Drogheda and published for security and diplomatic reasons in an expurgated summary in 1954.

The British Council was part of its remit. 'We do not believe that a knowledge of the English language, a taste for British books, admiration for British medical science or modern sculpture are likely to make the slightest difference to the outlook of the average educated European on the subject of Communism.'[36] This view is very different from the one that prompted the CIA to covertly fund modernist art as a way of influencing the non-Communist Left in Europe. In *What Is Culture?*, a pamphlet in a series written for distribution abroad and covertly funded and editori-ally supervised by the Foreign Office counter-propaganda section, the Information Research Department, T.R. Fyvel asserted 'that genuine culture rests as much on the art of civilised social relationships as on the level of literary or artistic proficiency'.[37] British Council experience, he claimed, had shown Britain's civic arrangements, for instance, local government, trade unionism, the work of the probation service, and so on, were the key to 'a genuine understanding of British culture'. Traditional high culture was secondary and the contemporary arts favoured by 'intelligent' opinion were near invisible in his account of British culture. It would seem that modernist art at home and abroad was assumed in the centres of official power to be culturally marginal and politically inconsequential.

Another reason why the ACGB was able to exhibit Picasso was that Keynes placed responsibility for the Arts Council in the Treasury. During the 1950s, there were no Government cultural policies, no Minister or Secretary of State for the Arts to answer detailed questions in Parliament. A price paid was a derisory level of funding compared to equivalent European countries. The journalist William Conner writing in his Cassandra column in the *Daily Mirror* reported in the late 1950s that the state spent more on military bands than on the arts. Further, the Council was structured to guard the integrity of its cultural judgements. The ruling council of the ACGB was a dog wagged by its multiple tails; its specialist panels, dominated by leading arts professionals, made the deci-sions as to who and what got funded. Many of the art professionals did not have a public school and Oxbridge education; but for their distinction in art, they were not part of the Establishment social matrix. Their professional integrity was the source of their status; they were people unlikely to take political interference without protest. 'We wish to affirm our distrust of political partisanship and

propaganda in artistic affairs from whichever side it comes … We deplore the attitude of a newspaper which says in effect: "Picasso is a Communist. Anyone who wants to meet Picasso must be a Communist sympathiser".' [38] This comes from a letter to the *New Statesman* in November 1950. The authors were reacting to a report in the *Evening Standard* of a party held in London to honour Picasso during his Peace Congress visit. They saw in the report a trend that could lead to a situation like Nazi Germany, 'when a man was judged not by his work but by his race and his politics'. Of the letter's seven signatories Henry Moore, Herbert Read, Rodrigo Moynihan and Roland Penrose served on the art panel of the ACGB.

To say that a person's work is not to be judged by their politics, is not to say that their work has no political or social significance. In modernism, art as art was read as constituting an ethical critique. Herbert Read, the most influential advocate in Britain of Picasso and modernism from the 1930s and into the 1950s, claimed that his art criticism was at one with his anarchism. He construed modernist art as a rejection of the inauthenticity of industrial society. It follows from the attribution of ethical import to modernist art, that it can be ethically betrayed. For Read, writing in 1951, Picasso's *Massacre in Korea* 1951 (Musée National Picasso, Paris, Zervos XV, 173) was just such a betrayal. Whereas *Guernica* was painting with political purpose, 'it is still first and foremost a painting – a composition of great complexity but of overwhelming unity', whereas *Massacre* looked like Moscow had dictated how it should be done. It was compositionally crude, 'the distortions ineffective even as caricature … Some power not Picasso has inspired its hatefulness; and the pity it induces is not for the victims of war, but for an artist who has lost his integrity'.[39]

Nevertheless, Picasso as the standard bearer for an ethos could be betrayed. Penrose was the curator of the 1960 Tate Picasso retrospective. At the opening event he was photographed in white tie and tails conducting the Duke of Edinburgh around the exhibition. Subsequently the Queen and Princess Margaret were given a well-publicised Penrose tour. In the politics of status this was seen as kowtowing to the enemy. George Melly wrote to his former comrade in surrealism, 'I hope you enjoyed the little jokes HRH will presumably have made in front of the pictures … I find the whole concept an insult to a great painter. What are you after? A title?'[40] Penrose was made a Commander of the British Empire in the New Year Honours List. It was advantageous for the Establishment to be associated with the Picasso retrospective and give an implied acknowledgement to the spirit of modernity of which he was an emblem. After eight years of Conservative Party Government, the Establishment needed to counter its image as anti-meritocratic, backward looking, insular, philistine.[41] It was a token embrace. Modernism and Picasso were not the kind of thing one bought for the Royal Collection or hung in the Officers' Mess or on the walls of Whitehall offices, Oxbridge Senior Common Rooms and in the homes of the great and the good. Picasso and modernism had won a place within the Establishment estate, but not at its heart.

In 1964 Connolly's 'we' were returned to power. The Labour Party won the election promising to empower expertise in a new meritocratic Britain. The funding of the arts and the British Council was increased; governments appointed Ministers and published policies for the Arts. In at least one respect, it was and continued to be too little too late. For lack of domestic collectors of modernist art and insufficient public funding many of those important works in London in 1945 went abroad, including in 1956 Sylvester's 'winner'. *Young Girl with a Mandolin* now hangs in The Museum of Modern Art, New York.

Fig.14
Douglas Cooper, Picasso and
John Richardson, 1959.

COOPER'S CAPERS

AND THEIR CONSEQUENCES FOR PICASSO, PENROSE AND THE TATE

John Richardson interviewed by
Chris Stephens, October 2011

The present show, *Picasso and Modern British Art*, needs to be seen in the light of two battles that took place more than fifty years ago: the so-called Tate affair, which involved the exorbitant cubist collector and mischief-maker Douglas Cooper's attempts to unseat the director of the Tate Gallery, John Rothenstein, and Cooper's efforts to undermine Roland Penrose's great 1960 Picasso retrospective. As one of the few survivors of these events, Picasso biographer John Richardson hopes to demonstrate how they paved the way for this exhibition.

cs First of all John, how do Douglas Cooper and Roland Penrose compare with today's collectors, who pay up to and over 100 million dollars for a major painting or sculpture?

JR Cooper and Penrose were anything but hedge fund billionaires. Besides their acumen for modern art, both were comfortably well off, but I doubt if either of them ever paid more than five figures for a work of art. Art has risen far higher in value than currency.

cs So you didn't have to be a millionaire, let alone a billionaire, to assemble a great collection?

JR No, you needed a very sharp eye and a very sharp perception of what a modern artist is all about and where he is going. Even the greatest of artists need reassurance from people they respect.

cs Had Douglas ever held a paintbrush?

JR No. Roland Penrose was trained as a painter; Douglas never even doodled. His obsession with modern art was primarily intellectual.

cs Is it true he was Australian?

JR As Douglas rightly insisted he was *not* Australian. True, his great-grandparents had migrated to Australia early in the 19th century and wound up with vast holdings in the Woollahra section of Sydney. In addition, they became the biggest shippers of gold in the country. After becoming Speaker of the House in the New South Wales Parliament in 1856, Douglas's great-grandfather was made a baronet:

Sir Daniel Cooper of Woolahra. Thenceforth the family spent most of their time in England.

cs How does Douglas fit into the family?

JR He was the eldest son of the second baronet, and therefore not a primary heir. According to Douglas, his 'idiot family' stupidly sold their vast Australian holdings In the 1920s. No wonder he resented being landed with a down-under provenance ('It's just possible I was conceived in Sydney Harbour, where my parents supposedly spent their honeymoon.') and jokes about Cooper's sheep dip ('nothing whatsoever to do with my family') and the Australian sheep that supposedly bleated, 'Bra-a-a-que.' Although a minor matter, it fuelled Douglas's paranoia; paranoia made for Anglophobia, the only form of patriotism that he permitted himself.

cs Why the vehemence?

JR Douglas inherited this from his art-loathing father, known as 'Artie'. Besides being a high-ranking Freemason, Artie 'did absolutely nothing with his life,' Douglas said, 'but vent his temper on anyone who disagreed with him.' Douglas inherited a vestigial sweetness from his plump, warm mother, Mabel, who was the last of a long line of backwoods baronets (the Smith-Mariots) whose seat had burnt down during the war, and the line had come to an end.

cs How did Douglas come to be an art collector?

JR From the start, he had defied his family, who wanted him to study law. Egged on by a gay uncle who became a distinguished musicologist, he decided to become an art historian and set about doing so systematically: a year at Cambridge, a year at the Sorbonne and a year at Marburg im Hessen. On returning to England, he tried to get a job at the Tate, but was turned down – way too modern – and had a go at being a dealer: not a success.

cs Tell us about the origins of Douglas's collection?

JR In 1932 he came into a trust fund of £100,000, in those days a hell of a lot of money; and being methodical by nature, he set aside a third of that

for his collection. Prices of works by Picasso, Braque and Léger had not changed since the early 1920s auctions of their pre-war dealer Kahnweiler's stock. By 1939, Douglas had been able to assemble one of the world's greatest collections of cubism. Prices were so low that he acquired Léger's coveted *Contrastes de formes* gouaches for the equivalent of £5 each from Léonce Rosenberg. For his greatest acquisition – the hugely powerful 1907 *Nudes in the Forest* (now in the Musée Picasso) – he paid the equivalent of £10,000 in the municipal pawnshop in Geneva, where the shadowy German collector G.F. Reber had put it in order to raise some money.

CS And then came the war. Did Douglas serve?

JR When World War II broke out, Douglas was living in Paris. Following the example of Jean Cocteau in World War I, he joined Etienne de Beaumont's chic ambulance unit. At first they had fun, delivering books to troops on the Maginot Line, but when the Germans broke through, Douglas did a heroic job driving a load of wounded soldiers to Bordeaux.

CS I recently found his book on the experience. I understand parts were used by the Ministry of Information for a pamphlet issued against panic.

JR Yes, but this episode ended tragicomically. On landing at Liverpool, Douglas was wearing a French ambulance driver's uniform. This and his preposterous, grand manner when cross-questioned got him arrested. Fortunately, his partner's father, a former Minister of Air, got him released and into the Royal Air Force. But Douglas never forgave the British authorities.

CS So he was in the RAF?

JR Yes, his fluency in German, even its dialects, resulted in Douglas becoming a star interrogator of top-brass prisoners during the North African campaign. Unfortunately, after Douglas took a handsome officer out to dinner at Shepherd's Hotel in Cairo and got him to disclose where the enemy's planes were hidden, the young man committed suicide. Douglas suffered some sort of breakdown and was packed off to Malta, which

was in a state of siege. At the end of the war he put his interrogating skills to art historical use, and got Swiss armament tycoons and others who had knowingly purchased works of art (including many Picassos) looted from Jewish owners, to hand them back.

CS How well did Douglas know Picasso when he was building his collection?

JR Casually. Picasso was fairly easy to know in the late 1930s, after he had left his wife Olga and taken up with Dora Maar. Douglas frequented the cafes of *Saint-Germain-des-Prés*, where they were often to be seen, as were Eluard and other Surrealist poets and painters. Douglas's principal rival, Roland Penrose, was already much closer to Picasso. In those days, Douglas saw far more of Fernand Léger, who was delighted to have a British backer.

CS So, how did Penrose and Douglas get along?

JR Not too badly at first. Roland came of a prosperous Quaker family (his grandfather, Lord Peckover, had done well as a banker). Although destined to become an anarchist and a Surrealist, Roland was very much a Quaker, intrinsically good, a benefactor. True, Quakers are not cut out to be disciples of the Marquis de Sade, but this wasn't an obligatory role for all Surrealists and not to be taken too seriously. Remember, too, that Roland was twelve years older than Douglas, and for most of the twenties, had lived in France. He didn't return to England until 1936, when he organised the London International Surrealist show, which launched the English Surrealist Movement.

CS Besides Penrose and Cooper, were there any other major British collectors of Picasso at the time? What about the elusive Peter Watson? Did you know him?

JR Yes, I knew and admired this charming, somewhat tragic figure. He didn't like Douglas, but he was a staunch backer of Roland's Institute of Contemporary Arts (known to Douglas as the Institute for Contemptible Amateurs). He also owned a major Picasso, *Reading at a Table* (no.62).

He, too, had lived mostly in Paris. Heir to a considerable fortune, he had a handsome apartment close to *Saint-Germain des-Prés*, where he led a glamorous life that revolved around Cecil Beaton and Cocteau. Besides his great Picasso, he owned works by Berard, Giacometti, Tchelitchev and Dalí. So far as I recall he never knew Picasso very well.

CS How did his Picasso end up at the Met in New York?

JR When war broke out, Peter gave it to his famously handsome *ephèbe* Denham Fouts (a character in books by Christopher Isherwood, Gore Vidal and Truman Capote), so that back in the US he would have something to live on besides his looks. In England, Peter became a generous supporter of up-and-coming artists – Lucian Freud, Graham Sutherland and John Craxton. However, he soon switched his patronage from art to literature. To his eternal credit, he backed Cyril Connolly and Stephen Spender's *Horizon*, the magazine that kept us nourished through the war with great contemporary writing.

CS You mentioned Freud. What did Picasso mean to him?

JR Lucian worshipped Picasso, but he was far too canny to let this surface in his work aside from a few early drawings. I had known Lucian since 1942, when he visited the art school I attended, and we often discussed Picasso, whose art we knew about largely from reproductions. There had been little enough to see in England. Like me, Lucian was excited by the show of Picasso's recent work at the Rosenberg and Helft Gallery in 1937. Both of us talked as if we had seen *Guernica* which Penrose had helped to have exhibited in England in 1938, but I doubt if he made it any more than I did. This mind-blowing masterpiece dinned its way into one's consciousness by way of illustrations, as no other contemporary work would do. To art-obsessed schoolboys like Lucian and myself, the painting's relevance to the menace of fascism took second place.

CS What aspect of Picasso's work fascinated Freud? The sexuality of it?

JR Lucian certainly loved his ribaldry – a quality that seldom surfaces in his own work – but Picasso's influence lay in the importance he attributed to drawing. This was an inspiration – maybe even a challenge – to a quirky, young artist obsessively honing his draughtsmanship.

After the war, Freud spent a lot of time in Paris. Later, he and his second wife Caroline Blackwood got to know Picasso. He fancied her and painted her nails black. I also suspect that the simplicity as well as the complexity of the artist's private life may have been an inspiration to him. Lucian's eyes were not as large as Picasso's, but the gaze was no less intense. Both had very good manners and, on occasion, very bad ones.

cs What about Francis Bacon? Wasn't he a neighbour of yours while he was painting his *Three Studies for Figures at the Base of a Crucifixion* (no.98)?

JR Yes, his cousin and patron, Diana Watson, lived opposite my mother. Bacon's studio on Cromwell Place was round the corner. After falling for Bacon's *Crucifixion* (no.89) in Herbert Read's 1933 compendium, *Art Now*, I was determined, like many other art students, to track down this otherwise unknown painter. And then one day, across from my mother's house, I saw someone who had to be Bacon. No one else could have painted the large canvas he was carrying. A friend, the artist Michael Wishart, turned out to know him, and took me to his studio.

Francis loved showing his paintings, while denigrating almost everyone else's, even Picasso's, whose work he knew by heart and either loved or hated. It was Francis who first informed me about the Picassos in Douglas Cooper's collection, lapsing into the feminine pronoun. 'She's hideous and hateful. Watch out, she'll be after you.'

cs How did Douglas know Francis?

JR Douglas had met Francis in the early 1930s through their mutual friend, the Australian painter Roy De Maistre. Francis had already developed a taste for Picasso, and was mostly doing pastiches of his work. So impressed was Douglas by *Crucifixion* that it was he who got Herbert Read to illustrate it in *Art Now*. He also commissioned Francis to design an exceedingly massive and menacing desk for him.

cs Why then, did they fall out? Birds of a feather perhaps?

JR Sort of. In those days, Francis was often very hard up – thanks usually to losses at roulette. He would put an advertisement in the personal column of the *Times*: 'Gifted young artist seeks position with generous patron' – that sort of thing. An aged cousin of Douglas's took him on, but soon fired him. 'Did you steal from him?' Lucian told me he once asked Francis. 'Probably' was the reply. This incident would have unfortunate consequences; though he didn't give a damn about his cousin, Douglas stupidly used it against Francis. Hence possibly his favouritism of Graham Sutherland over Bacon. Their alliance would have ramifications some years later in the Tate affair, but more on that later.

———————

cs When and how did Douglas, who must have been much older, come into your life?

JR He was thirteen years older. We met at a New Year's Eve party in 1947 given by the literary hostess Viva King (in those days the phrase 'a friend of Mrs. King's' was a euphemism for gay). Every Sunday, she and her husband Willie (curator of porcelain at the British Museum) threw a large party where young men could mingle with an assortment of writers, including the Sitwells, Angus Wilson, Compton Mackenzie, Norman Douglas, the Pope-Hennessey brothers, Ivy Compton-Burnett, and many others. Having heard so much about Douglas, I instantly recognised him, bulging self-importantly out of an RAF uniform and bearing down on me.

cs And then what?

JR I fled. Two years later I met Douglas again at a book party for the American writer Paul Bowles. This time, I was too curious to see the UK's greatest collection of modern art, not to mention the man who had assembled it. And this time I did not shy away from his approaches. When could I see his pictures? 'Right now, my dear, if you can tear yourself away from these hideous mediocrities.' The collection was a revelation. So was Douglas.

cs Where did Douglas live?

JR Douglas lived in a traditional terraced house off the Brompton Road. He shared it with a most accommodating friend, Lord Amulree, a gerontologist and Liberal politician known to Douglas as Basil or 'Our Lord'. Basil was loyal, kind, wise, and discreet. He was afflicted with a terrible stammer, which might explain why he shared his life with his antithesis. When they were apart, Douglas wrote Basil long, outrageously funny letters detailing his multitudinous projects and vendettas.

cs So you moved in?

JR I did. Basil was pleased that Douglas had found an amenable disciple. Douglas would teach me everything he knew. For my part, I tried but never quite succeeded in weaning him away from Academe and dreary theory.

cs How did you get along?

JR Fine at first, but his ugliness left him awash in self-hatred. 'Have a heart', I once said when he was being particularly difficult. 'Have you ever looked at me?' he said. 'As for my heart, it's nothing but an old, boiled nut.' In the course of spending the next decade trying to save Douglas from himself, I failed. But I found myself.

cs Was it Douglas who first introduced you to Picasso?

JR Yes, it was. A few weeks after we met, Douglas took me to Paris to 'meet Picasso'. We went to the Grands Augustin studio one morning and joined an assorted group of supplicants – publishers, museum directors, dealers, communist busybodies. They all seemed to want something. On this occasion, Douglas wanted only to impress me. After a somewhat fraught wait, the great man came down from his bedroom above – smaller but infinitely more charismatic than I had expected.

cs What was the protocol?

JR Jaime Sabartés, Picasso's secretary, choreographed the *levée* as smoothly as a courtier, extricating him from bores and opportunists.

Picasso was exceedingly, albeit ironically, good mannered, not least to Douglas. However, I soon realised that our fellow guests were mostly involved in the business of art or politics rather than being personal friends.

Later that day, Douglas took me to see Fernand Léger. He turned out to have been the first great modernist to ring, as Gertrude Stein used to say, Douglas's bell. Douglas and Léger had been close friends for fifteen years. It was Léger who tried and failed to make a communist of him.

cs How far left did Douglas go in his quest to keep in with Léger and Picasso at this time?

JR Not very far. He was briefly what we used to call a 'fellow traveller'. He talked a lot about attending one of the communists' *Congrès de la Paix*, but never did so. However, he got called upon to help when Picasso came to London in 1950 to take part in the Peace Congress at Sheffield. The British government was none too happy. They wanted to keep Picasso out of the country. Douglas arranged for Basil, in his capacity as a Liberal Whip in the House of Lords, to vouch for Picasso, and use his and Douglas's address as his whereabouts in the U.K.

cs Did Douglas attend the Sheffield Congress?

JR To his chagrin, the organisers ignored him. 'Such a relief', he lied. Nor was he invited to the party the then celebrated illustrator Felix Topolski gave for Picasso in London. 'Wall to wall dregs, my dear. Pablo hated it.'

cs When did you next get together with Picasso?

JR In February 1951. Thanks possibly to Basil's intervention, Douglas and I were warmly received when we visited Picasso at Vallauris. He lived modestly in a small, secluded villa that the grandmother of his mistress, Françoise Gilot, had bought for them. Françoise was busy with their children, so Picasso took us off to Le Fournas, the dilapidated former perfume factory where he painted and sculpted and stored the revolutionary ceramics he was doing at the nearby Madoura pottery.

No less astonishing were the lithographs – mostly portraits of Françoise – that he had been executing with Mourlot on his trips to Paris. They were a revelation. Picasso appeared to be reinventing every technique he touched. When he asked for news of Penrose, Douglas was evasive. I had not realised how jealous he was of Picasso's fondness for Roland.

cs By this time, hadn't you and Douglas also moved to the South of France? Hadn't you bought a chateau near Avignon?

JR Yes, the Château de Castille. The previous summer, Douglas and I had been touring Provence with Basil when we spotted an amazing colonnaded building surrounded by vineyards. This spectacular if somewhat derelict folly (known locally as the *Palais des Mille Colonnes*) turned out to be for sale. Douglas bought it more or less on the spot for around £10,000. It would make a perfect showcase for his cubist collection.

cs Had the parameters of the collection changed?

JR No, same as always: paintings, collages, drawings, sculpture, prints – mostly dating from 1907 to 1914 – by Picasso, Braque, Léger and Juan Gris. Later, Douglas branched out and bought their subsequent works. He also had a lot of Klees, Mirós and de Staëls. Nor should we forget his magnificent library. As yet, Douglas had never seen his collection in its entirety. As soon as the house was fixed and the collection installed, Picasso drove over and was staggered.

cs So would you say that your friendship with Picasso was the result of moving to Castille?

JR Yes. Remember too that Castille was close to Nîmes and Arles, where bullfights took place throughout the summer in the Roman arenas. Picasso would give a lunch before major fights; afterwards there would be a dinner at Castille. We would summon gypsies from the Camargue to entertain the artist and his entourage, and, on occasion, the star torero, Luis Miguel Dominguin, on his arm a beautiful girl, and at his knees, a pet dwarf.

cs These parties after the bullfights sound very lively. Wasn't Cocteau also usually present?

JR Yes, he was back in favour with Picasso, who liked having him around to mock. 'Don't let him embrace you', Picasso once told me, 'you will catch the skin disease he caught from the Germans during the war.' Cocteau's entourage consisted of his 'son' Doudou; Doudou's sister; Cocteau's companion, Francine Weisweiller and her daughter. They would arrive in two Bentleys, discreetly high on opium, a drug that Picasso tolerated but never took: 'It has such an intelligent smell.' Same with wine: he honoured it, but drank very little.

cs Who was Picasso's mistress at the time?

JR A cousin of Picasso's potters, the Ramiés, Jacqueline Roque, who would later become his second wife. As Dora Maar had told me, everything changed when the woman changed: the style, the house, the poet, the pets, the circle of friends. Douglas and I had become close friends with Jacqueline, and we became regulars at Le Californie, the belle époque new villa at Cannes that Picasso had bought after Françoise left him.

cs Now that you were seeing Picasso on a regular basis, did you keep a record of what you experienced?

JR Yes, I took notes. After Picasso told me that there were sometimes as many as three of the women in his life in a single image, I decided to write a book about his portraits. I knew better than tell Douglas about this project, but he later found my notes and destroyed them. Fortunately, enough memories survived for me to embark on a biography.

cs Is it true that Picasso tried to buy the Château de Castille from you?

JR Yes, it is true. Picasso bemoaned the loss of his Château de Boisgeloup to his first wife Olga when they separated. Much of his best painting and sculpture of the early 1930s had been done there. Though smaller, Castille would be the perfect replacement, he said, handy for the bullfights. He told Douglas he would give him major paintings in exchange for it. It was tempting, but the collection looked too good there and the answer was no. However, I had

heard that the much larger, much earlier, and more imposing Château de Vauvenargues outside Aix-en-Provence was for sale. Its wild park included the slopes of the Mont Sainte-Victoire. It was also protected by a vast wall. This was crucial. High-rise apartment buildings towering over his Villa Le Californie were doing away with his privacy. On the way back to Cannes, they stopped at Vauvenargues and bought it. 'Very Spanish', Picasso said.

CS Yes, I've seen Vauvenargues and its formidable towers and buttresses do give it a Spanish look; but what about the Mont Sainte-Victoire – Cézanne's favourite motif? Was he going to paint it?

JR That's what we all wanted to know. Picasso foisted us off with talk about shooting, 'I intend to take up *la chasse*,' he said. Somebody had once given him an expensive gun and he claimed to have been a great fairground shot. 'You won't starve,' he told Jacqueline. 'I'll bring back deer for you to gut and partridges to pluck.'

CS And then?

JR The expensive gun was never fired. A year or so later when he moved into this great stronghold, he inscribed paintings of Jacqueline in a parodic seventeenth-century Spanish manner, *Jacqueline de Vauvenargues*. More important, he faced up to Cézanne and did an enormous nude of Jacqueline as a landscape, the right side of her body following the long contour of the Mont Saint-Victoire, with the sole of her foot emulating the abrupt western face. This mountainous nude fits very well into the Chicago Art Institute's collection of great Spanish paintings.

CS Getting back to Douglas's collection, now that it had been moved out of England, where it was so desperately needed, to France, what do you think he envisioned doing with it? What was to be its fate?

JR Alas, Douglas's Anglophobia would always play a major role in his calculations. His early rejection by the Tate had soured him towards the British establishment, but his friend Anthony Blunt, who was Director of the Courtauld Institute at London

University and a frequent visitor to Castille, had tried to get him to modulate this prejudice. Douglas was flattered when Anthony asked him to teach and do the catalogue of the Courtauld Collection. He did a great job despite a tendency to quarrel in print with most other experts in the field. Nevertheless, he was appointed Slade Professor at Oxford in 1957, and was delighted that the Fogg Institute at Harvard invited him to teach.

CS Did the French do as much for him?

JR No. Douglas managed to antagonise key members of the French establishment.

CS Did he ever consider leaving his collection to France?

JR Sort of. Douglas and I discussed the possibility of leaving the chateau and its collection to a French equivalent of the British National Trust. We had visited Bernard Berenson shortly before he died. As was widely known, he had decided to leave his treasure-filled villa, I Tatti, to Harvard as a study centre. Why not make a similar arrangement with the Courtauld? In the event of Douglas's death, I was to be the curator and have the top floor of the chateau as a flat. That way, the collection and library would survive and be available to scholars. The project failed to materialise. It would have required massive funding, which Douglas would never have provided. Also, private museums in France were famously ill cared for.

CS I seem to remember that Graham Sutherland was a frequent visitor to Castille.

JR Yes. Graham and Kathy would play an important role in our lives. Originally Douglas had taken against Graham, who had become the most popular modern artist in England. He claimed that prolonged exposure to the Kenneth Clarks, who had sheltered them in the country when war broke out, had transformed Graham from an intensely romantic, albeit somewhat twisted painter of Celtic landscape, into a modish purveyor of lurid vegetation and celebrity portraitist on the side. Too much of Jane Clark, Douglas said, had rubbed off on Kathy, not least an addiction to champagne and haute couture.

CS But Douglas must have changed his view?

JR Yes, Graham wooed him, and Douglas, who, as we have seen, had no time for Bacon, made do with Graham. Both of them expected a quid pro quo.

CS As well as meeting at Castille, did you visit the Sutherlands in their villa in the South of France?

JR Yes. They had bought the house that Eileen Gray had built for herself at the back of Menton: an odd choice given that Graham had no taste for modernism. They exorcised the Eileen Gray look with some picturesque, eighteenth century grotto furniture. Too bad, given the £20 million one of her chairs fetched at the Saint Laurent auction in 2009.

The Sutherlands were overjoyed when Douglas took them to Cannes to see Picasso. The great man was friendly, as he almost always was with fellow artists, but despite Douglas's salesmanship, Picasso failed to take much interest in Graham's work. The Sutherlands felt they now belonged in Douglas's magic circle.

CS You mentioned a quid pro quo. What favour might Graham have had in mind?

JR Graham wanted and eventually got Douglas to devote a full-length study to his work – a study that would hopefully make him an honorary member of the Paris School. Douglas's shamefully half-hearted book would not materialise until 1962, by which time Bacon, whose influence on Sutherland was barely mentioned, had raced ahead of him, and would soon become the first British painter to rival the giants of the modern movement.

CS Was Picasso aware of any of this?

JR I don't think so. Bacon's triumph was a setback for Douglas. Instead of patching things up with his former friend, he became ever more vitupera-tive about him, not least to Picasso. Years later, I told Francis about this. He was vastly amused. 'Her mischief always came back to haunt her.'

CS So Sutherland's quid pro quo was a book. What did Douglas want from Graham?

JR Answering that question means talking about the Tate affair.

CS Which is a funny story.

JR Funny? In exchange for his promise to write a book, Douglas came up with what he wanted: In order to get the hated John Rothenstein out of the Tate, Graham, who was a trustee, had to resign as publicly as possible.

CS I wasn't thinking so much of that. More, given that Douglas had no time for England and lived in France, it's odd that he was so exercised by the Tate.

JR No, it was an obsession with Douglas – one that I came to share with him. Rothenstein was totally out of step with the modern movement, and a disgrace to a great institution. He had to go. True, Douglas also had a personal reason for his vendetta. Some ten years earlier, he had lent a number of works to a Paul Klee show at the Tate. Worried that they had not been returned to him, he stormed down to get them back. A terrified underling told him that they were being held in the Director's office so that the trustees could choose which ones they wanted to buy. 'But they're part of my collection and not for sale.' 'Aren't you from the Mayor Gallery?' Douglas was ashamed of his short stint as a dealer. He would never forgive Rothenstein for treating him as a salesman rather than a collector.

CS So Douglas had been biding his time?

JR Yes, he was manic about it. He and Graham would talk endlessly about the future of Tate: 'when are you going to resign, Graham dear? Do it now, we've got to topple Rothenstein.' And so Graham did, but as usual Douglas overplayed his hand, gave puffed up interviews to the press, circulated abusive letters, all of which enabled Rothenstein to claim that he was the victim of manic persecution. Questions were raised in Parliament.

CS So Douglas kicked the ball into his own goal?

JR Well, the climax came at the gala opening of Richard Buckle's Diaghilev show at Forbes House in Belgravia. George Harewood was chairman of the event. After dinner, Douglas, who was drunk, and I went round the show with George and his wife Marion. All of a sudden, Douglas caught sight of Rothenstein. He turned to George and, chuckling loudly, proclaimed, 'That's the little man who's going to lose his job.'

CS And Rothenstein hit him?

JR Yes, Rothenstein flew at Douglas, fists flailing, but Douglas was bigger and fatter and held the little man off, laughing at him. In those far off days, the press were obliged to play down scandals when members of the Royal Family were around, and as George Harewood's mother was the Princess Royal, the melée was covered up. No photographs appeared in the press. Nevertheless, the two pugilists became a laughing stock.

CS Did Douglas get his comeuppance?

JR Far from doing away with an inept director, Douglas had ensured Rothenstein's survival at the Tate.

CS Did any good come out of this farcical scene?

JR Yes, in the long run. Rothenstein stayed on – pathetically. Douglas had lit the match that caused a blaze. Most of the Tate Gallery trustees, in particular the chairman, Sir Dennis Proctor, praised him for doing what they should have done years earlier. As a result, Douglas was actually required, on occasion, to make purchases for the Tate over Rothenstein's head. This led Douglas and me to go on a buying trip to Paris. In consequence the Tate got two fine Picassos: the 1952 still life with a goat's skull, and a major cubist figure painting.

CS I imagine that Picasso was amused by this ever so British farce. Didn't he have a soft spot for the British? I know he originally intended to go to London, not Paris, when he first left Barcelona, but did his Anglophilia survive?

JR Very much so. It had got a tremendous boost when he came over to London with his Russian wife and Diaghilev's Ballet Russes for a sensationally successful season. The Bloomsbury group – painters as well as writers – adulated him. The art critic Clive Bell became a close friend. However, as Françoise Gilot (the mother of Picasso's children Claude and Paloma) told me, his Anglophilia was to some extent inherited. His tall, elegant Malagueño father prided himself on his English look. Remember that Gibraltar is not far from Malaga, Picasso's birthplace, and that British outpost is where don José Ruiz Blasco went to buy his clothes. His son followed his example. In London he bought suits from Poole, shoes from Lobb and hats from Lock. Thirty years later, he was delighted that the dinner jacket still fit, and he enjoyed wearing it when films he had worked on had their premieres.

CS What about English literature?

JR Picasso claimed to have read the classics – in translation of course – and mentioned the Brontës and Dickens. 'Clive Bell reminds me of Mr. Pickwick,' he once told me, and indeed there was a resemblance. He also had a penchant for one or two more esoteric books: Swift's *Instructions to Servants*, for example; but the pleasure he derived from Douglas William Jerrold's once famous, totally forgotten mid-Victorian farcical tales, *Mrs. Caudle's Curtain Lectures*, is more mystifying. His father must have owned it. The book would have been translated into French and Spanish, and probably a favourite in Mediterranean tourist centres.

CS Was Picasso pleased that Roland Penrose, an Englishman, should write his biography?

JR He was delighted, above all because it allowed him to play two of his major collectors, not to say friends, off against each other.

CS How did that play out?

JR Picasso had always respected Roland for his Quaker sense of honour rather than his sense of humour. He was trustworthy, exceedingly discreet, and deeply devoted. He also was a painter. However, Picasso derived more pleasure from Douglas's panache: his black humour, intellectual stimulus, outrageous behaviour and physical ugliness, not to mention his encyclopaedic knowledge of art and art world gossip. 'I like monsters,' Picasso said. 'They are a dying breed.'

CS So how would Picasso play Roland and Douglas off against one another?

JR When Roland announced he was flying over to Cannes to work on his biography, Picasso would call Castille and suggest we drive over for a day or two. In all innocence, we would go. Roland would arrive and be told to wait in his hotel. 'Sorry, you can't come today. Douglas and John are here'. Three or four days later, Picasso would relent and summon Roland to work on his book, talk to him for hours, and reward him with a fine drawing.

If Douglas seldom had to put up with such treatment, it was because he was Picasso's Rigoletto – a court jester doomed to do himself in. I was put in mind of the Spanish court at the time of Velazquez, with las meninas and dwarves. Douglas would have fitted in.

CS Was Picasso as manipulative with all of his friends?

JR Not all of them – just a chosen few, above all Cocteau, whose lifelong masochistic adoration of Picasso made him a prime victim. The women and children in his life were also often manipulated. However, to old friends and young ones like myself – above all if he saw that they understood his work and made no demands – he was infinitely affectionate and generous.

CS What did Douglas think of Penrose's collection?

JR He always welcomed this question. 'You see, it's not a collection', he would say. 'Roland simply bought-up other people's collections.' Granted, a principal source had been the Surrealist poet Paul Eluard, who made no money from his verse, and so, like many of his confrères, lived off handouts from Picasso in the form of frontispieces and book illustrations. In addition, Eluard and his first wife (subsequently Gala Dali) didn't so much collect as deal. Roland's other principal source was a man called René Gaffé.

CS Who was that?

JR A rich Belgian who had a sharp eye for modern art and lived on the Riviera. According to Douglas, a costly divorce had obliged him to sell part of his collection to Roland.

CS What about Douglas's sources?

JR Ironically, Douglas did much the same thing as Roland, but on a larger scale. His principal source was a brilliant, somewhat shady German art investor called G.F. Reber. He had amassed some sixty Picassos, sixteen Braques, eleven Légers, eighty-nine works by Juan Gris, as well as some great Cézannes in his chateau at Lausanne, but lost most of his money in the 1929 Paris Bourse Crash. The nucleus of Douglas's pre-war collection, including the 1907 *Nudes in the Forest*, had belonged to Reber. To his embarrassment, he was one of the dealer/collectors whom Douglas was obliged to investigate at the end of the war: he had been involved in some of Goering's art 'purchases.'

CS So much for the provenances of their paintings. What did you and Douglas feel about Roland's biography?

JR In my opinion, Roland did a great job. My only criticism is that it is a portrait without shadows. Roland was too loyal a friend to hint at Picasso's dark side. Douglas of course knocked the book, but used it. He felt that Roland lacked the necessary art historical knowledge and insight that biography requires. In other words, he was convinced he would have done a better job. Out of the question. At his best, Douglas was a brilliant and perceptive interpreter and one of the wittiest letter writers of his day. At his worst, he was academically nit-picking, bitchy and vindictive, especially so to his former Courtauld pupil, the scholar/painter John Golding, whose definitive study of cubism Douglas had enthusiastically encouraged until he realised that the apprentice was writing the masterpiece that the sorcerer had failed to do. Douglas's attacks on the book did Golding nothing but good and the perpetrator nothing but harm.

CS How did Douglas react to the Tate appointing Penrose to be the curator of their great Picasso retrospective in 1960?

JR Wounds suffered in the Tate war still smarted, so his rage – not least his Anglophobia – bordered on madness. He did all he could to sabotage the show, but as usual, tarred himself. Attempts to embroil the *Evening Standard* simply

strengthened Roland's hand. And his mean-spirited refusal to lend anything from his collection spurred Picasso on to be all the more generous.

Besides lending even more than he had originally intended, Picasso insisted that additional galleries be made available for the display of his fifty-eight recently completed variations on Velázquez's *Las Meninas*. Even more of a blow to Douglas's pride was Penrose's other great coup. He persuaded Picasso to sell the Tate his 1925 masterpiece, *La Danse* – a painting he had recently told Douglas and myself that meant more to him as an artist than *Guernica*.

CS I'd like to hear what you have to say about the Tate's acquisition of this great work. Some people mistakenly thought it was a gift and questioned the purchase. What do you feel about this?

JR Picasso was vastly rich and vastly generous with his money and work. However, had he given the painting outright to the Tate, he would have upset leading museums in France and the U.S. – museums whose directors had done far more to promote his work than the Tate ever did. Hence the reason for a sale rather than an outright gift.

CS Did you have anything to do with the 1960 Tate show?

JR No, by this time I was living mostly in the US and was organising a major Picasso exhibition in New York. Alfred Barr, a great authority on Picasso and Matisse, and the creator of the Museum of Modern Art, not to mention Bill Lieberman, the curator of drawing, had opened all the right doors for me. Consequently, I was able to come out from under the shadow of Douglas and embark on a new career.

CS Of course, abstract expressionists and their followers dominated the New York art scene. How did Picasso feel about that?

JR Quite angry. Picasso didn't say as much, but he felt that the new generation of abstractionists on both sides of the Atlantic, but predominantly in the US, were questioning his leadership of the avant-garde. On returning to France, he questioned me about this.

Fig.15
Lee Miller, Jacqueline Picasso,
Roland Penrose and Pablo Picasso
beside **The Three Dancers (La Danse)**
at Notre-Dame-de-Vie, Mougins,
January 1960.

cs Is that the reason you went to live there?

JR One of the reasons. Life at Castille had
become claustrophobic. Victor and Sally Ganz, in
those days the greatest Picasso collectors in the
world, played a key role in my move to New York.
Sally wanted to put on a Picasso show for her
pet charity that would commemorate the huge
holdings of his work in the US – in this respect,
not unlike the present show, which commemo-
rates his holdings in the UK She asked me to help
her organise it. Unlike any show before or since,
it was held in nine different galleries belonging
to dealers, many of whom had been mortal
enemies. Each gallery took on a separate period
or theme. For two months in the spring of 1962,
people could wander until quite late in the
evening from gallery to gallery. The American
Art Dealers' Association was one of the show's
consequences.

cs How did Picasso react to the show?

JR The thought of all those inimical dealers
working together amused him. He was a great
help with the catalogue. With Douglas out of
the way, I was able to establish a much closer
relationship with him. It helped that I had studied
art; I could discuss basic painterly matters that
art historians, let alone Douglas, would never
have deigned to raise. Also, unlike Douglas, I let
Picasso do all the talking. In the right mood,
explanations poured from him.

cs Did his fears have any substance?

JR Not really. I reassured him that some of his
greatest paintings, above all the *Demoiselles
d'Avignon*, had ended up in American museums
and collections, and they continued to exert
an enormous influence on the new generation.
In that case, why are they harking back to a
movement he believed to be déjà-vu, dead?
Why revisit it? Picasso was especially incensed,
and yes, bewildered, by the resurgence of
Dada. Marcel Duchamp – one of the very few
fellow artists he lashed out at – was a principal
target of his scorn. 'It's the same old stuff,'
he said. 'All they've done is change the
wrapping paper.'

cs Why did he take this so personally?

JR Blinded by innate distaste for abstractionism.
If only he had been able to foresee how much
the artists of the New York School were taking
from his brushwork and the supercharged marks
he made on paper; particularly de Kooning,
as his magnificent retrospective at MoMA
recently confirmed.

cs Did Picasso ever visit New York?

JR No. Though he was inundated with invitations
to visit the US, especially in 1939 when war
broke out, he never came. 'I prefer to do my
travelling in my head,' he said. However, Picasso
was very aware that most of his principal
collectors and dealers were to be found in
America. That is also where the most memorable
exhibitions took place.

cs Did he realise that one day you would
write a book about him?

JR I like to think he did. He sensed things. Thirty
years later, the first volume of my biography
would appear. Looking back on those days spent
mostly on the beach, I think Picasso realised
he wasn't wasting his time. He enjoyed playing

psychic games with people who loved him as well as his work. 'See you in October,' he said when I left. His eightieth birthday was on the twenty-third.

cs And so what transpired at Picasso's 80th birthday?

JR I flew over for the occasion and arranged to stay nearby with Rory Cameron, a man of considerable charm and taste. He shared the magnificent Villa La Fiorentina at Cap Ferrat with his mother, a beautiful, albeit lethal Australian, Enid Kenmare. However, I never made the birthday party. At the time, I did not realise that Lady Kenmare had formerly been married to a cousin of Douglas's mother called 'Caviar' Cavendish (later Lord Waterpark). Acting on advice from Australia, the Coopers had advised the Cavendishes against the marriage. And no wonder, according to Rory's neighbour, Somerset Maugham, Enid had murdered him as well as other of her husbands.

cs How did this situation impinge on the birthday party?

JR Well, Douglas had it in for Rory, and avenged the Cavendishes by trashing his amateurish travel books. So it was with a certain relish that Rory banged on my door with the news that Douglas had been brutally stabbed by an Algerian pick-up and was close to death in the hospital at Nîmes. Though Douglas and I had parted on the worst possible terms, I felt I had better go to him.

cs So that meant missing Picasso's birthday.

JR Indeed it did. Jacqueline had insisted to me that the only present Picasso wanted from Douglas and me was a reconciliation. This was not to be, but trust Picasso to derive maximum black humour, tinged with genuine concern, from the incident. Apparently Douglas had driven into Nîmes late at night to get his birthday tribute to Picasso rushed to London. And then, on the way home, he had given a lift to a *fellagah* from a local work camp. Unaccustomed to such encounters, he had stopped the car in a desolate area, whereupon the *fellagah* drew a knife. It was a 'your money or your life' situation. Averse to parting with petty cash, let alone a wallet bulging with banknotes, Douglas tried to escape, and got slashed – once vertically and twice horizontally. 'Though not a Gaullist, I bear the *Croix de Lorraine*', he told Picasso.

cs How on earth did he survive such a savage attack?

JR Douglas had a will of iron. Don't forget that he'd been an ambulance driver and knew how to hold his guts in as he crawled towards the nearest light. He was lucky. It was a school. A black caretaker took him in and called for an ambulance.

cs What sort of state was Douglas in when you arrived at the hospital?

JR Barely alive. A shortage of nurses meant that Douglas's housekeeper had to take care of him. I took over the deckchair by his bed. It was touch and go. One morning a week or so later, his one good eye ablaze with malevolence, he came to. 'Tell me, my dear, how did you seek out that assassin?'

cs Did he mean it?

JR Of course he didn't. He was getting better and his malice was recharging. Gratitude was not Douglas's forte. It was time for me to say goodbye – for good. I went back to Castille to collect my stuff. As I arrived, the telephone rang. Douglas! He whimpered that he was having a relapse and didn't know what he had said – please come back. I did. Later that day he perked up and asked me how much I had *paid* the assassin. If Jacqueline had not called to say that she and Picasso were driving over from Cannes to cheer up Douglas once he returned to Castille, I would have left, but I needed to see them.

cs How did their visit work out?

JR Tragically. Lunch went off well, but Douglas insisted on showing them a newly acquired 'cubist masterpiece' that had arrived while he was in hospital. This was a large slab of plaster wall on which in 1913 Picasso had painted a still life with the words of a popular song, '*Ma Jolie*,'

inscribed on it. It had belonged to a friend of mine, so I knew it well. Once upon a time it had been a thing of beauty and historical importance, but over the years it had suffered. Bits of plaster had flaked off or been badly restored. Worst of all, it had been varnished – badly. I had told a collector not to buy it. Alas, it filled a major gap in his collection, so Douglas could not resist.

cs It seems as if the demands of art history took precedence over connoisseurship.

JR And how! It rattled ominously when the gardener brought the crate into the living room at Castille. As he prised it open, we watched in horror. There was nothing left on the wooden backing, just bits of plaster at the bottom of the crate. '*Mon cher Douglas, il rien reste plus rien de moi*', Picasso said. Douglas looked as if he had been stabbed all over again. Worse, something seemed to have broken inside him.

cs What do you mean?

JR It's a shocking story. Five or six years later, Christie's summoned me back from New York to London to evaluate some important paintings bought by a Belgian art investor who had used Douglas as his advisor. One of his 'masterpieces' turned out to be *Ma Jolie* – resurrected from the dust and back on the market.

cs Did this come as a shock?

JR Yes. For all his brutal aggressiveness, Douglas had been scrupulously honest. He was forever vaunting his integrity at the expense of everyone else's.

cs And what happened to Douglas after that?

JR The last years at Castille were a *déringolade*. More and more people flocked to see the collection. Charles de Noailles, a great arbiter of taste, even brought the Queen Mother. Anglophobia obliged him to complain, but Douglas was in fact thrilled. Picasso and Jacqueline still came by when there were bullfights. However, even Basil Amulree seemed unable to halt the downward spiral. Partners came and went. So did servants. The beloved Marie left. Douglas had fights with one

replacement after the other. In revenge, one of them alerted the local mafia to the lack of security at Castille, not even locks on the shutters. As a result, thieves broke in and made off with a number of smaller works, many of them by Picasso.

CS Didn't Douglas get Picasso to design some huge murals for a building in the garden?

JR Yes, monumental drawings were sandblasted into the cement-covered walls of a loggia. A big mistake, he couldn't take them with him when he sold Castille and moved to an ultra-safe apartment building in Monte Carlo. Unfortunately, his new rooms were small, so he had to sell some of his largest and finest paintings. The collection lost its wonderful, unifying scope.

CS What happened to *Nudes in the Forest*?

JR It's a complicated story, and it all goes back to an agreement that Douglas and I signed before we went to live in Castille. When we moved everything from England, we had to submit an inventory of our possessions and have it signed at the French Consulate. This gave us the right to bring paintings in and out of the country for the next fifty years; otherwise the French would impose a hefty tax.

Years later, Douglas, who liked to show off, had asked the Minister of Culture to stay for a weekend. When he saw these masterpieces on the walls he thought, 'My God, we better block them; we don't want these works leaving the country.' He returned to Paris and somehow got the fifty years condition cut in half thereby blocking Douglas's collection.

CS How was this matter resolved?

JR Lest his *import temporaire* arrangement be reduced by this new regulation, Douglas was obliged to relinquish *Nudes in the Forest* to the as yet unopened Musée Picasso.

CS Did you ever see Douglas again after the stabbing and the *Ma Jolie* debacle?

JR Yes, on a few uncomfortable occasions. When I went to Castille to get back some of my own stuff, including inscribed drawings from Picasso and others, as well as some clothes and family silver, he threatened me with Interpol and called friends to shun me. The Sutherlands were the only ones to obey this ukase. Jacqueline Picasso called to see if I was all right.

CS So you went on seeing Picasso?

JR Yes, whenever I could. When Françoise Gilot's classic book, *Life with Picasso*, came out I was asked to review it for the *New York Review of Books*. Picasso, whom I went to consult, was too infuriated to discuss it. The book is fascinating – the most revealing portrait of the artist up-close – but I felt Françoise should have waited until Picasso died before settling old scores. As his biographer, I know all too well that whatever one says about this enormously complex man, the reverse often turns out to be no less true.

CS What about Douglas's relationship with Picasso? Did that survive?

JR Almost, but not quite to the end. Self-destructive and conceivably drunk, Douglas made an enormous – for once well-intentioned – gaffe. One evening, *circa* 1970, he arrived at Notre-Dame-de-Vie uninvited, and demanded to be let in. Although he was hard at work, Picasso allowed him into the studio so long as he kept quiet. Far from remaining silent, Douglas launched into a forbidden topic, telling him it was time he recognised his illegitimate children.

CS Why hadn't Picasso done so?

JR He hadn't done so for the same reason he hadn't made a will. It would have involved recognising the fact of his death. Picasso was hard of hearing so Douglas had to repeat the question. Picasso exploded, 'Out!' Jacqueline told me as she took Douglas down to the front gate he sobbed and pleaded for forgiveness. Picasso refused to see him ever again.

In an act of self-destructive vengeance, Douglas published a letter in *Connaissance des Arts* shortly after Picasso's death, condemning his late work as 'incoherent doodles done by a frenetic dotard in the anteroom of death.'

CS And when did you last see Picasso?

JR In the mid 1960s, after spending a night at Vauvenargues, we attended a bullfight. Thenceforth, I kept in touch by telephone. After Picasso's death, I used to go and stay with Jacqueline at Notre-Dame-de-Vie. She was enormously helpful with my books; I did my best to console her, but she could not live without him and committed suicide in 1986.

CS What happened to Douglas and his great collection?

JR After Douglas died in 1984, his adopted son, Billy McCarty Cooper, mercifully sold the core of the collection to a serious New York collector, Leonard Lauder, who has continued to add to *his* cubist collection. The rest of Billy's inheritance was squandered on grandiose parties, usually in Los Angeles, in honour, he said, of his adoptive father. He also arranged for a major performance of Mozart's *Requiem* to be given at his funeral following his death from AIDS.

CS What about Douglas's archive?

JR Some of it survives in the Getty Research Institute, but tragically the legendary correspondence, which Lord Amulree said he was leaving to the British Museum, has disappeared. Let us hope it resurfaces. It belongs in the Tate.

At least Penrose's smaller but no less significant collection and archive survives, partly at the Tate, partly in Edinburgh's Museum of Modern Art and partly in his Sussex farmhouse, which is open to the public. Had Douglas less Anglophobic self-destructiveness, he too could have left a great monument behind, instead of casting a shadow almost as long as John Rothenstein's over the present show.

PICASSO IN BRITAIN 1910–1914

JAMES BEECHEY

Before autumn 1910, Picasso was virtually unknown in Britain. In April 1905, in the artist's first British review, Théodore Beauchesne had predicted a confident future for him on the basis of a brief exhibition at the Galeries Serrurier, Paris.[1] But it was not until Roger Fry staged *Manet and the Post-Impressionists* in November 1910 that a British audience had its first opportunity to see his work in the flesh. To navigate the Parisian art world, Fry relied heavily on the expatriate American collectors Gertrude and Leo Stein and they almost certainly introduced him to the dealer Clovis Sagot.[2] Around the same time Fry also met Ambroise Vollard and Daniel-Henry Kahnweiler, the two most important of Picasso's early dealers.

Picasso was a peripheral figure in Fry's first Post-Impressionist exhibition in 1910. Two paintings were shown, and seven works on paper listed in the catalogue.[3] *Young Girl with a Basket of Flowers* 1905 (private collection. Zervos I, 256) drew praise for its 'wonderful subtlety',[4] and grudging admiration from Walter Sickert, who deemed its author 'a quite accomplished sort of minor international painter'.[5] A 1909 portrait of Clovis Sagot (fig.16), more representative of Picasso's recent practice, was one of the exhibits most pilloried in the press. Fry observed that 'of late years Picasso … has become possessed of the strangest passion for geometrical abstraction, and is carrying out hints that are already seen in Cézanne with a desperate logical consistency'.[6]

Picasso's first solo exhibition in Britain – at the Stafford Gallery in 1912 – comprised mostly drawings from the Blue and Rose periods (including no.4). The art critic Frank Rutter, arguably better informed than Fry about the development of European modernism, lamented, 'in London we have to take our foreign art as we can get it, not necessarily in the chronological order of its appearance'.[7] A murky reproduction of a cubist still life – *Mandolin and Glass of Pernod*, 1911 (National Gallery, Prague. Zervos IIa, 259) – had appeared in the *New Age* in autumn 1911 but it was only in Fry's *Second Post-Impressionist Exhibition* in 1912–13 that an attempt was made to outline cubism's progress. Here Picasso – represented by a dozen paintings and three drawings, mostly lent by Kahnweiler – was elevated, with Matisse, to the apex of the modern movement. Fry struggled to

grasp the full implications of cubism, which he defined as 'a purely abstract language of form – a visual music'.[8] Rutter got closer to an understanding of Picasso's intentions in a discussion with the artist in 1913: [Picasso] said not a word of abstraction … he maintained that he was a realist – "plus royaliste que le roi" – indeed, the only true realist in paint. It was not realism, he argued, to show merely one aspect of an object from one point of view: the reality included all possible aspects from all possible points of view.[9]

In Britain Picasso was primarily associated with the Bloomsbury group, and it was from around Bloomsbury's ranks that most of his first British collectors were drawn. Lady Ottoline Morrell was said to have owned several fine drawings, possibly acquired in Paris in 1909. Her brother, Lord Henry Bentinck, lent an unidentified study of 1907 to an exhibition in 1911–12.[10] In 1911 Clive Bell bought a proto-cubist still life, the first painting by Picasso to enter a British collection (no.2); Harry Norton bought a cubist composition from the *Second Post-Impressionist Exhibition* (no. 5); and in 1913 Fry acquired *Head of a Man* 1913 (no.8). Well-informed cross-Channel visitors made their way to Kahnweiler's and Sagot's shops and several, including Clive Bell, saw a scrappily assembled display of early paintings at Vollard's: gallery in the winter of 1910–11, to which, at the last minute, a few cubist works were added.

The artist himself was not impossible to track down. 'I saw a young artist called Picasso whose work is wonderful,' Augustus John told Henry Lamb in August 1907.[11] The two exchanged studio visits and John was one of the first to set eyes on *Les Demoiselles d'Avignon* 1907 (Museum of Modern Art, New York, Zervos II, 18). Painter J.B. Manson found Picasso in Montmartre in autumn 1911, 'surrounded by canvases of all sizes, all covered with these strange hieroglyphics, the results of his geometrical dreams'.[12] Jacob Epstein, Duncan Grant and Frederick Etchells met Picasso separately in 1912 and Grant saw him again two years later. Rutter published excerpts of a conversation with Picasso in the catalogue of his *Post-Impressionist and Futurist Exhibition* held at the Doré Galleries in London (1913). In January 1914 Clive and Vanessa Bell, Roger Fry and the writer Molly MacCarthy were taken by Gertrude Stein to see Picasso

Fig.16
PABLO PICASSO
Clovis Sagot 1909
Oil on canvas
82 × 66
Hamburger Kunsthalle
Zervos II, 129

in his new studio. 'I thought him perfectly charming and quite easy and simple,' Vanessa Bell told Grant, describing his latest *papiers collés* and constructions:

The whole studio seemed to be bristling with Picassos. All the bits of wood and frames had become like his pictures. Some of the newest ones are very lovely I thought. One gets hardly any idea of them from the photographs, which often don't show what is picture and what isn't. They are amazing arrangements of coloured papers and bits of wood which somehow do give me great satisfaction. He wants to carry them out in iron. Roger recommended aluminium, which rather took his fancy. Of course the present things are not at all permanent. He also showed us a lot of paintings he had done when he was 10 which were rather interesting, very laborious and careful. There were also more wonderful portraits of the blue period.

Her closing remark was perhaps the earliest utterance of a familiar refrain: 'I came to the conclusion,' she wrote, 'that he is probably one of the greatest geniuses that has ever lived'.[13]

Although this print was not listed in the catalogue of *Manet and the Post-Impressionists* at the Grafton Galleries in December 1910, Roger Fry referred to an 'etching of *Salome*' as proof of Picasso's 'technical mastery', suggesting that it was shown under another title.[14] The original print was one of sixteen made in 1905; Ambroise Vollard acquired and steel-faced the plates and, along with *The Frugal Meal* (no.7), issued them in an unsigned edition of 250 in 1913. This impression was bought by Campbell Dodgson, Keeper of Prints and Drawings at the British Museum, who circumvented the museum's policy of not collecting works by living artists by building his own collection of prints that he bequeathed.

Salomé was one of the last of the sequence, the majority of which were on the theme of the saltimbanque that then dominated the artist's work. Picasso's interest in the theme is associated with his new friendship with the poet Guillaume Apollinaire who published a poem entitled *Salomé*, also in 1905. The subject also evokes memories of Oscar Wilde's play that premiered in Paris in 1896 and of Aubrey Beardsley's illustrations for it. Picasso had known the work of both before leaving Spain. While Anthony Blunt and Phoebe Pool found Picasso's treatment of the Salomé theme 'almost without erotic implications', John Richardson has associated it with Apollinaire's opening up of Picasso's attitude to sexual expression.[15]

1
PABLO PICASSO
Salomé
1905, printed 1913
Drypoint on paper
40 × 34.8
British Museum.
Bequeathed by
Campbell Dodgson, 1949

PABLO PICASSO
Jars and Lemon 1907
Oil on canvas
55 × 46
Albertina, Vienna.
Batliner Collection
Zervos IIa, 32

In this and several related still lifes, executed around the time of *Les Demoiselles d'Avignon* in July 1907, Picasso expanded on the rhythmical treatment of space and objects that he employed in his great painting. X-ray examination of this painting revealed a seven-figure, horizontal compositional study for the *Demoiselles* beneath the still life; the outline of a squatting woman is clearly visible to the naked eye in the top right-hand corner of the canvas.[16]

Clive Bell purchased the work from Clovis Sagot's Galerie de Vingtième Siècle in Paris in October 1911. 'We're in a huge state of excitement having just bought a Picasso for £4,' Vanessa Bell wrote to her sister Virginia Stephen (later Woolf). 'I wonder how you'll like it. It's

"cubist" and very beautiful colour, a small still life.'[17] At the Bells' house at 46 Gordon Square, Bloomsbury, it was seen by, among others, Duncan Grant and Wyndham Lewis; Grant, in particular, cited it on several occasions in his own work. Its status in Picasso's early British reputation was extended by its widespread reproduction and exhibition. It was illustrated in Bell's best-selling treatise on aesthetics, *Art* (1914), included in Picasso's first major exhibition in London at the Leicester Galleries in 1921[18] and, when lent by Bell to the opening display in the Modern Foreign Galleries in 1926, it became one of the first two paintings by the artist to be shown at the Tate Gallery.

3

PABLO PICASSO
Girl in a Chemise c.1905
Oil on canvas
72.7 × 60
Tate. Bequeathed by
C. Frank Stoop 1933
Zervos I, 307

The girl in this painting has been identified as Madeleine (her surname is unknown), a married model who became pregnant by Picasso in 1905.[19] She appears in several other works of 1904–5 and provided a prototype for many of the waif-like female figures that populate the artist's imagery at this time. The painting marks the beginning of the transition from Picasso's Blue to Rose period, in which, besides a change in palette, heavy impasto, strong contours and bold outlines give way to veils of paint, notable here in the rendering of the girl's almost diaphanous chemise.

It was owned by the Dutch stockbroker (Cornelis) Frank Stoop (1863–1933), who is said to have acquired it around 1912. He may have bought the work when it was shown at the Stedelijk Museum, Amsterdam, in autumn 1911. It was later lent by him to the first two significant surveys in London of Picasso's work, at the Leicester Galleries in 1921 and at Alex. Reid and Lefevre in 1931.

This is one of the first in a series of studies for Picasso's major 1906 painting *Boy Leading a Horse* (Museum of Modern Art, New York, Zervos I, 264). The final work marked a new, classicising tendency in Picasso's art, in which his search for austerity and monumentality dictated the elimination of anecdotal detail prevalent in the Blue and Rose periods, together with the adoption of a neutral palette and a matte, fresco-like surface. Picasso drew on a variety of sources, from ancient Greek *kouros* to the pastoral visions of Puvis de Chavannes and Cézanne's heroic male bathers; he also looked at a reproduction of El Greco's *St Martin and the Beggar* 1597–9.

The work was included in an exhibition of Picasso's drawings at the Stafford Gallery, London, in April–May 1912. Priced at £22, it was the most expensive work on show, and one of the few to be noticed favourably by the critics. Denigrating 'childish pen-scribbles' and 'scraps that should never have been rescued from the wastepaper basket', P.G. Konody singled out 'one brilliant gouache study of a young man with a horse, the action and play of the muscles as well observed as the play of light on the animal's coat'.[20] Despite finding the horse 'quite comic', the *Athenaeum* commented approvingly that 'the drawing of the figure ... is firm and elastic, with a considerable grip on reality'.[21] It was bought by Stoop, possibly from the Stafford Gallery, although an unsigned and undated note suggests it may have been acquired subsequent to the exhibition from the Swiss dealer Hans Vollmoeller.[22]

4
PABLO PICASSO
Horse with a Youth in Blue
1905–6
Watercolour and gouache
on paper
49.8 × 32.1
Tate. Bequeathed by
C. Frank Stoop 1933
Zervos I, 270

This is characteristic of the small, sombre still lifes Picasso painted in Paris during the winter of 1910–11, at a point when he appears to have suffered a momentary crisis as his art hovered on the brink of abstraction. Here virtually all traces of modelling have been eradicated: the bottle and books, represented on a linear grid of planes and facets, have lost their individuality, their forms almost indistinguishable from the surrounding space, while their volume is conveyed solely by means of carefully graduated monochrome tones, and they are readable only to those already possessing some degree of familiarity with the syntax of cubism.

This is the only work by the artist known to have sold from the *Second Post-Impressionist Exhibition*. It was bought by a fringe member of Bloomsbury, the Cambridge mathematician H.T.J. Norton (1886–1937), probably on the recommendation of Vanessa Bell. Following a visit with André Gide to Cambridge in 1918, Roger Fry reported that 'Gide liked the Picasso',[23] but thereafter it remained largely unseen until lent, by Norton's sister Lucy, to Picasso's 1960 retrospective at the Tate Gallery.

Picasso and Georges Braque began introducing textural inscriptions (either hand-painted or stencilled) into their work in late 1911; these extended the lexicon of cubist signs that provided associations to the external world, at the same time as emphasising the flatness of the picture surface and reinforcing its material existence. These words, or fragments of words, often denote newspaper mastheads, sheet music or, as here, lettering on the window of a bistro or café.

This work was the most recent by Picasso shown at the *Second Post-Impressionist Exhibition* at the Grafton Galleries in 1912. For Fry it exemplified the artist's intention to create a purely abstract language. 'Do you know the effect of Picasso's Tête d'Homme (the one with G.R. on it) as lantern slide is simply amazing,' he wrote to Gertrude Stein, following lectures he gave in Leeds and Liverpool in 1913. 'The increase of scale and the intensity of light and shade make it a most impressive thing. But the difficulty with an English audience is that they haven't got the sensibility to form. They'll take one's ideas as pure ideas, but they can't fit them on to the pictures at all.'[24]

5
PABLO PICASSO
Bottle and Books 1910–11
Oil on canvas
38 × 46
Private collection
Zervos IIb, 241

7

PABLO PICASSO
The Frugal Meal 1904, printed
1913
Etching with drypoint
on paper
46.3 × 37.7
The Whitworth Art Gallery,
The University of Manchester
Ba 2; Bl 1; PiF I 994

7

Before the First World War Picasso's etchings were his
most widely admired works in Britain. Although only
the second one he produced, this is one of his most
celebrated prints. It has come to be seen as the quintes-
sential expression of the artist's empathy with figures
on the margins during his own destitute, early years
in Paris. Picasso, who had no formal training in print-
making, recycled a zinc plate on which his friend Joan
González had previously engraved a landscape, ghostly
traces of which are discernible beneath his composition.
About thirty copies of *The Frugal Meal* were printed
by Eugène Delâtre in 1904. In 1911 Ambroise Vollard
acquired the plates of this and fourteen other etchings,
including *Salomé* (no.1); a further edition of two hundred
and fifty was pulled by Louis Fort in 1913 and marketed
under the title *La Suite des Saltimbanques*. The present
version is from this second state, which was unsigned
and un-numbered.

This may have been the impression of *The Frugal
Meal* included in the *Post-Impressionist and Futurist
Exhibition*, organised by Frank Rutter at the Doré
Galleries, London, in October 1913.[25] It belonged to
Michael Sadler (1861–1943), Vice-Chancellor of Leeds
University and later Master of University College,
Oxford. Sadler was a prolific collector of both old masters
and contemporary artists (including no.55), notably of
Wassily Kandinsky, and was close to Rutter. On its
presentation in 1922 to the Whitworth Art Gallery at
the University of Manchester, it became the first work
by Picasso to enter a British public collection.

8

In the spring of 1913, following his first experiments
in cardboard constructions, Picasso created a ground-
breaking (albeit ephemeral) assemblage, consisting
of an unfinished life-size canvas of a man to which he
attached a pair of arms made from newspaper, playing a
real guitar. This head closely resembles the half-painted
head of the guitarist in the destroyed assemblage. As in
several related paintings of 1913, Picasso imitates here
the compositional and textural effects of *papier collé*,
which he had begun using the previous autumn.

Head of a Man was bought by Roger Fry from
Kahnweiler in late 1913. In January 1914 he showed it in
the Grafton Group exhibition at the Alpine Club Gallery,
London, together with photographs of Picasso's recent
constructions and assemblages. Reviewers were scathing,
with one accusing the artist of 'ponderously making game
of the public', as demonstrated by 'the fact that this "sculp-
ture" could not be trusted to cross the Channel without
falling to pieces [which] seems to point to a deficiency
in technique. We suggest screws instead of nails and glue,
as more monumental.'[26] Writing about this work, the
Saturday Review's critic quoted the exhibition's secretary,
Nina Hamnett, that 'in Mr. Roger Fry's opinion … the
painter ought not to have called it "Head of a man"
but rather "A Design"'.[27] Fry's ambivalence about its
subject seems to have endured; as there is no record of
him owning another work by Picasso, this was almost
certainly the painting he lent to the artist's 1921 Leicester
Galleries exhibition as 'Nature Morte, 1914'.

The work's influence can be seen in a number of
Grant's designs and paintings of 1914–15 and in Fry's
sole surviving non-representational work.[28]

8

PABLO PICASSO
Head of a Man 1913
Oil, gouache, varnish, ink,
charcoal, and pencil
on paper
61.6 × 46.4
The Museum of Modern Art,
New York. Richard S. Zeisler
Bequest, 2010
Zervos IIb, 431

DUNCAN GRANT AND PICASSO

JAMES BEECHEY

There was no British artist for whom Picasso's example proved more invigorating in the period immediately before the First World War than Duncan Grant (1885–1978).

Grant spent a year in Paris in 1906–7 but remained largely ignorant of the latest trends in French art. The agents of his introduction to Picasso and his work were Gertrude and Leo Stein, the most audacious and acquisitive of Picasso's early patrons. Grant first met Leo Stein in Florence in June 1907 and two years later, on a short trip to Paris, he noted in his diary: 'visited Stein. interesting conversation.'[1] By then, the Steins' unrivalled collection of Picasso's work included his celebrated portrait of Gertrude (Metropolitan Museum of Art, New York, Zervos I, 352) and the masterpiece of his *art nègre* style, *Nude with Drapery* 1907 together with fourteen related gouache and oil studies. Grant first met Picasso in December 1912, probably at one of Gertrude's famous Saturday soirées at 27 rue de Fleurus. In February 1914 she accompanied him on a visit to Picasso's studio in rue Schoelcher. Having been shown some of his recent *papiers collés*, many of which incorporated ornamental wallpapers, Grant told Picasso that in his room at the Hotel de l'Univers et du Portugal he had come across a roll of old wallpapers, 'which excited him very much as he makes use of them frequently and finds [them] very difficult to get. He sometimes tears small pieces off the wall, he said.'[2] Grant returned with the wallpapers several days later and was surprised that Picasso 'seemed to be shocked that I might have stolen them'.[3]

On the Steins' crowded walls Grant could follow the evolution of Picasso's art from the Blue and Rose periods to analytic and synthetic cubism. Although sometimes reckless in his assimilation of diverse styles, Grant was discriminating in the idioms and methods he utilised from Picasso.[4] Three paintings by Picasso proved especially effective catalysts: *Jars and Lemon* 1907 (no.2)

provided a formal touchstone; *Nude with Drapery* 1907 encouraged him to emulate Picasso's cross-hatching technique and to accentuate the rhythmical structure of his compositions; *Head of a Man* 1913 (no.8), together with Picasso's contemporaneous *papiers collés*, stimulated his experiments with collage and his production of some of the earliest abstract works in Britain. The years during which Picasso's influence was paramount in Grant's art coincided with his involvement in the Omega Workshops, the co-operative design studio founded by Fry in 1913 – a liberating experience for Grant, which enabled him to realise the most significant implication of Picasso's example, the freedom to experiment in different, but parallel, styles and media.

'In admiring Picasso a sense of contest is nearly always to be taken into account,' Grant once noted.[5] After the First World War he steered his painting in a more sober direction, independent of Picasso's influence. Picasso's only reported comment on Grant's work comes second-hand from an unreliable source, although it reflected a widely held view that Grant's reputation was inflated. 'Why, when I ask about modern artists in England, am I always told about Duncan Grant?' Picasso is said to have enquired.[6] It is unlikely that he saw much, if anything, of Grant's work after his visit to London in 1919, though the two occasionally met socially in Paris throughout the 1920s. Their last meeting was in May 1937, when Picasso invited Grant and Vanessa Bell to view the as yet unfinished *Guernica*; and their last contact came as late as 1971, when Grant sent Picasso congratulations on his ninetieth birthday and received in reply a drawing in coloured crayons of a grinning old man. Picasso's request to visit Charleston, the Sussex farmhouse shared by the Bells and Grant, while he was staying nearby with Roland Penrose in November 1950, was unaccountably put off by Vanessa Bell, to Grant's immense chagrin.

Fig.17
PABLO PICASSO
Nude with Drapery 1907
Oil on canvas
152 × 101
State Hermitage Museum,
St Petersburg

9
DUNCAN GRANT
Design for a Firescreen C.1912
Oil on paper
83 × 75
Private collection

9

Roger Fry's Omega Workshops, of which Grant was a co-director, opened at 33 Fitzroy Square, London, in July 1913, but for several months beforehand some of the artists involved in the project had been creating pieces of applied art in anticipation of its launch. A firescreen of a similar, though more highly coloured, design (and including two birds among the five flowers) was worked by Lady Ottoline Morrell in the autumn of 1912; a screen to this design (King's College, Cambridge) was embroidered in silk by Vanessa Bell the following year, and further versions of it were produced at the Workshops. The syntax and vocabulary of Picasso's proto-cubist and cubist painting resurfaced in a number of Grant's Omega designs; here distinct echoes of his *Jars and Lemon* 1907 (no.2) are found in the rhythmical composition of angular lines and schematic curves, in the striated facets of the planar background that reinforce the flatness of the design, and in the subdued colour scheme of cool grey-blue, dusty pink and ochre.

10, 11

The setting for Picasso's *Vase of Flowers* is the studio in the Bateau-Lavoir in which he had completed *Les Demoiselles d'Avignon* in July 1907. The central figure in the latter, which Grant recollected seeing in Picasso's studio (although at what date is unclear), is echoed in *The Tub*. Grant's assimilation of Picasso's *art nègre* style was most pronounced for a short period around 1913–14, and is nowhere more assertively demonstrated than in this dynamic painting of a female nude (probably Vanessa Bell) taking her bath in a rudimentary tub. Her frontal pose, with her hands held above her head, also recalls that of Picasso's nearly contemporaneous *Nude with Raised Arms* autumn 1907 (Zervos IIa, 35), whose distorted physical attributes – flat breasts, broad hips and tapered legs – she shares.

Although there is no evidence that Grant knew *Vase of Flowers*, the motif of an informal arrangement of flowers set on a table top or mantelpiece, often in the cluttered environment of the artist's studio, was an enduring one in his work. The technique of hatching, deployed both as a decorative device and as a form of stylised shading, was a hallmark of his immediate pre-war practice. As well as the dominant colour scheme of blue, yellow and black in *Vase of Flowers*, it is the use of vigorously hatched lines that places it as being contemporary with Picasso's *Nude with Drapery*, completed in the late summer of 1907. Grant certainly knew that work from visits to the Steins' and his cross-hatched decoration clearly imitates Picasso's, itself derived from the dog-tooth and basket-weave patterns commonly used as relief ornamentation in African wood-carving. However, whereas Picasso extends this decorative treatment across the surface of his painting, here Grant uses hatching only sparingly on the body of the nude, to delineate her ribs, thereby largely maintaining the division between figure and ground.

10
PABLO PICASSO
Vase of Flowers 1908
Oil on canvas
92.1 × 73
The Museum of Modern Art,
New York. Gift of Mr. and Mrs.
Ralph F. Colin, 1962
Zervos IIa, 30

11

DUNCAN GRANT

The Tub c.1913
Watercolour and wax on paper
laid on canvas
76.2 × 55.9
Tate. Purchased by the Trustees
of the Chantrey Bequest 1965

12

DUNCAN GRANT
The Modelling Stand c.1914
Oil and collage on board
75.6 × 61
Private collection

12

Grant started to incorporate collage into his work in mid-1914, following his visits to Picasso's studio earlier in the year. Initially, as here, he applied papers – either painted especially for the purpose or appropriated from an existing source, including printed papers, cigarette packets and newsprint – at the same time as paint, in front of the subject. Although his use of collage was certainly stimulated by exposure in Paris to Picasso's *papiers collés*, Grant generally employed it to very different ends: not as a conceptual equivalent for a represented object, but rather to enrich his palette and to increase the surface variety of his composition. This is one of his most elaborate collage paintings, in which the combination of media and the interplay of descriptive and near-abstract passages of painting are adroitly controlled. The two bowls on the top shelf of the sculptor's modelling stand and the ambiguous black oval object to their left (possibly a small Omega Workshops bowl) are an almost direct quotation from Picasso's *Jars and Lemon* (no.2).

13

This design was made anonymously at the Omega Workshops, but can confidently be attributed to Grant on grounds of style and handling. Whether it was executed with a specific object in mind is unclear, but it might have been intended for a printed fabric. Several areas of the design have been over-painted, while the border was probably added later, possibly by another hand. The scheme of interlocking and overlapping rectangles and lozenges is indebted to the most austere and economical of Picasso's *papiers collés* of 1912–13 (e.g. no.66) and to the contemporary series of paintings in which he sought to emulate the effects of collage, specifically *Head of a Man* (no.8), in Fry's collection.

13
ATTRIBUTED TO
DUNCAN GRANT
Abstract Design c.1913–15
Bodycolour and pencil on paper
60.8 × 48.3
The Samuel Courtauld Trust,
The Courtauld Gallery, London

This work marks a significant, albeit short-lived, shift in Grant's use of collage. It is a second (and larger) version of a subject already treated in oil (Tate T01143); in this case, the view, imaginatively recreated by the artist, through two first-floor rooms in Clive and Vanessa Bell's house at 46 Gordon Square, Bloomsbury. Although highly abstracted, certain features of the rooms are recognisable: doorframes; two windows; a pile of canvases stacked against a wall; and, seen side on, a long sofa on which sits a cushion, its slim, yellow ellipse recalling the lemon in Picasso's *Jars and Lemon* (no.2), which hung at the time at 46 Gordon Square. The work is composed entirely of *papier collé*, underscoring the autonomy of the medium and emphasising the distinct shapes of the composition. The papers used were cut from rolls painted beforehand by Grant.

Shortly before starting the painted version of this subject Grant had made a careful copy (whereabouts unknown) of Picasso's 1913 *Head of a Man* (no.8), which Fry had recently purchased, and Grant later thought this exercise may have influenced the appearance of his own painting; in both, the illusion of planes overlapping in space is a common feature.[7] The underlying geometric structure of Grant's image was also likely to have been informed by Picasso's *Man with a Guitar* (private collection. Zervos IIb, 436), acquired by Gertrude Stein shortly after it was completed in the spring of 1913, which Grant would have seen at her apartment in rue de Fleurus. Unusually in Picasso's cubist oeuvre, extensive sections of *Man with a Guitar* consist of broad rectangular bands of paint, in a range of deep, rich colours – olive green, cadmium red, sienna, ochre and orange – similar to those deployed by Grant in both his painted and collaged views of 46 Gordon Square.

14
DUNCAN GRANT
Interior at Gordon Square
1914–15
Papier collé on board
76 × 65
Private collection

As originally conceived around 1914 this was
a purely abstract, rectilinear painting; it may possibly
have also sported three-dimensional elements. When
Grant chose to rework it about four years later he added
three figurative devices: the white jug, the lemon and
what appears to be a fluted glass vase. The lemon and
jug were two of Grant's signature motifs at this time,
both with their sources in the iconography of Picasso's
proto-cubist and cubist work. The lemon is once again
quoted from his *Jars and Lemon* (no.2), while the jug,
which is repeated in Grant's *Venus and Adonis* 1919,
may derive from a similar white jug in Picasso's 1912
still life *The Bouillon Cube* (Zervos IIa 303), shown in
the *Second Post-Impressionist Exhibition*.[8]

15
DUNCAN GRANT
The White Jug 1914–18
Oil on panel
106.7 × 44.5
Southampton City Art Gallery

WYNDHAM LEWIS AND PICASSO

RICHARD HUMPHREYS

Wyndham Lewis encountered the work of Picasso, perhaps the man himself, and certainly his milieu, while living in Paris and travelling through Europe during the years 1902–8. It has been suggested that his *The Theatre Manager* of 1909 (no.16) is the first work by a British artist to show the influence of Picasso's *Les Demoiselles d'Avignon* 1907, which Lewis's friend and mentor, Augustus John, had seen in the artist's studio soon after it was made. Throughout Lewis's career Picasso's art was a touchstone for him, both positive and negative; as late as 1940 he wrote a long article in the United States about a recent major Picasso retrospective.[1]

By the time Lewis edited the two editions of *Blast* in 1914 and 1915, the magazine of the vorticist movement of which he was the controversial leader, he showed himself to be a highly knowledgeable though critical admirer of Picasso. His criticism rested on two concerns: Picasso's usually limited subject matter, and the lack of compositional energy in his recent synthetic cubist works. Lewis fully recognised Picasso's talent and eminent position within modernism, but saw him as a potentially negative influence, particularly on British art: 'The whole of the modern movement, then, is we maintain, under a cloud. That cloud is the exquisite and accomplished, but discouraged, sentimental and inactive, personality of Picasso.'[2] Lewis was aiming his views directly at the artist and critic Roger Fry and the other Bloomsbury artists, whom he felt had seriously distorted public perceptions of the possibilities of modernist art.

Following his service as an artillery officer during the First World War and his work as an official war artist, Lewis briefly attempted a re-invention of vorticism. His intense pre-war animosity towards the Bloomsbury artists and their supporters is revealed in his polemical long essay *The Caliph's Design* (1919), where he writes at length on Picasso: 'wonderful artist as he is … If we intend thoroughly to pursue our Pablo into the deplorable corner into which his agile genius has led him … we cannot do better than marry him, in our minds … to the erudite form of Mr Roger Fry.' Lewis identified a weakness in Picasso, 'a gnome-like child', as the unwitting source of a 'pretty studio game' and an obsession with studio subjects in the art of his British adversaries.[3]

Lewis's response to Picasso's exhibition at the Leicester Galleries in January 1921, with its catalogue preface by his now sworn enemy Clive Bell, was two-fold: critical and aesthetic. He wrote a glowing piece about its 'delicate labour and invention' for the *Daily Mail*'s large readership when the show opened.[4] Then, in April, Lewis held his own exhibition at the same galleries, *Tyros and Portraits*, which showed his recent powerful life drawing and often garish images of brash satirical figures, the 'Tyros' of the title. Discussing the 'hostile camps' in British art, Lewis identified the principal dispute as being about subject matter: 'Our present great general movement must be an emancipation towards complete human expression; but it is always liable in England to generate into a cultivated and snobbish game. My Tyros may help to frighten away this local bogey.'[5]

Lewis's other works of the early 1920s, his strangely exquisite and intellectually complex totemic water-colours of 1921–2, indicate the direction he favoured for a full-bloodied modernist art. He was in touch with dada, constructivist and expressionist circles in Europe and briefly conducted a 'one-man' avant-garde movement in the visual arts. By 1923, however, he turned for the next few years to writing a series of books intended to analyse the cultural collapse he saw around him and to lay the theoretical foundations for a new initiative in the creative arts.

16

Lewis returned to London in 1908 to begin his career as a painter and writer after six years of extensive travel in Europe. This drawing is typical of the few surviving pieces of this new phase in its grotesque and overtly literary character. It reflects themes of identity and power that Lewis had explored in his short stories about actors and other marginal figures – types that had been dominant characters in Picasso's art since the turn of the century – which were regarded by many as both brilliant and repulsive. Similarly, the painter Lucien Pissarro viewed works such as *The Theatre Manager* as 'quite impossible' when Lewis showed them at the New English Art Club in 1911.

Here, Lewis draws on earlier artists as diverse as Leonardo da Vinci, Albrecht Dürer and James Gillray, but he was also fascinated by contemporary avant-garde art in Europe and its frequent use of distorted 'primitive' art forms. Lewis lived near Picasso in Paris and his widow later recalled that he knew the 'Apollinaire Group' of avant-garde artists and writers well. Whether Lewis saw Picasso's great revolutionary masterpiece *Les Demoiselles d'Avignon* is uncertain, although the visual parallels with this work are striking. His mentor Augustus John did see the work in Picasso's studio and may have told Lewis about it in 1908 or 1909.

17, 18

By 1911 Lewis's art clearly reflected an intense interest in analytic cubist painting. He had asked the writer and painter Thomas Sturge Moore in 1909 whether he had seen any works by Picasso while in Paris, and by 1910 was creating images characterised by a sharp geometrical quality and distortions of perspective that indicate his precocious response to Picasso's and Braque's recent work.[6]

Lewis shared with Picasso a particular focus on his own identity as an artist. Lewis stares warily, almost inhumanly, out at the spectator, his face a subtle organization of delicate pencil lines and watercolour washes. He presents a sharply cerebral version of himself, emphasising a focus and clarity suggestive of a metaphysical realm of being typical of his idea of the self at this time. Lewis's character Arghol in his vorticist play *Enemy of the Stars* (1914) is described as being full of 'vast, subtle selfish things', while in *Blast 2* (1915) Lewis wrote: 'You must catch the clearness and logic in the midst of contradictions.'

Much of Lewis's intellectual disagreement with his artistic contemporaries concerned the role of narrative in the visual arts. Although he saw himself as in many respects a 'pure' artist, concerned – as the critic Roger Fry required – with the formal qualities of painting, Lewis believed this did not reduce the legitimate subject matter of art simply to portraiture, still life and landscape imagery. Narrative of some kind was at least implicit in all the greatest art, he believed, and animated it in subtle and powerful ways. Lewis shared with Picasso a tragic sense of human existence, though this was rarely expressed without a strong humorous or satirical flavour and, as in his short stories, his figures seem to struggle

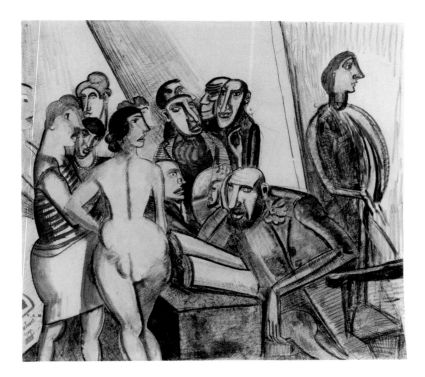

16
WYNDHAM LEWIS
The Theatre Manager 1909
Ink and watercolour on paper
50.8 × 61
Victoria and Albert Museum,
London. Presented by the
family of the late Capt. Lionel
Guy Baker, in accordance
with his expressed wishes.

with the limitations of their bodies, the mind or spirit
always at odds with its embodied condition.

Smiling Woman Ascending a Staircase is a study for
a lost oil painting, *The Laughing Woman* 1911 and seems
to be a satirical response to a more traditional recent
painting, Augustus John's famous *Smiling Woman*
c.1909. Lewis described his own painting in 1914 as
'rather a staid and conventional explosion'. It was,
he said 'done from life', and may depict… vorticism.[7]

Both these works show how, like Picasso, Lewis
gave his characters a powerful mask-like quality. Both
possess some kind of performative dimension, which is
reinforced in *Smiling Woman Ascending a Staircase* by the
mysterious mask on a stick apparently held by a figure
coming into the drawing on the left.

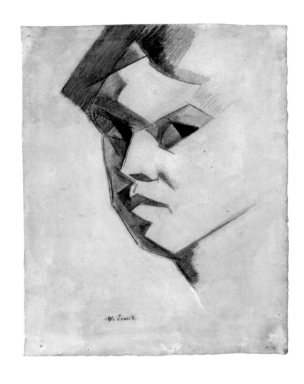

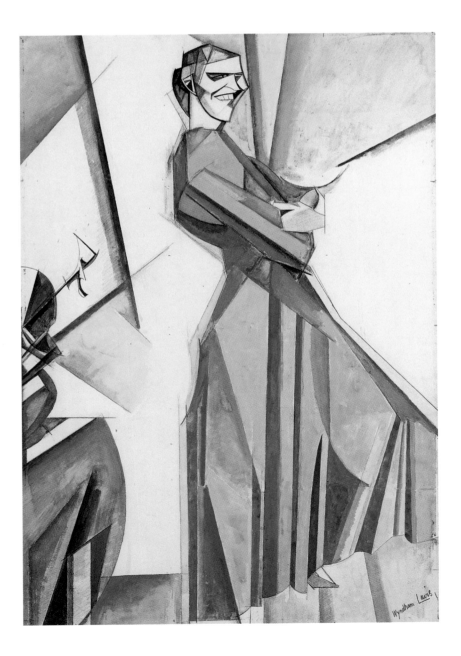

17
WYNDHAM LEWIS
Smiling Woman
Ascending a Staircase
1911
Charcoal and gouache
on paper
95 × 65
Private collection

18
WYNDHAM LEWIS
Self-Portrait 1911
Pencil and wash on paper
30.5 × 23.5
The Courtauld Gallery, London
The Samuel Courtauld Trust.
Acquired for the collection
by Daniel Katz, 2011

19

In 1914 Lewis opened the Rebel Art Centre as an angry response to Roger Fry's Omega Workshops, launched vorticism and in June published the first of only two editions of the journal *Blast*. Much of *Blast* was a vehicle for Lewis's own varied philosophies of life and art. His wide-ranging critique of contemporary art, an attempt to locate his group's distinctive aesthetic and cultural qualities in a wider context of avant-garde developments, both praised and attacked aspects of the main tendencies in the art of the day. Futurism was seen as splendidly energetic but too imitative and sentimental; cubism was a remarkable new direction in art but was too limited in its narrative ambition and too static and lacking in energy; and so on. In Picasso, to whose work Lewis dedicated a lot of attention, he sensed a brilliant and groundbreaking talent too inclined to the decorative, to pastiche and to the overly tasteful.

*Worksho*p, one of only two surviving vorticist canvases, was discovered by chance in an obscure American gallery in 1962. Lewis's large canvases of the period, which we can only see today in contemporary photographs, were bold attempts to inject a fierce energy into semi-abstract images evoking the actual forms of the modern world and its often violent and garishly discordant colours. Lewis believed aesthetic energy lived in the forms of art and could not be evoked by the simulation of movement, as in the case of the futurists, for instance. Where Picasso painted houses and landscapes using motifs similar to Cézanne's, Lewis chose designs densely suggestive of both the complexities of urban life and of the mind experiencing it.

19
WYNDHAM LEWIS
Workshop c. 1914–15
Oil on canvas
76.5 × 61
Tate. Purchased 1974

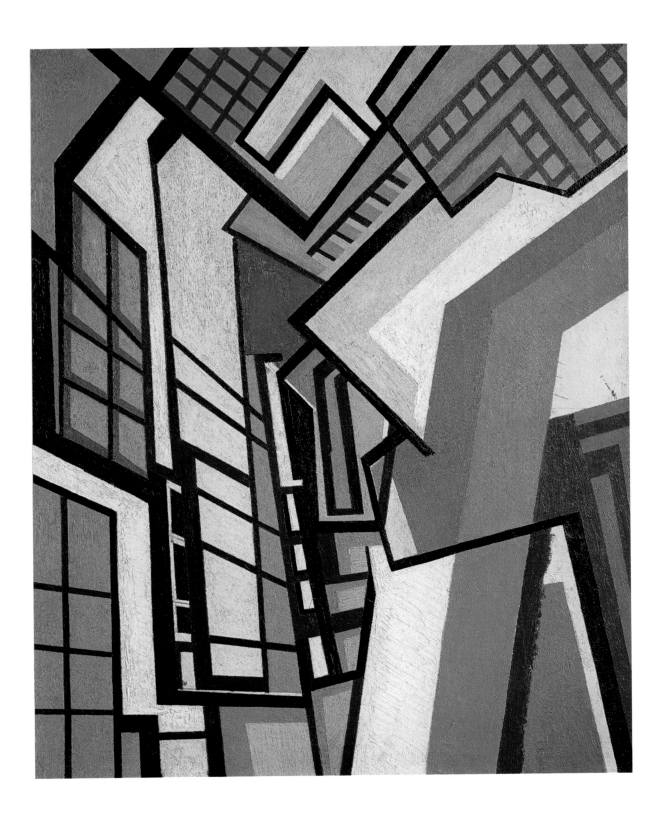

Following the First World War, Lewis returned to London hopeful of reviving the vorticist movement. With an increasingly conservative attitude among many artists in Britain in the wake of the war, this ambition inevitably failed to materialise, and by 1921 Lewis was determined on an individual course as a painter. He maintained close contacts with the Continental avant garde in Paris, Berlin and Holland. His exhibition *Tyros and Portraits*, at the Leicester Galleries in London in 1921, showed the impressive range of work he had been producing since 1919: figure and portrait drawings, complex semi-abstract drawings and images of a new breed of satirical creatures, 'Tyros', postwar 'immense novices' who 'brandish their appetites in their faces'.[8] He published two editions of a new journal, *The Tyro*, in 1921 and 1922, in which he published contemporary British writing and art.

These two luridly coloured figures read presumably erotic passages from the Roman poet Ovid, the nature and scale of their physical appetites suggested by their expressions. It is possible that the work was a response to Picasso's exhibition at the Leicester Galleries, a show Lewis reviewed mainly sympathetically but in which he saw a tendency to the facile which he thought dangerous for British art. Lewis was suspicious of the neoclassical revival in French art of the early 1920s, and Picasso's large classical figures from his London exhibition may here find themselves the objects of satirical attack.

20
WYNDHAM LEWIS
A Reading of Ovid (Tyros)
1920–1
Oil on canvas
165.2 × 90.2
Scottish National Gallery
of Modern Art, Edinburgh.
Purchased 1977

21

21

WYNDHAM LEWIS
Archimedes Reconnoitering
the Fleet 1922
Pencil, ink, watercolour and
gouache on paper
33 × 47
Private collection

This delicately organised and highly complex image makes a strong contrast with Lewis's 'Tyro' images, a strategy of contradiction Lewis employed throughout his career. Like Picasso, he was capable of working in different modes at the same time, insisting that intellectual and aesthetic lethargy needed to be avoided by all available means. In Lewis's case, a literary and critical career ensured his visual art was constantly re-invigorated by a wide range of interests and research. Typically, Lewis invokes various references to contemporary art in this work, such as dada, purism and Picasso's synthetic cubism, while also employing his own rich stylistic repertoire, to make an image of extraordinary historical and philosophical as well as visual resonance.

This work was one of a number Lewis made in 1921–2, which move across many intellectual themes and constantly attempt to create a modernist art capable of embodying profound ideas and experiences. The Greek mathematician Archimedes supposedly defended Syracuse against the Roman fleet using a series of innovative and deadly weapons, including a large mirror with which the Carthaginians reflected the sun's rays on to their enemy's ships to set them ablaze. Archimedes, a tragic hero in Lewis's eyes, ultimately fell prey to arrogance and naiveté before being killed by a Roman soldier at the height of his powers.

22

22

WYNDHAM LEWIS

Mrs Workman 1923

Pencil and wash on paper

33 × 47

Private collection

In the early 1920s Lewis began a series of brilliantly executed figure and portrait drawings, which have established him as one of the finest draughtsman of the twentieth century. In these he seems to present himself as the equal of Picasso, responding to the Spanish artist's extraordinary talent with his own unique style and vision of the human form. In fact Lewis employed a variety of styles within these figurative exercises, for instance conveying the power and energy of the naked body with sweeping arcs and unusual viewpoints in his life drawings, or using an almost miniaturist touch to suggest the character and tastes of a sitter.

This watercolour may seem atypical of Lewis's oeuvre. Mrs Workman, who was married to a Canadian magnate and happened to collect Picasso's work, had a strong interest in the work of the great French painter Jean Auguste Dominique Ingres – a source for much of the neoclassical revival in French art at the time. The delicate shading and close attention to the intricate patterns of the sitter's dress and her chaise longue are, perhaps, surprising aspects in a work by an artist usually associated with a geometric, harsh and satirical approach. In fact, Lewis deliberately and frequently changed his register, always keen to stay alert to the varying demands of different kinds of subject.

PICASSO IN BRITAIN 1919

JAMES BEECHEY

At the behest of Serge Diaghilev, impresario of the Ballets Russes, Picasso spent ten weeks during the summer of 1919 in London, staying at the Savoy Hotel and working in a studio in Floral Street on the decor for a new one-act ballet, *The Three-Cornered Hat* ('Le Tricorne'). While in London he also made a number of drawings of dancers in rehearsal and several portraits of members of the Ballet and its entourage.[1]

Picasso's involvement with the Russian Ballet had begun in 1916 when he designed *Parade*, first performed in Paris in May 1917. That year Picasso travelled with the Ballet to Italy and Spain, where he became engaged to one of the dancers, Olga Khokhlova; they married in July 1918. In Spain Diaghilev discussed with Picasso his plans for a ballet based on Pedro Antonio de Alarcón's 1874 novella, *El sombrero de tres picos*. For this comic tale of lust, greed and mistaken identity, set in the artist's native Andalusia, he commissioned the Spanish composer Manuel de Falla. In April 1919, Picasso agreed

to provide designs for *The Three-Cornered Hat*, part of the Ballet Russes's summer season at the Alhambra Theatre, Leicester Square. He and Olga arrived in London on 25 May and remained until 3 August.

Picasso worked in a large top-floor room in a warehouse at 48 Floral Street, Covent Garden. This was the studio of Vladimir and Elizabeth Polunin, Diaghilev's principal scene painters, and it was here that the set and stage curtain for *The Three-Cornered Hat* were executed. A series of photographs record work in progress on the curtain and some of the visitors to the studio. One such visitor, Sacheverell Sitwell, recorded:

> Diaghilev and Massine were there, and Picasso, in carpet slippers and with a bottle of wine standing near him, was at work. The canvas lay stretched upon the floor, and Picasso was moving about at a great speed over its surface, walking with something of a skating motion ... I recall, at the time, thinking that this was the nearest that modern eyes would ever get to the spectacle of Tiepolo, or another of the great Venetian fresco painters, at work.[2]

The Three-Cornered Hat premièred at the Alhambra on 22 July. Intense work on the ballet restricted Picasso's opportunities to explore London, although he was swept into the round of smart social events that life with Diaghilev engendered. He attended a party in Kensington, dined at the home of Flora Wertheimer, widow of the art dealer Asher Wertheimer, and lunched with Lady Ottoline Morrell at Garsington Manor in Oxfordshire. Visits he may have made to museums and galleries are unrecorded – but his hotel was close to the National Gallery; André Derain, also travelling with the Ballet, may have shared his enthusiasm for the British Museum;[3] Picasso might have sought out the paintings he had admired in his youth at the National

Gallery of British Art (renamed the Tate Gallery in 1932) at Millbank. During his stay Picasso renewed his acquaintance with Augustus John – 'the best bad painter in Britain'[4] – and Jacob Epstein; it was the Bloomsbury group, however, that paid him closest attention. Roger Fry invited him to dinner and showed him around the Omega Workshops. Clive Bell hosted several lunch parties for Picasso: 'not so exciting' was the brusque assessment of Lytton Strachey.[5] At Picasso's request, Bell took him to see the East End and he escorted the artist on a shopping expedition to Savile Row and Jermyn Street, to have him kitted out 'as an English gentleman'.[6] The culminating event was a supper given in honour of Picasso and Derain by Bell and Maynard Keynes at the Bells' house, 46 Gordon Square, on 29 July, the penultimate night of Diaghilev's season, the forty guests including a contingent from the Ballet, Duncan Grant, Edward Wolfe, Aldous and Maria Huxley and Lytton Strachey. It was, Picasso told Grant, 'the party he had been looking for ever since he had been in England'.[7]

Picasso's presence in London left scarcely any mark on British art. Laura Knight made paintings and sketches of *The Three-Cornered Hat*; Ethelbert White produced a series of drawings and prints illustrating the production; and Picasso's costumes informed those that Grant designed for the dancer and choreographer Léonide Massine's 1923 ballet *Togo*, or the *Noble Savage*. Otherwise, there was little reciprocity. Ottoline Morrell passed on to Mark Gertler Picasso's comment that he found 'most English art sweet and "pretty"';[8] for his part, Gertler 'did not like Picasso's ballet or even his scenery'.[9] Others were unimpressed by the company the artist kept: C.R.W. Nevinson told Clive Bell that a number of colleagues were furious with him for having monopolised Picasso, a fury that fuelled suspicion of the new direction in Picasso's life and art.

Fig.18
Serge Diaghilev, Vladimir Polunin and Pablo Picasso in the scene-painting studio at 48 Floral Street, London 1919
Private collection

23
PABLO PICASSO
Two Dancers 1919
Pencil on paper
30.4 × 23.2
The Whitworth Art Gallery,
The University of Manchester

During the first weeks of his stay in London, Picasso regularly attended the Ballet's rehearsal sessions at the company's hired dance studio in Chandos House, Shaftesbury Avenue, including the final run-throughs of the ballet that preceded *The Three-Cornered Hat* in the summer programme, *La Boutique Fantasque*, designed by André Derain and choreographed by Léonide Massine to music by Gioachino Rossini. He 'usually sat in the corner during the rehearsals … and made drawings', recalled Tamara Karsavina, who rejoined Diaghilev's troupe in May 1919 to dance the role of the miller's wife in *The Three-Cornered Hat*. 'He was very silent, very reserved, I would say. Always scribbling something.'[10]

With apparently effortless economy, and through the use of a muted palette, Picasso's backdrop for *The Three-Cornered Hat* evoked the parched and mountainous landscape of Andalusia, where the story is located. Before leaving Paris, he had experimented with some twenty variations of setting the stage, producing a huge number of studies. In London he simplified and softened his design, making more dominant the great arch that links the miller's house on the right with the building on the left. Although the design was essentially naturalistic, the incorporation of certain cubist elements, notably a planar structure and subtle perspectival distortion, was one of the earliest demonstrations of Picasso's desire to blend the two styles in which he was now working.

Collaboration stimulated Picasso and he was recognised as the most professional of all the artists Diaghilev employed. Vladimir Polunin recorded that he came daily to the studio in Floral Street, taking a keen interest in the scene-painters' methods and asking them to retain the individuality of his drawing and to pay particular attention to its colouring. The canvases were thinly primed to preserve the silky texture of his maquette and, to maintain the general unity of tone and opacity that the artist required, Polunin used large quantities of zinc white – a pigment abhorred by the Russian Ballet's earlier designers, since it destroyed the brilliance of their colours. Picasso involved himself in every aspect of the ballet's décor and he himself painted the silhouette of the distant village and the stars falling out of the Andalusian sky. At the dress-rehearsal, Diaghilev observed that the miller's house seemed 'a trifle dull' and suggested that Picasso enliven it by adding a vine growing against its wall; this, too, he painted on by hand.[11]

24

PABLO PICASSO
The Three-Cornered Hat:
Design for a set 1919–20
Pochoir on paper
19.8 × 28.8
PiF III 430
Royal Opera House,
Covent Garden
Donated by Sir John Ritblat
(original model illustrated)

The nimble minimalism of Picasso's design was clearly articulated by Polunin:

> Having dealt so long with [Léon] Bakst's complicated and ostentatious scenery, the austere simplicity of Picasso's drawing, with its total absence of unnecessary detail, the composition and unity of the colouring – in short, the synthetical character of the whole – was outstanding. It was just as if one had spent a long time in a hot room and then passed into the fresh air.[12]

The success of his scenic solution was immediately recognised at the ballet's first London performances: according to the Ballets Russes's first historian, 'there had been nothing in all the long series [of Diaghilev ballets] to compare with the ethereal beauty of this'.[13]

The Three-Cornered Hat was the largest ballet that Picasso designed, and over forty studies by him for costumes are extant, ranging from a drawing on a sheet of Savoy Hotel writing paper to a series of gouache and watercolour sketches and several hand-painted cardboard cut-outs. The following year, pochoirs (stencilled colour prints) were made of thirty-two of the gouaches, encompassing designs for sets, costumes and props, and published by Paul Rosenberg in an edition of 250.

To help him determine the cut of his costumes, Picasso regularly attended rehearsals of the ballet, as Tamara Karsavina recalled:

> During the rehearsals for *Le Tricorne* he used to sketch my costume, and I looked over his shoulder and said, 'How are you going to make the costume for me?' I expected something magnificent with spangles. 'Oh,' he said, 'very, very simple'. And he said, 'I am going to make it round you'. And that's why he did it at the rehearsal, because he wanted to watch the dance, and know how the costume would move with the dance. You know that wonderful compelling line of his; he really knew movement.[14]

The costume he finally evolved for Karsavina as the miller's wife was an appropriately Goya-esque dress with flounced skirts and a low neckline – described by the dancer herself as 'a symbol more than an ethnographic reproduction of a national costume'.[15] Léonide Massine was the miller, and with the design for his costume Picasso ran into difficulties with Diaghilev, who insisted that the nature of the miller's most important dance, the *farruca*, required very tight, long trousers, whereas the artist, in keeping with the eighteenth-century setting of the ballet, wanted him to wear knee-breeches. Reluctantly, Picasso compromised; the Miller wore breeches during the first half of the action and trousers for the finale.

Picasso's understated designs for the costumes of the two principal dancers were in sharp distinction to those he created for the corps de ballet, a kaleidoscopic parade of hoops, stripes and arabesques that, in their rich colouring and complex patterning, anticipated his highly decorative, theatrical still lifes of the mid-1920s. Although Massine wrote that, when he came to arrange

25
PABLO PICASSO
The Three-Cornered Hat:
The Miller 1919–20
Pochoir on paper
25.3 × 19.1
Royal Opera House,
Covent Garden.
Donated by Sir John Ritblat
(original gouache illustrated)

26
PABLO PICASSO
The Three-Cornered Hat:
The Miller's Wife 1919–20
Pochoir on paper
25.8 × 19.2
Royal Opera House,
Covent Garden.
Donated by Sir John Ritblat
(original gouache illustrated)

27
PABLO PICASSO
Costume design for
The Three-Cornered Hat:
The Corregidor's Wife 1919
Gouache, indian ink,
watercolour and pencil
on paper 26.5 × 19.6
Musée national Picasso, Paris
donation Pablo Picasso, 1979.
MP1714. Zervos III, 318

28
PABLO PICASSO
Costume design for
The Three-Cornered Hat:
The Dandy 1919
Watercolour, black gouache
and pencil on paper
26.3 × 19.7
Musée national Picasso, Paris
donation Pablo Picasso, 1979.
MP1683. Zervos III, 322

the choreography for the individual dancers, 'I found that [Picasso's] colourful and authentically eighteenth-century costumes were a great help',[16] they were not universally applauded, with several of the ballet's critics complaining that their monotonous devices and harsh and noisy accents confused the audience and distracted from the sobriety of the set.

As well as the costumes, Picasso designed a large number of props and accessories. He also made sketches for each dancer's make-up and, where possible, applied the *maquillage* himself. Cyril Beaumont watched in the wings on the first night as the stage was set:

> [Picasso] strolled into view, accompanied by a stage-hand carrying a tray of grease paints … One of the dancers, dressed as an Alguacil [constable], came on stage, walked towards Picasso, bowed, and waited. Picasso made a selection of grease-paints and decorated the dancer's chin with a mass of blue, green and yellow dots, which certainly gave him an appropriately sinister appearance. As he went off, another Alguacil appeared and I well remember his startled look on seeing his fellow-artiste.[17]

None of the costumes for the original production of *The Three-Cornered Hat* survives, though faithful replicas were made for Massine's 1947 revival of the ballet at the Royal Opera House, in which he reprised the role of the miller.

PICASSO'S CHOICE of a bullfight – unrelated to the plot of *The Three-Cornered Hat* – as the subject for its stage curtain was probably in part a homage to Massine, a fellow aficionado of the *corrida*. An early idea was to offset the representational view of the arena with a cubist still life resting on a huge *trompe l'oeil* easel (Zervos XXIX, 366–8); when this idea was rejected by Diaghilev he instead surrounded the central image with decorative panels. As with the sets, he made numerous studies for the design. One shows an empty arena (Zervos XXIX, 352), another a toreador tossed up towards the crowd, and several a mounted picador lancing the bull (Zervos III, 308). The scene he eventually chose was less spectacular: the *arrastre*, the moment at which horses drag the dead bull from the ring. In their *palco* above the arena, five spectators turn their backs on the drama to face the audience and each other. On the right, three *majas*, in shawls and mantillas, gossip among themselves. While no.30 is one of two oil sketches for the final curtain, *Three Seated Women*, which was purchased by the economist John Maynard Keynes from an exhibition of *French Drawings and Watercolours* at the Chelsea Book Club, London, in December 1919, is an early compositional study for the right-hand group.

The Polunins helped Picasso draw the outline of his drop-curtain design, retaining the heavy contours in order that the image, which occupied a comparatively small section of the huge grey canvas, would be readable from the back of the theatre. After the general tones had been roughed in, the artist himself painted the curtain, to which he also insisted on putting the finishing touches. These included painting the eyelashes of the female spectators, and Massine recounted that 'there was much amusement when [he] was seen in the street, approaching the studio which was accustomed to the sight of brooms in use – carrying two tooth-brushes!'[18] Picasso worked for over a fortnight on the curtain, asking Polunin 'to stop him when, according to the demands of the stage (which he said I knew better than he did), he had achieved the most suitable result'.[19] His final flourish was to add his signature at its bottom right-hand corner: 'PICASSO PINXIT 1919.'

In 1928, during one of his periodic financial crises, Diaghilev cut out the central section of Picasso's curtain and sold it. Since 1959 it has been a permanent fixture of the Seagram Building in New York, where it hangs in the foyer of the Four Seasons restaurant.

30

PABLO PICASSO

**Sketch for the stage
curtain for 'The Three-
Cornered Hat'** 1919

Oil on canvas

36.5 × 35.4

Private collection

Zervos III, 303

31

PABLO PICASSO

Portrait of Lydia Lopokova

1919

Pencil on paper

35.6 × 25.1

Lent by the Syndics of
the Fitzwilliam Museum,
Cambridge. Acquired
with assistance from the
National Art Collections Fund
administered by the V&A on
behalf of the Museums and
Galleries Commission, 1999

Zervos III, 297

32

PABLO PICASSO

Portrait of Vladimir Polunin

1919

Pencil on paper

53 × 34

Private collection

Besides a number of drawings and sketches he made of
her at rehearsal, Picasso also made three posed portraits
of the ballet dancer Lydia Lopokova in her room at the
Savoy Hotel. Executed on the same day, these must
date from before 9 July, when Lopokova fled the Ballet
– ostensibly on the grounds of physical exhaustion,
but in fact to escape her disintegrating marriage to the
company's business manager Randolfo Barocchi. She
did not therefore perform in the original production of
The Three-Cornered Hat, and nor was she present, as has
often been suggested, at the famous Bloomsbury supper
party for the Ballet on 29 July. Of the three drawings
this is the most finished and the only one in which the
chevron pattern on her dress is indicated. Lopokova was
Olga Picasso's particular friend in Diaghilev's company;
she liked and greatly admired Picasso but was wary of his
attentions towards the female members of the corps de
ballet. 'Luckily Olga was present' at the sittings for these
portraits, she told Richard Shone many years later.[20]

In 1925 Lopokova married the economist Maynard
Keynes. Her last meeting with Picasso was on the artist's
visit to England in November 1950 when, as the then
widowed Lady Keynes, she entertained him to lunch
at 46 Gordon Square, Bloomsbury – the setting for the
party given in his honour thirty-one years previously.
Picasso asked his fifty-eight-year-old hostess whether
she still danced; when she replied that she did, they
danced together in the street.

This drawing was owned successively by two of
Diaghilev's staunchest supporters in Britain, the dance
historian Cyril W. Beaumont (1891–1976) and the writer
on art and architecture Sacheverell Sitwell (1897–1988),
both of whom published vivid accounts of their
encounters with Picasso in London in 1919.

Vladimir Polunin (1880–1957), a Russian émigré to
Britain, worked as a scene painter and poster designer
(for London Underground and other firms). Before the
First World War he was employed by Thomas Beecham's
opera company; on the Russian Ballet's return to
England in 1918, he was engaged for the first time by
Diaghilev. Thereafter he became, along with his English-
born wife Elizabeth (also known as Violet), the Ballet's
principal scene painter, travelling with the company
between London and Paris. In 1927 Polunin published
The Continental Method of Scene Painting, a manual of
the technique, of which he was the foremost exponent in
England, whereby canvases are laid flat on the floor and
painted using long-handled brushes. Two years later he
established the theatre design course at the Slade School
of Fine Art, the first of its kind in a British art school.
Picasso enjoyed a respectful working relationship with
Polunin, to whom he gave this sympathetic, hitherto
unpublished, portrait. Later in 1919 Polunin mounted
in a leather-bound book – now known as the 'Album
Polunin' (Musée Picasso, Paris) – twenty-one photo-
graphs of Picasso and others taken in the studio in
Floral Street, into which he also inserted a painted
sketch of the set for *The Three-Cornered Hat*, which he
dedicated and sent to the artist.

33

33

PABLO PICASSO
Design for the costume
of the Chinese conjuror
in *Parade* 1917
Watercolour on paper
28 × 19
Family Helft
Zervos XXIX, 253

Parade, for which Picasso had designed the set and costumes in 1917, was one of the quartet of ballets presented during the Russian Ballet's 1919 summer season at the Alhambra Theatre, Leicester Square. Though Picasso had left London by the time it actually opened in November 1919, he did spend a week refreshing its sets, which he complained had been so hurriedly and unsatisfactorily painted at the time of the original production in Paris that they required retouching before almost every performance. Before then, however, Londoners were already familiar with the striking design for the costume worn by the Chinese conjuror (a role originally danced by Massine), for it was reproduced in colour on posters prominently displayed throughout the West End and on the Underground advertising the Ballet's summer season and was the subject of much comment and speculation in the press. Picasso and his wife were photographed standing in front of one of these posters outside the Alhambra. Commenting on a vandalised copy, Picasso said: "'Wherever I go I see that people have instinctively improved my picture. No sooner is it posted up than someone comes along and pencils a curly moustache on the face, or draws an umbrella in the uplifted hand. I find myself charmed by the naïveté of these efforts. Offend me? Not at all! I like them. They are most instructive.'"[21]

BEN NICHOLSON AND PICASSO

CHRISTOPHER GREEN

John Summerson's monograph on Ben Nicholson appeared in 1948. It had an agenda, one arrived at in close collaboration with Nicholson: to present him as a fiercely independent modern. Summerson acknowledged that Nicholson's still lifes of 1926–33 were 'closely related to the Paris school of the 1920s', naming Picasso and 'Braque especially', but insisted that 'every Nicholson canvas stands separate against the Paris background'.[1] For him, Nicholson had progressively shaken off all dependencies in pursuit of his own artistic identity, starting with his dependence on the stylish good manners of the fashionable portraits and still lifes of his father William. Picasso, it could be said, already had the stature of a father figure for modernism in Europe by the early 1920s; one who, more than Braque, induced anxiety alongside respect, as well as the need to resist dependence.[2]

As children do with their teachers, Nicholson used nicknames for Picasso among friends like Jim Ede and his first wife Winifred. He was 'Piccy' and 'Picz', but Nicholson always acknowledged his debt to him. In December 1933, in his statement for the modernist group publication *Unit-One*, he listed Picasso, after Cézanne and before Braque and Constantin Brancusi, as one who had made 'a vital contribution' in 'the last epoch'.[3] He had already joined Henry Moore and Ede in campaigning (in vain) for the Tate to purchase its first Picasso.[4] According to Summerson, a scrapbook compiled by Nicholson in 1922, after his first 'terrific adventure' exploring Parisian galleries, listed Picasso among his 'loyalties'.[5] Most telling of all, he recalled to Summerson the experience of seeing a cubist Picasso in Paul Rosenberg's Paris gallery (the date given is 1923) as setting a standard 'by which I judge any reality in my own work'.[6]

Whereas Braque became a friend, Nicholson was able to meet Picasso only a few times in the interwar years, the first being in March and April 1933.[7] His relationship was not with the man but with the work, encountered above all during his visits to Paris. Before 1934 – when his attention shifted towards Piet Mondrian and International Style abstraction – opportunities to see works by Picasso in London were scarce. In 1930 Nicholson encouraged the director of the Lefevre Galleries to mount an exhibition, but the gallery director doubted whether the London public was 'ready for a Picasso exhibition yet'.[8]

Nicholson's modernist priorities were consistent with those of Roger Fry. Form was what counted.[9] Confronted with the brutal eroticism of Picasso's new work in 1930,

he dismissed it as a 'psychological by-pass'.[10] Nicholson's Picasso was very much his own. Given his conviction that there was something common to art and tennis or billiards, he could respond to Picasso's treatment of art as play; given his rejection of the virtuoso refinement of his father's painting, he could not respond to the sophisticated displays of talent that Picasso allowed himself (Braque's lack of conspicuous talent would have been an attraction); given his liking for the crude and the 'primitive', he could respond to Picasso's relish, like Braque, for coarse materials and ad hoc methods; and just as he could not follow the Picasso the surrealists admired, he could not respond to the Picasso who loved to exploit the metamorphic potential of signs: to turn a jug, say, into a woman.

Fig.19
PABLO PICASSO
Guitar Spring 1913
Graphite, cardboard,
charcoal, newspaper
and paper
44 × 32.7
Musée Picasso, Paris
Zervos XXVIII, 301

Nicholson claimed that *1924 (painting – trout)* was his second abstract painting, following *1924 (first abstract painting, Chelsea)* and, when he saw the subtitle 'trout' in an exhibition catalogue, he crossed it out and wrote: 'completely *abstract* painting.'[11] The overlapping flat planes and insistent rectilinear patterning of both works have their origins in Picasso's collage-like paintings of 1914–15, for instance *Bowl of Fruit, Violin and Bottle.* Picasso was still structuring his cubist pictures in this post-collage way in the early 1920s, for instance the tiny *Composition with a Blue Cigarette Packet* . There is an echo as well, in *1924 (painting – trout)* of the rhythmical striations found in such later cubist works as Picasso's *Guitar, Compote Dish and Grapes* of the same year (no.40), but Nicholson's stripes find stronger echoes closer to home. Commenting on his 'trout' painting, Nicholson pointed to their relationship to a striped jug he owned that features in one of his early still lives, a painting

supposedly of 1911 in the style of his father William. Tellingly, he exhibited this small painting with abstract work in 1924.[12]

Anything resembling a trout may be difficult to find in the picture, but there is a tension in the work between the abstractness of Nicholson's planar vocabulary and the hint of a remembered still-life arrangement in a dimly lit interior space. The relation to late cubist still life is clear enough. The pictures connect with an aspect of Picasso's production between the late 1910s and the early 1920s that Nicholson could not have missed on his visits to the Parisian galleries: its repetitiousness, both in the way it deployed near decorative configurations, often linear, and in its repertoire of still-life objects.

In comparable works to *1924 (painting – trout)*, pencil traces remain of a process that mirrors Picasso's and Braque's *papier collé* practice of 1912–14: Nicholson, like them, began with cut and torn paper stuck to the canvas.

34

PABLO PICASSO
**Bowl of Fruit, Violin
and Bottle** 1914
Oil on canvas
92 × 73
Tate. Lent by the
National Gallery, 1997.
Zervos IIb, 529

35
BEN NICHOLSON
**1924 (first abstract
painting, Chelsea)** c.1923–4
Oil and pencil on canvas
55.4 × 61.2
Tate. Accepted by
HM Government in lieu
of tax and allocated to
the Tate Gallery 1986

36
BEN NICHOLSON
1924 (painting – trout) 1924
Oil on canvas
22 × 23
Private collection

Picasso's *Composition with Blue Cigarette Packet* similarly
plays with the memory of *papier collé*, with its painted
representations of wood veneer and the kind of cigarette
packet that might easily have been glued to the surface
of such a work. In his *papier collé* works of 1913, Picasso
could certainly come as close to abstraction as Nicholson
does here, but overwhelmingly the late cubist Picassos
that Nicholson would have seen in the galleries of D-H.
Kahnweiler, and Léonce and Paul Rosenberg between
1921 and 1923 were from the war years and after, work
that employed, where still life was the subject, a clearly
legible vocabulary of signs for objects. Nicholson, it
seems, chose to see in such paintings only what he called
'abstraction'. Writing to his mother-in-law on New Year's
Day, 1923, he is apparently referring to such late cubist
paintings when he announces his increasing interest in
'the abstract stuff'.[13]

John Summerson cites a letter that Nicholson wrote
to him of 1944 describing a revelatory encounter with
a Picasso painting. The year 1923 is given as the date
(though this is not certain).[14] Precisely which painting
he saw is still unclear. Nicholson remembers 'coming
on a cubist Picasso upstairs in Paul Rosenberg's gallery'.
It seemed to him 'completely abstract', and had in the
centre 'an absolutely miraculous *green* – very deep, very

37

PABLO PICASSO

Composition with a Blue Cigarette Packet c.1921

Oil on canvas

30 × 17

Private collection

Courtesy fundacion Almine and Bernard Ruiz-Picasso para el Arte

potent and absolutely real'. He also sent Summerson a well-known photograph of Picasso himself in front of a major cubist figure-piece, *Man Leaning on a Table* 1915–16, (Pinacoteca Agnelli, Turin. Zervos IIb, 550), noting that it was the kind of picture he saw.[15] This is indeed Picasso at his least legible and most constructive – and green is a feature – but Nicholson would have had a limited supply of Picasso reproductions to send, and notes that the work he saw 'was a much smaller ptg'.[16] There is also a letter from Winifred, Nicholson's first wife, to her brother Wilfred, which recalls visits to the Parisian galleries late in 1921, and especially seeing '2 abstractions' by Picasso: 'One a large one of a mandolin … on a table, the other a little gem, green of young dog Mercury black and pure white.'[17] There are several candidates for Winifred's 'large one'. The identity of her 'little gem' remains a subject of speculation, though her report of its green as being as sharp as that of the woodland plant Dog's Mercury suggests that she is writing about the same painting that Ben remembered giving him 'quite one of the nicest experiences of my life'.[18]

Ben's and Winifred's compulsion to use the term 'abstraction' for such a cubist Picasso, despite Winifred's belief that they cannot do without a mandolin, underlines Ben's refusal to focus on the possibilities opened up by Picasso as an inventor of signs that could shift meaning with minimal changes – from figure to object, for instance. Many of Picasso's table-top still lifes of 1918–21 can be read as figures playing musical instruments.[19] What mattered to Nicholson was not this metamorphic potential, but the immediacy with which spatial relationships could be experienced in his cubist work. His 1924 paintings distil from Picasso what for Nicholson was a new kind of pictorial space that does without linear and atmospheric perspective. The overlapping of planes, and colour relationships, give depth yet remain on the picture surface. Nicholson discovers for himself the classic cubist/modernist space, within which he later said he could live imaginatively.[20]

38

BEN NICHOLSON
1932 (Au Chat Botté) 1932
Oil and pencil on canvas
92.5 × 122
Manchester City Galleries

The best documented and most often recalled instance of mirroring as a theme in Ben Nicholson's work is without doubt *1932 (Au Chat Botté)*. The evidence is readily available in Nicholson's contribution to *Horizon* in October 1941, 'Notes on Abstract Art'. Here he describes how, passing through Dieppe on the way home from Paris with Barbara Hepworth in 1932, he was struck by the mingling of objects in a shop-window, with reflections on the glass through which he looked, and also with the red lettering on the glass, which spelled out (for him mysteriously) the shop's name, 'Au Chat Botté' (Puss in Boots). He writes of three superimposed planes, which were 'inter-changeable', creating 'some kind of space or imaginary world in which one could live'.[21] This actual experience of cubist space/ surface oscillations generated

by reflection was certainly the stimulus for the painting, but the way Nicholson took artistic control of them positions the work securely in his dialogue with Braque and especially Picasso.

The canvas was painted in London, and deploys objects that were in the studio, making reference, with its decapitated head, to Barbara's stone carvings as much as to shop-window mannequins.[22] He thus goes back home to his familiar objects, as Picasso and Braque might have done; and the objects he chooses are like those they painted. Tellingly, too, the placing of a bust alongside still-life objects returns to a theme introduced in the mid-1920s by Picasso, though Nicholson's studied refusal to make his bust a classical Hera or Aphrodite asserts his independence.

When Ben Nicholson showed at Tooth's Gallery in London late in 1932, Jim Ede's catalogue preface reflected on the restricted repertoire of objects in the still lifes. He noted how this echoed practices 'on the Continent', but stressed the 'intimacy', the 'intensely felt' quality expressed through Nicholson's objects, as against the intellectual character of what he called 'latin' style.[23] Like Summerson, Ede insisted on the 'continental' (for which read Picasso-and-Braque) relationship but also on Nicholson's independence.

Picasso's *Guitar, Compote Dish and Grapes* 1924 brings to a dazzling climax a long sequence – almost a series – of still-life paintings, begun in 1922, which deploy a restricted selection of objects on table-tops reduced to the simplest of signs, in combination with repeated patterns (earlier more often stripes and checks than stars). These paintings, usually of a saleable domestic size, were on view quickly as they were released on to the market. They display the role of play – serious, exploratory play – in Picasso's late cubism. He explores the boundaries between signification and meaninglessness, between sign-making and pattern-making, and does so within the rules of a game that rigorously restricts the objects and patterns allowed.[24]

Nicholson similarly enjoyed game-playing – in his life and his art – and equally relied on a limited repertoire of objects. Initially, these were most often common domestic plates, bowls, mugs and jugs, patterned and unpatterned, as in the jug and plate of fruit in *1929 (still-life with green*

jug)*. These were the sort of objects that were in regular use in Banks Head, the Cumbrian farmhouse bought in 1924 by his wife Winifred. He treated these objects with child-like directness, something especially to be seen in *1929 (still-life with green jug)*. His objects have none of the now-you-see-it, now-you-don't, abstracted sophistication of the signs for fruit-bowl and stringed instrument in Picasso's *Guitar, Compote Dish and Grapes.* The ambiguity of Picasso's signs, which allowed him to leave it open whether we read the stringed instrument as a guitar or a mandolin, is set aside.[25] In 1932, Nicholson added to his vocabulary of forms the profile of his new lover, Barbara Hepworth. These images have a certain hieratic quality, as if stamped on a coin and in *1932 (crowned head – the queen)* he gives her royal status. This insertion into Nicholson's work of coded messages of an intimately personal nature is an uncanny echo of Picasso's practice – uncanny because Nicholson could not have been privy to Picasso's messages to his new lover, Marie-Thérèse Walter, in his paintings of 1927 and after (the affair was kept well under cover).[26] It is also worth recalling that the profile – usually a self-portrait profile – makes regular appearances in Picasso's work through the later 1920s.

1932 (crowned head – the queen) is a late manifestation of Nicholson's commitment to the Picassian game of variation through the near repetition of pattern motifs. The overlapping planes that he had taken from Picasso's post-collage paintings of the late 1910s in his 1924 abstract compositions, here become areas of patterning – red and black striations, straight and wavy lines, dots and squares of solid colour – surrounding the central motif of Barbara's head, just as patterned planes surround Picasso's guitar.

1932 (crowned head – the queen) evinces an intensely personal sensitivity through its scraped down and roughed up surfaces, and its precise yet never mechanical line. Nicholson's treatment of his surfaces engages touch in ways not hinted at by Picasso's earlier still lifes, even when they too are more textured and not as flatly worked as the Stedelijk picture. After the summer of 1928, the paintings of the near illiterate retired seaman and rag-and-bone man, Alfred Wallis, had opened the way to a newly intensified awareness that paintings could be treated as things – things that retain the traces of human contact, like old furniture and utensils. The wavy and straight lines and the wonky patterning here are in and on this 'worn' surface. Nicholson plays Picasso's game but with his own counters, on his own board, with his own kind of intensity.

39
BEN NICHOLSON
1929 (still-life with green jug) 1929
Oil and pencil on board
45.7 × 54.5
Private collection

40

PABLO PICASSO

**Guitar, Compote Dish
and Grapes** 1924
Oil on canvas
98.5 × 132
Collection Stedelijk Museum,
Amsterdam

41

BEN NICHOLSON

**1932 (crowned head –
the queen)** 1932
Oil and pencil on canvas
91.5 × 120
Abbot Hall Art Gallery,
Kendal, Cumbria

42

PABLO PICASSO
Head of a Woman 1926
Pen and charcoal on paper
62 × 47
Staatsgalerie Stuttgart/
Graphische Sammlung
Zervos VII, 007

In 1932, Nicholson's relationship with Barbara Hepworth, initiated in 1931, deepened to the point of total immersion. Their passion inevitably opened a gap between him and his wife Winifred, which, however, she and Nicholson never allowed to become unbridgeable. In 1932–3, his life veered between time with Barbara in the studio they shared in Belsize Park and in France, and time with Winifred and his children, who moved to Paris late in 1932. In this brief but prolifically productive period, before he committed himself to International Style abstraction in 1934, Nicholson was more immediately involved than ever before with the Paris art world and its modernist stars, including Picasso.

Between his first visit to Picasso, on 15 March, and the second, on 18 or 19 April 1933, Nicholson and Hepworth went for a short Easter break to Saint-Rémy-de-Provence.[27] Back in London, Nicholson painted a rare figure piece, *1933 (St-Remy, Provence)*, which centred on a head in triplicate above, with a bare breast, hand and shoulder below. The framing profile heads update the images of Barbara that featured in such works as *1932*

(crowned head – the queen). The painting *1933 (St-Remy, Provence)* unmistakably takes up the fused double-head theme developed by Picasso in the late 1920s, especially as he broached it in two closely related heads, which seem to anticipate the arrival of Marie-Thérèse Walter. One of these is *Head of a Woman* 1926; the other is an oil of the same subject.[28] Barbara Hepworth was with Nicholson for the April visit to Picasso in his Paris studio at 23, rue La Boétie. Later she recalled him taking out a succession of 'miraculous paintings' to show them, as they negotiated the cigarette stubs and other rubbish on the floor.[29] Double heads might have been among these canvases. It is also worth noting that Nicholson could have seen Brassaï's photographs of Picasso's plaster busts of Marie-Thérèse published in the first number of the glossy periodical *Minotaure*, which appeared the following month and would quickly have reached London after his return. The most classical of these busts, photographed in cool profile, has obvious affinities with Nicholson's *St-Remy* profiles.[30]

1933 (St-Remy, Provence) has most often been seen in the context of Braque, because of the connection between Nicholson's incised line and Braque's use of sgraffito (scratched lines) in paintings on gesso made at this time (something Nicholson recalled being struck by).[31] Picasso, however, is at least as relevant, and not just the 1926 double heads and the Marie-Thérèse busts. The work has its origins, in fact, in a drawing, usually dated 1932, of Barbara naked in their Belsize Park studio, her head in profile reflected full-face in an oval mirror.[32] The doubling of the mirror reflection instigates the triplicate image. Stylistically, Nicholson's drawing is clearly related to Picasso and mirroring was a current Picassian theme: *Girl before a Mirror* 1932, which is especially in tune with the Nicholson, though its rich colour and solar and lunar allusions are not, may still have been in the rue La Boétie studio in April 1933.[33]

43

BEN NICHOLSON

1933 (St-Remy, Provence) 1933

Oil on board

105 × 93

Private collection

In a number of works of the 1920s, Picasso's line is sometimes scratched into the painted surface – or drawn in white with the brush to appear to be sgraffito – exposing the white of the ground beneath coats of black, brown and blue. Nicholson's responsiveness early in 1933 to Braque's similar practice of scratching lines into black to expose the gesso ground beneath, could well have been encouraged by an earlier awareness of Picasso's use of the technique. Both *1933 (musical instruments)* and *1933 (coin and musical instruments)* were painted against a 'Parisian background', as John Summerson describes it, that included Picasso and others too, not just Braque.[34]

The fanned-out pairing of the guitar with its twin (or shadow) in *1933 (musical instruments)* finds echoes especially in Juan Gris in 1913, while the isolation of the instruments in the shadowy space recalls Picassos of 1912, and the dark, coarsely textured surfaces, scratched into with a knife or etcher's burin, relate to Picasso of the mid-1920s and Braque of the early 1930s.[35] Allusions to Picasso are merged with other references. Of these two paintings by Nicholson, Picasso's presence is felt most strongly in *1933 (coin and musical instruments)*, where Hepworth's profile, more insistently than in *1932 (crowned head – the queen)*, echoes Picasso's own profile in his work of the mid- to late 1920s. Nicholson uses a scratched line to open up different possible readings, thus heightening affinities with Picasso's late cubist practice. The profile inscribed in a circle, as if in a mirror or stamped on a coin, the violin on the left and the more angular stringed instrument on the right, as well as the wavy edge of the table cloth, are easily read, but the swerving, unravelling line edges towards abstraction in such a way as to risk metamorphic suggestion: could there be a hint of a feminine presence in those curves?

By 1933, Nicholson was looking at Miró's least obviously figurative work as well as the late cubism of Braque and Picasso. He responded to Miró's work as if it was pure abstraction, but now and again he can seem to slip into a kind of ambiguity that invokes Picasso as well as Miró.[36] Norbert Lynton suggests that the paired guitars of *1933 (musical instruments)* are metaphors for the coming together of Ben and Barbara, whose relationship was certainly at its most passionate at this time.[37] This work resists cliché, but the musical-instrument-equals-woman formula is certainly a possibility, and its mazy drawing is manifestly spontaneous as well as controlled. The way line swings free of its representational function in this picture, especially to right and left of centre, is the product of the decisive yet impulsive act of cutting into the picture surface, lighting up its darkness with the white of the gesso beneath.

The importance to Nicholson of Picasso's coarsened surfaces and scratched incisions in his mid-1920s still lifes is underlined by the fact that he was already drawing by scratching into roughened surfaces in *1928 (Pill Creek)* (Private Collection), long before his encounter with Braque's sgraffito works in 1933.[38] It is necessary, however, to stress just how different Nicholson's compulsive treatment of the work as a material object was from Picasso's. Most strikingly, the way he treats his picture-objects avoids the almost sadistic violence with which Picasso often attacks the picture surface. Nicholson's drawing with the blade or point is never out of control, and he scrapes down, rubs and coaxes surfaces to bring out beauties that humanise things as they are worn by age and use, not because he was driven, like Picasso, to confront the ugly and the abject.

44
BEN NICHOLSON
1933 (musical instruments)
1932–3
Oil on board
104 × 90
Kettle's Yard, University of
Cambridge

45
BEN NICHOLSON
**1933 (coin and musical
instruments)** 1933
Oil on board
106.7 × 121.9
Lent by The Metropolitan
Museum of Art, New York,
Bequest of Richard S. Zeisler,
2007

PICASSO IN BRITAIN 1920–1939

**JAMES BEECHEY, PATRICK ELLIOTT
HELEN LITTLE AND CHRIS STEPHENS**

Of the three artists that Diaghilev brought to London in 1919 – Derain, Picasso and Matisse – it was Picasso whose market remained lowest in Britain during the following decade. The exhibition of his work at the Leicester Galleries in 1921 – the most comprehensive yet seen in Britain, with seventy-two paintings, drawings and prints (including nos. 2, 3 and 8) – attracted a large public, considerable (though mixed) press coverage but hardly any sales. While the most expensive painting (*Woman in an Armchair* 1913. Private collection. Zervos IIb, 522) was priced at £780, the entire exhibition reaped only £92, reflecting the sale of one or two drawings and a few prints. The Leicester Galleries' show had already been postponed from autumn 1920 so that Léonce Rosenberg's loan of cubist works could be supplemented with a wider representation of Picasso's art. The proprietors' belief that with 'a fine and typical' range of Picasso's work they 'could repeat the triumphant success obtained for the Matisse show last year' proved wildly optimistic.[1] Responding to their plea that the prices were too high, Rosenberg wrote sarcastically (in English):

Fig.20
Spread from the exhibition catalogue for *Thirty years of Pablo Picasso*, Alex. Reid and Lefevre Gallery, London 1931
Tate Library and Archive

I know that London is, at present, a very bad market for archaic art and advanced modern art, and that *very small* places on the continent are very much better markets than the huge, old town of London. But I am not at all prepared to sell under value things because your people are not up-to-date. Never mind if you do not sell anything, I can sell my Picassos on the Continent and in America very much better. If the London people are not prepared to pay the necessary prices well, let them go … They forget that Picasso is the greatest artist living since Cézanne.[2]

The response to the Leicester Galleries show set the tone for the 1920s, when no gallery dared mount a Picasso exhibition and only one or two British collectors acquired works by the artist.

Though focusing on the American market, Paul Rosenberg was instrumental in helping the expatriate Hugh Willoughby assemble the first substantial British collection of Picasso's work, and Rosenberg's premises next door to Picasso's apartment in rue La Boétie were an important port-of-call for visiting artists from Britain, including Henry Moore, Ben Nicholson and the young Francis Bacon. A few British commercial galleries exhibited and sold works by Picasso in the 1920s (often on commission for Paris dealers); the two most significant were Alexander Reid in Glasgow and the Lefevre Gallery in London, who joined forces midway through the decade. Encouraged by Ben Nicholson, in 1931 Alex. Reid and Lefevre mounted a part-loan, part-selling exhibition, *Thirty Years of Pablo Picasso*, that included among its thirty-seven exhibits seminal pieces from the current or recent collections of some of the artist's leading patrons – Ambroise Vollard, Paul Guillaume, Alfred Flechtheim, John Quinn and G.F. Reber – supplemented by a handful of works lent by British owners and a revelatory selection of Picasso's latest abstracted figures hitherto unseen in Britain. The exhibition, declared the *Observer*, 'should leave little doubt that [Picasso] is the dominating, the most significant and

the most inspiring figure in twentieth-century art'.[3] For many who saw it (including Douglas Cooper), it was a compelling introduction to Picasso's career and an enlightening demonstration of the internal coherence of his oeuvre; it also acted as a spur to the monumental retrospectives held in Paris and Zürich the following year. In its aftermath, a small group of interconnected galleries began to develop a market in London for Picasso's work.

Since 1923 Zwemmer's bookshop in London's Charing Cross Road had been a magnet for those avid to keep up with the evolution of Picasso's art and Parisian modernism in general, through colour reproductions and European magazines.[4] It also co-published in 1930 the first English monograph on the artist, by Eugenio d'Ors. In 1929 Zwemmer opened a separate gallery, which soon became a major outlet for Picasso's work: in 1936 it held an important and commercially successful exhibition of pictures from all periods of his career and the following year showed a collection of fifty of the artist's drawings and nineteen outstanding, mostly cubist, paintings acquired from the Belgian collector René Gaffé.[5] The Mayor Gallery, relaunched in Cork Street in 1933 following a strikingly modernist make-over and with Douglas Cooper as a partner, regularly presented Picasso in mixed exhibitions and organised a show of his drawings in 1934. In 1937 Paul Rosenberg and his brother-in-law Jacques Helft opened Rosenberg and Helft, a London branch of Rosenberg's Paris gallery, where they staged two exhibitions of Picasso's recent work. These significant presentations brought to the London audience some of the artist's most recent works, leaving, for example, a lasting impression on a teenage Lucian Freud.[6] From 1938, when Roland Penrose acquired a share in the business, Picasso was central to the activities of the London Gallery, directed by the Belgian surrealist E.L.T. Mesens, and of its house journal, the *London Bulletin*. Its last major exhibition before war intervened was a (highly selective) compilation of works by Picasso borrowed from English collectors. By then, Picasso's role as a crucial animator of modern art in

Britain was widely acknowledged. One of his geometric still lifes of the early 1920s had provided the frontispiece to Myfanwy Evans's 1937 anthology *The Painter's Object*, which carried a translation of Christian Zervos's 1935 'Conversation avec Picasso'. Picasso provided a model for the book's polemic in favour of subject matter over abstraction. The London Gallery exhibition coincided with the publication of the first full-length study of Picasso by a British writer, Robert Melville's idiosyncratic *Picasso: Master of the Phantom*.[7]

The majority of the fifty-one exhibits in *Picassos in English Collections* at the London Gallery in 1939, including eighteen lent by Penrose himself, had been acquired only in the previous three or four years – often, as a result of the Depression, at bargain prices. The exhibition reflected a fresh intensity in buying Picasso's work, largely fuelled by a new breed of collector. It contained almost no examples of his Blue and Rose periods, favoured by most of Picasso's earlier British collectors, nor of his neoclassical phase, which failed to find a receptive audience in Britain. Its focus was cubism, around which were built the two exceptional Picasso collections formed in Britain during the late 1930s, by Cooper and Penrose. Those who bought Picasso's pictures in the 1920s (mainly early works, and rarely more than one apiece) tended to be prominent, wealthy businessmen, such as Samuel Courtauld (no.50) and William McInnes (no.49). Some representatives of this caste – Robert Sainsbury (no.51) and Oswald Falk (no.60) – emerged as collectors of Picasso's more challenging work in the 1930s, but most of those buying his cubist and surrealist paintings were figures already involved in the British art world in some aspect.

Between the wars Picasso's etchings, particularly his early Saltimbanques suite, continued to be widely admired and collected.[8] Indeed, it was primarily as a printmaker that Picasso was represented in public collections. The Victoria and Albert Museum acquired its first print by him, a copy of *The Frugal Meal*, in 1930. But besides very occasional short-term loans, and the exhibition of Hugh Willoughby's collection at the Tate Gallery and then at Cheltenham Museum and Art Gallery in 1934–5, Picasso's paintings were absent from Britain's museums and galleries, as they were also in France. In 1933 there was a concerted campaign by a number of artists and critics to raise funds to buy a work by Picasso to be presented to the Contemporary Art Society and so, ultimately, to a public gallery, perhaps the Tate. The work in question was discussed as *Profile* and is also known as *Woman in an Armchair* 1927 (Zervos VII, 78); the campaign was unsuccessful.

Of the six paintings by Picasso to enter British public collections, mostly by bequest, before the end of the Second World War, only one (no.58) post-dated his Blue and Rose periods and three (nos. 46, 47 and 49) were painted in 1901, the year in which, aged twenty, he had just begun to make his mark in Paris. If by end of the 1930s Picasso was recognised by nearly all advanced creators, critics and collectors of contemporary art in Britain as the most inventive and influential artist of his age, institutionally he seemed still to be regarded as the 'quite accomplished sort of minor international painter' described by Walter Sickert in 1911.[9] JB/CS

Picasso returned from Spain for his second visit to Paris in May 1901 in anticipation of his exhibition at the Galerie Vollard arranged for the following month. He painted a number of flower pieces shortly after his return. Six were included in the exhibition that opened on 25 June. This may have been amongst that group. Flower paintings continued to be a feature of the artist's production for another three years.

The present work was the first by Picasso to be acquired by a British public collection, as it was bought from Alex. Reid and Lefevre by the Tate Gallery in 1933 with assistance from the Contemporary Art Society. In 1933 Picasso was not only a well-established avant-garde artist, but the London public had already had the opportunity to see such challenging works as his bone-period Dinard paintings at Reid and Lefevre and other galleries. The decision to buy this more conservative early work suggests the Tate Gallery trustees were resistant to Picasso's more radical developments even as they recognised his importance as a painter. In the same year, the gallery acquired two further Picasso paintings by bequest from Frank Stoop (nos.3, 58). CS

46
PABLO PICASSO
Flowers 1901
Oil on canvas
65.1 × 48.9
Tate. Purchased with assistance from the Contemporary Art Society 1933
Zervos I, 61

Following his return to Paris in May 1901, Picasso launched into a period of feverish activity, adding to the works he had brought from Madrid and Barcelona to arrive at a total of sixty-five by the time his exhibition at Galerie Vollard opened on 25 June. This rooftop view from his studio at 130 Boulevard de Clichy was listed as 'Les Toits' in the exhibition.[10]

This was the first painting by Picasso to enter a British public collection outside London when it was bequeathed to the Ashmolean by the Bolton mill-owner and collector Frank Hindley Smith, who died in 1939. The significance of this regional triumph is somewhat diminished, however, by the fact that Hugh Willoughby's more up-to-date collection of around twenty Picassos had by that date already been exhibited twice at Cheltenham Museum and Art Gallery. Hindley Smith was close to the Bloomsbury group: Roger Fry designed the interior of his house at Seaford in Sussex, and Hindley Smith helped establish the London Artists' Association along with John Maynard Keynes and Samuel Courtauld. He had built a significant collection and left paintings by Henri Matisse and Georges Braque to the Ashmolean, as well as bequeathing a significant group of impressionist paintings to the Fitzwilliam Museum in Cambridge. CS

47

PABLO PICASSO
Blue Roofs, Paris 1901
Oil on board
39 × 57.7
The Ashmolean Museum, Oxford. Bequeathed by Frank Hindley Smith, 1939
Zervos I, 82

48

PABLO PICASSO
The Race Course at Auteuil
1901
Oil on board
47.3 × 62.2
Private Collection
Not in Zervos

48

Picasso produced a number of paintings in 1901– mostly on cardboard or wood panel – depicting racecourse scenes in the Bois de Boulogne. The present work is thought to be that shown at Galerie Berthe Weill, Paris, in June 1902 as 'Grand Prix d'Auteuil'.[11] A more precise date of spring 1901 has been suggested, however, which could mean the subject was the fashionable season of races at Chantilly and Auteuil leading up to the annual Grand Prix in June.[12] Picasso's exhibition at Vollard's gallery that opened on 25 June 1901 included a racecourse scene, and John Richardson has highlighted that, in listing the 'modern life' subjects addressed by the artist, Gustave Coquiot's introduction to the exhibition refers to 'smartly dressed women seen at the racetrack "against finely bedecked grandstands and the carefully tended turf of the course".'[13] It may be that *The Race Course at Auteuil*, with its view of the finishing line and stewards' box, is the work listed in the 1901 Galerie Vollard exhibition catalogue as 'Les Courses'.[14]

The painting passed through Paul Rosenberg's hands to Arthur Tooth & Sons Gallery in London. There it was bought by the British collector Lee Hardy in 1937. It was included in a large exhibition, *Since the Impressionists*, at London's Wildenstein Gallery in May–June 1945, and appeared in Picasso's great retrospective at the Tate Gallery in 1960. CS

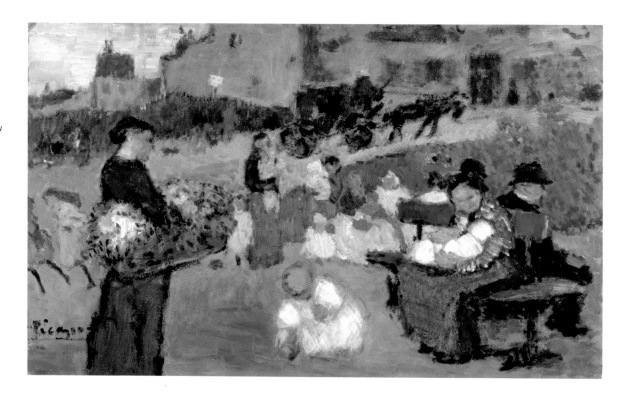

49

PABLO PICASSO

The Flower Seller 1901
Oil on board
33.7 × 52.1
Lent by Culture and Sport
Glasgow on behalf of Glasgow
City Council. Bequeathed by
William McInnes, 1944
Not in Zervos

49

The Flower Seller was one of the earliest Picassos bought
by a Scottish collector, and the first work by the artist
to enter a public museum in Scotland. It was acquired
by the Glaswegian shipping magnate William McInnes
sometime in the 1920s, and was one of the seventy
paintings, including works by Claude Monet and Vincent
van Gogh, bequeathed by him to the City of Glasgow on
his death in 1944. McInnes was a regular client of the
Glasgow art dealer Alexander Reid and it was probably
from him that he acquired the painting.

The Flower Seller was painted on Picasso's second
visit to Paris in 1901, and is characteristic of the broadly
brushed vignettes of Parisian life that the artist painted
in and around Montmartre that year. It might be the
work exhibited in 1904 as 'Marchandes des quatre
saisons', though it has been noted that two children
running on the left-hand side resemble another work
exhibited at Ambroise Vollard's gallery in June 1901.[15] CS

50

From 1924 to 1928 *A Child with a Dove* was owned by
Mrs R.A. Workman, a considerable, if now rather over-
looked, collector of impressionist and post-impressionist
painting. Coincidentally, her portrait had been drawn
by Wyndham Lewis in a manner not unlike Picasso's
classicising style of the early 1920s (no.22). This painting
had been with Alexander Reid in Glasgow, where it was
exhibited in 1924. Mrs Workman lent it to the opening
display of the Modern Foreign Galleries at the Tate
Gallery in 1926, before selling it to Samuel Courtauld,
the greatest of all British collectors of modern French
art, two years later. Although Courtauld subsequently
bought a handful of drawings and etchings by Picasso,
this remained the only painting by the artist in his
collection.

A Child with a Dove was painted in the later part of
1901, when Picasso abandoned the eclectic range of
impressionist styles that had characterised his Galerie
Vollard exhibition that summer. As the broken brush-
work of those earlier works was replaced by a broader,
coarser handling, so his depiction of modern urban life
was displaced by more intimate subjects such as this. In
this way and in its colouring, *A Child with a Dove* marks
the beginning of the artist's Blue period. CS

110

50

PABLO PICASSO

A Child with a Dove 1901

Oil on canvas

73.3 × 54

Private collection,

on long loan to

the Courtauld Gallery

Zervos I, 83

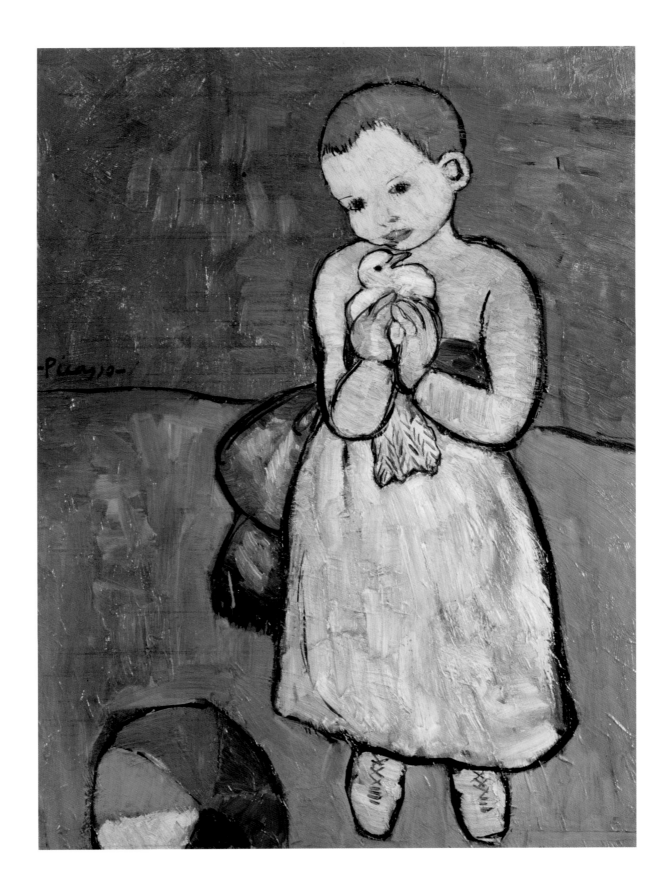

51
PABLO PICASSO
Female Nude with Arms Raised 1907
Gouache on paper
63 × 46
Robert and Lisa Sainsbury Collection, University of East Anglia
Zervos VI, 906

Female Nude with Arms Raised is an early study for the central figure in *Les Demoiselles d'Avignon* 1907, and demonstrates decisively the influence of Iberian sculpture on the original conception of Picasso's great painting. The figure's sexually provocative and yet vulnerable pose has also been associated with a recurring motif in the work of Peter Paul Rubens.[16] This is one of the few extant works relating to the early stages of *Les Demoiselles* that the artist did not retain. The figure embodies Picasso's fascination around 1906–7 with African tribal masks and the work was a natural fit for the collection of Robert Sainsbury, who bought it from Hugh Willoughby in 1939. Willoughby presumably acquired it after January 1935, as it does not feature on the plans for an exhibition of his Picasso collection that opened that month.[17]

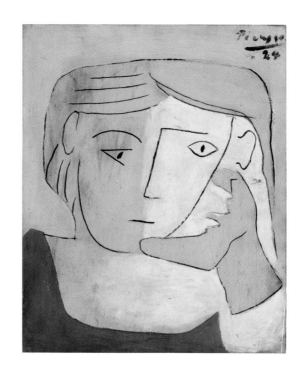

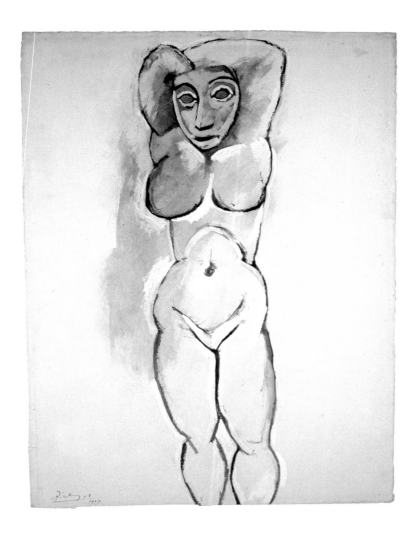

Hugh Willoughby (1884–1952) had perhaps the largest, most wide-ranging and certainly most visible Picasso collection in Britain in the early to mid-1930s. He had lived in or near Paris from around 1911 until his return to Britain in 1934. He had gone there to study painting but became an art critic and, possibly, a dealer. He was certainly associated with Picasso's principal dealer Paul Rosenberg, but at what stage Willoughby began collecting is unclear. Shortly after his return to Britain, his Picassos were displayed at the Tate Gallery in November 1934, the exhibition travelling to Cheltenham Museum and Art Gallery in January 1935. Both *Head of a Woman* 1924 and *Guitar Suspended on a Wall* 1927 were shown. A second exhibition in Cheltenham of the expanded collection opened in July 1937, by which time the latter included *Female Nude with Arms Raised* and *Minotauromachy* 1935 (no.63), as well as the drawing *Weeping Woman* 1937 (no.106), which he had just bought on 24 June at an auction at the Albert Hall, London, in aid of Basque refugees. In the late 1930s, Willoughby seems to have befriended the critic Robert Melville, and the illustrations for the latter's 1939 monograph *Picasso: Master of the Phantom* are all works in the collection of Willoughby to whom the book is dedicated. The book

52

PABLO PICASSO
Head of a Woman 1924
Oil on canvas
34.5 × 26.5
Tate. Accepted by
HM Government
in lieu of tax and allocated
to the Tate Gallery 1995
Zervos V, 357

included a major work acquired by Willoughby the previous year, *La Nicoise* 1937 (Museum Berggruen, Berlin, not in Zervos), which he lent to the exhibition Aid for Russia held at Erno Goldfinger's Hampstead house in June 1942. A few months later, in a similar fashion, he held an exhibition at his own flat in Hove, Sussex, with his Picassos supplemented by Roland Penrose's *Weeping Woman* (no.107). Fifteen works from the collection were shown again, at Eugene Slatter's London gallery at the war's end in May 1945.

Guitar Suspended on a Wall was one of the more substantial works owned by Willoughby, being one of three significant oils in his collection by the end of the 1930s. In this work the instrument is indicated by vertical lines for strings, horizontal frets and an eye-like central sound hole. Its curvilinear forms intermingle with the patterned wallpaper and dado of the background in a style that marks the transition from late cubism to

Picasso's more surrealist mode of the late 1920s. Painted in early 1927, the work coincides with the artist's new love affair with the teenage Marie-Thérèse Walter; John Richardson has argued that, to conceal his new affair, Picasso would transform Walter in his paintings, 'often into the ideogram of a guitar hanging on the wall'.[18] Willoughby's third oil, *Woman in an Armchair* 1929 (Private collection, Zervos VII, 246), was one of Picasso's more convulsive and tortured female figures and the range of the collection is perhaps epitomised by the contrast between it and the sobriety of the 1924 *Head of a Woman* (also inscribed February 1925 on its stretcher). The gentle angularity of this small oil marks Picasso's gradual progression from the classicising figuration of the early 1920s. That the artist valued the work might be suggested by the fact that it was included in his 1932 retrospective at Galerie George Petit, lent by Willoughby and available for sale. CS

53

PABLO PICASSO
Guitar Suspended on a Wall
1927
Oil on canvas
81.5 × 81.5
Guggenheim Art Holdings/
W.H. Patterson Ltd.
Zervos VII, 170

This work was painted in the spring or early summer of 1909 in Paris, before Picasso departed for Horta de Ebro for the summer. It typifies his work of that period, marking the transition from images for which he drew heavily upon artefacts of African and other non-Western or ancient cultures, to the full-blooded cubism of 1910 onwards. The composition lacks the hard, straight lines typical of the cubist paintings of the following year. Instead, this figure is given energy and physical credibility by being modelled from sections of Cézannesque small brushstrokes. The figure thus has a sculptural quality, a fact not disconnected from Picasso's production of his sculpture *Head of Fernande* 1909. While it was in Horta de Ebro that Picasso produced a sequence of proto-cubist paintings of his lover, Fernande Olivier, she also seems to be the subject here with her high forehead and hair drawn back into a bun.

The painting was in the collection of Eardley Knollys, a painter who ran the Storran Gallery in London. He was also known for his connections with artists such as Graham Sutherland and with a circle of upper-class gay, or bisexual men. It may be the painting listed in Douglas Cooper's ledger as 'Seated Woman 1909 sold Knollys 1939'.[19] From around 1932, Cooper had set out to establish a definitive collection of cubism based around the four leading artists: Picasso, Braque, Fernand Léger and Juan Gris. If it is not the same work, then, by the end of the 1930s, Knollys must have owned two 1909 Picassos. CS

This portrait of Picasso's lover Fernande Olivier demonstrates the development of cubism at around 1909–10. Unlike the sculptural modelling of *Bust of a Woman* 1909 set against an identifiable background, this work is flatter and more schematised. The fracturing of the background, especially, demonstrates the rapid development of the cubist style while, typically, the artist retains the ability to capture the sitter's appearance and character. The distinctive style of Fernande's hair and the slight sideways tilt to her head is a recurring feature of her portrayal in both two and three dimensions.

Cubist Head (Portrait of Fernande) was owned during this period by Michael Sadler, and was lent by him to the exhibition *Picasso in English Collections*, organised by Roland Penrose at the London Gallery in 1939. It is also listed as having been in the collection of John Quinn, the great Irish-American collector of Parisian and English modernism, whose collection was sold after his death in 1926.[20] Sadler was one of the great collectors in modern Britain, although relatively little is known about the extent of his Picasso collection. His collection ranged from medieval carving, through Aztec and Aboriginal works, to Thomas Gainsborough, John Constable and Wassily Kandinsky. As Vice-Chancellor of Leeds University in the 1910s and 1920s, Sadler had a significant impact on artists and others such as Herbert Read and Henry Moore. His son recalled, however, that it was in 1932 (when he was Master of University College, Oxford) during a busy buying trip to Paris that he 'bought a Picasso portrait and eleven masks from the Ivory Coast'.[21] CS

54

PABLO PICASSO

Bust of a Woman 1909

Oil on canvas

72.7 × 60

Tate. Purchased 1949

Zervos IIa, 143

55

PABLO PICASSO

**Cubist Head (Portrait
of Fernande)** 1909–10

Oil on canvas

66 × 55

Lent by the Syndics of
The Fitzwilliam Museum,
Cambridge

Zervos IIa, 219

56

PABLO PICASSO

Man with a Clarinet 1911–12

Oil on canvas

106 × 69

Museo Thyssen-Bornemisza,
Madrid

Zervos IIa, 288

One of the masterpieces of Picasso's hermetic cubism,
in which the image depicted becomes increasingly
elusive as form and space are almost indistinguishably
fused together, *Man with a Clarinet* was bought in 1937
from G.F. Reber of Lausanne by the collector, writer
and curator Douglas Cooper. Cooper, who would later
become a close associate of the artist and a leading
authority on cubism, had got to know Reber when he
was a director of the Mayor Gallery in London and
acquired from him a number of works by Picasso and
the other cubists. In that way, by the end of the 1930s
Cooper had been able to establish, if not the largest
collection of Picasso's art in Britain, certainly the
most focused. Setting out to create a collection that
documented the progressive development of cubism,
alongside work by Braque, Gris and Léger, Cooper
amassed work by Picasso dating from 1906 to 1932 but
with a strong bias towards paintings, drawings and
collages of the period from 1909 to 1921. PE

Painted at Picasso's studio in Paris's rue La Boétie in
the autumn of 1918, when the end of the First World War
coincided with the death of Picasso's dearest friend, the
poet Guillaume Apollinaire, this work is unique in his
output. The question of cubism's continued relevance
after the war was then being debated, and it is significant
that this work was included in Douglas Cooper's collection
which he amassed with the intention of documenting
the history and development of that movement. Here,
Picasso plays with pictorial convention by setting a
familiar cubist still life of interleaving, flattened forms
against a suggested horizon and within a decorative
frame. The theme echoes the series of paintings, made
around the same time, in which a cubist still-life arrange-
ment is set upon a guéridon in front of a window. It has
been suggested that this subject reflected the artist's
unease at the bourgeois lifestyle he shared with his
wife Olga at that time.[22] There certainly seems to be
a tension between the rough surface of the painting,
achieved by the addition of sand (common in Picasso's
work of this period), and the delicate refinement of
the framing device. CS

57

PABLO PICASSO

Still Life with Garlands 1918

Oil and sand on canvas

46.4 × 46.4

J. Hutchinson

Zervos III, 142

58
PABLO PICASSO
Seated Woman in
a Chemise 1923
Oil on canvas
92.1 × 73
Tate. Bequeathed by
C. Frank Stoop 1933
Zervos V, 3

The Dutch stockbroker (Cornelis) Frank Stoop (1863–1933) had arguably as great an impact on Picasso's visibility in Britain as anybody. Along with a small number of individuals associated with the Bloomsbury group, he acquired the artist's work before the First World War. He continued to collect after the conflict during the 1920s, a time when few in Britain seemed to have an appetite even for Picasso's more orthodox works. Most importantly, having established themselves as prominent patrons, Stoop and his wife Bertha bequeathed their collection to London's National Gallery. That 1933 bequest formed the heart of the national holdings of modern French art then housed at the Tate Gallery on Millbank. cs

Still Life: Bowl and Apples is a small but fine example of Picasso's curvilinear still-life paintings of the mid-1920s. It demonstrates with particular clarity the anthropomorphic potential of the still-life theme that dominated Picasso's work of that year. It was one of fourteen works by Picasso sold at Christie's by a Mrs G. Bevan.[23] The purchaser was Maynard Keynes, though his association with Picasso was of much longer standing.

As a member of the Bloomsbury group, Keynes, the leading economist of his time, was a significant collector and patron of the visual arts. He began collecting around 1908 and acquired several works from the great Degas sales in 1918. On 29 July 1919, he co-hosted a supper for Picasso while the latter was in London with the Ballets Russes. Four years later, Keynes married the Ballets Russes dancer Lydia Lopokova, several portraits of whom Picasso had made while the company was staying at the Savoy Hotel. Though he had purchased in December 1919 one of the designs for the *Three-Cornered Hat* that Picasso had made in London a few months earlier, this 1924 still life was Keynes's first purchase of a painting by the artist. cs

59
PABLO PICASSO
Still Life: Bowl and

Apples 1924
Oil on board
32 × 38
By kind permission of the
Provost and Scholars of
King's College, Cambridge,
on loan to the Fitzwilliam
Museum, Cambridge
Zervos V, 253

Dated 27 July 1932, this work belongs to the remarkable sequence of portraits that Picasso made of Marie-Thérèse Walter in his studio at the Chateau de Boisgeloup. Marie-Thérèse is presented here – as in almost all her portraits – as a series of sensuous curves. Even the scrolling arms of the chair have been heightened and exaggerated to echo the rounded forms of her body. The face is a double or metamorphic image: the right side can also be seen as the face of a lover in profile, kissing her on the lips.

Unusually, this work has been in Britain almost since its production. Paul Rosenberg secured it from Picasso in the year that it was made and it was sold by his London entity, Rosenberg and Helft, to the stockbroker and economist Oswald T. Falk (1879–1972). Falk was a close associate of Maynard Keynes. He was part of the team led by Keynes at the 1919 Paris Peace Conference and was Keynes's broker and co-speculator in investment. The more liberal-minded Keynes fell out with Falk, a right-wing opponent of market regulation, over the latter's belief that investors should sell their shares in British industry. The two continued, however, to enjoy parallel passions for ballet and art. The full range of Falk's art collection is not recorded, but it included contemporary British art and a number of other Picassos, including *Dying Bull* 1934 (The Metropolitan Museum of Art, New York. Zervos VIII, 228). C S

60
PABLO PICASSO
Nude Woman in
a Red Armchair 1932
Oil on canvas
129.9 × 97.2
Tate. Purchased 1953
Zervos VII, 395

61

61

PABLO PICASSO
Nude, Green Leaves and Bust
(also known as **Bust Nude
with Sculptor's Turntable**)
1932
Oil on canvas
164 × 132 cm
Tate. Lent from
a private collection
Not in Zervos

This luscious painting of Picasso's young lover, Marie-Thérèse Walter, was hung by the architect Serge Chermayeff in one of the premises he had designed when it was photographed for publication. The interior was an apartment in London belonging to Commander Teddy Haywood Lonsdale. It is not clear whether Chermayeff had bought the work for his client or whether, as seems often to have been the case, he had borrowed it from a dealer in order to furnish the premises.

The work is one of a series Picasso made of Marie-Thérèse Walter at his country house at Boisgeloup. The precise dating of each allows us to trace the development of the series. This work is inscribed 8 March 1932 and was followed the next day by another, similar image of the model reclining in front of foliage. The present work has greater dramatic tension, however, as the bust that casts a shadowy profile across the curtain backdrop suggests a voyeuristic aspect. The resultant erotic effect is all the more striking in light of the recent suggestion that the black bands that traverse the nude body of Marie-Thérèse have their origin in a bondage photograph by Man Ray.[24]

62

PABLO PICASSO
Reading at a Table 1934
Oil on canvas
162.2 × 130.5
Lent by The Metropolitan
Museum of Art, New York.
Bequest of Florence M.
Schoenborn, in honor of
William S. Lieberman, 1995
Zervos VIII, 246

Picasso's representation of his young lover Marie-Thérèse Walter is generally characterised by an emphasis on her voluptuous sexuality. This work, painted at the Chateau de Boisgeloup in March 1934, is one of a series that, in contrast, show her reading, writing or engaged in other forms of quiet, sedentary activity. The result is an unexpected tenderness. This change of tone has been attributed to the influence of Matisse's earlier work.[25]

Reading at a Table was acquired from Rosenberg and Helft, probably by 1937 and certainly by 1939, by the patron and collector Peter Watson (1908–56). As the financial backer and de facto art editor of *Horizon*, the leading cultural magazine published in Britain in the 1940s, and as a co-founder, alongside Roland

Penrose, Herbert Read and others, of the Institute of Contemporary Arts, Watson played a vital role in the wider dissemination of Picasso's work in Britain. Though he was a major patron and close associate of such artists as Graham Sutherland, Francis Bacon and Lucian Freud, Watson's extensive collection of modern European and British art was largely housed in his apartment in Paris and so not readily available to them, especially when it became isolated by the Nazi occupation of the city. Given the short period of his possession of the present work, however, it seems likely that it remained in London. At the beginning of the Second World War, Watson sent it to New York along with his boyfriend, the American Denham Fouts. cs

63

PABLO PICASSO

Minotauromachy 1935

Print

57.7 × 77.5 cm

Lent by the Syndics of
The Fitzwilliam Museum,
Cambridge

Minotauromachy was Picasso's largest and most techni-cally brilliant etching to date. Although its meaning has generally been interpreted as private and autobiographical (referring to Picasso's relationship with his young mistress Marie-Thérèse Walter, whose features bear a strong resemblance to each of the female characters), the dramatic confrontation between the protagonists antici-pates the themes of violence and destruction pervading the overtly political work Picasso was to make during this period of mounting tension after the onset of the Spanish Civil War. For Herbert Read, who in the early 1950s examined the iconography of *Minotauromachy* in the context of mythology and the unconscious, Picasso's universal allegories of the Minotaur, horse and the woman bearing light provide several direct visual sources for *Guernica* 1937. It is, Read wrote, 'a picture so rich in symbolic significance ... one is almost persuaded that Picasso at some time made a study of [the Swiss psychologist Carl] Jung'.[26]

Minotauromachy was first seen in Britain in an exhibition of Picasso's work in 1936 at Zwemmer's bookshop and gallery on Charing Cross Road, an emerging touchstone in London for the latest develop-ments across the Channel in modern art and literature. There it provoked considerable critical comment, nota-bly from Anthony Blunt, whose description of the image as 'the nightmare of a great artist, reflecting both the general instability of the time and, it is said, personal disturbance', contributed to the fierce debate concerning Picasso's effectiveness as a modern political propagandist. This print was purchased from Zwemmer's by Helen Inman and immediately presented to the Fitzwilliam Museum, Cambridge, at a time when Picasso was barely represented in British public collections, hardly at all outside London, and only then by works from very early in his career. HL

64

64

PABLO PICASSO
Woman in Green 1909–10
Oil on canvas
99 × 80
Collection Van Abbemuseum,
Eindhoven
Zervos IIa, 197

Woman in Green is one of the last in an extensive series of paintings, drawings and sculptures based on Picasso's mistress Fernande Olivier and produced by the artist in 1909–10, in which he subjected her form to far-reaching critical analysis, rigorously dissecting its features and reconstructing them in rectilinear planes and facets. A magnificent example of the artist's fully defined analytical cubism, this was an outstanding work in a group of fourteen Picassos acquired by Roland Penrose from the Belgian collector René Gaffé in 1937. With their purchase Penrose became, at a stroke, the foremost collector of

Picasso in Britain. He had met Picasso for the first time the previous year and went on to become a close friend of the artist, his chief apologist in Britain, where he organised numerous exhibitions devoted to Picasso, and eventually his official biographer. During the twenty years that *Woman in Green* remained in Penrose's possession it was shown in several significant exhibitions in Britain of Picasso's work, including *Picasso in English Collections* at the London Gallery in 1939 and *The Cubist Spirit in its Time* at the same gallery in 1947. PE

65

PABLO PICASSO
Guitar, Gas-Jet and Bottle
1913
Oil, charcoal, varnish
and grit on canvas
70.4 × 55.3
Scottish National Gallery
of Modern Art, Edinburgh:
purchased 1982
Zervos IIb, 381

This work was acquired in the late 1930s by Roland Penrose who, alongside Douglas Cooper, formed one of the two most extensive and outstanding collections in Britain of Picasso's work. *Guitar, Gas-Jet and Bottle*, a critical work for understanding the development of Picasso's work in 1913 after he began to replicate the effects of *papier collé* in his paintings, was one of the group of fourteen Picassos that Penrose purchased from Gaffé in 1937. During the artist's lifetime, the present work was shown in a number of significant Picasso exhibitions in Britain, including *Picasso in English Collections* at the London Gallery in 1939, *The Cubist Spirit in its Time* at the same gallery in 1947, the great 1960 Tate retrospective and *Picassos in London: A Tribute on his Ninetieth Birthday* at the Institute of Contemporary Arts in 1971. PE

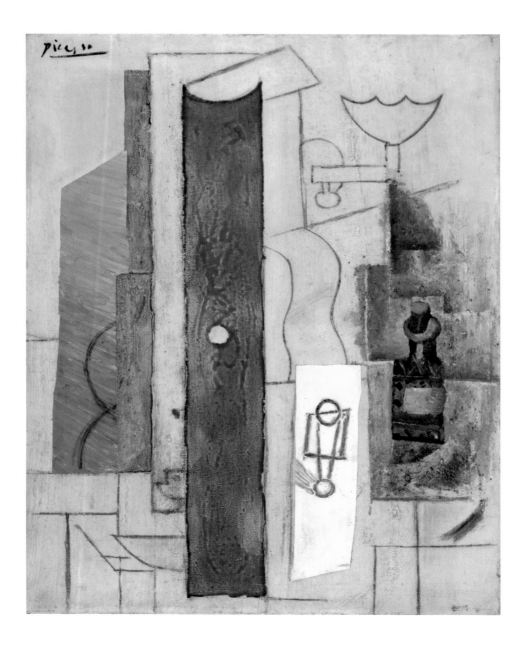

Penrose acquired this important *papier collé* from the leader of the surrealist movement, André Breton. Somewhat surprisingly, given its date, it was shown at the *International Surrealist Exhibition* in London in 1936. The simple forms of roughly cut paper strips seem to describe something like a sculptor's modelling stand, but the semi-circle drawn in charcoal is clearly intended to suggest a head. The small circle thus becomes an eye and the long arrow a nose; similar motifs appear in the *Head of a Man* (no.8), belonging to Roger Fry, that Picasso made later that year.

The present work is one of the most minimal of the series of collages that Picasso made in either Paris or Céret in early 1913. Those that followed would incorporate such decorative elements as wallpaper and newsprint. CS

66
PABLO PICASSO
Head 1913
Papier collé and chalk on card
43.5 × 33
Scottish National Gallery
of Modern Art, Edinburgh:
purchased with help from the
National Heritage Lottery Fund
and the Art Fund 1995
Zervos IIb, 414

67
PABLO PICASSO
Still Life 1914
Painted wood and
upholstery fringe
25.4 × 45.7 × 9.2
Tate. Purchased 1969

Picasso's relief constructions, which he began making in 1912–13, extended traditional still-life painting into three-dimensional space. This composition is closely related to his paintings of the period: it appears to depict a table top or small sideboard, with a knife, a beer glass, two slices of sausage and a slice of cheese or pâté. This work, however, emphasises that the painting is an object in itself. The incorporation of found objects – in this case, the real upholstery fringe to represent a table – helped to establish a new freedom in the artist's choice of materials.

The work is visible in a photograph of Penrose in his London home (fig.13). It was rare in being a sculpture by Picasso held in a British collection. Such works were rarely seen in the flesh before the landmark exhibition *Picasso: sculpture, ceramics, graphic works* organised for the Arts Council by Penrose and held at the Tate Gallery in June 1967. PE

68

PABLO PICASSO
Portrait of Lee Miller as
l'Arlésienne 1937
Oil on canvas
81 × 60
The Penrose Collection,
England
Not in Zervos

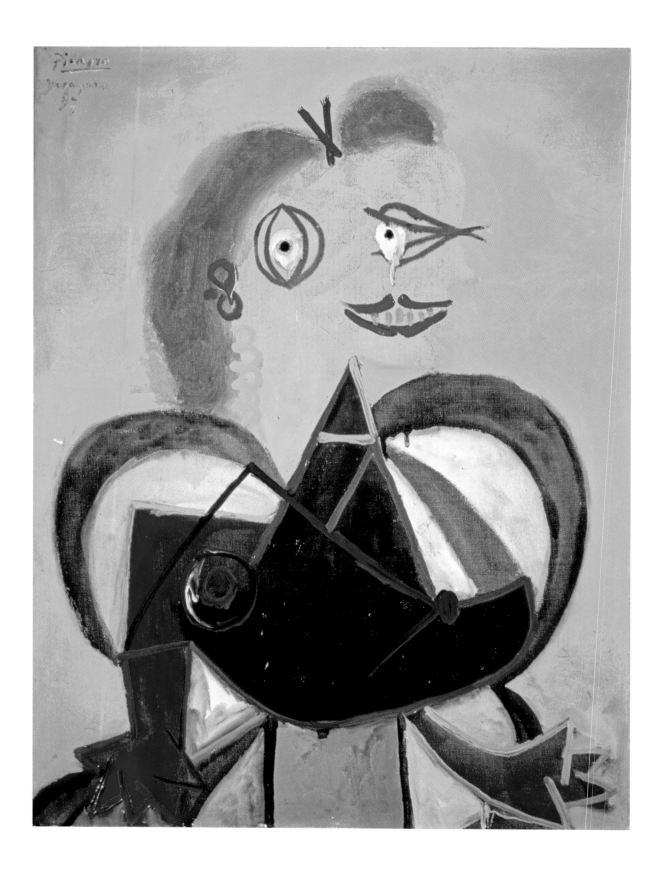

These two paintings were both acquired in the late 1930s by Roland Penrose. The reclining figure was one of the first Picassos to enter Penrose's collection, and the first work he bought directly from the artist on a visit to his country house at Boisgeloup in March 1937. Its convulsive, surrealist forms highlight the contrast between Penrose's collection and that of his British rival, Douglas Cooper. Whilst the former covered a wide period and a broad type of work, the latter was more focused on the development of cubism.

Picasso's facetious portrait of Penrose's future wife, Lee Miller, dressed as an *Arlésienne* (a woman of Arles) was acquired from the artist the same year. It was a souvenir of a summer holiday they spent with a group of friends at Mougins in the south of France, and is one of several on the same theme made at that time; Picasso is also said to have made comparable portraits of Penrose himself in the guise of a female sitter. During the artist's lifetime most of these paintings were included in a number of significant exhibitions of his work in Britain, including *Picasso in English Collections* at the London Gallery in 1939, *The Cubist Spirit in its Time* at the same gallery in 1947, the great 1960 Tate retrospective and *Picassos in London: A Tribute on his Ninetieth Birthday* at the Institute of Contemporary Arts in 1971. PE

69

PABLO PICASSO

Nude on the Beach 1932

Oil on canvas

33 × 40

The Penrose Collection, England

Zervos VII, 353

HENRY MOORE AND PICASSO

CHRISTOPHER GREEN

Henry Moore's way of dealing with potential artistic father figures before celebrity released him from the anxiety of influence was not to mention them in public.[1] Picasso does not feature among the big formative events he would regularly recall until 1937, when Moore met him for the first time. The occasion was unforgettable: he was one of a group of surrealist faithful (including André Breton, Paul Eluard, Alberto Giacometti and Roland Penrose) invited to a performance by Picasso in his role as great radical contemporary, at work in his studio on *Guernica*.[2]

There is, however, the trace of a much earlier formative engagement with Picasso: that name accompanies a sketched figure in a notebook (no. 72) almost certainly executed in 1924.[3] Moreover, Moore was quick to acknowledge in an interview to mark Picasso's death in 1973 that Picasso was a factor from his earliest student days, 'because one knew about Cubism'. 'He has dominated … even sculpture as well as painting – since Cubism,' he added.[4] Again, as his work of the early 1930s makes abundantly clear, a major stimulus for Moore's move into more abstracted work was the erotic monumentalism of Picasso in the late 1920s as he knew it, especially through reproductions in the leading Parisian avant-garde periodicals, *Cahiers d'art* (from 1926), *Documents* (1929–30) and *Minotaure* (from 1933).[5]

For Moore looking back, the Picasso who mattered to him was Picasso the sculptor–painter, but equally important perhaps is the fact that both artists put drawing at the centre of their practice. As a sculptor, Picasso was a modeller and a constructor or *bricoleur*; he worked additively with clay or bits and pieces of metal or found material, often realising ideas compulsively pursued in drawing. Moore, of course, was fundamentally a carver, at least in his exploratory modernist days. He worked mostly subtractively in the 1920s and 1930s, shattering or cutting, abrading or rubbing to extract from stone and wood ideas often arrived at in relatively complete form in drawing.[6] It was in Picasso's image-making, drawings as well as paintings, and only rarely in his sculptures, that he found something his sculptural

imagination could take over and develop. It is significant that his sources were so often black and white photographs in reproduction; images without colour, even where paintings were concerned.

Moore's response to the Picasso of the late 1920s and 1930s was implicated in his much wider response to surrealism. In notes made in 1937 at the point of his deepest involvement with surrealism, Moore recorded his 'dislike' for surrealist 'mixed salads of literary fantasy … pornographic shock stuff, and the echoes of nineties decadence'.[7] His surrealism centred on Picasso, because enough of Picasso's surrealist-related work centred not so much on the obviously literary or explicitly 'pornographic', however erotic, but rather on the human body as physical presence. Crucial to both artists were their academic beginnings drawing from the living model, and both continued to develop ideas rooted in their

knowledge of the human body however far they moved from straight representation.[8] Moore was not interested in the Picasso who invented signs within flat cubist architectures; he was interested in the Picasso who moved through a kind of 'classicism' into the monumental erotic ideas of the later 1920s and the 1930s (nos. 75, 77) driven by the need to grasp graphically and pictorially the bodily presence of living beings; the Picasso whose imagining of possible sculptural bodies could seem to have morphed into existence from boulders and bones.

Finally, it is important to realise that Moore's Picasso was not at all simple. Like Herbert Read, Moore saw conflict as critical to the creative drive.[9] Quoted in 1960, he insisted on the 'conflicting attitudes' he found in 'today's greatest painter, Picasso'.[10] Those 'attitudes' parallel, evidently, conflicts he liked to think he resolved in his own work: between the 'classical' and the 'primitive', between control and intuition, between integration and disintegration; in the terms of British avant-garde debates in the 1930s, between abstraction and surrealism.[11] Resolution was certainly what he, like Read, wished for, at least in the rhetoric of his published statements. The term he favoured was 'synthesis'. Recently, however, commentary on Moore has stressed his willingness in certain works of the mid- to late 1930s to use dismemberment and defamiliarisation to disrupt any possible sense of resolution.[12] These are works (nos.86, 87) that, as we shall see, have strong Picassian resonances.

Fig.21
PABLO PICASSO
Figure 29 July 1928
From a sketchbook of sculptural
drawings, **Project for a Monument**
Graphite on paper
Private collection
Zervos VII, 202

Tiny it may be, but Picasso's *Nude Seated on a Rock* has the massive sculptural presence that he achieved in his so-called neoclassical painting at its most monumental in 1921. There is no evidence that Moore actually saw this work either in fact or in reproduction, but Michael Phipps has now identified another specific work as the starting point in reproduction for the figure to which the name 'Picasso' is attached in the notebook drawing *Figure Studies* (no.72). It is a pastel of the same date as the little oil panel, 1921, which was reproduced in dingy greys in the English edition of the Parisian critic Waldemar George's Picasso monograph of 1924, a booklet that Moore owned (fig.22).[13]

The pastel comes across in the reproduction as a depiction of sculpted female figures, not actual women (though their warm, scumbled colour gives them a fleshy softness lost in black and white). Moore singles out a reclining nude, whose raised arm pose reprises that of the famous, antique Ariadne type.[14] He stands her up on feet suitably enlarged and repositioned to support her weight, and uses strong hatched modelling to stress her sculptural bulk. Moore's nude becomes both a statement of the basics of figurative sculpture as an art of masses in relation to each other and, robbed of any mythic allusion, a reminiscence of the patient postures of life-class models. *Nude Seated on a Rock* shows Picasso similarly engaged with sculptural basics, while remembering a life-class pose.

The English edition of Waldemar George's monograph included reproductions of two extremely spare linear drawings of nudes on beaches by Picasso, their bodies wispily idealised. Moore's drawing *Two Seated Figures*, also of 1924 (no.71), is a rare instance of him trying out a mode of graphic figuration restricted only to outline. His penned lines are certainly as decisive

as Picasso's, and he shows himself just as capable of doing without modelling yet giving volume through the shaping of body parts. Again, there is a tension struck between bodies known through life drawing and bodies conceived as sculpture, but Moore's sculptural references are not to the idealised models of the antique or the classical, but to archaic and non-Western sculpture (in the pillar-like legs of the nude on the right with knees drawn up to the stomach, and the vaguely mask-like faces).[15] The references so often made in relation to Picasso's linear classicism – Etruscan mirror backs, red figure Attic vases, John Flaxman, Ingres – have no relevance to this Moore drawing.

In 1930, six years after this convergence of stimuli from Picasso the classical figure painter on Moore's drawings, he carved his *Seated Figure* in alabaster (no.73). The broad shoulders, the breasts, each an up-ended cup placed separately on the torso, the huge clasped hands, and the feet set apart, all relate to Picasso's classical figures, especially those of 1920–1. The seated pose is one of Moore's favoured life-drawing poses. There is also, however, a strong relationship to a range of ancient and non-Western sculpture available in the British Museum or in illustrated books. Alan Wilkinson mentions Cycladic, Sumerian and pre-Columbian connections. The clasped hands in particular echo those of both a Sumerian and an Aztec piece in the British Museum. But Moore opens up the stiff, hieratic stances common to both by a turn of the head and a swivel at the hip.[16] He repeatedly stressed the primary importance to him in the 1920s of pre-Columbian sculpture after reading of Roger Fry.[17] The soft, pale alabaster of *Seated Figure* denies both the hard stony quality that he valued so much in Mayan and Aztec carving and the warm, fleshy pinks often dominant in

70

PABLO PICASSO

Nude Seated on a Rock 1921
Oil on wood
15.8 × 11.1
The Museum of Modern Art,
New York. James Thrall Soby
Bequest, 1979
Zervos IV, 309

71

HENRY MOORE
Two Seated Figures 1924
Pencil and pen on paper
24.8 × 34.1
Collection Art Gallery of
Ontario. Gift of Henry Moore
1974

Fig.22
PABLO PICASSO
Group of Four Women
Plate from the monograph,
Pablo Picasso, by
Waldemar George 1924
Private collection

72

HENRY MOORE
Figure Studies 1924
From notebook no.3 1922–4
Pencil on cream light-weight
laid paper
22.4 × 7.2
The Henry Moore Foundation:
Gift of the Artist 1977

Picasso's classical figures, but this is a piece in which
Moore's absorption of archaism fuses very obviously
with his absorption of Picasso as the acknowledged
heir to Western classicism.

In an interview of 1947, Moore spoke of something
'capricious' he found in Picasso's work: 'a conflict
between an interest in the approach illustrated by archaic
art and the art of primitive peoples and a respect for the
Mediterranean tradition.' He goes on to confess his own
consciousness, 'looking back, of such a conflict through-
out my own work'. He singles out especially the gap that
opened up in his practice, after his visit on a travelling
scholarship to Italy in 1925, between a Mediterranean
classicism that found an outlet in life drawing, and a
continuing avant-gardist pursuit of archaic and non-
Western sculpture, especially pre-Columbian. It was,
he said, an uncomfortable conflict of interests only
resolved with the Shelter Drawings during the Second
World War.[18] That conflict – an acceptance of divergent
practices whose precedent lay in Picasso – is plainly
declared in *Seated Figure*, and perhaps for once
at this date resolved.

73

HENRY MOORE
Seated Figure 1930
Alabaster
46.1 × 27.7 × 19.6
Collection Art Gallery
of Ontario, Toronto.
Purchased 1976

Letters written by Moore, apparently in the summer
of 1927, mention that he has started on 'a half figure of
a woman with arms and hands reaching upwards'; it is
in Hopton Wood stone, and is 'blamed hard'.[19] He must
be referring to the sculpture *Woman with Upraised Arms*.
One of these letters, to Evelyn, Kendall ends with a
drawing in which the image of a sculpture very close
to it appears.

The separated cupped breasts and the blocky
massiveness of the raised arms and head all put Moore
in touch with Picasso's most sculptural classical figure
paintings of 1920–3. As Andrew Causey has stressed,
mass rather than volume or space was the most impor-
tant sculptural element for Moore in the jottings he
made in his 1920s notebooks.[20] It was only in the 1930s
that his ideas on the 'life' to be extracted by the sculptor
from the masses with which he works were fully articu-
lated. In the avant-garde group publication *UnitOne*,
which appeared in 1934, he insists that he does not
mean 'moving' or 'dancing' when he calls for 'the vitality
of life' in sculpture, but rather 'a pent up energy' distinct
from anything the representation of movement could
suggest.[21] The release of energy through movement in
Woman with Raised Arms is unusual even in the work
of the 1920s. Could Moore have allowed himself this
experiment because one of Picasso's most memorable
and well-publicised classical inventions showed how
heavy bodies – bodies as masses – in dynamic movement
could have force? Picasso's little gouache *The Race* of
1922, (Musée Picasso, Paris, Zervos IV, 380) with its hefty
females, arms outstretched, bounding along the beach,
had been hugely enlarged as the drop curtain for Serge
Diaghilev's Parisian production of *Le Train bleu* in 1924.[22]
It is extremely unlikely that Moore saw the ballet, but his
1927 attempt to combat bodily weight and mass by the
sheer élan of arms stretched upwards suggests that he
knew the image and was tempted to rival it in stone.

74
HENRY MOORE
Woman with Upraised Arms
1924–5
Hopton Wood stone
48.2 × 21 × 15.7
The Henry Moore Foundation:
Gift of the Artist 1977

Picasso was involved from 1921 in a committee to raise money for a monument to his poet friend Guillaume Apollinaire. At the end of 1927, he presented to the committee a project for a monument that caused bafflement and shock, especially to its convenor, André Billy, who wrote of seeing 'something bizarre, monstrous, crazy, incomprehensible, almost obscene'. Billy describes genitalia issuing from it, 'here and there'.[23] The consensus is that Picasso presented something related to the plasters for a pair of bronzes entitled *Metamorphosis*. This little sculpture was reproduced in the Parisian periodical *Cahiers d'Art* in 1929, and in his 1965 monograph on Moore, Herbert Read, who worked closely with the artist, made a point of relating it to Moore's break-through sculpture of 1931, his Hornton stone *Composition* (no.80).[24] *Cahiers d'Art* was easily available in Zwemmer's bookshop on the Charing Cross Road – the sculptor called it his library – and there was much more to be seen of Picasso's recent work in the issues published in 1929.[25] The first issue illustrated a sequence of bather paintings produced on holiday at Dinard in the summer of 1928 (fig.24); issue 6 illustrated a sequence of beach and monster paintings of 1929; and issue 8/9, along with *Metamorphosis I*, illustrated a sequence from a sketchbook filled with heavily sculptural drawings produced during that summer in Dinard, titled *Project for a Monument* (fig.21). The painting *Standing Nude* 1928 (no. 77) does not appear in any of these issues, but takes to grand *non finito* conclusions ideas whose germ is evident in the Dinard monument drawings.

In *Metamorphosis* Picasso squeezes and stretches a squashy organic body into a grotesque monument to a male vision of Eros, its huge foot a heroic phallic appendage attached to a soft feminine torso swollen with receptive fecundity. A prong-like arm reaches up to the split head approximating the coiffure pose often favoured by Picasso; a sardonic reflection on ugliness and beauty. The work descends from sculptural drawings that are comparably organic, their forms comparably squashed and stretched, made in Cannes in the summer of 1927 (fig.25).[26] It is significant that, at the end of 1929, *Cahiers d'art* featured the much more architectonic Dinard drawings of 1928; drawings whose dolman-like stability is far more in tune with the monumental imagined sculpture in *Standing Nude*, and more amenable to Moore's need to reconcile the classical, the archaic and the non-Western. As Moore flicked through the Picasso reproductions, he would, incidentally, have encountered a succession of articles on Oceanic, Cycladic and even pre-Columbian art.[27] Picasso images came to him in a rich visual stew.

Moore was not afraid of the erotic in art, but he was more interested in the metamorphic possibilities opened up by Picasso's work of the late 1920s, not merely in breasts or feet that could become phalluses, but especially in stones and bones that could become something like bodies while remaining at the same time stones and bones.[28] Picasso's Dinard drawings and such paintings as *Standing Nude* acted as a confirmation, for Moore had already started collecting natural *objets trouvés* on Norfolk beaches.[29] The smooth rounded surfaces of *Standing Nude*, treated as if eroded by natural forces, invites juxtaposition with Moore's African wonderstone *Composition*. In Moore's case, the upwards push of the head from the shoulders carries associations not just with eroded rocks or boulders but also of a much wider biological kind, as especially did Picasso's Cannes drawings of 1927. Christa Lichtenstern has linked this

75
PABLO PICASSO
Female Figure
Metamorphosis II 1928
Bronze
22.8 × 18.3 × 11
Private collection
Courtesy fundación Almine
y Bernard Ruiz-Picasso
para el Arte
Not in Zervos

responsiveness to vegetable and animal growth forms to Moore's early purchase, long before his encounter with late 1920s Picasso, of the 1917 edition of the biologist D'Arcy Wentworth Thompson's exploration of the topic, *On Growth and Form*, which endorsed the sculptor's belief in the intimate relationship between form, scale and the different orders of natural organic growth.[30] It was this kind of sculpture by Moore, in fact, that led to his friend the poet critic Geoffrey Grigson coining the term 'biomorphism' in 1935.[31] The following year, Alfred H. Barr Jr., in his major survey of modernism, *Cubism and Abstract Art*, identified biomorphic abstraction as the most significant new development in international abstract art, and named Moore as its paradigmatic representative. In doing so, however, he did not forget Picasso's impact on his biomorphic work.[32]

76

HENRY MOORE
Composition 1932
African wonderstone
44.5 × 45.7 × 29.8
Tate. Presented by
the Friends of the
Tate Gallery 1960

77

PABLO PICASSO
Standing Nude 1928
Oil and chalk on canvas
162 × 130
Private collection
Zervos VII, 138

78–80

The sheet of *Sixteen Ideas for Sculpture*, which Moore later dated 1929, is more likely to be from 1930–1. The two-legged, two- or three-breasted 'idea', the centre image in the second row of drawings, directly relates to sketches from a drawing book (dubbed Drawing Book 1), which is usually dated 1930–1, and also contains drawings of a foetus-like baby fastened to a disembodied breast in the act of suckling. The way the two or three breasts are placed on a rounded pedestal supported by stump legs anticipates (or follows) the Hornton stone *Composition*, which came out of the ideas in Drawing Book 1. In this sculpture and these drawings Moore responds directly – but very much with his own agenda – to the images of Picasso's *Metamorphosis* and his paintings and drawings of 1927–9 available in *Cahiers d'Art* (fig.24), as well as any actual Picassos he might have seen on his biannual visits to Paris.[33]

The sheet of 'Ideas' surrounds the two- or three-breasted *Composition* idea with standing nudes (above) and reclining nudes (below). It is as if Moore is seeing how the example of this assemblage of body parts, the breasts swelling upwards like buds, might transform his customary sculptural repertoire of vertically and horizontally posed bodies, which strongly suggests that these may be developments from the green Hornton stone sculpture rather than preludes to it. Above, breasts and sometimes buttocks jut out of protoplasmic figures, but the extrusions from a soft centre found in the pencil sketches from Drawing Book 1 are far more extreme, and so is their erotic suggestiveness. In sheet 828R, Moore adds an aperture that could be read as either a navel or the female sex. Picasso's 1927 Cannes drawings and their sculptural outcome, *Metamorphosis I*, are more attuned both to these explicitly erotic details and to this squeezing and stretching of soft forms than are the hardened bony or stony structures of the Dinard drawings of 1928 discussed in the last entry.

Moore's 'ideas', as well as the sculpture they relate to, repeatedly give the breast precedence over the phallus – though the incised ellipse crossed by a single line in

78
HENRY MOORE
Studies of Torso Figures
1930–1
From no.1 Drawing Book
1930–1
Pencil on cream
light-weight wove paper
16.2 × 20.1
The Henry Moore Foundation:
Gift of the Artist 1977

79
HENRY MOORE
Sixteen Ideas for Sculpture:
Standing and Reclining
Figures 1929
Pencil, crayon, wash on cream
medium-weight wove paper
29.5 × 23.2
The Henry Moore Foundation:
Gift of the Artist 1977

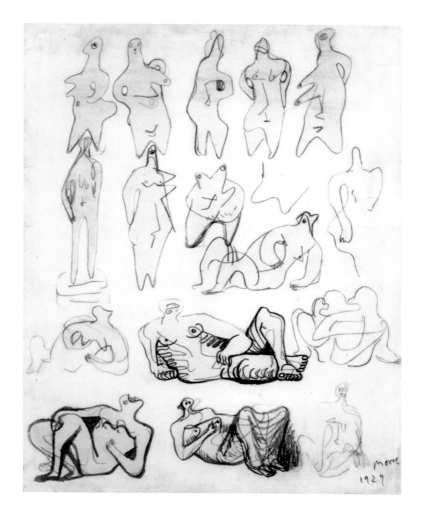

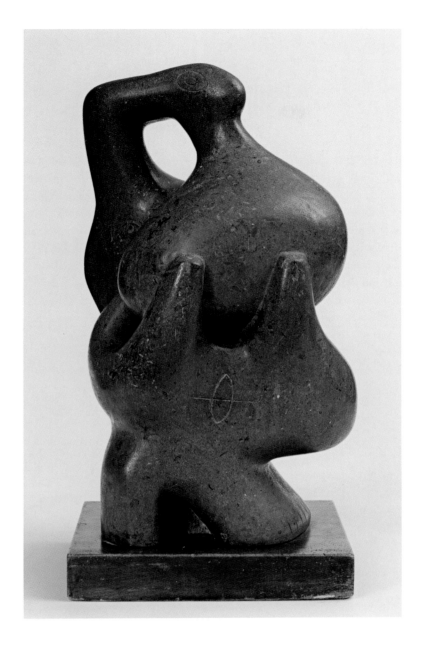

80
HENRY MOORE
Composition 1931
Blue Hornton Stone
48.3 × 27 × 24.5
Henry Moore Family Collection

Composition might still be vaginal. His compulsive need to return to the maternal body as a subject drives the very particular way he responds to the possibilities opened up by Picasso at Cannes and Dinard. *Composition* is an overwhelmingly female, maternal work, something emphasised by the suckling child sketches that anticipate it in Drawing Book 1. Anne Wagner draws attention to the starting point of the suckling child theme in Moore's sculpture, a remarkable cast concrete piece of 1927, now lost, in which the baby embraces a disembodied breast, and where, at least from one photographed angle, the spectator fills the place of the missing maternal body.[34] The possibility that the spectator can replace the mother remains in one or two of the sketches, but in the finished carving a standing structure made up of female

forms has taken over. It is an assemblage of part objects, including breasts, which can be felt to be a complete figure, like Picasso's *Metamorphosis*. Moore even includes, at the top of the sculpture, the suggestion of an arm raised in Picasso's often repeated coiffure pose.[35]

Composition emerges from graphic 'ideas for sculpture' much more evidently than from found pebbles or bones transformed into figures. These ideas are essentially more fleshy and protoplasmic than hard and stony. Carved in a notably hard stone, *Composition* remains a soft amalgam of forms. Moore rarely compromised his commitment to the hard durability of stone to such a degree. The fact that he does so here is one marker of the hold that Picasso's soft organicism exerted over his imagination at this time.

Picasso's small rebarbative figure painting, *Reclining Woman* 1929 was given a full-page black and white reproduction in the special Picasso number of the 'dissident' surrealist periodical *Documents*. Moore bought and kept that issue.[36] This is one of Picasso's most brutally dismembered female nudes of the late 1920s, something that comes across as forcefully in black and white as in the lurid colour of his palette. It does not relate to the *Project for a Monument* drawings (see fig.21) It is, rather, a late variant of the torn-apart Dionysiac dancer on the left of another work reproduced in *Documents*, 'La Danse' (no.135). The dancer is now at rest on a couch but still a violent centre of energy. The dagger breast and swollen buttocks pulling away from the torso, and the narrow slits of navel and vagina, all desecrate the tired classical idea of 'beauty' declared by the naked Maja pose.

If Moore wanted any encouragement to deny the classical appetite for resolution and stability that had led him in the 1920s to take up the reclining figure as one of his subjects, he could find it here. His bronze *Reclining Figure*, one of six casts from a lead piece executed in 1931, pulls the female body apart with almost equal force. Moore treats limbs and belly, hips and shoulders, as viscous matter somewhere between liquid and solid, which can flow as molten metal might where his imagination directs, whatever the consequences for the integrity of the body as an organic whole. The flow of curves, broken only by the rib-like bars, gives the figure a residual elegance denied by the hard angularity of Picasso's contouring, but Moore arrives at a version of the human body that might actually have fitted as an image beside the Picassos reproduced in *Documents* and the texts published there, especially by Georges Bataille, attacking the very idea of organic unity.[37]

In 1934, Moore went so far as to break reclining bodies into pieces. One such sculpture is the carving in Cumberland alabaster, *Four Piece Composition: Reclining Figure*. Set upon a pedestal, leg and thigh, belly with incised navel marking, breast, shoulders and head become separate shaped and polished stones: the reclining figure as a beachcomber's collection. A relationship with Giacometti's table-top sculptures of the early 1930s has regularly been remarked on, but Picasso obviously remains an active force working on Moore's sculptural imagination. The Picasso of the Dinard drawings remains a factor , but a more recent stimulus was the series of drawings published under the heading 'An Anatomy' in the first number of *Minotaure* in 1933.[38] Picasso turns breasts, bellies, thighs, heads and limbs into objects of many kinds, but they include rounded stony forms and balls as breasts, sometimes placed on table-like platforms. Picasso's anatomies are teetering assemblages of body parts that might collapse at any moment. Moore's body parts are securely placed on a

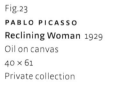

Fig.23
PABLO PICASSO
Reclining Woman 1929
Oil on canvas
40 × 61
Private collection

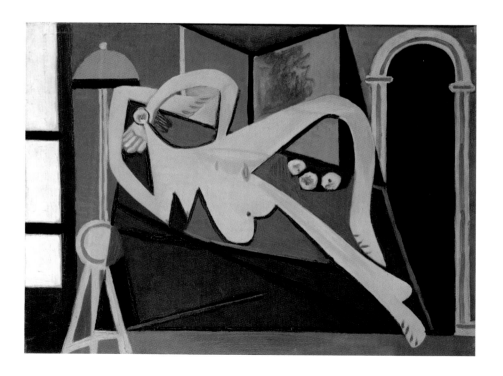

stable surface, positioned and spaced to maintain balance, even though it is likely that, to begin with, positions could be changed. The poise with which his collection of stones has been arranged for display makes it difficult to think of them as the result of an imagined act of violence against the body. Three years later, in Moore's most comprehensive public statement of the 1930s, he sums up a position that might seem fundamentally antagonistic to the Picasso that *Documents* had presented as the enemy of aesthetic certainties: 'We can now begin to open out. To relate and combine together several forms of varied sizes, sections and directions into one organic whole.'[39]

If there is one subject that shows a continuity between the Moore who kept in touch with the classical Picasso of the early 1920s and the Moore who kept in touch with Picasso the surrealist fellow traveller of the late 1920s and the 1930s, it is the reclining figure. He might have re-imagined it as a collection of stones in 1934, but with the elmwood *Reclining Figures* of 1936–9, he succeeded in resurrecting it as an alert, taut yet serenely stable body whose swelling masses are both biomorphic and the obvious descendant of Picasso's monumental classical women. The second of the elmwood *Reclining Figures*, carved in 1936, with her raised knee, her supporting arm and her erect head, makes a remarkably comfortable companion to Picasso's 1921 oil *The Source*, though there is no evidence that this is a work Moore knew at first hand from his visits to Paris between 1922 and the mid-1930s.[40] The relationship underlines how securely Moore's commitment to the reclining figure places him within a continuous idea of Western classicism that brings together Picasso, the High Renaissance Italians at the Palace of Fontainebleau (so important to *The Source*) and the river goddesses of antiquity.[41] Moore quickly saw the potential of the analogy between the lie of the land in nature and the sculpted female figure lying down, head up to survey the distance, but at rest; it was an analogy that had a long past, and one that Picasso also exploited.

Between the mid-1920s and the mid-1930s, as Moore developed his avant-garde reputation as the carver of primitivised figures and soft or stony biomorphs, he kept in contact with his Mediterranean approach by continuing to draw from the model. The pen and wash *Reclining Nude* 1934 is such a drawing. Picasso in the early 1920s invariably drew his classical nudes without models; Moore made what he thought of as his 'academic' drawings from the life. He drew them, however, as Picasso often did, as generalised sculptural images, working to get hold of their all round presence in his studio space, attention fixed, as in this case, especially on the legs, thighs and haunches, the supports for the body's weight.[42] From the time of their marriage in 1929, his wife Irina posed for him, but her petite looks never distracted him from a generic sense of the figure as hefty masses in balanced relation. By the mid-1930s, the period of the first of his elmwood *Reclining Figures*, the practice of life drawing filled a diminishing proportion of his time, and was something kept clearly separate from his work as a sculptor.[43] This drawing is a late reminder of earlier compulsions, which he would not forget.

83
HENRY MOORE
Reclining Nude 1934
Pen and wash on paper
26 × 46
Victoria and Albert Museum,
London

84

PABLO PICASSO

The Source 1921

Oil on canvas

64 × 90

Moderna Museet,
Stockholm. Gift 1970 from
Grace and Philip Sandblom

Zervos IV, 304

85

HENRY MOORE

Reclining Figure 1936

Elmwood

64 × 115 × 52.3

The Hepworth Wakefield

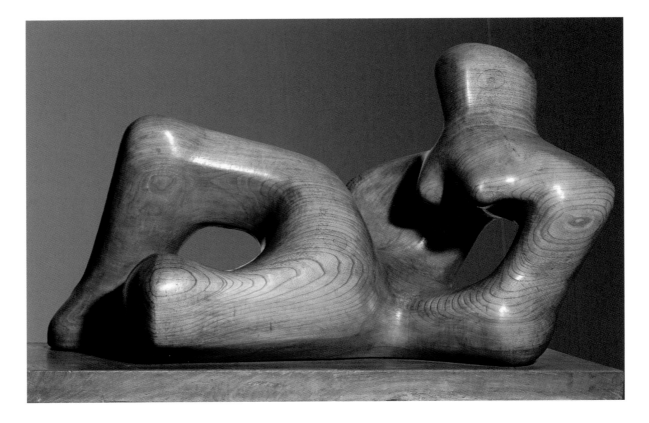

Besides the Anatomy drawings, there was another Picasso series published in the first number of *Minotaure* in 1933 in which he construed Matthias Grünewald's Isenheim *Crucifixion* 1506–15 as assemblages of bones (fig.27). At their most pulled apart, least integrated around the cross, the *Crucifixion* drawings are strikingly in tune with Moore's cast concrete *Composition*, a multi-part table-top sculpture far more to be associated with an ossuary than with a beachcomber's collection. As in the Anatomy drawings, the teetering instability of Picasso's imagined *Crucifixions* is denied by the way Moore's concrete bits and pieces are laid out like unearthed skeletal remains. That association with skeletons carries other associations: with death, possibly violent death.

This is a piece that stands apart from the impulse in Moore to find life-enhancing unities – resolution – as in *Four Piece Composition* (no.81) or the elmwood *Reclining Figure* 1936 (no.85). Like the bronze *Reclining Figure* of 1931 (no.82), it would have fitted well with the Picasso celebrated by Bataille in *Documents* in 1930. For Bataille, the new Picasso of the late 1920s represented not an ascent to an ideal, but a catastrophic fall from a 'rotten sun': the irresistible fall towards death.[44] The scattered pieces of Moore's cast concrete *Composition* have the look of the aftermath of a fatal fall.

The works by Moore that most obviously respond to Picasso's *Anatomy* drawings in *Minotaure*, are highly finished drawings made in 1937–8 of imagined sculptural 'ideas' (possible or impossible) arranged in rows, as Picasso's were on the page, but in landscape or stage-like settings. *Five Figures in a Setting* of 1937 is such a drawing. As published, the one Picasso 'Anatomy' drawing to be given a setting jumps about on a beach, a space for leisure, erotic display and games.[45] Andrew Causey has stressed the disturbing character of the settings Moore imagined for his 'figures'; here, a prison-like wall with openings like spy-holes.[46] Moore later recalled that in a notebook of the 1920s he warned himself against the influence of Giorgio de Chirico, but Causey is right to associate the way the setting for a drawing like *Five Figures* creates a mood of theatrical dread easy to relate to the Italian's 'metaphysical' townscapes of 1911–19.[47] Aptly he quotes the surrealist sympathiser Robert Melville introducing an exhibition of Moore's drawings of this kind in 1953. Melville calls them 'the unique revelation of the sinister, melancholy, serene and tragic life of sculptural communities in worlds of dreams and reality which are equally strange'.[48] Causey writes of the 'dead-alive' character of these 'figures', developing a reading informed by Freud's essay on the uncanny, with its stress on the death drive.[49] Certainly, Moore's *Five Figures*, drawn with the Spanish Civil War well under way, are set out on a stage where killing can easily be imagined, and where their amputated organic (yet somehow mechanised) forms carry a threat not found at all in the playful absurdity of Picasso's Anatomy drawings.

86
HENRY MOORE
Composition 1934
Cast concrete
20.5 × 44 × 21
The Henry Moore Foundation:
Gift of the Artist 1977

87
HENRY MOORE
Five Figures in a Setting 1937
Charcoal (rubbed), pastel
(washed) and crayon on paper
38 × 55.5
Henry Moore Family Collection

88
HENRY MOORE
Three Points 1939–40
Bronze
14 × 19 × 9.5
Tate. Presented by the artist
1978

Death too is a strong undercurrent in Moore's tiny bronze *Three Points* produced in 1939–40 as Britain was launched into world war, and in this case the Picasso echo that has been remarked on by David Sylvester and others is one whose associations are all of war, death and terror. Sylvester noted a telling similarity between the open-mouth-like bracketing of the central point and the screaming mouths with dagger tongues that Picasso developed in studies that led to the wailing mother on the left of *Guernica*. Moore had been one of those who witnessed Picasso at work on his great anti-Fascist, anti-war mural, and must have seen it in its finished form at its London showing in 1938. There are other connections that could be suggested for this sculpture, such as a display at the Paris International Exhibition of 1937 featuring a spark that leapt seven metres between contacts in front of the Pavilion of Electricity and Light. The points can certainly be read as contacts drawn together by invisible forces. Yet, however abstract it may be, this sculpture's *Guernica* resonances are strong enough to ensure that death is kept well in view.[50]

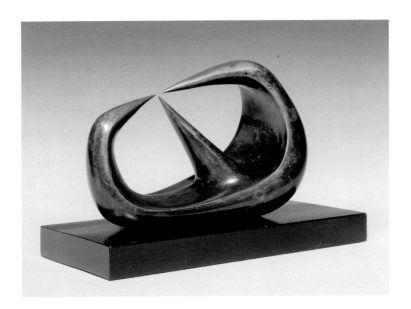

FRANCIS BACON AND PICASSO

CHRIS STEPHENS

The collected interviews that David Sylvester conducted with Francis Bacon – and through which Bacon managed the interpretation of his work – begin with Picasso. His landmark work *Three Studies for Figures at the Base of a Crucifixion* c.1944 (no.98) was influenced, he said, 'by those Picasso things which were done at the end of the twenties'.[1] Bacon spoke of a formative encounter with Picasso's work at Paul Rosenberg's gallery in Paris. Anne Baldassari has highlighted the fact that he variously offered 1926, 1927 and 1928 as alternative dates for this event.[2] Even with a single interviewer and within a short space of time, Bacon could be inconsistent. On 19 May 1973, he told Hugh Davies that, 'having seen a show in Paris in 1928 or 1929 of Picasso's Dinard bathing figures, the surrealistic women etc.', he had realised 'the possibilities of painting'. Five weeks later he spoke specifically about 'the 1929 Rosenberg show',

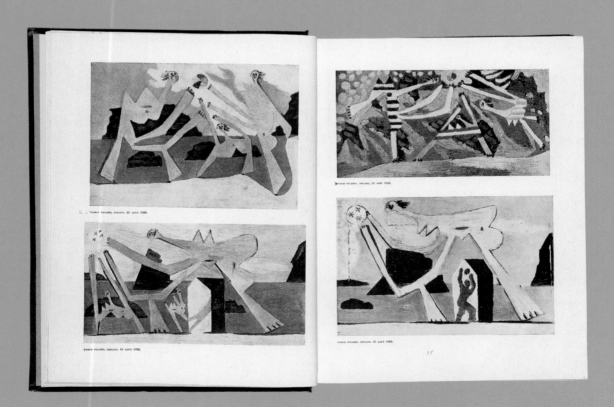

Fig.24
Dinard paintings by Picasso, reproduced
in *Cahiers d'Art* no.1, 1929, pp.14–15

but singled out for recollection 'some very decorative still lifes … that I liked but I don't like now'; Davies notes that these still lifes were of 1926–7.[3]

Clearly such an encounter was of fundamental importance to the narrative Bacon made of his career. Baldassari shows that, if 1927 is the key date, the exhibition in question is Rosenberg's *Cent dessins par Picasso* of June of that year, which consisted mostly of more conventional drawings from the years 1917 to 1926. Picasso's work was, in any case, frequently available to be seen in mixed exhibitions at Rosenberg's gallery or, for example, the Galerie Surréaliste, or Galerie Pierre, which showed recent work in December 1927.[4] More reliable in a painter's memory than dates would be the work that was seen. It might, therefore, be prudent to give most credence to Bacon's recollection that it was, specifically, Picasso's Dinard paintings that made him realise 'the possibilities of painting'.[5]

From the concrete evidence of his work, it appears that it was only around 1933 that Bacon started to produce an art that betrayed its debt to Picasso. By that stage, he could have seen a range of Picasso's paintings, including the Dinard bathers, without leaving London, most particularly in the exhibition *Thirty Years of Pablo Picasso*, presented at Alex. Reid & Lefevre in summer 1931. Before that, such works had been extensively reproduced in the journal *Cahiers d'Art*, available in London, which would fit Bacon's predilection to absorb imagery through photomechanical reproduction, rather than from direct encounter.

Bacon's response to the Dinard series and related works is evident in the few works of the 1930s that he failed to destroy. An idea of some of the lost works can be derived from depictions of his studio by the Australian painter Roy de Maistre; these too reveal his debt not only to the Dinard bathers but also to the more linear paintings of Picasso, made between 1927 and 1930, some of which appeared in Herbert Read's 1933 *Art Now*. Bacon's continued engagement with the most abstracted and biomorphic of Picasso's figures is also clear in his *Three Studies for Figures at the Base of a Crucifixion* of

c.1944. Bacon's work soon changed. From the late 1950s he developed his signature style of the human figure distorted both to create a sense of character and movement and to express deeper, more psychological dimensions. The most obvious model for this new form of figurative painting was Picasso, whom Bacon saw as nearer 'to what I feel about the psyche of our time' than any other artist.[6] The sentiment was reciprocated, at least in part, with Picasso telling Penrose on 28 June 1962 that he had looked at the catalogue of Bacon's recent Tate Gallery retrospective. Penrose noted that Picasso had 'liked it – some of it very much – please tell B. Liked ideas and technique – sometimes very good.'[7] It was, after all, in the work of Picasso that Bacon discerned what he called 'the brutality of fact', a phrase that came commonly to be used to describe his own art.[8]

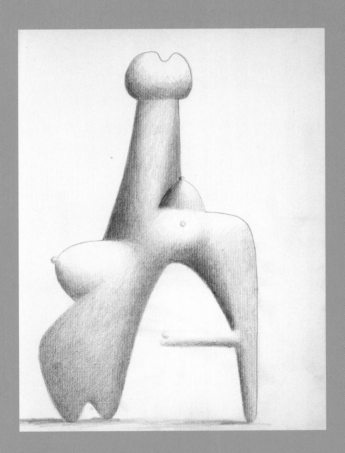

Fig.25
PABLO PICASSO
Bather 11–24 September 1927
Carnet 36, folio 14 recto
Graphite
30.5 × 23.2
Musée Picasso, Paris
Zervos VII, 109

151

Bacon produced several works on the theme of the Crucifixion around this time. The grisaille oil painting was reproduced in Herbert Read's book *Art Now* of 1933 and was exhibited in the associated exhibition at the Mayor Gallery, London, in October that year. There seems no reason to question the common relationship that has been drawn between it and the drawings made by Picasso after the Crucifixion of Grünewald's Isenheim altarpiece, which were illustrated in the inaugural issue of *Minotaure* in May 1933 (fig.27).[9] While these drawings

show the theme to be current in the historically significant year of 1933, and there are visual coincidences between Bacon's grisaille and the dense black ink background in some of the Picassos, the raised arms of Bacon's figure is distinct from the horizontality of Picasso's. The small head and the angle of the arms in Bacon's painting are closer to Picasso's small, highly coloured *Crucifixion* in oil of 1930 (Musée Picasso, Paris. Zervos VII, 287) but it is difficult to say how he could have seen that work. The uppraised arms and small head

89
FRANCIS BACON
Crucifixion 1933
Oil on canvas
60.5 × 47
Murderme, London

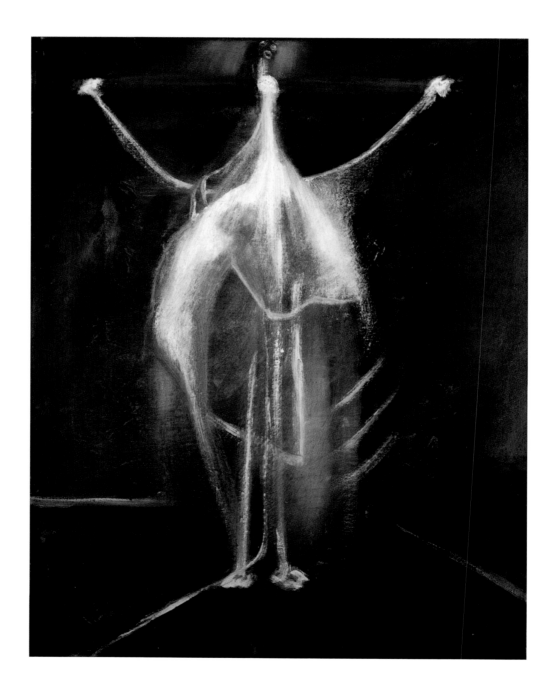

echo another painting by Picasso – not a Crucifixion – his *Three Dancers* 1925 (no.135), which was reproduced as 'Le Danse' in *Documents* in 1930.[10]

A less specific association of Bacon's skeletal *Crucifixion* with Picasso's bathers was suggested in *Art Now*, the images for which were selected by Douglas Cooper, where the Bacon was reproduced alongside Picasso's *Bathers*, 1929, potentially one of the works Bacon might have seen in Paris.

The *Crucifixion* on paper from the same year shows similarly Picasso-esque qualities, with elongated limbs, miniscule head and, now, cartoonish fingers and toes. Bacon shows three crucified figures, bringing his subject closer to the narrative of Christ's death. A pattern of paired, vertical lines, reminiscent of the planking of a wooden partition, dominates the image and creates the effect of seeing the Crucifixion through a cage.

90
FRANCIS BACON
Crucifixion (the dance) 1933
Chalk, gouache and
pencil on paper
64 × 48
Private collection

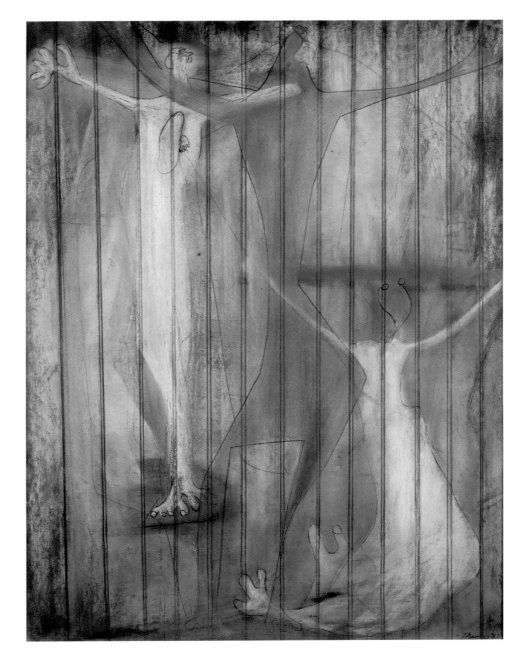

The coincidence between the rhomboid patterning in these two paintings, and of certain formal echoes in each, invite speculation that Bacon made his *Interior of a Room* with this specific work of Picasso's in mind. *Head* 1929 had been exhibited in the summer of 1932 at the Galeries Georges Petit, and we know Bacon was a frequent visitor to Continental Europe at that time. Conversely, however, the wallpaper pattern is different in each work and, in any case, generic enough for such a direct connection not to be the case. Decorative patterning had been a distinctive element in the still-life compositions of 1926–7 that Bacon had seen but later turned against.[11] Bacon's rendition of an interior through successive planes and patterns is different from the flatness of Picasso's work.

Head belongs to a group of paintings by Picasso in which the human bust is reduced to simplified, often linear forms, whether geometric as here or more biomorphic. The subject is only identified by the most economic suggestions of facial features: two vertically arranged eyes, three black arcs as hair, and a vertical form that becomes a displaced mouth and the suggestion of the *vagina dentata*. Though the jagged teeth give this head an aggressive air, it lacks the symptoms of psychic disintegration and hysteria identified in other works of this kind.[12] There is a close relationship between this family of paintings and Picasso's ideas for a monument to the poet Guillaume Apollinaire). Some of those envisaged a monument that was an abstracted human figure, or head, constructed from tubular and planar elements.[13] Around 1936, these images were echoed in two lost works by Bacon in which the figure is represented in one as a human mouth and, in the other, as a biomorphic bodily form, mounted on a tripod.[14]

91

PABLO PICASSO
Head 1929
Oil on canvas
55 × 46
Moderna Museet, Stockholm
Zervos VII, 289

92

FRANCIS BACON
Interior of a Room 1933–5
Oil on canvas
112 × 86.5
Heli Investments Ltd.

155

A number of Bacon's few surviving works of the early 1930s are on the theme of the studio interior. Picasso's influence can be seen here – specifically, perhaps, that of the small-headed figures of the Dinard paintings such as *Bathers at the Beach Hut* 1929. The influence might almost have been mediated through the example of Henry Moore. By 1933 Moore was well established in London and Bacon could readily have seen his drawings and sculptures. The small head and broad, squared-off shoulder in *Corner of the Studio* 1934 are undoubtedly close to some of Moore's figures. The Bacon image particularly echoes Moore's drawings of around 1933, such as one belonging to Geoffrey Grigson that was reproduced in the first book on the sculptor published by Zwemmer in 1934.[15]

Bacon recalled having seen Picasso's Dinard pictures in Paris in the late 1920s. He would also have known them through reproduction in *Cahiers d'Art*. Even at this early date, Bacon had a predilection for photographic reproductions as a source for his art and this may have been his preferred mode of encounter. The figures in the two black and yellow drawing here are especially close to a similar motif in some of Picasso's images derived from his new lover Marie-Thérèse Walter on the beach that were published in *Cahiers d'Art* in 1929 (fig.24).[16] There is also a compelling echo in the pose and treatment of Bacon's running figure of the central dancer of *Three Dancers* 1925 (no.135).[17]

93

PABLO PICASSO

Bathers at the Beach Hut

19 May 1929

Oil on canvas

33 × 41.5

Musée national Picasso, Paris,
Donation Pablo Picasso, 1979,
MP114

94

FRANCIS BACON

Composition (Figure) 1933
Gouache, pastel, pencil
and pen on paper
53.5 × 40
Collecion Abello

95

FRANCIS BACON

Crucifixion / Figure 1933
Gouache, pastel, pencil
and pen on paper
53.5 × 40
Collection Triton Foundation,
The Netherlands

96

FRANCIS BACON

Corner of the Studio 1934
Ink and wash on paper
52.5 × 40.5
Heli Investments Ltd.

97

FRANCIS BACON

Composition 1933
Gouache on paper
52.2 × 39.7
Henry Moore Grandchildren
Settlement (HMGS)

Bacon's three panels belonged to a larger group of wartime paintings, the rest of which drew more evidently upon photographs of Adolf Hitler and other Nazis. That Bacon sought to destroy those and to establish the *Three Studies* as the first work of his mature career suggests his preference for its lack of specificity. Comparisons with those related images, albeit lost or totally or partially destroyed, are revealing. There are variations on both the left- and right-hand panel of the triptych and it may be that these three panels were not intended, at the outset, as a triptych, but were three single paintings brought together at a later stage.[18] Another work of the war years, partially painted over but known from photographs, is *Figure Getting Out of a Car* c.1943–4. The motif of the car was appropriated from a Heinrich Hoffmann photograph of Hitler taking the salute at a Nazi rally at Nuremberg in 1933.[19] Bacon substituted for the Führer a monstrous anthropomorph with a long, serpentine neck, suggesting a similar association for the central figure of the *Three Studies*.

Bacon shared the motif of the long-necked anthropomorph with his mentor Roy de Maistre, himself heavily indebted to Picasso and cubism. A ready source for such distortion was Picasso's work of the late 1920s and 1930s. Despite his repeated reference to work seen at Paul Rosenberg's gallery in Paris in the late 1920s, Bacon was especially responsive to photographic reproduction. As with Henry Moore in the early 1930s, instructive comparisons can be made with three series of works by Picasso from the late 1920s and early 1930s. Paintings based on bathers on the beach, which were reproduced in *Cahiers d'Art* in 1929, offer a model of the figure reduced

to etiolated limbs that create a sense of urgent movement and a head reduced to a miniscule polyp at the end of an elongated neck (fig.24). The bodies become poignant and aggressively animated, absurd and threatening. The sculptural quality of some of those beach paintings, which is shared with Bacon's figures, was even more emphatic in the series of drawings Picasso made in relation to a commission for a monument to Guillaume Apollinaire (fig.21). A related group of Picasso's images of 1927–30, characterised by a particularly savage degree of abstraction, had been reproduced in *Cahiers d'Art* in 1938 (fig.25). In these the human figure was reduced to rounded, biomorphic and frequently phallic sculpture-like forms that clearly anticipate Bacon's bestial presences.

Some have also related the figures in the *Three Studies* triptych to details in or drawings for *Guernica*.[20] If the left-hand panel might be related to Picasso's drawing of a draped woman clutching the body of her dead baby, the right-hand image echoes the elongated neck and screaming mouth of the figure that rushes into Picasso's painting from the right-hand side. Such comparisons can be offset by the contrast between Bacon's sculptural treatment of his figures and the flat linearity of the Picasso. More generally, a comparison has been made between Bacon's sketchy description of a spatial setting and *Guernica* and between his triptych format and the tripartite structure of Picasso's mural. Speculative though they may be, there seems little doubt that, among the range of photographic and painted images underlying Bacon's *Three Studies*, Picasso is one of the most significant.

98
FRANCIS BACON
Three Studies for Figures
at the Base of a Crucifixion
c.1944
Oil on board
Each 94 × 73.7
Tate. Presented by Eric Hall
1953

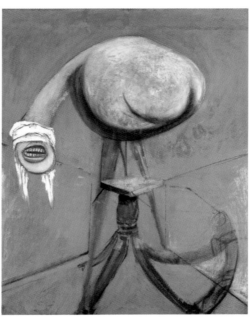
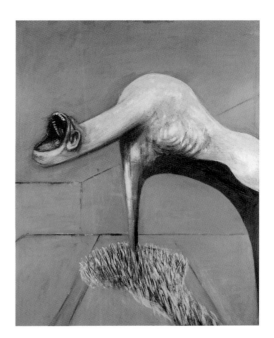

For many artists the challenge after the war was that
of forging an art in the wake of Picasso. How could his
inventiveness be progressed or bettered? For Graham
Sutherland, writing in November 1948, it was the work of
Francis Bacon alone that contained 'the germ of recovery
& the possibility of a post-Picasso development'.[21] One of
the works that inspired such admiration could have been
Head I, which had been exhibited at the Redfern Gallery,
London, a few months earlier.

As Bacon developed a distinctive and mature style,
the debt to Picasso became more embedded. As much
as anything, the two artists shared an approach to
the human figure that expresses emotion or attitude
through physical distortion. Here the upraised, snarling
or screaming mouth inevitably recalls similar motifs in
Guernica and in such related works as *Weeping Woman*,
1937 (no.107), which Bacon might have seen at Roland
Penrose's London home if not the 1938–9 *Guernica* tour.
Equally, Bacon recuperates the theme from an earlier,
somewhat different treatment by Picasso in the paint-
ings of 1929. Those convulsive images of distorted figures
and heads with savage teeth were undoubtedly known
to him, since one had been reproduced in *Art Now*.[22]

99
FRANCIS BACON
Head I 1947–8
Oil and tempera on board
100.3 × 74.9
Lent by the Metropolitan
Museum of Art, New York,
Bequest of Richard S. Zeisler,
2007

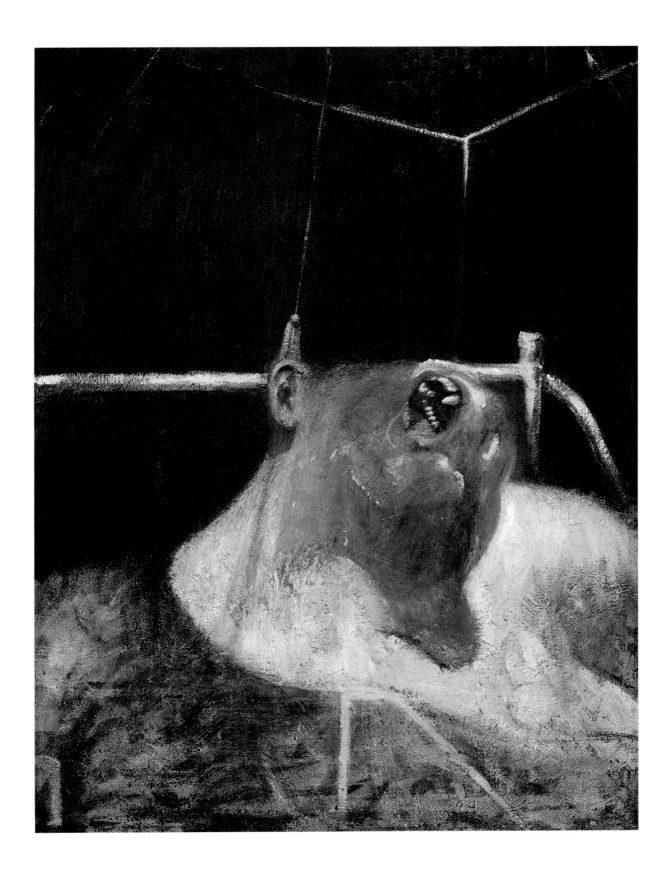

PICASSO IN BRITAIN 1937–1939

HELEN LITTLE

Picasso made his protest at the bombing of the Basque city of Guernica during the Spanish Civil War for the Spanish Pavilion at the Paris International Exhibition in May 1937. Soon after, he consented to an extensive tour of the mural and related works to Scandinavia, Britain and the United States, which proved to be of great historical significance for the artist's legacy in Britain.[1] The arrival of *Guernica* on British soil on 30 September 1938 coincided with the signing of the Munich Pact and Prime Minister Neville Chamberlain's weakening policy of non-intervention.[2] British engagement with the Spanish Republican cause – both political and artistic – had gained considerable momentum by the time *Guernica* crossed the Channel, with left-wing press accounts having pronounced at the height of the conflict that the ruthless destruction of Guernica 'will rouse unquenchable hatred of General Mola and his men in the breast of every Basque in Spain … [that] is felt here.[3] The Artists' International Association (AIA), a British group aligned with the international popular front against fascism and war, was instrumental in raising awareness of the Spanish conflict during this period of mounting political tension. Its 600-strong membership, which united an otherwise mixed bag of British artists including William Coldstream, Stanley Spencer, Duncan Grant, Ben Nicholson, Barbara Hepworth and Henry Moore, had already facilitated – among other initiatives – the exhibition *Artists Help Spain* in December 1936 and a rally at London's Albert Hall in support of exiled Basque children the following June. The AIA hoped Picasso might appear as a guest speaker but, preoccupied with painting *Guernica* in Paris, he instead gave permission for a preliminary sketch by him of a mother and dead child to be reproduced on the cover of the programme, and donated a drawing – *Weeping Woman* 1937 (no.106) – to be auctioned to raise funds.[4]

British exhibitions of *Guernica* were planned with 'maximum force and solemnity', taking full advantage of an opportunity to 'reach that sector of the public for whom this argument may prove convincing'.[5] Masterminded by Roland Penrose, who had witnessed the mural in progress in Picasso's studio in May 1937, the exhibition *Guernica with 67 Preparatory Paintings, Sketches and Studies* opened on 4 October 1938 in the

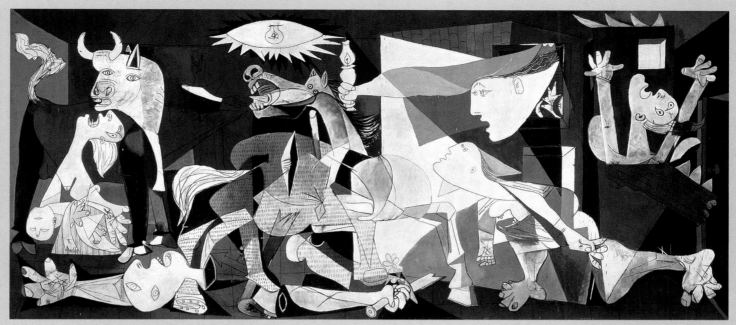

Fig.26
PABLO PICASSO
Guernica 1 May– 4 June 1937
Oil on canvas
349 × 777
Museo Nacional Centro de Arte Reina
Sofía, Madrid
Zervos IX, 065

New Burlington Galleries in London's West End, in aid of the National Joint Committee for Spanish Relief.[6] The following month, the studies travelled to Oriel College, Oxford, and Leeds City Art Gallery before being reunited with the mural at the Whitechapel Art Gallery, London, in January 1939.[7] In contrast to the indifference of the largely erudite crowd visiting the New Burlington Galleries,[8] in the working class area of Whitechapel *Guernica* attracted over 15,000 visitors in a fortnight, during which time it was touted by the press as a 'big banner of truce between the pinks and the duns'.[9] As recounted by David Hockney, whose father visited the exhibition, the entrance fee of a pair of boots (later sent to the Brigadists on the Spanish front) made for a remarkable juxtaposition, as heaps of them accumulated at the mural's base.[10] Inaugurated by Labour opposition leader Clement Attlee and accompanied by educational films and lectures, the exhibition was deemed to have had a significant political impact, raising awareness of the conflict and over £250 towards Stepney Trades Council's 'Million Penny Fund' to send an East London

food ship to Spain.[11] Bizarrely, through the efforts of local art students, *Guernica*'s last appearance in this country was in a car showroom on Manchester's Victoria Street in February 1939.[12]

Despite drawing large crowds and publicity, the British exhibitions of *Guernica* triggered a mixed critical reception. One critic proclaimed the painting the 'most advanced and provocative of modern times';[13] another feared that 'for people without considerable artistic sophistication *Guernica* will probably appear quite meaningless'.[14] Others were more fiercely critical, among them Anthony Blunt, who as a Marxist advocate of socialist realism had criticised Picasso's *Dream and Lie of Franco* for its aesthetic obscurity and the artist's failure to understand the issues of the Spanish conflict.[15] In spite of Blunt's estimation of Picasso's imagery as 'useless horror', *Guernica*'s impact in Britain – two years before the Blitz – was perhaps more succinctly captured in Herbert Read's prophetic riposte that 'Not only *Guernica* but Spain; not only Spain, but Europe, is symbolised in this allegory'.[16]

Picasso's most politically explicit work prior to *Guernica* was his pair of engravings *The Dream and Lie of Franco*, which he began in January 1937. Each of its eighteen scenes were originally intended to be cut up and made available as postcards, but they were produced in their current form and sold in support of the Republican cause at the Spanish Pavilion at the 1937 Paris International Exhibition, where *Guernica* was being exhibited to great acclaim. A few months later Roland Penrose bought two sets of the etchings from the artist and gave one to his wife, the photographer Lee Miller. The present set was dedicated 'pour Roland Penrose' by the artist on 5 October 1937, the same date Penrose bought *Weeping Woman* 1937 (no.107). The following year it was included in the British tour of *Guernica* and related studies, drawing attention to the visual and political correlations between the two bodies of work.

In a derisive portrayal of General Franco, Picasso's cartoon-strip style tableau casts the Nationalist leader as an outlandish turd-like monster, much like Alfred Jarry's absurdist character Ubu in his play *Ubu Roi* (1896). Tracing key moments of the Spanish Civil War (July 1936–March 1939), Franco is first seen riding a disembowelled horse before masquerading in traditional Spanish dress. He is then defied by a heroic fighting bull, Picasso's customary symbol for the Spanish people. In later scenes Franco metamorphoses into a peculiar pig-like animal before a bloody battle ensues. Picasso added the last four, angrily scrawled scenes of the conflict's aftermath, a few months later in June after he had completed *Guernica*. Here the motifs of the weeping woman and the woman holding her dead child are consistent with the vigorous preliminary sketches for the mural. Accompanied by a surrealist-style prose-poem that vividly captures the sensory aspects of the terror, these images also prefigure the series of weeping women that were to become Picasso's principal preoccupation in the months thereafter.

100, 101
PABLO PICASSO
The Dream and Lie of Franco I and II 8 January and 7 June 1937
Etching and aquatint on paper
Each 38.1 × 57.4
The Penrose Collection, England

102

PABLO PICASSO

Study for the Horse's Head II

2 May 1937

Pencil on blue paper

26.9 × 21

Museo Nacional Centro
de Arte Reina Sofía, Madrid

Zervos IX, 7

103

PABLO PICASSO

Weeping Head VII (Postscript)

19 June 1937

Pencil, tempura and gouache on board

11.8 × 8.8

Museo Nacional Centro
de Arte Reina Sofía, Madrid

Zervos IX, 53

102–104

Picasso's preliminary studies for *Guernica* had a lasting effect on many British artists; Herbert Read observed that their depth and intensity symbolised a universal contemporary sense of 'disillusion, despair and destruction'.[17] During the summer of 1937 Picasso's cataloguer and friend Christian Zervos devoted almost an entire issue of *Cahiers d'Art* to *Guernica's* history and making.[18] An indispensable portal to the most recent cultural news from Paris, the journal presented the sketches as autonomous works of art, amplifying the political tenor of Picasso's imagery and heralding *Guernica's* emerging iconic status. Moreover, it gave a number of British artists a significant first opportunity to engage with Picasso's emotive sketches and studies, reproduced alongside Dora Maar's photographs documenting the mural's progress. Revealing his highly charged and symbolic repertoire of the dying horse, mother and

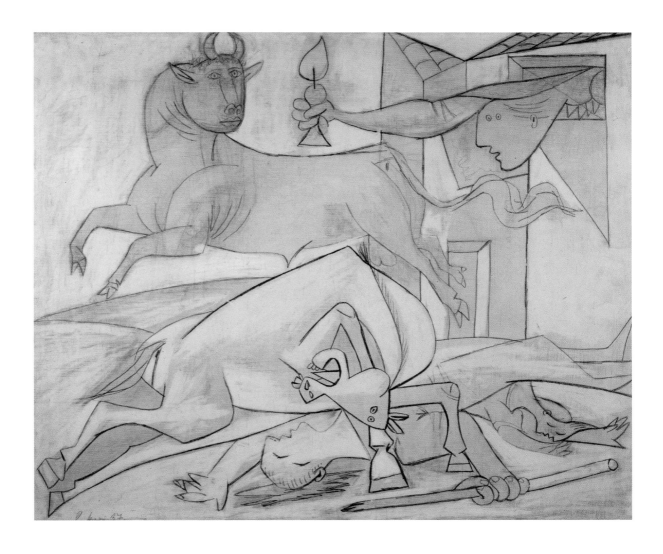

104

PABLO PICASSO
Composition Study V:
Sketch for 'Guernica'
2 May 1937
Pencil and oil on plywood
60 × 73
Museo Nacional Centro
de Arte Reina Sofía, Madrid
Zervos IX, 8

dead child and weeping female head, they not only give us an insight into the rapid development of the final mural, but reveal Picasso's ability to 'violate, to control our synthetic reaction by means of simplified forms'.[19] For Read, the sketches explored the expressive tensions of distortion and exaggeration. For others, the studies were marked by their ferocity and reduction of form; in 1939 Kenneth Clark considered the impact of them in the context of Picasso's wider oeuvre and concluded that 'Picasso is most himself when he is violent ... In the studies for *Guernica* he was fighting with the gloves off ... and the result was the most powerful creation in all his work.'[20]

For Myfanwy Evans, editor of *Axis* and of the book *The Painter's Object* (1937) – the first British book to reproduce *Guernica* – the painting was 'a passionate recognition of the facts, so purged as to become almost detached statement, and ultimately so unrealistic as to be almost as abstract as his most abstract painting'.[21]

Edward Wadsworth saw *Guernica* at the Paris Exhibition in 1937 and, judging it 'the only recent nightmarish war painting that I can think of,' it stimulated him to paint his own macabre still life with animal skull.[22] Likewise for other British artists coming to terms with the aftermath of cubism and embroiled in debates about abstraction, *Guernica* seemed to offer a new visual model – one of metamorphosis and of the metaphorical power of distortion, expressed for example in the work of John Piper, as well as in Graham Sutherland's use of anthropomorphic natural forms. Picasso's many variations of the horse, and particularly the study with its head tilted back with an angular tongue thrust upward, proved to be a vital source for Henry Moore's ambiguous *Three Points* 1939–40 (no.88) with its formal, psychological and sexual tensions, pointing to 'a metaphor for the anxiety of the outbreak of another global conflict'.[23]

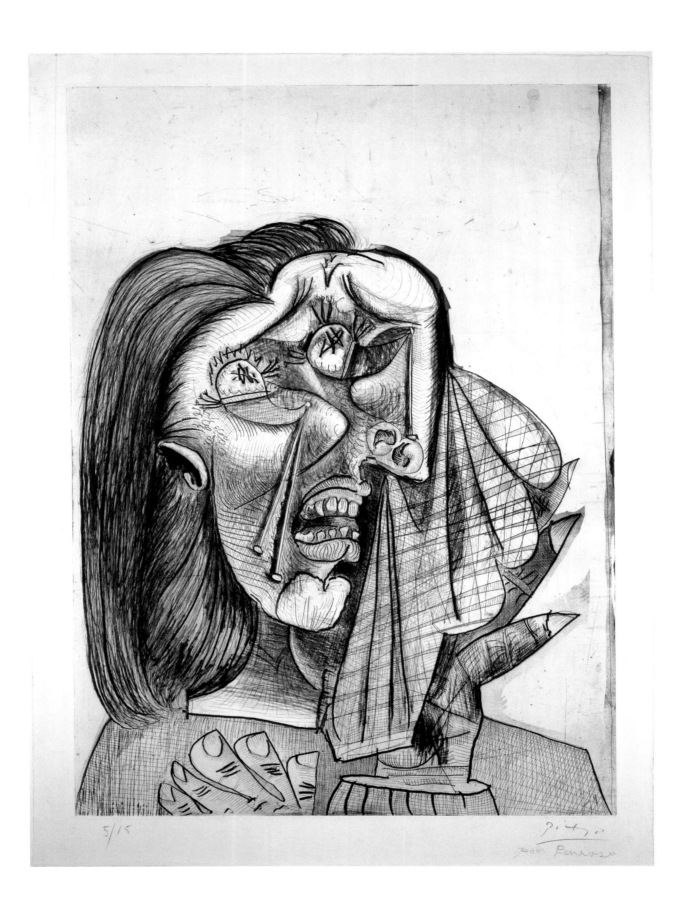

5/15

During 1937 Picasso became obsessed with the motif of the weeping woman, which symbolised for him the anguish and devastation of the Spanish Civil War. In the run up to making the painting *Guernica*, during the process, and for several months after its completion, he returned to the subject, making a total of twenty-seven drawings and nine paintings.[24] The earliest here is the crayon drawing, dated 16 June, about a fortnight after the completion of the mural. Within a further two weeks, Picasso had donated the drawing to be auctioned in support of Basque refugee children. It was bought at the Albert Hall on 24th June 1937 by the noted Picasso collector Hugh Willoughby and exhibited with the rest of his collection at Cheltenham Museum and Art Gallery

the following month. The drawing was subsequently acquired by Roland Penrose, who had purchased both the etching and the oil on the subject directly from the artist in November 1937. The etching is the fifth of fifteen made of the seventh (final) state.

For Penrose, *Weeping Woman* was above all a surrealist painting as well as *the* postscript to the great mural; he noted how the 'sombre monochrome of *Guernica* … [gave] way to brilliant contrasts of red, blue, green and yellow in a highly disconcerting way. It was as if this girl, seen in profile but with both the dark passionate eyes of Dora Maar, dressed as for a fête, had found herself suddenly faced by heartrending disaster.'[25] The robust oil painting is the last and most elaborate

105

PABLO PICASSO

Weeping Woman

1 July 1937

Drypoint, etching and aquatint on paper

77.2 × 56.9

Scottish National Gallery of Modern Art, Edinburgh. Accepted by H.M. Government in lieu of Inheritance Tax on the Estate of Joanna Drew and allocated by H.M. Government to the Scottish National Gallery of Modern Art 2005

106

PABLO PICASSO

Weeping Woman

16 June 1937

Pencil and crayon on paper

29.2 × 23.2

Tate. Accepted by H.M. Government in lieu of tax and allocated to the Tate Gallery 1995

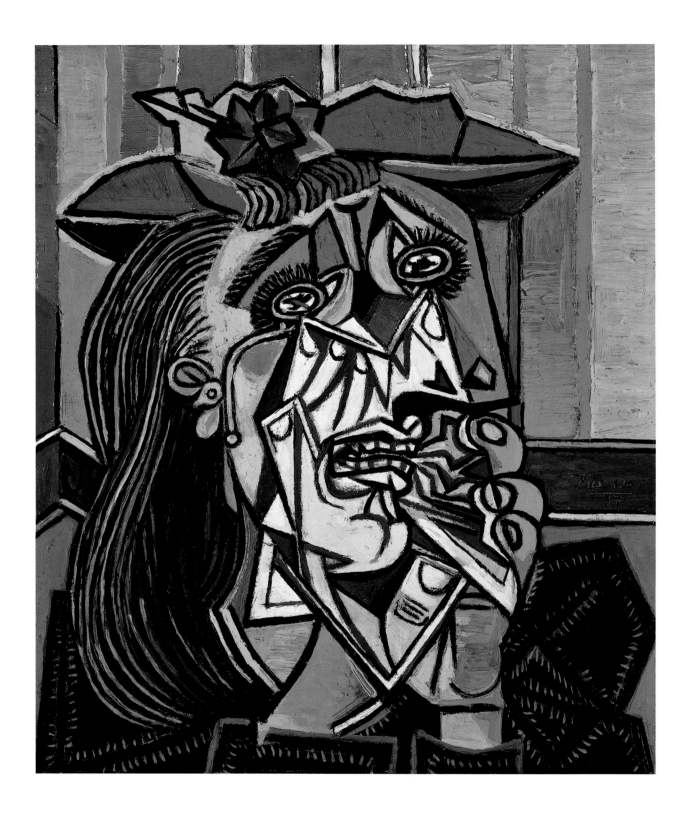

of the series. Penrose bought it in the year in which his relationship with Picasso is said to have developed as Penrose and his wife Lee Miller holidayed with Picasso and his surrealist friends Paul and Nusch Eluard in Mougins in the south of France. Seeing the work for the first time in Picasso's studio, Penrose recalled its captivating power, and 'unprecedented blend of realism and magic', writing later to the artist that 'in these dreadful times when we live on a diet of atrocities, each worse than the next, this picture is like a drug and gives me courage. It misses nothing of this tragedy, but surpasses it.'[26] In 1939 Penrose lent the oil *Weeping Woman* to the survey exhibition *Picasso in English Collections* at the London Gallery, the last exhibition of Picasso's work in Britain before the Second World War. In 1942, he lent it again to a private exhibition at his friend Hugh Willoughby's flat in Hove, where a young Lucian Freud escorted the unwrapped painting on the train from London. 'I was amazed that the bright sunlight in no way made it any worse or more garish or weaker or more painty,' Freud later remarked; 'It seemed it was as powerful and strong as possible'.[27]

The enduring impact of *Weeping Woman* in Britain continued during the post-war period, when it featured in a succession of major exhibitions. It was the first work by Picasso to be seen by David Hockney, who recalled he was never able to forget it because it made him 'realise that somehow his Cubism could accomplish more than any other means of depiction'.[28] Later, Hockney included a graphic, stylised nod to the theme of the weeping woman in *What is this Picasso?* from the suite of etchings *The Blue Guitar* 1976–7 (no.126).

107
PABLO PICASSO
Weeping Woman
26 October 1937
Oil on canvas
60.8 × 50
Tate. Accepted by
H.M. Government in lieu of
tax with additional payment
(Grant-in-Aid) made with
assistance from the National
Heritage Memorial Fund, the
Art Fund and the Friends of
the Tate Gallery, 1987
Zervos, IX, 73

GRAHAM SUTHERLAND AND PICASSO

CHRIS STEPHENS

On 12 November 1947, Graham Sutherland reported from the south of France to Kenneth Clark: 'The Picassos at Antibes are a poor lot – except one which is *magnificent* & new.' Since he paraphrased it in a painting of his own that same year, he referred presumably to the great *La joie de vivre* 1946 (Musée Picasso, Antibes, Zervos XIV, 289).[1] His disdain might have been designed to reassure Clark, his major patron. Since the later 1930s, Sutherland's art had trodden a delicate balance between an English romantic tradition and Parisian modernism associated with the surrealists and, in particular, with Picasso. Clark generally strove to develop and promote the former, although he seems to have both given Sutherland a copy of Gertrude Stein's 1938 book on Picasso and passed on his own copy of Melville's *Picasso: Master of the Phantom*.[2] In any event, the painter met Picasso shortly after he wrote to Clark and became a fairly regular visitor and acquaintance, if not a friend. Sutherland's biographer records that the journalist and Labour politician Tom Driberg introduced Sutherland to Picasso in Vallauris on 20 November 1947; it was Driberg who photographed Sutherland and his wife Kathleen both in the Chateau Grimaldi (later renamed the Musée Picasso) in Antibes and with Picasso himself at Vallauris.[3] Although this formative encounter came late in the year, it was also in 1947 that Sutherland painted his *Homage to Picasso* based on *La joie de vivre* (no.115).

Sutherland had for some years acknowledged his admiration of and profound debt to Picasso. During the earlier 1930s, Sutherland's art had moved from a fairly close echoing of the style of Samuel Palmer (1805–81) to a mode in which a Palmeresque mood and appearance was abstracted to fit a more contemporary style. Traditionally, the turning point in Sutherland's career has been identified as his discovery of the landscape of south-west Wales in 1934, which led to his subsequent paintings of stylised natural forms. However, he himself recorded:

I became aware, after I had started work in Pembrokeshire, that unconsciously some of my forms – to me at least – started to look a bit like the kind of things I had been seeing at the time as reproductions in *Cahiers d'Art*. My feelings then were, not that I was trying to be un-English, but that for the first time in my life I was aware there was something going on beyond the English tradition.[4]

If there was a general tendency in Sutherland's art towards the language of contemporary practice in Paris, the largest impact in the late 1930s and 1940s was unquestionably Picasso's *Guernica* and its related studies.

Sutherland would not only have seen *Guernica* and its studies in late 1938 or early 1939 at one of the two London exhibitions, but he also knew the 1937 issue of *Cahiers d'Art* in which the mural and its evolution, documented by Dora Maar's photographs, was illustrated.[5]

In these works, Picasso offered an example of an artist engaging in a modern manner with the terrible events of the time, as well as presenting a model for a certain kind of pictorial metamorphosis as an expressive device. As Sutherland put it:

> Picasso's Guernica drawings seemed to open up a philosophy and to point a way whereby – by a kind of paraphrase of appearances – things could be made to look more vital and real. The forms I saw in this series pointed to a passionate involvement in the character of the subject, whereby the feeling for it was trapped and made concrete. Like the subject and yet unlike … Only Picasso however seemed to have the true idea of metamorphosis, whereby things found a new form through feeling.[6]

The result, as Martin Hammer has put it, was that the impact of Picasso on Sutherland's art of the next few years was 'everywhere apparent'.[7]

Fig.27
Drawings by Picasso after **Crucifixion**
by Matthias Grünewald, reproduced in
Minotaure no.1, 1933, pp.30–1

Sutherland began to make in earnest paintings in which natural objects take on an anthropomorphic aspect in 1936. In the second version of his *Red Tree* 1936 (BP Collection, UK), for instance, the broken branch suggests both an animal bone and a reclining human figure. This aspect of his work rapidly developed, and became dominant, following the impact of Picasso's *Guernica* and the related studies, which he first saw in *Cahiers d'Art* in 1937. Until the commissions of the War Artists Advisory Committee in 1942 and of the Church of England in 1944, Sutherland had rarely addressed the subject of the human figure directly. Instead, he continued to use found organic objects to suggest both a human presence and a deeper sense of anxiety and implied aggression. Made in the early months of the war, the present works should be seen in light of a sense of threat and foreboding that prevailed as people waited to see the consequences of the conflict with Nazi Germany. As the leading example of modern art's response to the violence of fascism, *Guernica* offered a model for this engagement with contemporary events.

In *Gorse on Sea Wall*, Sutherland adopted a Picasso-esque grisaille for the plant that coils out towards the viewer. He set it, however, against a portentous, glowering, blood-red sky. Painted in Sutherland's peculiar style – using oil paint as if it were watercolour – the gorse with its threatening thorns appears to be both plant and beast. Triffid-like, its roots or branches curl out like clutching fingers. Martin Hammer has directly related various details of *Gorse on Sea Wall* to *Guernica*: the hands to the dying horse's head, the prickly forms on the left to the glare of the light bulb.[8]

But, as he acknowledges, while Picasso offered a model for metamorphic images such as this, it was surely the writhing fingers of Matthias Grünewald's dying Christ in his Isenheim altarpiece 1506–15 (as copied by Picasso and reproduced in *Minotaure)* that suggested the particular motif of the finger-like root (fig.27).[9]

In *Green Tree Form* and *Association of Oaks* the trees of the titles become suggestive of human figures in a more generalised sense. If *Gorse on Sea Wall* evoked an agonised anxiety through the form of a twisted hand, these have a more powerful underlying suggestion of the body as sensuous and erotic. While roots become legs, stumps of branches allude to breasts and buttocks, declivities in the trunks to orifices. Again, Picasso is undoubtedly a source for this metamorphic transformation of one thing into the suggestion of another but the actual tree-bodies owe as much, one might speculate, to the deformed bodies of Hans Bellmer's *Poupées*.[10] This concentration on a suggestive body has also been related to Picasso's influence, specifically to the phallic abstractions of the human figure from his 1927 sketchbook that had been reproduced in *Cahiers d'Art* in 1938 (fig.25).[11]

Picasso also, perhaps, offered a model as an artist concerned with deeper sources and meanings, like the surrealists, who yet remained committed to the importance of nature as the artist's primary source. 'There is no abstract art. You must always begin with something,' was a Picasso quotation that Sutherland would have known since it appeared in translation in Myfwany Evans's book *The Painter's Object*.[12] A little later, in 1945, Sutherland would himself observe that, 'Surely Picasso is, at his best, deeply concerned with nature'.[13]

108

GRAHAM SUTHERLAND
Gorse on Sea Wall 1939
Oil on canvas
62.2 × 48.3
National Museums
Northen Ireland

109
GRAHAM SUTHERLAND
Association of Oaks 1939—40
Gouache, watercolour and
pencil on paper
68.6 × 48.6
Scottish National Gallery of
Modern Art, Edinburgh

110
GRAHAM SUTHERLAND
Green Tree Form 1940
Oil on canvas
60.5 × 54.5
British Council Collection

111

GRAHAM SUTHERLAND
Composition: Devastation
1942
Pencil, pastel and gouache
on paper
23.5 × 36.5
Private collection

Commissioned by the War Artists Advisory Committee to record bomb damage in South Wales and London, Sutherland found in his subject figurative allusions similar to those he had unearthed in his pre-war landscapes. As he was prohibited from depicting dead bodies, he used such features of the broken buildings as shattered roof-timbers and twisted steel girders to suggest some kind of animal presence. This continued the use of paraphrase and a metamorphic approach to imagery that Sutherland had drawn from – or at least been encouraged by – his encounter with Picasso's *Guernica* and its related studies. *Guernica* offered a model for the painting of the aftermath of aerial bombardment.

An inscription on Sutherland's drawing suggests he had something more epic in mind than simple observation: 'This was an attempt to combine several elements, intended for a large painting.' In contrast to Picasso's screaming mouths and distorted and broken bodies,

the elements in the ink drawing are all architectural, though Sutherland typically employs such motifs as the fragmented rafters, broken stonework and twisted metal to suggest something more visceral, like the spilling entrails of a body. Nevertheless, his drawing clearly pays homage to *Guernica*. As an ink drawing, it makes use of a similar grisaille. The rhythm of Sutherland's pattern of light and dark passages echoes Picasso's and, while details differ, particular aspects like the upward diagonal movement from the bottom right-hand corner, and the vertical feature just to the right of centre, can be related back to the composition of *Guernica*. Most striking is the starburst motif at the very centre of the top edge of *Devastation*, which very clearly refers back to the stark flare from Picasso's light bulb. It is as if, in approaching a generalised statement on the London Blitz, Sutherland consciously refers back to and draws inspiration from Picasso's great precedent.

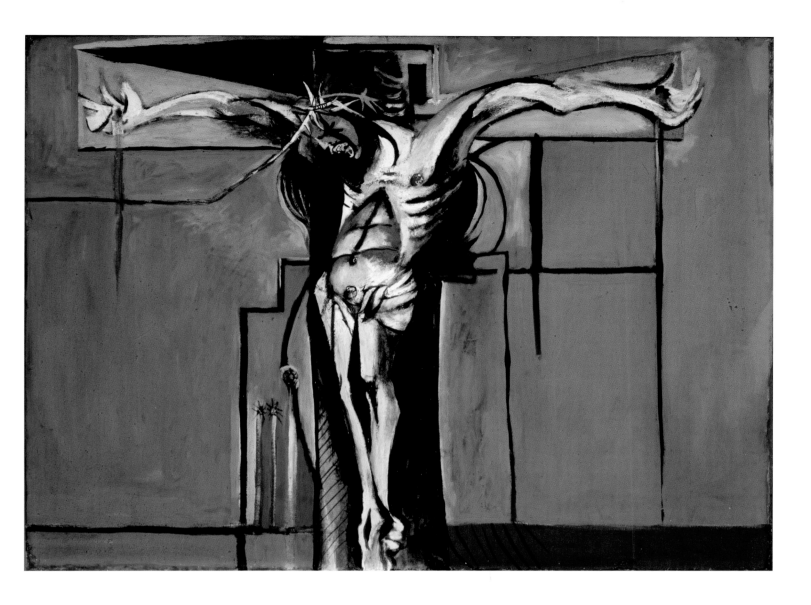

112–114

112

GRAHAM SUTHERLAND
Crucifixion 1946
Oil on board
90.8 × 101.6
Tate. Purchased 1947

In 1944, Sutherland was invited by Canon Walter Hussey to paint a Crucifixion for the church of St Matthew, Northampton. Sutherland, a Roman Catholic convert, had proposed the subject in preference to an 'Agony in the Garden'. The painting here is one of a number relating to that commission.

At the end of the Second World War, Sutherland's evident debt to Picasso had been commented upon. He recalled an encounter with painter and critic Michael Ayrton:

He immediately attacked me – saying that he had looked on me as a sort of St George to Picasso's dragon – but now ... if I continued in my present vein – which he thought was 'very Freud' and 'so obviously derived from Picasso' he thought it would be a 'grave national calamity'! I said 'don't be a fool – Picasso has always been an influence & that Picasso had opened up ways which just couldn't be ignored.[14]

Sutherland certainly wasn't put off by Ayrton's attack, as Picasso was one of those to whom he looked when addressing his *Crucifixion*. Like Picasso, he sought to embody in the traditional subject something of the horrors of recent history. Having struggled with the idea for a year, Sutherland was stimulated by *KZ* (1945), a booklet containing photographs of the Nazi concentration camps published in German by the United States Information Services.[15] The emaciated and tortured bodies recorded there reminded him of Grünewald's depiction of the dying Christ in the Isenheim altarpiece.

Sutherland would have known Picasso's drawings after Grünewald, which were reproduced in the first issue of *Minotaure* in 1933. These might have been on his mind as much as the Grünewald itself. While the twisting fingers derive from the original altarpiece, the upward arc of Christ's arms – as if caught by some convulsion of pain – is closer to Picasso's sketch of it.

It is also said that, in order to better understand his subject, Sutherland had himself tied up and suspended from a roof beam and that direct, physical experience might have informed this detail in what Kenneth Clark called a 'corporeal crucifixion'.[16]

While engaged on and shortly after finishing the Northampton *Crucifixion*, Sutherland made a number of related paintings. *The Deposition* is dated 23 November 1946. The conglomeration of figures combine references to traditional, Renaissance treatments of the subject and more recent work, particularly that of Picasso.

The position and up-turned head of Mary Magdalene towards the bottom recalls Picasso's *Three Dancers*, 1925 (no.135), itself reminiscent of a crucifixion, but relates especially closely to the screaming mother holding the lifeless body of her child in *Guernica*.[17] Though less readily related to actual details, Sutherland's other faces also reflect the impact of Picasso's work. This would be consistent with a sketchbook used around this time that contains several studies of Picasso heads: one appears to be a copy of an unidentified painting of the sort Picasso made of Dora Maar in the late 1930s and early 1940s, or a pastiche, and two others apparently relate to the upper right-hand figure of *Les Demoiselles d'Avignon* 1905.[18]

While preparing for his *Crucifixion*, Sutherland had painted a series of 'thorn trees'. By his account, 'pre-occupied with the idea of thorns (the crown of thorns) and wounds', he noticed thorn trees and bushes more readily when in the countryside. At the same time, he had 'several ideas for "Thorn Heads"', though these he would develop later.[19] In Douglas Cooper's words, Sutherland 'sublimated' the Crucifixion in these thorn paintings, finding in the natural world symbolic evocations of suffering and cruelty. As the curving forms suggest a human head, so they recall the welded forms of Julio González's cubist sculptures. Equally, it has been suggested, they seem to reference Picasso's *Weeping Woman*, which Sutherland knew well from Roland Penrose's collection.

113
GRAHAM SUTHERLAND
The Deposition 1946
Oil on millboard
152 × 121.9
Lent by the Syndics of
Fitzwilliam Museum,
Cambridge

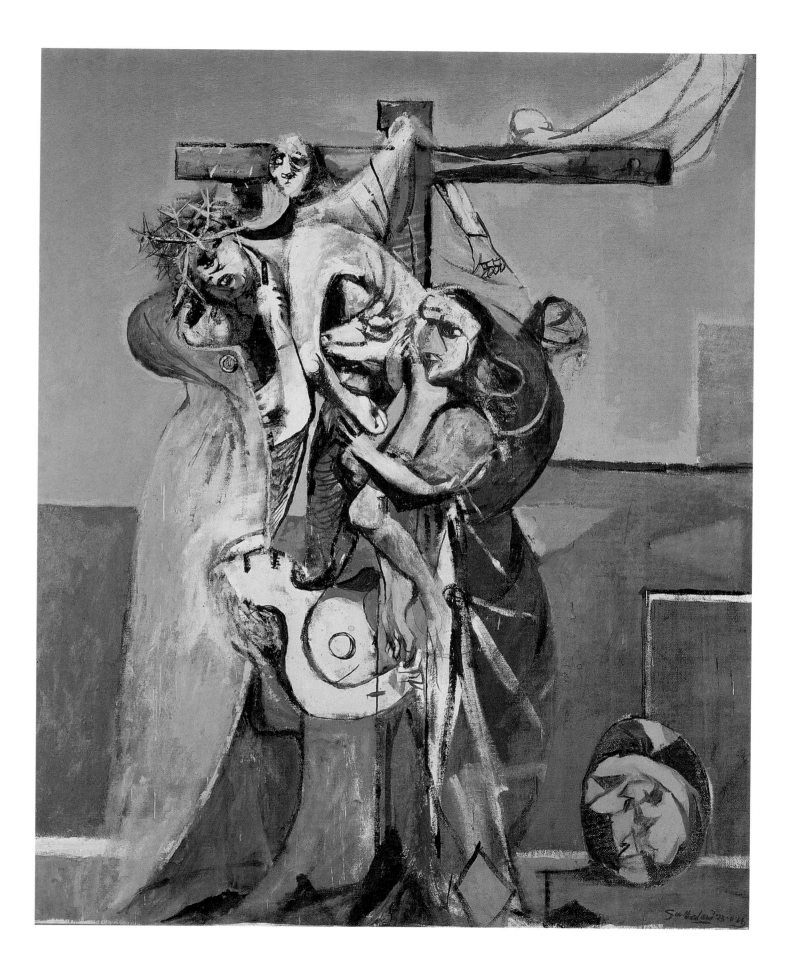

181

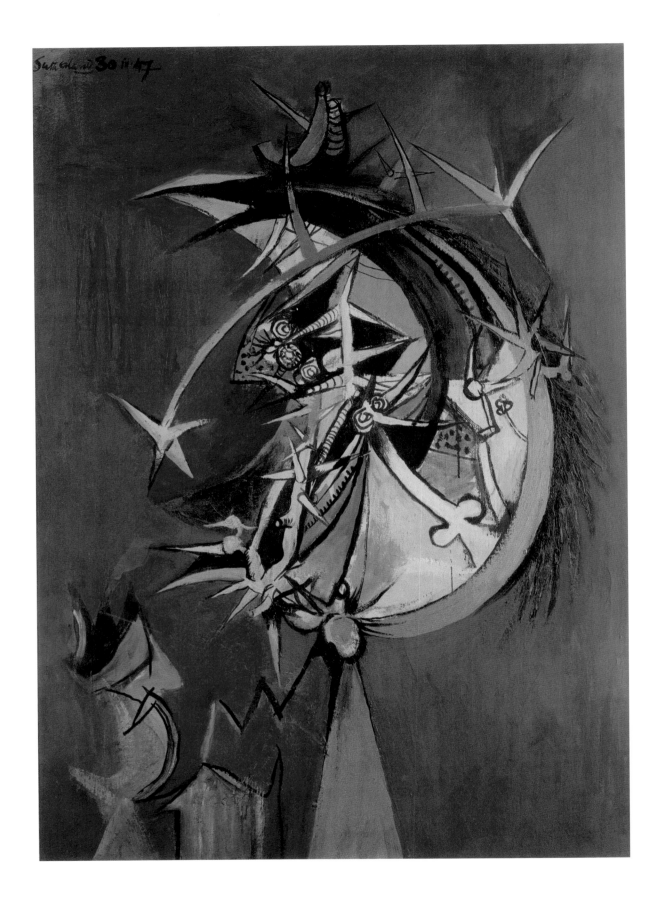

114

GRAHAM SUTHERLAND

Thorn Head 1946

Oil on canvas

113 × 80

Private collection, London

115

115

GRAHAM SUTHERLAND
Homage to Picasso 1947
Oil on canvas
30 × 50
Private collection

The present title for this work derives from the artist's dedication, on the back of the canvas, to his New York dealer Curt Valentin: 'To C.V. Sutherland 1947 Antibes. Homage to Picasso Free copy after seeing a painting by Picasso & noticing similarity of certain forms to some I have used in Wales.' It was, however, reproduced in Douglas Cooper's monograph on the artist as 'Landscape'.[20]

Cooper noted that the work was painted shortly after Sutherland's visit to the Chateau Grimaldi (later the Musée Picasso), Antibes, and that its 'formal organization corresponds with that of a *Pastorale* which he had seen there'.[21] However, he continued, 'Sutherland's canvas is not even a variant of the original but a trans position or "paraphrase" in strictly personal terms'. A comparison reveals Sutherland's model to be the masterpiece of Picasso's residency in Antibes, *La joie de vivre* 1946. While Picasso translates his seaside location into a bacchanalian scene of piping fauns and buxom women, Sutherland's homage seems to remain rooted in the Welsh landscape. One can imagine how he would have recognised echoes of his own compositional style in the spindly plant forms on the left-hand side of *La joie de vivre*, and in the declivity of the horizon. The frieze-like composition is remarkably similar in both works: Sutherland repeats Picasso's pattern of arcs and triangles, even re-using such details as the black oblong on the left, an adjacent triangle, the curved indentation towards the middle and the rising, curved form to its right. Yet, even as Sutherland was beginning to make paintings based on such Mediterranean themes as palms, gourds and cacti, this 'homage' remains entirely consistent with earlier Welsh landscapes.

PICASSO IN BRITAIN 1945–1960

HELEN LITTLE

During the period 1945–60, Picasso's reputation in Britain as a figure of controversy and celebrity reached unprecedented heights.[1] After the Second World War there were as many opportunities in Britain to see the latest developments in his art as there were in France or the United States. The first major institutional exhibition of Picasso's work in Britain opened at the Victoria and Albert Museum in late 1945, touring the following year to Manchester and Glasgow. This double-bill of the two foremost exponents of modern French painting, *Matisse – Picasso* was organised by the British Council in collaboration with the Direction Générale des Relations Culturelles du Ministère des Affaires Etrangères as part of a symbolic revival of cultural exchange.[2] While the exhibition offered a retrospective of Matisse's work, Picasso's section comprised twenty-seven canvases painted in Paris during the war, along with *Night Fishing at Antibes* 1939 (Museum of Modern Art, Zervos IX, 316).[3] The exhibition created a storm in the London art world, attracting 170,000 visitors in 5 weeks. 'For the first time in many decades, London has been discussing art,' the British Council declared triumphantly, 'and the name of Picasso has become a household word, and even, it is said, a verb'.[4] Yet the critical reception of Picasso was largely overshadowed by Matisse's display of 'dazzling Mediterranean atmosphere'. Comparisons with *Guernica* – the intensity of which had struck such an immediate chord among British audiences six years before – ensued, with critics disillusioned by the artist's apparent lack of political engagement.

For Roland Penrose, the reception of the V&A exhibition reinforced his cause to establish a British gallery devoted to modern art. In a letter to the *Times* in 1945, he used it to argue for the need for a wider public to engage with work by living artists. 'Before the war other countries had developed institutions such as the Museum of Modern Art in New York and similar foundations in Paris and Brussels,' he maintained, 'which we would do well to study if we wish to catch up on the habitual time lag in our artistic appreciation for which this country is notorious'.[5] A few years later Penrose facilitated the first of only two appearances in Britain of Picasso's *Demoiselles d'Avignon* 1907 for his exhibition *40,000 Years of Modern Art* of 1948, which opened

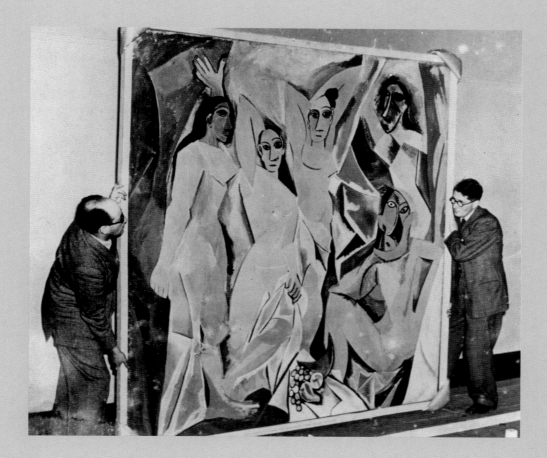

Fig.28
Ewan Phillips, Director of the
Institute of Contemporary
Arts, and Roland Penrose with
Picasso's **Les Demoiselles
d'Avignon**, London,
December 1948
Lee Miller Archives

under the auspices of the newly formed Institute of Contemporary Arts (ICA) at the Academy Cinema on London's Oxford Street in 1948. He later recalled how the large canvas was squeezed into the building via an unrepaired bomb crater in the basement (fig.28).[6]

Arrangements for a major retrospective at the Whitechapel Art Gallery were abandoned in 1952 amid concerns about Picasso's politics.[7] Nevertheless, the 1950s saw a succession of exhibitions of his work, organised chiefly by the Arts Council of Great Britain (ACGB) and the British Council. An exhibition of lithographs at the ICA in 1948 was followed by *Picasso in Provence*, toured by the British Council throughout 1950, *Homage to Picasso on his 70th Birthday*, at the ICA in 1951, and *50 Years of Graphic Art* organised by the Arts Council, and *Picasso Himself* at the ICA in honour of the artist's seventy-fifth birthday in 1956. Picasso reciprocated Penrose's support by contributing generously to the ICA's annual Picture Fair, consenting to the reproduction of his sketch of *Leaping Bulls* in the ICA visitors' book as a scarf to be sold to raise funds, and

supporting Penrose's 1958 biography *Picasso: His Life and Work*, the first comprehensive biography of Picasso in any language.

Selected by Penrose and organised by the Arts Council, Picasso's 1960 retrospective at the Tate Gallery was the most comprehensive exhibition of his art then staged. It featured 270 works in all media including the drop curtain for the ballet *Parade* installed in the central Duveen Galleries. It also included a selection of his recent work, including the entire series of reworkings of Diego Velázquez's *Las Meninas* 1656. Overwhelming critical success, the appearance of Hollywood celebrities and royalty at the opening reception and crowds queuing each day thereafter prompted the term 'Picasso-mania'. In the press, a number of features feverishly reported Picasso's love of all things English: 'His Spanish father was nicknamed "the Englishman" for his love of English customs ... furniture and clothes' reported one newspaper, 'and though he has a great variety of hats ... [Picasso] likes his English bowler best'.[8]

At the end of the war, British audiences were eager to see Picasso's wartime work. Yet when National Gallery director Kenneth Clark visited Picasso's studio after the Liberation of Paris in August 1944, he did not have the opportunity to see any of the recent paintings that would shortly be shown at the Salon d'automne, a selection of which Picasso would exhibit at the Victoria and Albert Museum the following year. To Clark's disappointment, surrounded by hundreds of canvases stacked in the studio, they instead discussed a recent portfolio of drawings around the theme of Cupid and Psyche.[9] During the visit, Picasso is said to have become consumed by the copy of Herbert Read's recent book on Henry Moore that Clark had taken with him. 'C'est bien,' Picasso exclaimed somewhat irreverently after studying the volume, 'Il fait le Picasso'.[10]

Moore and Read saw Picasso's wartime canvases during a visit to his studio in November 1945, and sent a positive report back to London.[11] As had been the case at the 1944 Salon d'automne – Picasso's first exhibition in Paris since the Occupation also known as the Salon de la Libération – when these paintings were unveiled in London they excited enormous criticism and controversy. 'The fact that this is an exhibition only of Picasso's wartime paintings has produced a shock of horror to the public and the critics,' noted Roland Penrose in the press shortly after the opening, 'few of whom have appreciated the immense and even tender understanding of life that his work reveals'.[12]

The Enamel Saucepan (no.117), a deceptively simple memento mori still life in which three everyday domestic objects suggest the difficulty of normal life under the Occupation, was one of the most significant of the works on display. 'I have not painted the war because I am not the kind of painter who goes out like a photographer for something to depict,' Picasso famously told an American war correspondent upon the Liberation of Paris, 'But I have no doubt that the war is in these paintings'.[13] The symbolism was, perhaps, more explicit in a series of still lifes in which a skull – human or animal – was depicted alongside less dramatic objects like jugs and vegetables. A number of paintings from earlier in the war, in which the figure is especially brutally distorted, seem to speak of a general and pervasive violence.

That these works ostensibly ignore specific events, offering instead a strong visual record of the corrosive effect of the war through their sombre palette and tight spatial arrangements, seized the attention of a number of British artists and commentators including Patrick Heron, who commented that Picasso could 'extract significance from almost any object, however dead and commonplace'.[14] Indeed, the raw power and brutal expression of the repertoire of Picasso's wartime art made a considerable impact on a generation of British artists associated with the neo-romantic movement, including John Minton, Ithell Colquhoun, Keith Vaughan, John Craxton, Robert Colquhoun and Robert MacBryde, cementing Picasso's status as the dominant European influence on postwar British art. For Keith Vaughan, writing in January 1946 on the problems facing painters striving to create an equilibrium between pure form and engagement with the material world, Picasso had got nearer than any artist to evolving 'a coherent vocabulary of plastic form appropriate to our ages'.[15]

116
PABLO PICASSO
Woman Dressing her Hair
June 1940
Oil on canvas
130.1 × 97.1
The Museum of Modern Art, New York. Louise Reinhardt Smith Bequest, 1995
Zervos X, 302

117

PABLO PICASSO

The Enamel Saucepan

16 February 1945

Oil on canvas

82 × 106.5

Musée National d'Art Moderne,

Centre Georges Pompidou,

Paris. Donation Pablo Picasso,

1947

Zervos XIV, 71

Touring Britain throughout 1950, the exhibition *Picasso in Provence* was the first major opportunity for British audiences to see Picasso's postwar work, particularly his most recent developments in sculpture.[16] By this time Picasso's practice was increasingly focused on the innovative ceramics he had been making in the town of Vallauris in the South of France. Picasso gave this decorative wine vessel to the Victoria and Albert Museum following the *Picasso: Ceramics* exhibition held there in 1957.[17] The exhibition was curated by the British critic and collector Douglas Cooper who, having moved from London to the south of France in the early 1950s, was suitably placed to provided the most up-to-date information concerning Picasso's collaboration with the Madoura Pottery (run by the Ramié family) as well as the artist's process. Referring to a 'popular' industry with a repertoire of traditional forms, Cooper explained this piece:

> This Cavalier is painted on a form known as a 'gargoulette' or water jar. The form was produced by the Ramiés in accordance with Picasso's original design. But all the painting and glazing was done

by Picasso personally, who will certainly have given instructions about the baking and may well have put the object himself into the oven. Thus everything on the surface of the basic earthenware form is entirely by Picasso. The 'gargoulette' is a form he has not used a great deal. This ceramic is a unique example.[18]

Picasso's virtuosic and inventive ceramics, often taking the form of a plate or jug playfully transformed into an animal or a human figure or face, immediately struck a chord with an emerging generation of British ceramicists associated with Chelsea School of Art and Central School of Art and Design, including William Newland, Margaret Hine and Nicholas Vergette. Renowned for their use of brightly coloured tin-glazed earthenwares, the group was collectively referred to during the later 1950s as the 'Picassoettes'.[19] Abandoning the constraints imposed by a 'rigid conformity to the ethic of wheel thrown stoneware', the group adopted a freer approach to the medium, liberated by Picasso into exploring a Mediterranean rather than an oriental tradition.[20]

118
PABLO PICASSO
Pitcher – Horse and Rider
c.1951
Tin-glazed earthenware
painted in black and brown
with scratched detail
41.6 × 31.5 × 26.3
Victoria and Albert Museum,
London

Picasso's political fame in Britain culminated in his second and last visit to Britain, as a delegate to the 1950 Third Congress of the World Council of Peace in Sheffield. This event sparked considerable public interest, not least because of the Labour Government's refusal to grant visas to a large number of the invited international delegates. As one of only two French delegates allowed to enter the country, in protest Picasso boycotted the opening of his exhibition *Picasso in Provence* that month, writing to the Director of the Arts Council: 'I understand that the exhibition of my work organised by your council is, in effect, an exhibition held under Government auspices. In view of the Government's repressive actions towards so many of my friends and colleagues I have decided to cancel my acceptance of your invitation.'[21]

In spite of the disruption, Picasso travelled to Sheffield to address the conference before the main proceedings transferred to Warsaw. Greeted with rapturous applause, he spoke of the development of his images of doves for posters announcing the World Peace Congress, standing 'for life against death [and] peace against war'.[22]

Back in London, at a party given by the distinguished crystallographer and Communist Party activist J.D. Bernal (who had met the artist when he was shown the unfinished *Guernica*), Picasso took up the invitation to make an impromptu drawing directly on to Bernal's sitting-room wall. Bernal's notes describe in detail the rapidity with which Picasso drew, in a few strong and sensitive lines, the central image:

> It started off as a typical Picasso devil, with closed eyes, a small mouth, and horns. He stood back from this and had second thoughts. A devil was not the right thing for a professor's wall, and so by skilful touches he opened the eyes, touched up the nose and mouth, put a wreath of leaves around the head, and turned the devil into a god. He then stood back and said, 'mais il a l'air solitaire', and created his companion, which he did even more quickly. He then added the wings which made the drawing symbolic of the whole peace movement.[23]

The drawing remained in Bernal's flat in London's Torrington Square, Bloomsbury, for fifteen years, before being donated to the ICA in 1969.

119

PABLO PICASSO

Mural known as Bernal's

Picasso 12 November 1950

Crayon on plaster

135.1 × 226.4 × 17.8

Wellcome Collection, London

Picasso painted fifteen canvases based on Eugène
Delacroix's *Les femmes d'Alger* (two versions, 1843 and
1849) between December 1954 and February 1955.
Roland Penrose saw the development of this series in
Picasso's studio:

> P. showed me about 6 large canvases and 12 small.
> The theme taken from Delacroix['s] 'Demoiselle[s]
> d'Alger' which he had not seen for years and refuses
> to look at while he is still at work [on] the series. He
> is working very hard, has not be[en] out for three
> weeks and is well and happy in spite of Olga's death
> last week. The paintings range from the earlier
> ones, which are to some degree representational,
> with large fleshed nude legs in the air and a hieratic
> veiled seated figure in the foreground, a negress
> bringing coffee and a seated odalisque further back,
> to more abstract, cubist versions of the same compo-
> sition. Of these Kahnweiler remarked they are
> the logical development of cubism, in spite of the
> 1914–18 break in its development. The colour has
> an oriental taste – 'my idea of the orient in spite of
> never having been there' – a Moorish atmosphere
> of cool rooms sheltered from the outside heat.[24]

The north African theme may relate to the recent
death of Matisse, the impact of which is revealed by
Penrose's conversations with Picasso.

120
PABLO PICASSO
Women of Algiers (Version O)
14 February 1955
Oil on canvas
114 × 146.4
European private collection,
courtesy of Libby Howie
Zervos XVI, 360

Shortly after completing *Women of Algiers (Version O)* 1955 – the most elaborate and highly wrought painting from the series based on Delacroix's 1843 painting of the same subject – Picasso and his partner Jacqueline Roque moved to 'La Californie', a large art-nouveau style villa on the outskirts of Cannes. As Picasso's biographer John Richardson has revealed, the oriental interior setting of the Delacroix picture – reconfigured by Picasso into a series of complex cubist facets and decorative patterns – had left such a mark on his vision that he wanted his new studio 'to match'.[25] In October and November of 1955 Picasso depicted his new work-cum-living space twelve times, each variation revealing his pursuit of stylistic experiment. As Lee Miller's photographs documenting her visits to La Californie with her husband Roland Penrose that year demonstrate, the grand ornamental windows and balconied doors of the studio provided Picasso with a simple but animated composition, its explosive Mediterranean palette a world away from the wartime paintings exhibited in London a decade before. For Penrose, the atmosphere of *The Studio* (no.121) – which he was to include in Picasso's great retrospective at the Tate Gallery in 1960

– moved him in its cathedral-like effect, the unity and scale of the artist's furniture and objects giving it a great sense of space and movement. All twelve *Studio* paintings were shown at Galerie Louise Leiris in May 1957 accompanied by an essay by Picasso's veteran dealer, Daniel-Henry Kahnweiler. It was at that time that this work was bought by Kahnweiler's younger brother, Gustav, and his wife Elly. They had lived in Britain since 1935–6, and were important patrons of Henry Moore and ultimately the nation when they bequeathed their collection to the Tate Gallery.

In the decade leading up to the Tate retrospective in 1960, Picasso was at last beginning to be properly represented in British public collections. During this period, the Tate Gallery purchased five important works: in 1949 *Bust of a Woman* 1909 (no.54) and *Seated Nude* 1909–10; in 1953 *Nude Woman in a Red Armchair* 1932 (no.60) and the small bronze *Cock* 1932 (cast 1953); and in 1957 *Goat's Skull, Bottle and Candle* 1952. Picasso contributed to the selection of the Tate show and, of the 270 works, he lent almost 100, including *Women of Algiers (Version O)* 1955 and, in its entirety, his recent series after Velázquez's *Las Meninas*, 1656. This series of fifty-eight canvases had

121
PABLO PICASSO
The Studio 1955
Oil on canvas
80.9 × 64.9
Tate. Presented by Gustav
and Elly Kahnweiler 1974,
accessioned 1994
Zervos XVI, 497

122
PABLO PICASSO
Las Meninas
(Maria Agustina Sarimento)
20 and 26 August 1957
Oil on canvas
46 × 37.5
Museu Picasso, Barcelona
Zervos XVII, 352

123
PABLO PICASSO
Las Meninas (Group)
2 October 1957
Oil on canvas
161 × 129
Museu Picasso, Barcelona
Zervos XVII, 374

been seen only once, at the Galerie Louise Leiris, Paris in June 1959, Picasso having previously refused requests for them to be shown elsewhere.[26] Tate Director John Rothenstein expressed interest in acquiring the paintings, dispatching Penrose – a trustee of the gallery – to investigate their availability. Penrose reported that

> none of the *Las Meninas* are for sale ... Picasso has said very firmly ... he wishes to give the whole series to a museum, but he has not specified which ... I am afraid the restricted conditions would make it difficult for the Tate to become a candidate. It looks like a forlorn hope but if you can give me any encouragement, I am willing to test Picasso out on this matter.[27]

Wanting it to endure as a discrete entity, Picasso gave the entire series to the new Museu Picasso, Barcelona, in 1968.

Premiered at the Tate Gallery, the *Las Meninas* series invested Picasso's variations on the old masters with a Spanish dimension and provided an insight into the power and vitality of his recent work. Hung together at the end of the exhibition in strict chronological order, *Las Meninas* simultaneously cast Picasso as traditionalist and revolutionary, sharply confronting British audiences with the complexities of his relationship to the past, present and future. For John Golding, reviewing the exhibition for the BBC, *Las Meninas* was a vital 'summary of all Picasso's work and of his contribution to modern art', the exploratory works revealing the metamorphosis of his image making, synthesising and renewing his work to date and solidifying his trajectory as a Spanish artist.[28]

DAVID HOCKNEY AND PICASSO

CHRIS STEPHENS

David Hockney has taken inspiration from Picasso for almost the entire length of his career. The revelations of cubism have formed a major foundation for his art, in painting and photography, certainly since 1980. Beyond that, Picasso has offered Hockney a way forward in his artistic development repeatedly and so consistently that he becomes a kind of talisman in the narrative of the younger artist's career.

Hockney recalls, as a student, visiting the great Picasso exhibition at the Tate Gallery in 1960 at least eight times. In fact, he had known of Picasso's work from an early age, citing a reproduction of *Weeping Woman* 1937 (no.107) he had seen when still at school and the publication in a newspaper of *Massacre in Korea* 1951 (Musée Picasso, Paris, Zervos XV, 173), which resonated in the pacifist Hockney household (Hockney's father had seen *Guernica* in 1938/9). While one might compare the abstract patterning of Picasso's *Seated Man with a Glass* 1914 (whereabouts unknown. Zervos IIb, 845), which was exhibited at the Tate (80), with features in Hockney's paintings of the early 1960s, the principal lesson Hockney took from the Tate exhibition was that an artist need not restrict themselves to a single style. This was the impetus behind the four paintings he contributed to the 1962 *Young Contemporaries* show in London which he described as *Demonstrations of Versatility*. The influence of Picasso was not immediately evident in the paintings themselves but, increasingly, it became central to Hockney's negotiation between the tenets of modernist painting and ideas of realism. Picasso drove Hockney's ironic reflection on artistic representation.

Hockney engaged directly with the idea of Picasso as master in two etchings made following the artist's death on 8 April 1973 (nos. 124 and 125). Before that, Picasso and cubism had occasionally featured in his work: in 1970, two paintings, derived from a stay in the south of France, focus on the mural at Douglas Cooper's Chateau Castille that was based on drawings by Picasso.[1] In 1976 Hockey embarked upon a suite of twenty etchings inspired by Wallace Stevens' 1937 poem *The Man with the Blue Guitar*, which was itself inspired by Picasso's *The Old Guitarist* 1903 (Art Institute of Chicago, Zervos I, 202). Employing various Picasso motifs, these and a few related paintings explored a realm of imagination as

opposed to rational observation that anticipated a major turning point in Hockney's art.

It was, however, in 1980 that Picasso seemed to offer Hockney an escape from what he felt had become the rut of realism. A commission to design a production of Erik Satie's ballet *Parade*, famously designed by Picasso in 1917, and a major Picasso retrospective at The Museum of Modern Art, New York, combined to excite Hockney into new directions. After a summer of intense activity in London, he returned to Los Angeles 'free of the jam' in his work, and embarked upon the monumental *Mulholland Drive* 1980 (Los Angeles County Museum of Art), which launched a new direction in his work at the centre of which were the aesthetics and ideas of cubism.[2]

For Hockney, cubism marked the fundamental shift away from the paradigm of Renaissance, one-point perspective. It re-introduced space and time to pictorial representation. As well as encouraging a certain spatial vocabulary in paint, cubism – and Picasso – became inextricably tied to Hockney's sustained critique of photography's claim to objectivity. Photography perpetuates the convention of depiction as if through a window. In painting, this monocular view had been countered by the movement of the artist's hand, evident in the mark, but for Hockney photography lacked even this temporal dimension. In 1982, he embarked on a series of works made up of assembled photographs, applying the lessons of cubism to that newer technology. Around the same time, he became an early advocate of Picasso's late style, devoting a lecture on 'Important Works of the 1960s' solely to the paintings of his last years.[3]

Although his analysis and use of cubist values were most marked in the early 1980s, Hockney has continued them. He has lectured and published on the subject and expanded on his views on photography.[4] Cubism embodies for him the shortcomings of photography, and in 2003 he again used Picasso to make this point. Prompted by photographs of abuse of prisoners during the war in Iraq, Hockney produced his own version of Picasso's *Massacre in Korea* 1951, with the addition of a photographer, making the point that such a record could never be made by a photographer as they would necessarily have been killed or complicit in the crime (fig.29). Even Hockney's most recent experiments with video, in which multiple cameras counteract the monocular view of traditional lens-based technologies, are predicated on a cubist conception of time and space. Beyond that, he has admired Picasso's emotional range.[5] Hockney's is a postmodern Picasso that validated his own instinct away from orthodoxy and stylistic consistency towards irony and reflexivity.

Fig.29
DAVID HOCKNEY
The Massacre and the Problems of Depiction 2003
Watercolour on paper (7 sheets)
143.1 × 183.5
Collection of the
David Hockney Foundation

Hockney made these two etchings in response to an invitation from the German publisher Propyläen Verlag to contribute to a print portfolio *Homage to Picasso*. Both were made in Paris with master printer Aldo Crommelynck, who had worked closely with Picasso and showed Hockney the technique of sugar lift that Picasso had used for aquatint. In *The Student*, which was the work included in the collection, the artist appears as a fashionable young man carrying his portfolio as if seeking approval from the statuesque, and equally youthful, head of Picasso. The image relates to *L'Atelier du sculpteur* from Picasso's Vollard Suite which addressed the artist's recognition of the impossibility of perfection.

The second etching – not included in the portfolio – shows Hockney seated naked across the table from Picasso dressed in a Breton shirt, as he appears in a famous sequence of photographs by Robert Doisneau. The younger artist is literally stripped bare before the master who considers, perhaps, a drawing presented to him. The contrast between the master Picasso and the subservient Hockney is reinforced by technique, as the figure of the former is achieved using the new technique of sugar lift and the latter with traditional hardground etching. Crommelynck's stories of working with 'Pablo' had made Hockney regret missing the opportunity to meet his hero when he was staying with Douglas Cooper in 1970; in *The Student*, he showed himself seeking approval from a Picasso elevated to the role of idol; in the second etching he imagines an actual encounter.

124

DAVID HOCKNEY

The Student:

Homage to Picasso 1973

Printer's proof XV/XV

Etching and aquatint on paper

75.6 × 56.5

Collection of the

David Hockney Foundation

125

DAVID HOCKNEY

Artist and Model 1973–4

Artist's proof XII

Etching and aquatint on paper

74.9 × 57.2

Collection of the

David Hockney Foundation

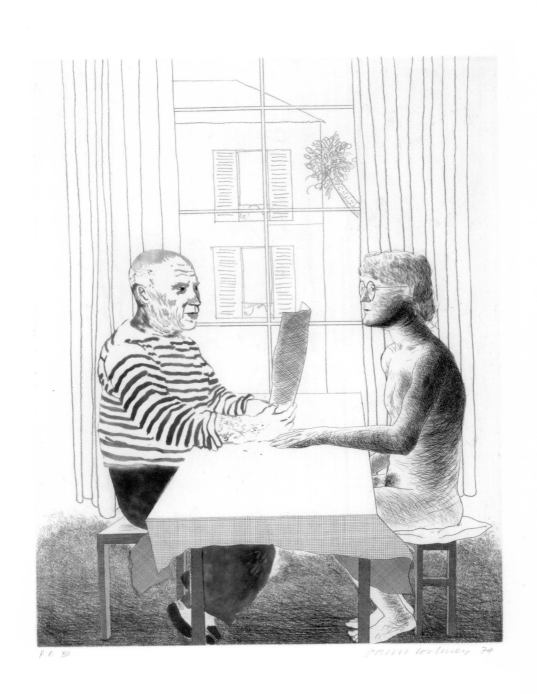

P.P. XII David Hockney 74

201

Hockney was introduced to Wallace Stevens' poem *The Man with the Blue Guitar* by Henry Geldzahler, Curator of modern art at The Metropolitan Museum of Art, New York, while staying on Fire Island in the summer of 1976. The poem takes as its starting point Picasso's iconic Blue Period painting, *The Old Guitarist* 1903, and is, Hockney recognised, a reflection on the creative imagination. Since Picasso already represented for Hockney the embodiment of the artist's response to reality and imagination, he was naturally attracted to the piece. Hockney initially made ten drawings from which he produced a suite of twenty coloured etchings, using the etching technique devised by Crommelynck for Picasso himself, which were published both as a portfolio and, in a smaller format, as a book.[6] Indicating

the genealogy of imaginative reaction that underlay the images, Hockney entitled his portfolio *The Blue Guitar, etchings by David Hockney who was inspired by Wallace Stevens who was inspired by Pablo Picasso.*

The artist explained that the etchings are not, 'literal illustrations of the poem' but 'an interpretation of its themes in visual terms. Like the poem, they are about transformations within art as well as the relation between reality and the imagination.'[7] The varied images are united by the inclusion throughout of motifs from Picasso's work. Among these images, as well as the 'Old Guitarist' himself, we can identify the dog from one of Picasso's paraphrases of Velázquez's *Las Meninas* (no.123), one of the series of portraits of Dora Maar and, in Hockney's *A Picture of Ourselves*, a long-necked

126

DAVID HOCKNEY

What is this Picasso?: from 'The Blue Guitar' 1976–7

Etching and aquatint on paper

45.7 × 52.3

British Council Collection

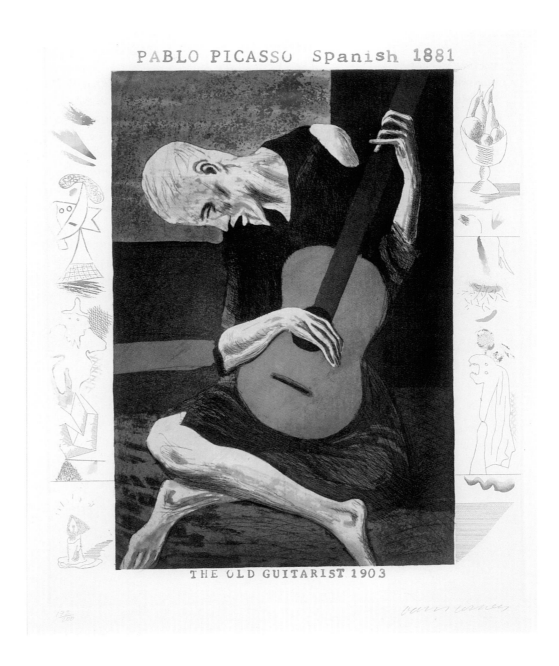

PABLO PICASSO Spanish 1881

THE OLD GUITARIST 1903

127
DAVID HOCKNEY
The Old Guitarist: from 'The Blue Guitar' 1976–7
Etching and aquatint on paper
52.3 × 45.7
British Council Collection

humanoid figure from *Two Nude Women on the Beach*, 1 May 1937 (Musée Picasso, Paris, Zervos IX, 217) is reflected back at a classical figure derived from Picasso's Vollard Suite.

Allusive and cryptic, the images of this suite stand out from the realism of most of Hockney's work of the 1970s. The project stimulated two paintings, which are, again, both reflections on the role of the imagination in artistic creativity and a sophisticated and ironic reflexive play on representation. In *Self-Portrait with Blue Guitar* 1977 (Museum Moderner Kunst Stiftung Ludwig Wien,

on loan from the Ludwig Collection, Aachen), Hockney depicts himself working on the etchings surrounded by some of their motifs; that painting then appears as a backdrop to a painting of a young man sleeping in *Model with Unfinished Self-Portrait* 1977 (private collection); Hockney then made a third generation of image as he photographed his model lying in front of the painting of him lying in front of the *Self-Portrait*.[8] This family of works marks a shift away from realism towards a more imaginary depiction, which Hockney has attributed to the inspiration of Picasso.

Hockney had already designed several theatrical projects before John Dexter, Director of Production at the Metropolitan Opera, New York, invited him in September 1978 to design sets for a French triple-bill of one ballet and two operas.[9] That the ballet was *Parade*, with music by Erik Satie, libretto by Jean Cocteau, but most famous for Picasso's designs for its original production in 1917, motivated him to accept the invitation.[10] Hockney has been credited with the proposal that the two operas – Francis Poulenc's *Les Mamelles de Tirésias* and Maurice Ravel's *L'Enfant et les Sortilèges* – should be preceded by *Parade*, which was conceived as 'a sideshow with a barker in front of a curtain trying to get people into the theatre'.[11] He abandoned his first thought to make the curtain a version of Picasso's original, which would be painted as the performance progressed. He did, however, follow Dexter's original idea and base his designs closely on Picasso's. The various characters in Cocteau's story of circus performers demonstrating their acts appeared before a simple red curtain, as appropriate to a sideshow, which was designed to barely hide the scenery for the subsequent performances. The triple-bill premiered in New York on 20 February 1981 and was an enormous success.

That Hockney looked closely at Picasso's original designs is clear from his drawing for the costume of the Chinese conjuror. Although Hockney leaves the figure's hat without colour, and the legs are a little straighter than in the original, the figure is clearly taken from Picasso's 1917 watercolour (no.33). To it Hockney added the top hat, with the inscription 'chinese conjurer [sic.] cat will come out of hat'.

chinese conjurer. cat will come out of hat DH.

128

DAVID HOCKNEY
Chinese Conjuror, from 'Parade Triple Bill' 1980
Gouache and pen on paper
35.6 × 43.2
Collection of the David
Hockney Foundation

129

DAVID HOCKNEY
The Set for 'Parade' 1980
Oil on canvas
152 × 152
Private collection

Hockney's biographer, Peter Webb, recalled visiting Hockney's London studio on the artist's birthday, 9 July 1980, while the designs for the Metropolitan were nearing completion. There he found a profusion of new paintings based on *Parade*: '*Parade Curtain after Picasso* … a picture of Picasso's Harlequin doing a handstand … a five-foot-square canvas of the whole stage with the composers' names around the proscenium arch, Harlequin doing his handstand in a spotlight in front of a red curtain, and the conductor and orchestra in the foreground and so on.'[12]

While the designs for the French triple-bill were clearly stimulating Hockney, his own explanation for this sudden burst of creativity is telling. 'I saw the Picasso retrospective at the Museum of Modern Art in New York last month,' he told Webb; 'He didn't spend much time on one picture, he was constantly open to new ideas and inspiration which he put into his painting immediately. I came to London feeling that I must work and work, paint and paint. I must catch his spontaneity. I'm painting a new picture every few days.'[13]

During July and August 1980, in his Pembroke Studio in London, Hockney painted sixteen canvases relating to ballet and opera. From Webb's account, it is clear that *Harlequin* and *The Set for 'Parade'* were among the first. The former shows Harlequin in his Picasso-designed costume executing a handstand among various props that combine Picasso and Hockney characteristics. The character's name, and the work's title, appears across the top of the canvas as if an idea for a poster and, indeed, the image was adapted to provide the poster for the Met's production.[14]

Harlequin reappears in *The Set for 'Parade'* along with other elements from the production, including the Picasso-designed horse. The painting shows various details of Hockney's design: the red curtain backdrop, behind which various props and bits of scenery are stored, the striped ladder seen also in *Harlequin*, and the Chinese conjuror's over-sized top hat. Barbed wire surrounds the stage – an addition made by Dexter to set the three performances into their original context of the end of the First World War. Around the proscenium arch appear the names of the composers of the three pieces featured in the French triple-bill – Erik Satie, Maurice Ravel, Francis Poulenc – and, in the foreground, the conductor's silhouette appears against the light of his music stand and surrounded by the comb-like glow of the musicians' lamps down in the orchestra pit. The work is both a painting in its own right and an anticipation of how the Metropolitan Opera might look in seven months' time.

Harlequin.

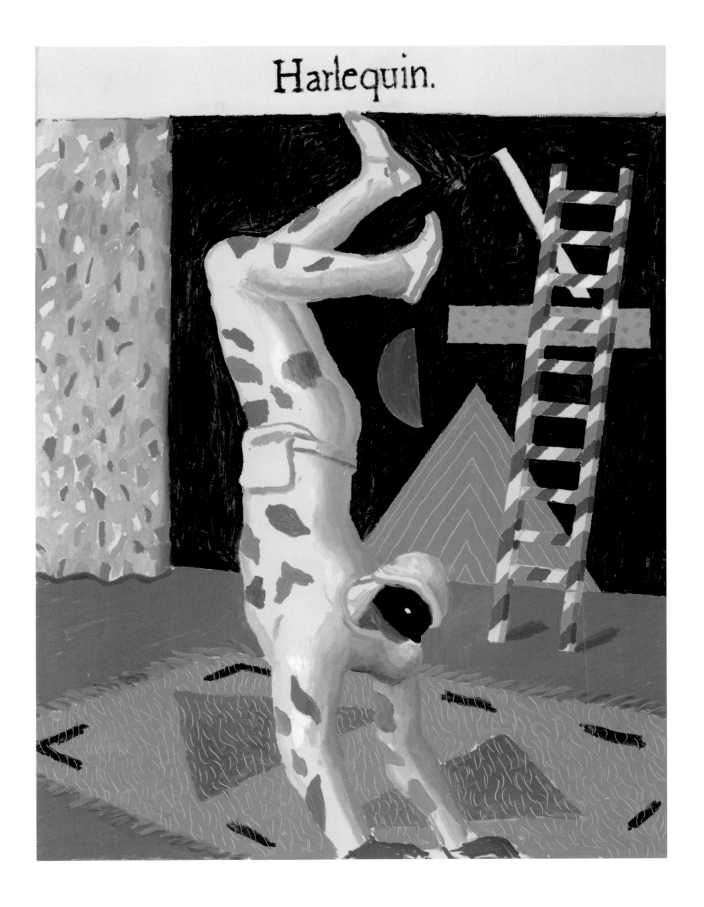

131

DAVID HOCKNEY
Still-Life Blue Guitar
April 4, 1982
Composite Polaroid
62.2 × 76.2
Collection of David Hockney

Hockney made his first 'joiner' – a picture made up of an assembly of Polaroid photographs – on 26 February 1982. By early May he had made more than 140. To make them he used a Polaroid camera (a technology that produced instantly developed photographs) to take multiple shots of a subject over a period of time. The practice directly addressed his belief that photography was inferior to painting or drawing because it did not accommodate the idea of time and so lacked life. Now, he could capture a subject not only from a variety of viewpoints and depths of focus but also as it changed over a short period of time. So he photographed figures in movement – swimming, say – or a couple interacting.

This is one of two works that include such objects as a guitar, a newspaper and a wine bottle: all classic elements in a cubist still-life painting. They are deliberate pastiches of cubism, using Picasso's and Braque's technique of depicting an object by the conglomeration of numerous details and facets. Hockney saw this breakthrough as akin to the dramatic departure of cubism. For him, cubism represented a break from centuries of tradition – a tradition that was kept alive in conventional photography. In a lecture in 1983, he contrasted cubism with photography, in which

> You're simply looking through a window. Cubism is a much more involved form of vision. It's a better way of depicting reality, and I think it's a truer way. … People complain when they see a portrait by Picasso where for instance someone has three eyes. They say: 'But people don't have three eyes!' It's much simpler than that. It's not that the person had three eyes. It's that one of the eyes was seen twice. This reads the same way in my photographs.[15]

The Polaroid 'joiners' were first exhibited in New York in June 1982 as 'Drawings with a Camera', reflecting how Hockney saw this new practice as comparable to an intimate graphic exploration of a subject in space and time.

132
David Hockney
Paint Trolley, L.A. 1985
Edition 1/2 1985
Photographic collage
101.6 × 152.4
Collection of David Hockney

Paint Trolley can be seen as a homage to Picasso, made all the more significant, perhaps, by the fact that it is also a representation of a simple, but central, detail of Hockney's quotidian life. Mounted on wheels for easy movement around his large studio, Hockney's trolley is furnished with the tools of his profession. Amongst the essential paraphernalia are canvases, brushes, paint, glue and a complete set of Christian Zervos's legendary catalogue of Picasso's work. Hockney had sought and purchased a set of Zervos following the

1980 MoMA Picasso exhibition. His debt to Picasso is further signalled by the presence on the bottom shelf of his design for the cover of the December 1985 issue of French *Vogue*, a painting of a canvas on which is depicted a Picasso-esque portrait of Hockney's old friend Celia Birtwell. The detail reinforces a sense that, alongside his debt to, and referencing of, Picasso, reflexivity – a knowing self-referentiality – became a central aspect of Hockney's art.

133

DAVID HOCKNEY
**Christopher Without
His Glasses On** 1984
Oil on canvas
65.1 × 46
Collection of David Hockney

Following two years of work with a Polaroid camera, the summer of 1984 saw Hockney's first sustained period of painting since the *Parade* season of 1980. The new paintings and drawings demonstrated his continued engagement with Picasso that had been re-energised by the 1980 MoMA retrospective. He recalled seeing around that time Picasso's portrait of Marie-Thérèse Walter's mother: *Portrait of Emilie Marguerite Walter (Mémé)*, 1939.[16] Hockney has written that the displacement and repetition of facial features in such paintings are not a distortion but actually an accurate description of how a face or body can appear when seen close-to.[17] He applied the same principles in the present portrait of his old friend, the author Christopher Isherwood. The work is evidently a pastiche of, or homage to, Picasso's characteristic 1930s portrait style.

The Isherwood portrait is one of a pair. While this work shows *Christopher without his Glasses on*, the other depicts *Christopher with his Glasses on*, 1984 (private collection). The distinction may also derive from Picasso's portrait of *Mémé*; Hockney had seen a photograph of the sitter in which she had removed her striking bottle-bottom spectacles for the camera. These appear in the painting and are an important element for the communication of the subject's character. Whether she had worn them for her sitting or not, Picasso painted her with her glasses on demonstrating not only his sensitive communication of personality but also the superiority, for Hockney, of painting over photography as a medium for portraiture.[18] Hockney's alternative depictions of Isherwood play with that memory of Madame Walter portrayed with and without her spectacles.

134
PABLO PICASSO
Portrait of Emilie Marguerite
Walter (Mémé) 1939
Oil and pencil on canvas
41 × 33
Private collection
Zervos IX, 367

135

Emblematic of the artist's affection for Britain, Picasso's landmark painting *The Three Dancers* 1925 was acquired by the Tate Gallery in 1965 after lengthy negotiations in the wake of his retrospective there five years earlier. An energetic play on a love triangle, Picasso considered *The Three Dancers* one of his two greatest paintings (with *Les Desmoiselles d'Avignon*) and he told Roland Penrose he thought it more of a 'real painting' than *Guernica*, 'a painting in itself, without outside considerations'.[1]

The acquisition was facilitated by Penrose, then a trustee of the Tate Gallery, who recalled that, despite his misgivings about the proposition when he approached the artist about selling, Picasso exclaimed 'Ça, quand même est bien, si ça les fera plaisir' (If it gave them pleasure that would be good).[2] Some months later, when Penrose returned to the south of France to collect the painting from Picasso's studio, the pair talked at length about the recent death of Winston Churchill, Picasso exclaiming his admiration for the British leader, who saved 'Angleterre ... et bien plus – c'est il a sauvé nous tous'.[3]

This acquisition was not only significant as the first work to be sold directly from the artist to a museum, but also, for Penrose, symbolic of Picasso's affection for Britain. Despite the popular success of the 1960 retrospective, the gallery's new star acquisition did not enter its collection without comment in the House of Lords, where there was criticism of the use of public money for the purchase. HL

135
PABLO PICASSO
The Three Dancers 1925
Oil on canvas
215.3 × 142.2
Tate. Purchased with a special Grant-in-Aid and the Florence Fox Bequest with assistance from the Friends of the Tate Gallery and the Contemporary Art Society 1965
Zervos V, 426

NOTES

PICASSO IN BRITAIN

1 Geoffrey Grigson, 'Selling Pictures', *Design for Today*, May 1934.

2 Roland Penrose, *Picasso: His Life and Work*, London 1958, p.62.

3 See Elizabeth Cowling, *Picasso: Style and Meaning*, London and New York 2002, pp.50–2.

4 'I remember being delighted when [Picasso] told me of his admiration for Burne-Jones and that as a boy he had wanted to come to England to see the works of the master'; letter from Duncan Grant to Richard Shone, 5 Sept. 1970, private collection.

5 Some of these connections with late nineteenth-century British art were first noted in Anthony Blunt and Phoebe Pool, *Picasso: The Formative Years. A Study of his Sources*, London 1962, pp.8–10. See also John Richardson, *A Life of Picasso I*, London 1991, pp.121, 141, 387; Andrew Wilton, 'Symbolism in Britain', in *The Age of Rossetti, Burne-Jones and Watts: Symbolism in Britain, 1860–1910*, exh. cat., Tate Gallery, London 1997, pp.32–3.

6 'Oscar Wilde – English author of this century/age'.

7 Sickert, 'Modern French Painting', *Burlington Magazine*, vol.45, no.261, Dec. 1924, p.308.

8 Chesterton, 'The Unutterable', *Daily News*, 9 Dec. 1911, p.6 reprinted in J.B. Bullen (ed.), *Post-Impressionists in England: The Critical Reception*, London and New York 1988, p.256.

9 Christopher Sykes, *Evelyn Waugh: A Biography*, rev. ed., Harmondsworth 1977, p.43. Waugh, 'Matisse and Picasso', letter to the *Times*, 18 Dec. 1945.

10 Munnings, speech at the Royal Academy annual dinner, 29 April 1949, quoted in Brandon Taylor, *Art for the Nation: Exhibitions and the London Public 1747–2001*, Manchester 1999, p.199.

11 Bell, 'Matisse and Picasso', *New Republic*, 19 May 1920, reprinted in Bell, *Since Cézanne*, London 1922

12 For information on Willoughby, his collection and its exhibition see Anne Strathie and Sophia Wilson, *Hugh Willoughby: The Man Who Loved Picassos*, Cheltenham 2009; the Tate exhibition was reviewed by John Piper, *Axis*, no.1, Jan. 1935, pp.27–8.

13 Gabo, 'The Constructive Idea in Art', in J.L. Martin, Ben Nicholson, N. Gabo (eds.), *Circle: International Survey of Constructive Art*, London 1937, p.6.

14 Evans, 'Dead or Alive', *Axis*, no.1, Jan. 1935, p.3.

15 See James Hyman, *The Battle for Realism: Figurative Art in Britain during the Cold War 1945–60*, New Haven and London 2001, esp. pp.160–4.

16 Blunt, 'Two Artists and the Outside World', *Listener*, 28 July 1938, pp.182–3; Herbert Read, 'Guernica: A Modern Calvary', *London Bulletin*, no.6, 1938.

17 Ayrton, 'The Master of Pastiche', 1944, republished in *Penguin New Writing*, No.32 1947, pp.125–36 and Ayrton, *Rudiments of Paradise*, London 1971, p.266; Heron, 'Picasso', *New English Weekly*, 10 Jan. 1946, p.125.

18 Lawrence Gowing, 'Light, Love and Picasso', *Observer*, 10 July 1960.

19 Sylvester, 'Picasso at the Tate', *New Statesman and Nation*, 16 July and 27 Aug. 1960, revised and published in 'Picasso I' in Sylvester, *About Modern Art: Critical Essays 1948–96*, London 1996, pp.79–85.

20 Michel Leiris, John Richardson and David Sylvester, *Late Picasso*, exh. cat., Tate Gallery, London 1988.

21 See, for example, Cooper, *The Cubist Epoch*, London 1970; Cooper and Gary Tinterow, *The Essential Cubism 1907–1920: Braque, Picasso and Their Friends*, exh. cat., Tate Gallery, London 1983; Cooper, *Picasso Theatre*, London 1968. Cooper was behind the first exhibition in Britain of Picasso's ceramics at the Victoria and Albert Museum, *Picasso: Ceramics*, exh. cat., 1957.

22 A small number of sculptures were included in Picasso's exhibition at the Salon d'Automne in Paris in 1944 and a book on his sculpture by Daniel-Henry Kahnweiler was translated into English by David Sylvester (Kahnweiler, *The Sculptures of Picasso*, London 1949). However, Penrose's exhibition, *Picasso: Sculpture, Ceramics, Graphic Work* (Arts Council, Tate Gallery, London 1967), was the first substantial public presentation of Picasso's three-dimensional work.

23 Roland Penrose, *Picasso: His Life and Work*, London 1958.

24 John Richardson, *A Life of Picasso I, 1881–1906*, London 1991; *II, 1907–17*, London 1997; *III, 1918–32: The Triumphant Years*, New York 2007.

25 Maurice Raynal, *Picasso*, Paris 1922; Jean Cocteau, *Picasso*, Paris 1923; Waldemar George's *Picasso* (1924) was translated into English that same year (both published in Rome) and Henry Moore owned a copy; Anthony Bertram, *Pablo Picasso*, London 1930.

26 On the idea of influence as an active strategy see Michael Baxendall, *Patterns of Intention: On the Historical Explanation of Pictures*, New Haven and London 1985, pp.58–62.

27 John recounts their meeting in *Chiaroscuro: Fragments of an Autobiography*, London 1962.

28 *Rhythm*, vol.1, no.1, Summer 1911, p.7. See Kirsten Simister, *Living Paint: J.D. Fergusson 1874–1961*, Edinburgh and London 2001, p.32.

29 See Richard Ingleby, *Christopher Wood: An English Painter*, London 1995.

30 Jeremy Lewison, 'Chronology' in *Ben Nicholson*, exh. cat., Tate Gallery, London 1993, p.241.

31 Nicholson, notes from an interview with Anthony Lousada, Tate Archive 8514.2 (I am grateful to Jovan Nicholson for drawing this passage to my attention); Barbara Hepworth: *A Pictorial Autobiography*, rev. ed., London 1978, p.26.

32 See Agar, *A Look at my Life*, London 1988, pp.135–43; Agar, *Muse of Construction* 1939 (private collection).

33 McWilliam, *Eye, Nose and Cheek* 1939 (Tate.); Ceri Richards, *The Sculptor and his Object* 1934 (Tate) and *The Sculptor and his Object* 1936 (Tate).

34 Frances Spalding, *Dance Till the Stars Come Down: A Biography of John Minton*, London 1991, pp.26–30.

35 Ibid. p.216.

36 Ayrton, 1944

37 Heron, 'Braque', in *The Changing Forms of Art*, London 1955, p.81 (an amalgam of articles from 1946, 1951 and 1953).

38 *The Sculpture of Picasso*, curated by Roland Penrose, was shown at the Tate Gallery in summer 1967.

39 See, for example, Lanyon, *Porthleven Boats* 1950 (Tate).

40 Compare, for example, Caro, *Emma Dipper* 1977 (Tate), with Picasso, *Figure (Proposed Monument to Guillaume Apollinaire)* 1928 (Musée Picasso, Paris).

41 Adler, 'Paul Klee', *Horizon*, Oct. 1942.

42 Cooper, *The Work of Graham Sutherland*, London 1961, p.64.

43 See John Galsworthy, *To Let*, London 1921; and Leonee Ormond, 'The Soames Forsyte Collection: A Study in Fictional Taste', *Burlington Magazine*, vol.119, Nov. 1977, pp.752–7. Galsworthy was not himself a collector of art; however, among English writers not represented in this exhibition who owned pictures by Picasso were: W.S. Maugham, who had *The Death of Harlequin* 1905 (Zervos I, 302) in St-Jean-Cap Ferrat; Hugh Walpole, who at his death in 1941 owned at least twenty-three works in various media by Picasso; and Harold Nicolson.

44 *La Vie* (no.3 in that exhibition) was included in *Thirty Years of Pablo Picasso* at Alex. Reid and Lefèvre, London, 1931; *Harlequin* (no.31) and *Two Seated Nude Women* (no.34) were shown in *Picasso* at Zwemmer Gallery, London 1936; *The Three Musicians* was sold by Zwemmer (possibly with the involvement of the Mayor Gallery, London) to the American collector A.E. Gallatin in 1936; *Girl Before a Mirror* (no.9) was shown in *Recent Works of Picasso* at Rosenberg and Helft, London 1937; and *The Studio* was lent by Rosenberg and Helft to the exhibition *Realism and Surrealism* in Gloucester in 1938.

THE PICASSOS OF BRITISH CRITICISM c.1910–c.1945

1 *The Grafton Group exhibition*, Alpine Club Gallery, January 1914.

2 *Athenaeum*, 10 Jan. 1913.

3 Especially since Yve-Alain Bois's elevation to iconic status of Picasso's iron *Guitar* (MoMA), New York conceived in 1912. See Bois, 'Kahnweiler's Lesson', *Representations*, no.18, California, Spring 1987, reprinted in Bois, *Painting as Model*, Cambridge, Mass. and London 1993. Fry's own collage *Bus Tickets* c.1915 (Tate) is a direct response to the Picasso he bought from the Alpine Club Gallery exhibition.

4 Wilenski, *Modern French Painters*, London 1940, pp.203–4. Wilenski's analysis almost uncannily anticipates Greenberg's in his famous essay on 'collage', see Greenberg, 'The Pasted Paper Revolution', *Art News*, vol.57, no.5, Sept. 1958, pp.46–9ff. Republished with revisions as 'Collage' in Greenberg, *Art and Culture*, Boston 1959.

5 See especially Apollinaire's eulogy to the material factuality of the things Picasso presents in his collages, in his article 'Pablo Picasso', *Montjoie!*, Paris, 14 March 1913. Reprinted in Leroy C. Breunig (ed.), *Apollinaire on Art: Essays and Reviews 1902–1918*, trans. Susan Suleiman, London 1972, p.279; and Salmon's extraordinary passage on Picasso's 1912 metal *Guitar*, almost certainly written before the declaration of war in 1914, in his book *La Jeune Sculpture française*, Paris 1919, pp.103–4.

6 Lewis, 'Relativism and Picasso's Latest Works', *Blast*, no.1, 20 June 1914, p.139.

7 Picasso actually calls his work, not himself, a 'sum of destructions'; see Christian Zervos,

'Conversation avec Picasso', *Cahiers d'Art*, nos 7–10, 1935, p.173.

8 Barr Jr., *Picasso: Forty Years of his Art*, exh. cat., The Museum of Modern Art, New York 1939.

9 This is not to say that Miller fails to deal with the more 'conservative' or 'classical' Picassos of European criticism. He brings into his analysis such important commentaries as those of Eugeni d'Ors, Waldemar George and C.J. Jung. Charles F.B. Miller, 'Interwar Picasso Criticism', in Yve-Alain Bois (ed.), *Picasso Harlequin, 1917–1937*, exh. cat., Complesso del Vittoriano, Rome 2008, pp.37–45.

10 For Picasso's showing in the *Second Post-Impressionist Exhibition*, which opened at the Grafton Galleries, 5 October 1912, see Anna Greutzner Robins, *Modern Art in Britain 1910–1914*, exh. cat., Barbican Art Gallery, London 1997, pp.64–107.

11 Lewis, 'The Exploitation of Vulgarity', *Blast*, no.1, 20 June 1914, p.145.

12 He writes of a 'unity emotion' underlying both science and art; see Fry, 'Art and Science', *Athenaeum*, 6 June 1919, reprinted in Fry, *Vision and Design*, London 1920.

13 Fry, 'The Grafton Galleries: an Apologia', 1912, pp.249–51.

14 Lewis, 'The Exploitation of Vulgarity', 1914.

15 He ends in judgemental mode: 'It may be doubted if such is the character of the greatest artists, but it is typical of great originators and innovators'; Fry, 'The Grafton Galleries: an Apologia', 1912, pp.249–51.

16 For important new work and thinking on Bloomsbury in the First World War, see Grace Brockington, *Above the Battlefield: Modernism and the Peace Movement in Britain, 1900–1918*, New Haven and London 2010, especially chapter 2.

17 Bell, 'Matisse and Picasso', in Bell, *Since Cézanne*, London 1922, pp.83, 84–5.

18 Bell 1922, p.34.

19 'It takes as a datum that the aesthetic sense finds its satisfaction in certain harmoniously & [*sic*] rhythmically ordered relations of notes in music and volumes and spaces in architecture and declares that the essential quality of painting is to produce similar results'; Fry, 'Representation in Art', unpublished lecture notes, Jan. or Feb. 1929, for a lecture given to an unnamed 'philosophical society'. King's College Cambridge, Roger Fry Archive, 1/126.

20 Wilenski, *The Modern Movement in Art*, London 1927, pp.169–71.

21 'All reasonable people contemplating the great original architectural buildings, sculpture and pictures in the world must recognize, I think, that the artists who made them were men of fundamental normality, great energy, great intelligence and great organizing power'; Wilenski 1927, p.187.

22 Ibid. pp.9–10.

23 Ibid. p.160.

24 His preface is dated December 1926.

25 Wilenski 1927, p.160.

26 'Picasso a little *dérouté* for the moment but saw some splendid things all the same – among others an Ingres-like realistic drawing of Vollard'; Fry to Vanessa Bell, 3 July 1916, in Denys Sutton (ed.), *Letters of Roger Fry*, vol.2, London 1972, p.399.

27 I explore this in depth in Christopher Green, *Cubism and its Enemies: Modern Movements and Reaction in French Art, 1916–1928*, New Haven and London 1987.

28 Fry, *Transformations: Critical and Speculative Essays on Art*, London 1926. The 'operatic' and 'symphonic' categories are explored especially in 'The Literary Element in Painting', given as the Henry Sidgwick Memorial Lecture at Newnham College, Cambridge on Saturday, 21 Nov. 1931. Unpublished lecture notes, King's College, Cambridge, Roger Fry Archive, 1/158.

29 Fry to Vanessa Bell, 15 March 1921; in Sutton 1972, pp.504–6.

30 Fry to Vanessa Bell, 12 April 1922; in ibid. p.524.

31 Lecture notes for a series on principles of design given at University College London after 1920, Lecture V. Modern Art. King's College, Cambridge, Roger Fry Archive, 1/90/5. Also Fry, unpublished lecture notes 1931, Fry Archive, 1/158.

32 He added: 'Architecture, though it may be abstract, gives us space – cubism could not do this without using likeness to real space, without representation'; unpublished lecture notes for two lectures on modern art given at Bangor College, Bangor, 17–18 Jan. 1927, King's College, Cambridge, Fry Archive, 1/117.

33 Wyndham Lewis, *Time and Western Man* (1927), reprint ed. Paul Edwards, Santa Rosa 1993, pp.61–2. Cited in Paul Edwards, *Wyndham Lewis: Painter and Writer*, New Haven and London 2000, pp.306–7.

34 Freud, 'The Uncanny' (German edition, *Imago*, no.5) pp.297–324; in Freud, *Art and Literature*, Pelican Freud Library, London 1985, pp.335–76.

35 Fry, *The Artist and Psychoanalysis*, London 1924.

36 Fry to Bridges, 23 Jan. 1924; in Sutton 1972, pp.547–8.

37 'France is still in the doldrums and curiously disillusioned. Surrealism has left them with a bad stomach ache'; Fry to Kenneth Clark, 25 June 1933. See also, for example, Fry to Helen Anrep, 1 May 1925; in Sutton 1972, pp.567–8, 680.

38 Read, 'Psychoanalysis and the Critic', *Criterion*, vol.3, London, 1924–5, pp.471–2.

39 Read, *The Meaning of Art*, London 1931, p.15.

40 Read, *Art Now: An Introduction to the Theory of Modern Painting and Sculpture*, London 1933, p.15.

41 Read, 'Pablo Picasso', in Read, *In Defence of Shelley and Other Essays*, London and Toronto 1936, pp.212–13 (essay first published in anon., *Great Contemporaries*, London 1934).

42 He sees reason as a constant in humanity; see Read, *Art and Society*, London and Toronto 1937, p.71.

43 For Read's early awareness of Friedrich Nietzsche, see his article, 'Why I Was Inspired by Nietzsche', *Listener*, 13 Feb. 1947, pp.295–6, and David Thistlewood, *Herbert Read: Formlessness and Form. An Introduction to his Aesthetics*, London, Boston, Melbourne and Henley 1984, p.3.

44 Fry, 'Art Now – An Introduction to the Theory of Modern Painting and Sculpture', *Burlington Magazine*, vol.64, London, May 1934, pp.242–5.

45 Evans, 'Dead or Alive', *Axis*, no.1, Jan. 1935, pp.3–4.

46 Piper, 'Picasso Belongs Where?', *Axis*, no.6, Summer 1936, p.30.

47 In *Axis* no.1, Jan. 1935, Evans might take him as a key example in her discussion of abstraction and representation, but Read himself, in 'Our Terminology' (pp.6–7), takes him as a key example in his discussion of what he calls 'superrealism'.

48 Picasso quoted in Zervos, 'Picasso', *Cahiers d'Art*, nos.3–5, Paris 1932, p.87.

49 As quoted by Read from Picasso in ibid.; also in Read 1936, p.121.

50 Zervos, 'Picasso', *Cahiers d'Art*, nos.3–5, Paris 1932, p.87.

51 Penrose reviewed David Gascoyne, *A Short Survey of Surrealism*, London 1936, in *Axis*, no.5, Spring 1936. He was at that point working on the selection and organisation of the *International Surrealist Exhibition*, which opened in June.

52 'We are now concerned with a subconscious or intuitive symbolism. Such symbolism is always a concretion of some kind: the discovery of an objective definite thing to represent a vague, even vast, field of subjectivity'; Read 1936, pp.128–9.

53 Read 1937, p.201.

54 Read 1933, p.121.

55 Grigson, 'Comment on England', *Axis*, no.1, Jan. 1935, pp.8–10.

56 Read, 'Introduction', in Read (ed.), *Surrealism*, London 1936, p.90.

57 Piper, 'Picasso at the Tate', *Axis*, no.1, Jan. 1935, p.29.

58 Penrose in *Axis* 5, 1936, p.29.

59 Recently, a new stress on Read as a post-1930s anarchist has tended to draw attention away from David Thistlewood's important analysis of this point. See Thistlewood 1984 . Read's anarchism was clearly crucial to what he called his philosophy of art. He first declared as an anarchist in 1937, as he moved away from a brief engagement with Marxist dialectics, but dialectics continued to structure his thinking, without Marx. For this move in the late 1930s, see David Goodway, 'The Politics of Herbert Read', in Goodway (ed.), *Herbert Read Reassessed*, Liverpool 1998, p.177. It is possible, of course, to read the overtly apolitical approach to art that survived alongside Picasso's membership of the Communist Party, as sanctioned by anarchist values developed very early in his career; see Christopher Green, *Art in France, 1900–1940*, New Haven and London 2000, pp.288–9. Recently, the last major conference centred on Read offered a strong case for the anarchist Read, though the anthology to which it led contains a wide range of important contributions not necessarily focused on anarchism; see Michael Paraskosos (ed.), *Rereading Read*, London 2007.

60 See Thistlewood 1984, pp.38–45.

61 Miller in Bois 2008.

62 Read 1931, pp.218–19.

63 Read 1937, p.90.

64 Ibid. p.xii.

65 Read 1933, p.146.

66 His quotation comes from a source he used a great deal, Freud's *New Introductory Lectures*, which also contained a summing up of the late topography. Read 1937, p.197.

67 Blunt, 'Two Artists and the Outside World', *Listener*, 28 July 1938. See also Christopher Green, 'Anthony Blunt's Picasso', *Burlington Magazine*, vol.147, Jan. 2005, pp.26–33.

68 He only knew Rivera's mural work from reproduction; see Green in *Burlington Magazine* 2005, p.30, and Blunt in *Listener* 1938, p.182.

69 Blunt, 'Picasso Unfrocked', *Spectator*, 8 Oct. 1937, p.584.

70 Ibid.

71 Penrose, 'Letter to the Editor', *Spectator*, 29 Oct. 1937, p.747.

72 For Read, Freud and Jung, see Thistlewood 1984, pp.112ff.; and John R. Doheny, 'Herbert Read as Literary Critic', and 'Herbert Read's Use of Sigmund Freud', in Goodway 1998.

73 Read 1937, p.xiii.

74 The phrase 'realism of the imagination' was coined by David Sylvester, writing on Bacon alongside Klee, Masson and Giacometti, in Sylvester, 'Les Problèmes du peintre: Paris-Londres 1947', *L'Age nouveau*, no.31, part 2, Paris 1948. See the discussion in Hyman, 2001, pp.13–18.

75 Ades, 'Web of Images', in *Francis Bacon*, exh. cat., Tate Gallery, London 1985, pp.8–23.

THE POLITICS OF PICASSO IN COLD WAR BRITAIN

1 Commentary, 'French Art Hits Town', *British Paramount News*, no.1544, 17 Dec. 1945.

2 McColl and Bodkin, 'Picasso Matisse', *Times*, 17 Dec. 1945, p.5.

3 'The Editor's Table – Art Ancient and Modern', *Church Times*, 25 Jan. 1946.

4 Lewis, *Art and the Demon of Progress*, London 1954, p.66.

5 'Famous Artists Joins French Communist Party', *Daily Worker*, 7 Oct. 1944, p.3.

6 Zhdanov, 'Soviet Literature: The Richest in Ideas, the Most Advanced Literature', in Maxim Gorky, Karl Radek, Nikalai Bukharin, Andrey Zhdanov et al., *Soviet Writers' Congress, 1934: The Debate on Socialist Realism and Modernism* (first published in English as *Problems of Soviet Literature*, 1935), London 1977, p.19.

7 'An historic scene', *Our Time*, vol.4, no.4, Nov. 1944, p.3.

8 Trevelyan , 'Picasso and Matisse', and Arnold Rattenbury , 'Picasso and the Press', *Our Time*, vol.5, no 6, Jan. 1946, pp.120–1.

9 Kartun, 'Picasso', *Modern Quarterly*, vol.1, no.2, March 1946, pp.69–72.

10 Thompson, 'Edgell Rickword', *Persons & Polemics*, London 1994, p.240.

11 Connolly, 'Comment', *Horizon*, vol.13, no.78, June 1946, pp.364–5.

12 Skidelsky, *John Maynard Keynes 1883–1946: Economist, Philosopher, Statesman*, London 2003, p.253.

13 Fry, *Vision and Design* (1920), Harmondsworth 1961, pp.56, 63, 205.

14 Connolly, 'Comment', *Horizon*, vol.12, no.69, Sept. 1945, p.149.

15 Amis, *The Letters of Kingsley Amis*, ed. Zachary Leader, New York 2001, p.36.

16 Connolly, 'Comment', *Horizon*, vol.13, no.73, Jan. 1946, p.6.

17 Waugh, 'Picasso and Matisse', *Times*, 20 Dec. 1945, p.5.

18 Annan, *Our Age: The Generation that Made Post-War Britain*, London 1991, p.213.

19 Alfred Munnings, *An Artist's Life: The Second Burst. The Finish*, abridged by W.G. Luscombe from 3 volumes, London 1955, pp.227–9.

20 See David Cannadine, *The Decline and Fall of the British Aristocracy*, New Haven and London 1990.

21 Unsigned, 'Introduction', *The Royal Academy Illustrated*, London 1949, condensed and amended from Walter Lamb, Chapter 17, 'The Exhibitions', *The Royal Academy: A Short History of its Foundation and Development*, London 1935.

22 See Robert Jensen, *Marketing Modernism in Fin-de-Siècle Europe*, New Jersey 1996.

23 Rothenstein, 'Introduction', *Modern English Painters*, vol.1, London 1952.

24 'London Diary', *New Statesman and Nation*, Oct. 1950, p.340.

25 Phillip Deery, 'The Dove Flies East: Whitehall, Warsaw and the 1950 World Peace Congress', *The Australian Journal of Politics and History*, vol.48, no.4, Dec. 2002, pp.449–68.

26 Andrew Defty, *Britain, America and Anti-Communist Propaganda 1945–53: The Information Research Department*, London 2004, p.196.

27 Mr Ede, Congress Sheffield (Admission of Foreigners), *Hansard*, House of Commons Debate, vol.480, 14 Nov. 1950, column 1685.

28 'Profile – Pablo Picasso', *Observer*, 12 Nov. 1950, p.2.

29 Lynda Morris, 'The Sheffield Peace Congress and Anti-Apartheid', in Morris and Christopher Grunenberg (eds.), *Picasso: Peace and Freedom*, exh. cat., Tate Liverpool 2010, pp.60–7.

30 James Johnson Sweeney, press release, 18 April 1952, quoted in Frances Stonor Saunders, *Who Paid the Piper: The CIA and the Cultural Cold War*, London 1999, p.119.

31 Sylvester, 'At the Tate Gallery: Twentieth-Century Masterpieces', *Tablet*, 9 Aug. 1952, p.115.

32 Muggeridge, 25 April 1950, *Like It Was: The Diaries of Malcolm Muggeridge*, selected and edited by John Bright-Holmes, London 1981, p.386.

33 Berger, 'Why Picasso', *New Statesman and Nation*, 15 May 1954.

34 Thompson, 1994,p.237.

35 De Francia, 'Commitment in Art Criticism', *Universities and Left Review*, vol.1, no.1, Spring 1957, pp.49–51.

36 See Stonor Saunders, 1999.

37 Fyvel, *What Is Culture?*, London 1953, p.10.

38 Henry Moore, Rodrigo Moynihan, Graham Sutherland, Ruskin Spear, Herbert Read, Roland Penrose and Stephen Spender, 'Picasso Party', *New Statesman and Nation*, 25 Nov. 1950, p.505.

39 Read, 'Kicks and Ha'pence', *Freedom*, 2 June 1951, republished in *A One-Man Manifesto and Other Writings for Freedom Press*, edited and with an introductory essay by David Goodwin, London 1994, p.180.

40 Melly, letter to Penrose, 23 June 1960, quoted in Elizabeth Cowling, *Visiting Picasso: The Notebooks and Letters of Roland Penrose*, London 2006, p.238.

41 For a contemporary anthology of negative characterisations of establishment culture, see *Declaration*, ed. Tom Maschler, London 1957.

PICASSO IN BRITAIN 1910–1914

1 See Marilyn McCully, 'Picasso in the "Burlington": His First English Review', *Burlington Magazine*, vol.150, Dec. 2008, p.829.

2 The short-lived journal *Rhythm* (1911–13), edited by J.M. Murry and J.D. Fergusson, reproduced in its pages four Picasso drawings belonging to Sagot. 'Every lover of modern art who has lived in Paris has been at some time indebted to M. Sagot's sympathy and appreciation,' its editors affirmed, 'and when the history of the modern movement comes

to be written none will hold a higher or more honourable place'; 'Acknowledgements', *Rhythm*, vol.1, no.4, Spring 1912, p.34.

3 For recent work on the content of this exhibition see Anna Greutzner Robins, '"Manet and the Post-Impressionists": a checklist of exhibits', *Burlington Magazine*, vol.152, no.1293, Dec. 2010.

4 Laurence Binyon, 'Post-Impressionists', *Saturday Review*, 12 Nov. 1910, pp.609–10.

5 Sickert, 'Post-Impressionists', *Fortnightly Review*, Jan. 1911, pp.79–89.

6 Fry, 'The Post-Impressionists – 2', *Nation*, 3 Dec. 1910, pp.402–3.

7 Rutter, 'Round the Galleries. Pablo Picasso', *Sunday Times*, 28 April 1912.

8 Fry, 'The French Group', in *Second Post-Impressionist Exhibition*, exh. cat., London 1912, p.14.

9 Rutter, *Evolution in Modern Art*, London 1926, p.83.

10 *Loan Exhibition of Works Organised by the CAS (Contemporary Art Society)*, Manchester City Art Gallery, Dec. 1911–Jan. 1912.

11 John, letter to Henry Lamb, 5 Aug. 1907, Tate Archives.

12 J.B.M[anson]., 'The Autumn Salon and the "Cubists"', *Outlook*, 14 Oct. 1911, p.485. As director of the Tate Gallery in the 1930s, Manson would contrive to exclude Picasso from the national collections.

13 Bell, letter to Grant [29 Jan. 1914], in Regina Marler (ed.), *Selected Letters of Vanessa Bell*, London 1993, pp.160–1 (where misdated 25 March 1914).

14 Roger Fry, 'The Post-Impressionists', *Nation*, 3 Dec. 1910, p.402, quoted in Greutzner Robins, 2010, p.791.

15 John Richardson, *A Life of Picasso I*, 3rd ed., London 2009, p.334.

16 See Hélène Seckel, 'Une Etude pour *Les Demoiselles d'Avignon*', *Poésie*, no.60, 1992, pp.121–5.17

17 Bell, letter to Stephen, 9 Oct. 1911; reproduced in Marler 1993, p.109.

18 No.15 as 'Nature Morte, 1912'.

19 See Pierre Daix, *La Vie de peintre de Pablo Picasso*, Paris 1977, p.61.

20 Konody, 'The Stafford Gallery', *Observer*, 26 April 1912, p.6.

21 Unsigned, 'M. Pablo Picasso and Mr Joseph Simpson at the Stafford Gallery', *Athenaeum*, 27 April 1912, p.478.

22 Tate Archives.

23 Fry, letter to Vanessa Bell, 23 Aug. 1918, in; Denys Sutton (ed.), *Letters of Roger Fry*, II, London 1972, p.431.

24 Fry, letter to Stein, 5 March 1913, in ibid. I, p.365.

25 No.126 or 127 as 'Etching'.

26 G.R.H., 'The Grafton Group at the Alpine Gallery', *Pall Mall Gazette*, 8 Jan. 1914, p.5.

27 C.H. Collins Baker, 'The Grafton Group Academy', *Saturday Review*, 31 Jan. 1914.

28 Roger Fry, *Essay in Abstract Design* 1914 or 1915, Tate T01957.

DUNCAN GRANT AND PICASSO

1 Grant, diary entry, April 1909, private collection. This contradicts an earlier suggestion that Grant became familiar with the Steins only in 1913, in Frances Spalding, *Duncan Grant. A Biography*, London 1997, p.130.

2 Grant, letter to Clive Bell, 26 Feb. 1914, Tate Archives.

3 Interview with Grant by Quentin Bell, 1969; transcribed in Simon Watney, *The Art of Duncan Grant*, London 1990, p.84.

4 Richard Shone has described how, in the most exhilarating phase of Grant's Post-Impressionist development, 'borrowings and influences – from the Byzantine, from Picasso, from Persian miniatures, from newspaper photographs and "contemporary" life …, from Matisse, Blake and the early Italians – are used in an intoxicating shuffle and reshuffle, all equally suitable and suggestive as catalysts to work'; Shone, *Bloomsbury Portraits*, Oxford 1976, p.130.

5 Undated note in sketch-book, private collection.

6 Quoted in Jeffrey Meyers, *The Enemy: A Biography of Wyndham Lewis*, London 1980, p.162.

7 See *The Tate Gallery 1968–70*, London 1970, pp.83–4.

8 This was proposed in Watney 1990, p.43. See *Venus and Adonis* c.1919, Tate T01514.

WYNDHAM LEWIS AND PICASSO

1 *The Kenyon Review*, 2, no.2, (Spring) 1940, pp.196–211.

2 'A Review of Contemporary Art', *Blast*, 2, 1915, quoted in Walter Michel and C.J. Fox (eds.),*Wyndham Lewis on Art*, 1969, p.66.

3 *The Caliph's Design*, 1919, quoted in Michel and Fox (eds.) 1969, pp. 171–8.

4 'Why Picasso Does It', *Daily Mail*, 10 January 1921, p.6.

5 Foreword, *Tyros and Portraits* , exh.cat, Leicester Galleries, London April, 1921., pp.187–8.

6 Lewis letter to Sturge Moore, September 1909, in Victor Cassidy (ed) *The Sturge Moore Letters: Wyndham Lewis to Thomas Sturge Moore*, in 'Lewisletter', no.7, Oct. 1977, p.11.

7 *Daily News and Leader*, 7 April 1914.

8 'Tyros and Portraits', p.188.

PICASSO IN BRITAIN 1919

1 The two most comprehensive accounts of Picasso's visit are James Beechey and Richard Shone, 'Picasso in London, 1919: The Première of "The Three-Cornered Hat"', *Burlington Magazine*, vol.148, Oct. 2006, pp.666–79; and John Richardson, *A Life of Picasso III: The Triumphant Years, 1917–1932*, London 2007, pp.113–33.

2 Sitwell, 'An Appreciation of Leonide Massine', in *Massine: Camera Studies by Gordon Anthony*, London 1939, p.20.

3 Two sketchbooks in the Musée Picasso, Paris, containing drawings otherwise dated to 1921 or 1922 also include studies after the Elgin Marbles; see Brigitte Léal, *Musée Picasso. Carnets: catalogue des dessins*, vol.1, Paris 1996, pp.310–11, 318, and Elizabeth Cowling, *Picasso: Style and Meaning*, London 2002, p.412.

4 Picasso, quoted in Michael Holroyd, *Augustus John: A Biography*, rev. ed., London 1976, p.439.

5 Strachey to Dora Carrington, 9 June 1919, in Paul Levy (ed.), *Letters of Lytton Strachey*, London 2005, p.441.

6 Bell, letter to Mary Hutchinson, 4 Aug. 1919, Harry Ransom Humanities Research Center, University of Texas at Austin.

7 Duncan Grant, letter to Vanessa Bell [30 July 1919], Tate Archive 8010/5.

8 Morrell, letter to Gertler, 11 July 1919, private collection.

9 Gertler, letter to S.S. Koteliansky [Aug. 1919], in Noël Carrington (ed.), *Mark Gertler. Selected Letters*, London 1965, p.175.

10 Karsavina, quoted in John Drummond, *Speaking of Diaghilev*, London 1997, p.98.

11 Diaghilev, quoted in Sergei Grigoriev, *The Diaghilev Ballet 1909–1929*, London 1953, p.148.

12 Polunin, *The Continental Method of Scene Painting*, London 1927, p.54.

13 W.A. Propert, *The Russian Ballet in Western Europe, 1909–1920*, London 1921, p.55.

14 Karsavina, quoted in Drummond 1997, p.98.

15 Karsavina, *Theatre Street*, London 1930, p.304.

16 Massine, *My Life in Ballet*, London 1968, p.40.

17 Beaumont, *The Diaghilev Ballet in London*, London 1940, pp.143–4.

18 Massine, quoted in Nesta MacDonald, *Diaghilev Observed by Critics in England and the United States*, New York and London 1975, p.232.

19 Polunin 1927, p.55.

20 Lopokova, quoted in Shone (ed.), *The Art of Bloomsbury*, exh. cat., Tate Gallery, London 1999, p.255.

21 Picasso, quoted in Drypoint, '"Your Artistic London." Picasso on the Beauty of the Streets', *Weekly Dispatch*, 1 June 1919, p.2.

BEN NICHOLSON AND PICASSO

1 Summerson, *Ben Nicholson*, Penguin Modern Painters series, West Drayton 1948, p.8.

2 My allusion here is to Harold Bloom, *The Anxiety of Influence: A Theory of Poetry*, London, Oxford, New York 1973.

3 Barbara Hepworth's letters to Nicholson encouraging him to complete this statement, show that he did so by 19 December 1933 (Hepworth to Nicholson, 3, 14, 17, 19 Dec. 1933, Tate Gallery Archive, 8717.1.1.153, 162, 163, 167). Nicholson in Herbert Read (ed.), *Unit 1: The Modern Movement in English Architecture, Painting and Sculpture*, London 1934.

4 According to Sarah Jane Checkland, they only raised £7; Checkland, *Ben Nicholson: The Vicious Circles of his Life and Art*, London 2000, p.122.

5 Summerson 1948, p.7.

6 Summerson dates the experience to 1923, but there is no hard evidence to corroborate this. Nicholson, letter to Summerson, 3 Jan. 1944, in ibid. p.7.

7 15 March and 18 or 19 April. My thanks to Sir Alan Bowness for giving me these precise, documented datings.

8 D.M. Macdonald (director of Alex. Reid & Lefevre Ltd), letter to Nicholson, 24 Nov. 1930. Tate Gallery Archive 8717.1.2.2404.

9 See my essay, pp.22–6.

10 This phrase is used in a letter to H.P. Roché, 20 June [1930], Lake Collection, Harry Ransom Humanities Research Center, University of Texas at Austin; cited in Jeremy Lewison, *Ben Nicholson*, exh. cat., Tate Gallery, London 1993, p.37.

11 Checkland relates how, when Nicholson came across the word 'trout' in Paul Nash's copy of

the catalogue of his retrospective exhibition at Leeds City Art Gallery (Temple Newsam House) in 1944, he crossed it out and substituted 'completely *abstract* painting'; Checkland 2000, n.4, p.61. Lewison publishes photographs of two lost paintings that are more or less abstract. He also cites a letter from Nicholson to Summerson of 25 April 1944 dating the first 'abstract' to 1923, and the first time he showed one to the London Group in 1924; see Lewison 1993, pp.24, 206.

12 Norbert Lynton reports that the collector who bought the painting in 1929 said that Nicholson pointed out the relationship with his father's striped jug. The striped jug picture, now lost, is reproduced as fig.3, p.12, in Lewison 1993; see Lynton, *Ben Nicholson*, London 1993, p.28.

13 Nicholson, letter to Lady Cecilia Roberts, 1 Jan. 1923. Tate Gallery Archive.

14 For the letter, see n.6 above. Nicholson visited Paris in April 1923, a fact corroborated for me by Sir Alan Bowness, but there is no incontrovertible evidence that this was the visit when he saw the 'cubist Picasso'. Artists' memories of dates at twenty years and more distance, as was the case with Nicholson's letter to Summerson, are not necessarily reliable.

15 The photograph is reproduced, with the caption '5 bis rue Schoelcher, Paris, 1916', in Pierre Daix and Joan Rosselet, *Picasso: The Cubist Years, 1907–1916. A Catalogue Raisonné of the Paintings and Related Works*, London 1979, p.359.

16 Nicholson note to Summerson, Tate Archive 20045/1/50/2.

17 Winifred Nicholson to Wilfred Roberts, 2 Dec. 1921, in Lewison 1993, p.17.

18 I am grateful to Matthew Gale for pointing out that this reference is most probably to the plant rather than a black and white pet; the same distinction is made in the Tate catalogue entry for Ben Nicholson, *1924 (first abstract painting – Chelsea)*, http://www.tate.org.uk/servlet/ViewWork?cgroupid=999999961&wo rkid=10715&searchid=9916&roomid=false& tabview=text&texttype=8; Nicholson's reference comes from a letter to Leslie Martin that reads: 'I should like to say how much it has meant knowing you & Sadie & having your appreciation & help on the work … it has been quite one of the nicest experiences of my life, along with a bit of green in the centre of the first cubist Picasso I ever saw!'; Nicholson to Martin, 'Wednesday' [late 1939] Box 1, letter XLIX, Sir Leslie Martin Personal Archive, Scottish National Gallery of Modern Art, Edinburgh, G M A A 70.

19 I have discussed these anthropomorphic table-top still lifes at length in Christopher Green, *Life and Death in Picasso: Still Life/ Figure, c.1907–1933*, New York 2009.

20 Nicholson said as much in his revealing statement on his painting *1932 (Au Chat Botté)*; see the following entry.

21 Nicholson, 'Notes on Abstract Art', *Horizon*, vol.4, no.22, Oct. 1941, reprinted in Maurice de Sausmarez (ed.), *Ben Nicholson*, London and New York: A Studio International Special, 1969, p.34.

22 Lee Beard shows how the bowl and jug, and the stringed instrument, all came from Nicholson's collection of objects; see Lee M. Beard, '"Modernist Cell" or "Gentle Nest": Ben Nicholson's Art, Design and the Modern

Interior, 1924–39', PhD dissertation, Courtauld Institute of Art, London, 2003, pp.138–9.

23 Ede, preface, 'Ben Nicholson', in *Ben Nicholson and Barbara Hepworth*, exh. cat., Tooth's Gallery, London, Nov.–Dec. 1932.

24 I discuss Picasso's pursuit of variation through repetitive games playing in still-life paintings produced between 1922 and 1924, in Green 2009, n.17, pp.107–8.

25 The Stedelijk Museum now catalogues the picture as *Guitar, Compote Dish and Grapes*; it has often been referred to previously as *Still Life with Mandolin*. If the cursive white shape is read as part of the instrument's body, it can become a mandolin; if not it is definitely a guitar.

26 Picasso produced a series of still lifes in which the signs for objects form the letters 'MT' in 1927.

27 My thanks to Sir Alan Bowness, for giving precision to the dating of Nicholson's visits.

28 The oil is *Head of a Woman 1926* (Musée Picasso, Paris. MP 1990–12. Not in Zervos).

29 Barbara Hepworth, *A Pictorial Autobiography*, Bath 1970, p.23. My thanks to Sir Alan Bowness for alerting me to the fact that Hepworth's description of a window overlooking chimney tops can only mean that this April visit, which he dates to 18 or 19 April, was to Picasso's Paris studio, and not to the chateau of Boisgeloup at Gisors, as has too often been stated. See, for example, Checkland 2000, n.4, p.118.

30 See the double-page spread of photographs of Marie-Thérèse Walter busts in *Minotaure*, no.1, May 1933, pp.26–7.

31 See especially Sophie Bowness, 'Ben Nicholson and Georges Braque: Dieppe and Varengeville in the 1930s', in *The Dieppe Connection*, exh. cat., Brighton Museum and Art Galleries 1992, p.45.

32 *1932 (Girl in a mirror, drawing)* 1932. Reproduced in Lewison 1993, p.122.

33 Pablo Picasso, *Girl before a Mirror*, 14 March 1932. The Museum of Modern Art, New York, Gift of Mrs Simon Guggenheim (Zervos VIII, 379). This relationship is noted in Jeremy Lewison, 'Ben Nicholson: An English Modern', in *Ben Nicholson*, exh. cat., Institut Valencia d'Art Modern, Valencia 2002. Lewison, however, sites the visit to Picasso's studio at Boisgeloup. The fact that it was to the rue La Boetie studio in Paris immeasurably increases the chances that this Picasso was there for Nicholson and Hepworth to see.

34 Summerson 1948, p.8.

35 See especially Douglas Cooper with the collaboration of Margaret Potter, *Juan Gris: Catalogue raisonné de l'oeuvre peint*, vol.1, Paris 1977, nos.54, 57, 60. For Picasso's isolated instruments in shadowy spaces, see Daix and Rosselet, n.15, nos.481, 483, pp.281,–2. The year 1924 saw a series of Picassos that use either sgraffito or the look of sgraffito, achieved by overdrawing with the brush in white.

36 Nicholson told Summerson that 'the first *free* painting' he saw was a Miró, which Lewison suggests he could have seen in Pierre Loeb's Galerie Pierre, Paris. Nicholson's description suggests it was one of Miró's so-called dream paintings of 1924–7, a small one, which Ede bought probably at this time. See Summerson 1948, p.12 , and Lewison 1993, pp.39–40.

37 Lynton 1993, n.20, pp.104–5.

38 For *1928 (Pill Creek)*, see Lewison 1993, pp.34, 208.

PICASSO IN BRITAIN 1920–1939

1 Ernest Brown & Phillips Ltd., letter to Rosenberg, 14 Jan. 1921, Leicester Galleries archive. We are extremely grateful to Christopher Phillips for allowing us access to this archive.

2 Rosenberg, letter to Ernest Brown & Phillips Ltd., 15 Jan. 1921, ibid.

3 P.G. Konody, 'Thirty Years of Pablo Picasso', *Observer*, 14 June 1931, p.12.

4 The 'Picasso scrapbook' that John Piper compiled at this time consists almost entirely of illustrated articles and reviews culled from foreign journals.

5 For a more detailed account of Zwemmer's dealings with Picasso and his work in the 1930s, see Nigel Vaux Halliday, *More than a Bookshop. Zwemmer's and Art in the Twentieth Century*, London 2001.

6 Freud to John Richardson, conveyed in conversation with Chris Stephens, 18 Oct. 2011.

7 The surrealist painter Conroy Maddox reported in the *London Bulletin* that in a debate at Birmingham between Melville and Thomas Bodkin, the director of the Barber Institute, Melville gave a 'brilliant and illuminating survey of Picasso's extraordinary career', while Bodkin's 'opposition speech was so weak and paltry that several people who had come with the intention of remaining neutral felt constrained to contest against his performance'; Maddox, 'Note', *London Bulletin*, nos.15–16, May 1939, pp.35–6.

8 Not least by Campbell Dodgson, Keeper of Prints and Drawings at the British Museum from 1912 to 1932, who bequeathed a complete set of this portfolio to the museum in 1948.

9 Sickert, 'Post-Impressionists', *Fortnightly Review*, Jan. 1911.

10 Listed as no.23 at the exhibition; Josep Palau i Fabre, *Picasso: Life and Work of the Early Years 1881–1907*, trans. Kenneth Lyons, Oxford 1981, p.250.

11 No.24 at the exhibition. Pierre Daix and Georges Boudaille, *Picasso: The Blue and Rose Periods, A Catalogue Raisonné, 1900–1906*, trans. Phoebe Pool, London 1967, p.171.

12 Fabre 1981, p.233.

13 John Richardson, *A Life of Picasso I: 1881–1906*, 2nd edn, 1992, pp.194, 198.

14 Fabre 1981, p.252.

15 Daix and Boudaille 1967, p.183.

16 Cowling 2002, p.173.

17 Willoughby's manuscript layout plan for the arrangement of his works at Cheltenham is reproduced in Anne Strathie and Sophia Wilson, *Hugh Willoughby: The Man Who Loved Picassos*, Cheltenham Museum and Art Gallery 2009, on which I am entirely dependent for information on Willoughby.

18 Richardson, *A Life of Picasso III: The Triumphant Years, 1917–1932*, New York 2007, p.332.

19 Book listing works in Cooper's collection, Cooper papers, Getty Research Institute, Los Angeles 860161.52.1.

20 Pierre Daix, *Le cubisme de Picasso: catalogue raisonné de l'oeuvre peint 1907–1916*, Neuchâtel 1979, p.253, where it is listed as '*Tête d'homme*'.

21 Michael Sadleir, *Sir Michael Sadler: A Memoir by his Son*, London 1949, p.389.

22 Cowling 2002, pp.344–7.

23 Madeleine Korn, 'Collecting Paintings by Matisse and Picasso in Britain before the

Second World War', *Journal of the History of Collections*, vol.16, no.1, 2004, p.125.

24 John Richardson, 'Picasso and Marie-Thérèse Walter', in Richardson and Diana Widmaier Picasso, *L'Amour Fou: Picasso and Marie-Thérèse*, exh. cat., Gagosian Gallery, New York 2011, p.30.

25 Cowling 2002, p.570.

26 See Read, 'Minotauromachy and Guernica: The Form of Things Unknown', *Eranos Jahrbuch*, vol.21, 1952, reproduced in Ellen C. Oppler (ed.), *Picasso's Guernica*, New York and London 1988, pp.332–6.

HENRY MOORE AND PICASSO

1 Alan Wilkinson remarks that it is not until the last twenty-five years of his life that Moore begins publicly to mention contemporary artists as being significant to him; see Wilkinson (ed.), *Henry Moore: Writings and Conversations*, London 2001, p.29.

2 Moore considered his meeting with Picasso, Giacometti, Breton and Eluard more important than his involvement in the English modernist project of 1933–4, *Unit-One*. See Henry Moore, interview by Maurice de Sausmarez, in *Ben Nicholson: A Studio International Special*, London and New York 1969; reproduced in Wilkinson 2001, p.161.

3 This is one of ten notebooks that survive from Moore's early years, in which he made written notes as well as sketches. The dating and source in Picasso's work of this drawing is discussed below, p.122.

4 Henry Moore, interview with Elizabeth Blunt, *Kaleidoscope*, BBC Radio 4, 9 April 1973; reproduced in Wilkinson 2001, p.167.

5 This is a point returned to in the entries that follow in this section.

6 This working method is discussed by Andrew Causey in Causey, *The Drawings of Henry Moore*, Farnham, Surrey and Burlington, Vermont 2010, p.7.

7 Unpublished notes for 'The Sculptor Speaks', *Listener*, 1937, HMF Archive; reproduced in Wilkinson 2001, pp.112–13.

8 The formation of both had its starting point in relatively provincial art schools, in Barcelona and Leeds, where copying antique sculpture was combined with the separate discipline of the life class.

9 See the discussion in my essay in this catalogue, pp.27.

10 Undated notes by Moore cited in Will Grohman, *The Art of Henry Moore*, London 1960 [n.p.]; extracts in Wilkinson 2001, p.117.

11 For abstraction and surrealism, which stood for other antitheses still alive in his mind, see especially Henry Moore, 'The Sculptor Speaks', *Listener*, 18 Aug. 1937; reproduced in Wilkinson 2001, p.197.

12 See especially Andrew Causey, 'Henry Moore and the Uncanny', in Jane Beckett and Fiona Russell (eds.), *Henry Moore: Critical Essays*, Aldershot 2003, pp.81–106; and Chris Stephens, 'Anything but Gentle: Henry Moore – Modern Sculptor', in Stephens (ed.), *Henry Moore*, exh. cat., Tate Britain, London 2010, pp.12–17.

13 My thanks to Mary Moore for generously allowing me access to her father's copy of this book. My thanks also to Mike Phipps of the Henry Moore Foundation, who shared with

me his important discovery of the connection between this drawing and this reproduction. See Waldemar George, *Picasso*, Rome 1924. Moore also owned Jean Cocteau's Picasso monograph of 1923.

14 The most famous of the Ariadne types is in the Vatican Museum; variants are known, for instance in the Louvre. The subject is Ariadne left on the island of Naxos by Theseus, waiting to be woken from her slumber by the arrival of Dionysus.

15 Christa Lichtenstern compares both the mask-like face of the nude on the left and the pillar-like legs, with knees drawn up to the stomach, of the nude on the right, to a stone Aztec carving of a *Sitting Man* 1325–1521, in the British Museum, which is related to Moore's 1922 Portland stone *Mother and Child*; see Lichtenstern, *Henry Moore: Work-Theory-Impact*, Royal Academy of Arts, London 2008, p.31.

16 Wilkinson refers to *Gudea, Ruler of the City State of Lagash*, a Sumerian piece, c.2100 BCE, in the British Museum. See Wilkinson, *The Moore Collection in the Art Gallery of Ontario, Toronto*, Art Gallery of Ontario, 1979, pp.99–101.

17 Moore acknowledged the importance of his reading of Fry before leaving Leeds for the Royal College of Art in London in 1921. See in particular, Roger Fry, 'Ancient American Art', in Fry, *Vision and Design*, London 1920; revised edn by J.B. Bullen, Mineoloa, New York 1981.

18 Moore, interview by James Johnson Sweeney, 'Henry Moore', *Partisan Review*, March–April, New York, 1947; cited in Wilkinson 2001, p.54.

19 Undated letter, Moore to Evelyn Kendall, and letter dated 26 Aug. 1927 from Moore to Cecilia Dunbar Kilburn, both cited in Roger Berthoud, *The Life of Henry Moore*, rev. ed., London 2003, pp.76–7. Berthoud argues convincingly that the two letters must be close in date, given that a passage from the Kendall letter is repeated in the Dunbar Kilburn letter verbatim. The sculpture is dated 1924–5 in the oeuvre catalogue compiled with the collaboration of Moore, but a question mark is added. This evidence establishes firmly a 1927 date. See David Sylvester (ed.), *Henry Moore, Volume 1: Sculpture and Drawings 1921–1948*, revised edn, London 1957, p.3.

20 See Causey 2010, p.24.

21 Moore, Statement, *Unit-One: The Modern Movement in English Architecture, Painting and Sculpture*, Herbert Read (ed.), London, Toronto, Melbourne, Sydney 1934, in Wilkinson 2001, pp.191–3.

22 Picasso, *The Race*, summer 1922, gouache on plywood. Musée Picasso, Paris.

23 Billy, quoted in Paul Léautaud, *Journal littéraire Mercure de France*, vol.4, p.257; cited in Brigitte Léal, *Musée Picasso: Carnets. Catalogue des dessins, vol.2*, Paris 1996, p.75.

24 Christian Zervos, 'Projets pour un monument', *Cahiers d'Art*, no.8/9, Paris 1929; Read, *Henry Moore*, London 1965, p.84.

25 Moore in *The Donald Carroll Interviews*, London 1973; reproduced in Wilkinson 2001, p.46.

26 See Léal 1996, pp.81–90, 94–5.

27 See, for 1929, for example, Christian Zervos, 'Oeuvres d'art océaniennes et inquiétudes d'aujourd'hui', and Tristan Tzara, 'L'Art et l'océanie', nos.2–3, pp.57–8, 59–60; Etienne Michau, 'Idoles des Cyclades (Musée du Louvre)', no.6; and Coecilia Seler-Sachs, 'L'Architecture et la sculpture chez les Aztèques', no.10.

28 Moore's first published piece on what he termed 'primitive' art ends with the observation that the 'two preoccupations' it expresses are 'sex and religion, which are often interwoven'; unsigned foreword to *Primitive African Sculpture*, exh. cat., Lefevre Galleries, London 1933; in Wilkinson 2001, p.99.

29 As Lichtenstern and Causey both point out, Moore's first mention of pebbles in the context of his ideas for sculpture comes in Notebook 6 (1926); see Lichtenstern 2008, p.52, and Causey 2010, p.44.

30 Moore was proud of the fact that he was aware of D'Arcy Thompson's *On Growth and Form* before he met Herbert Read, who had read 'everything'; see Lichtenstern 2008, p.245.

31 Grigson, 'Comment on England', *Axis*, no.1, Jan. 1935, pp.8–10. For Grigson and 'biomorphism', see Jennifer Mundy, 'Comment on England', in Stephens 2010, pp.22–37.

32 Alfred H. Barr, Jr., *Cubism and Abstract Art*, exh. cat., The Museum of Modern Art, New York 1936, reprinted Cambridge, Mass. and London 1986, p.200.

33 See pp.138–9

34 Anne Middleton Wagner, *Mother Stone: The Vitality of Modern British Sculpture*, New Haven and London 2005, p.81.

35 See pp. 138–9

36 *Documents*, Year 1, no.3, Paris 1930, p.131.

37 Most notoriously, Bataille's definition of 'l'informe'; G. Bataille, 'Informe', *Documents*, Year 1, no.7, Paris 1929, p.382.

38 Picasso, 'Une anatomie', *Minotaure*, no.1, Paris, 1933.

39 Moore, 'The Sculptor Speaks', *Listener*, 18 Aug. 1937; reproduced in Wilkinson 2001, p.195.

40 The first *Reclining Figure* in elm, usually dated 1935–6, is in the Albright-Knox Art Gallery, Buffalo; see Sylvester 1957, no.162, p.10.

41 For the role in Picasso's work of 1921 of the Ecole de Fontainebleau painting in the Palace, which was near Picasso's rented home for the summer of 1921, see especially Katharina Schmidt, 'Pablo Picasso: Three Women at the Spring', in Gottfried Boehm, Ulrich Mosch and Schmidt (eds.), *Canto d'Amore: Classicism and Modern Art and Music, 1914–1935*, exh. cat., Öffentliche Kunstsammlung Basel/ Paul Sacher Foundation, Basel 1996, pp.246–66.

42 For the life drawings, see Wilkinson 2001, pp.9–18, and Causey 2010, chap.1, 'The Human Figure'.

43 Causey notes that life drawings become rare by the later 1930s; see Causey 2010, p.9.

44 Bataille, 'Soleil pourri', *Documents*, Year 2, no.3, Paris, 1930, pp.173–4.

45 Picasso, 'Une anatomie', *Minotaure*, no.1, Paris, 1933.

46 Causey in Beckett and Russell 2003, pp.81–106.

47 Moore himself remembers a note to himself from the 1920s: 'Beware of Chirico. It will lead to the wrong path'; interview with Edwin Mullins, *Kaleidoscope*, BBC Radio 4, 27 June 1978; reproduced in Wilkinson 2001, p.123.

48 Melville, 'Introduction', *Communities of Statuary*, exh. cat., Institute of Contemporary Arts, London 1953; cited by Causey in Beckett and Russell 2003, p.86.

49 Ibid.

50 Sylvester, *Henry Moore*, London 1968, p.36; he also identifies other possible points of reference for this sculpture.

FRANCIS BACON AND PICASSO

1 Bacon, Oct. 1962 quoted in David Sylvester, *Brutality of Fact: Interviews with Francis Bacon*, London 1993, p.8.

2 Anne Baldassari, *Bacon Picasso*, Paris 2005, p.31. This is quite the fullest consideration of Bacon's relationship with Picasso's art.

3 Davies, notes from interviews published in 'Interviewing Bacon, 1973', in Martin Harrison (ed.), *Francis Bacon New Studies: Centenary Essays*, Göttingen 2009, pp.114, 118.

4 *Oeuvres recentes de Picasso*, Galerie Pierre, Dec. 1927.

5 John Richardson has recorded that Bacon told him that it was 'the *farouche* paintings of 1932–3 exhibited at Rosenberg's in London in April 1937 – as well as reproductions in *Minotaure* and *Cahiers d'Art* – that had opened his eyes to the violence and sexuality of Picasso's work and jump-started his own sado-masochistic vision': Richardson III, 2007, p.338

6 Bacon quoted in David Sylvester, *Looking at Francis Bacon*, London and New York 2000, p.244.

7 Elizabeth Cowling, *Visiting Picasso: The Notebooks of Roland Penrose*, London 2006, p.247.

8 Bacon quoted in Sylvester 2000, p.244.

9 See ibid. pp.13–14, and Baldassari 2005, p.148.

10 *Documents*, no.3, 'Hommage à Picasso', 1930, p.172, reproduced in Baldassari 2005, p.139.

11 Bacon, recalled in Hugh Davies, notes from interviews published in 'Interviewing Bacon, 1973', in Harrison 2009, pp.114, 118.

12 Cowling 2002, pp.486–7.

13 These feature in Picasso's Cannes sketchbooks of 1928 and include the sculpture *Head* 1928, painted brass and iron, Musée Picasso, Paris.

14 Bacon, *Abstraction from the Human Form* c.1936, and *Abstraction* c.1936, both reproduced in the *Referee*, 17 Jan. 1937, and recorded in Ronald Alley, *Francis Bacon*, London 1964, as nos.D2 and D1 respectively.

15 Herbert Read, *Henry Moore: An Appreciation*, London 1934 [pl.4].

16 See *Cahiers d'Art*, no.1, 1929, pp.14–15, 16–17, reproduced in Baldassari 2005, p.89.

17 See n.8 above.

18 For a detailed discussion of this work see Matthew Gale's catalogue entry at http://www.tate.org.uk/servlet/ViewWork?cgroupid=99999 9961&workid=674&searchid=9490&roomid= false&tabview=text&texttype=8

19 See Martin Hammer and Chris Stephens, '"Seeing the story of one's time": Appropriations from Nazi Photography in the Work of Francis Bacon', *Visual Culture in Britain*, vol.10, no.2, Nov. 2009, pp. 317–53.

20 These aspects are discussed in Martin Hammer, *Bacon and Sutherland*, New Haven and London 2003, pp.202–3.

21 Sutherland, letter to Robert Melville, 20 Nov. 1948, quoted in ibid. p.40.

22 Picasso, *Bust of a Woman with Self-Portrait*, February 1929, Zervos VII, 248, reproduced in Herbert Read, *Art Now*, London 1933, pl.107, as 'Abstraction. 1929'.

PICASSO IN BRITAIN 1937–1939

1 At Picasso's request, *Guernica* returned to Madrid only after the restoration of democratic government, and therefore remained on loan to the Museum of Modern Art, New York, until 1981, when it entered the current collection of Museo Nacional Centro de Arte Reina Sofia, Madrid.

2 See Gijs van Hensbergen, *Guernica: The Biography of a Twentieth-Century Icon*, London 2004.

3 *Morning Post*, 28 April 1937.

4 The mother and child sketch reproduced was that dated 8 May 1937, in the collection of the Museo Nacional Centro de Reina Sofia, Madrid; see Lynda Morris and Robert Radford, *AIA: The Story of the Artists International Association, 1933–1953*, exh. cat., Museum of Modern Art, Oxford 1983, p.33.

5 Letter from Juan Larrea to Roland Penrose, quoted in Van Hensbergen 2004, p.83.

6 During the summer of 1936, the New Burlington Galleries hosted the *First International Surrealist Exhibition*. Organised by David Gascoyne, Roland Penrose and Herbert Read, it was the first major exhibition of the movement in Britain.

7 Due to a shortage of space, the mural itself could not be exhibited in Oxford and Leeds.

8 As described by Roland Penrose in 'Notes', *London Bulletin*, no.6, Oct. 1938, p.59.

9 *New English Weekly*, 12 Jan. 1939. Interestingly, given the overtly political campaign of the *Guernica* exhibition, papers in the Whitechapel Art Gallery archive reveal that in 1938 the gallery had expressed concern about the political activity of artists' groups such as the AIA: 'So many of these bodies are political that we really must exercise considerable care in ensuring that we do not allow our gallery to be used for propaganda by any political or semi-political organisation'; 16 Dec. 1938, Whitechapel Art Gallery Archive/2/EAR/47 ii.

10 Hockney learned his father had seen the exhibition after sending him a postcard of *Guernica* from New York at the time of Picasso's retrospective at The Museum of Modern Art in 1981. See the interview with the artist in *ARTnews*, vol.82, no.1, Jan. 1983, pp.52–9.

11 '15,000 See Picasso', *News Chronicle*, 9 Jan. 1939.

12 Hyman 2001, p.160.

13 W.J.A. Busby, 'At Whitechapel Art Gallery: Spanish Painter's Guernica', *The Voice of East London*, Jan. 1939, Whitechapel Art Gallery Archive.

14 W.R. Wackrill, 'The Art Exhibitions', *Listener*, 13 Oct. 1938, p.772; Whitechapel Art Gallery Archive.

15 Blunt, 'Art: Picasso Unfrocked', *Spectator*, 8 Oct. 1937, p.584.

16 Read, 'Guernica: A Modern Calvary', *London Bulletin*, no.6, Oct. 1938, p.6.

17 Ibid.

18 Christian Zervos (ed.), 'Histoire d'un tableau de Picasso', *Cahiers d'Art*, vol.12, nos.4–5, 1937.

19 Zervos, ibid. pp.105, 106, 108, 110–11.

20 Clark, quoted by Martin Hammer in *Bacon and Sutherland*, New Haven and London 2005, p.196.

21 Myfanwy Evans, 'The Painter's Object' in Evans (ed.), *The Painter's Object*, London 1937, pp.6–9.

22 Wadsworth, quoted in Jonathan Black, *Edward Wadsworth: Form, Feeling and Calculation. The Complete Paintings and Drawings*, London 2005, p.105.

23 Chris Stephens, 'Modernism', in Stephens (ed.), *Henry Moore*, exh. cat., Tate Britain, London 2010, p.127.

24 See Tate catalogue entry at: http://www.tate.org.uk/servlet/ViewWork?cgroupid=1&workid=11871&searchid=24117&roomid=false&tabtype=text&texttype=8

25 Penrose, *Scrap Book 1900–1981*, London 1981, p.88.

26 Penrose, quoted in Cowling 2006, p.38.

27 Freud interviewed by William Feaver, broadcast on BBC Radio 3, on 7 February 1992, quoted in Feaver, 'Beyond Feeling', in *Lucian Freud*, exh. cat., Art Gallery of New South Wales, Sydney 1992.

28 Hockney, *Picasso*, New York 1990, p.9.

GRAHAM SUTHERLAND AND PICASSO

1 Sutherland, letter to Clark, 12 Nov. [?1947], Kenneth Clark papers, Tate Archive 8812/1/3/3149. Sutherland's biographer, however, notes that Sutherland had 'been much impressed' by Picasso's work in the Chateau Grimaldi, Antibes, in spring 1947: Roger Berthoud, *Graham Sutherland: A Biography*, London 1982, p.135.

2 There is a copy of the Stein inscribed by Clark among Sutherland's papers; Martin Hammer, *Bacon and Sutherland*, New Haven and London 2003, p.191, n.146 and also there is the Melville, inscribed with Clark's name; I am grateful to Rachel Flynn for drawing this to my attention and for her advice on this section in general.

3 Roger Berthoud 1982, p.136. The photographs appear in Maria Elena Ruggerini, 'Biographie', in *Sutherland: une rétrospective*, exh. cat., Musée Picasso, Antibes 1998, pp.123, 124. Despite the dating of Driberg's photograph of the Sutherlands with Picasso to 1947, Ruggerini gives 1948 as the date of the meeting.

4 Sutherland, 'Landscape and Figures: Graham Sutherland OM discusses his art with Andrew Forge', *Listener*, 26 July 1962, p.132.

5 Hammer points out that it was the same *Guernica* issue of *Cahiers d'Art* that also reproduced a Miró, which Sutherland specifically recalled seeing in the magazine.

6 Sutherland, quoted in Douglas Cooper, *The Work of Graham Sutherland*, London 1961, p.17.

7 Hammer, *Graham Sutherland: Landscapes, War Scenes, Portraits 1924–1950*, exh. cat., Dulwich Picture Gallery, London 2005, p.20.

8 Hammer 2003, p.193.

9 Hammer has highlighted the fact that *Cahiers d'Art* had run a special issue dedicated to Grünewald's Isenheim altarpiece in 1936 – ibid. p.112 – and that Sutherland had ready access to back issues of *Cahiers d'Art*, *Minotaure* and other foreign journals through his friend Peter Watson, ibid. p.181.

10 See Chris Stephens, catalogue entry for *Green Tree Form*, http://www.tate.org.uk/servlet/ViewWork?cgroupid=-1&workid=14013&searchid=29440&roomid=false&tabview=text&texttype=8

11 Hammer 2003, p.197.

12 Christian Zervos, 'Conversation with Picasso' (1935), trans. in Myfanwy Evans (ed.), *The Painter's Object*, Gerald Howe, London 1937, pp.80–8.

13 Sutherland, letter to Michael Ayrton, cited in Hammer 2003, p.190.

14 Sutherland, letter to Edward Sackville-West, 10 April 1945, Tate Archive 926/17.

15 *KZ: Bildbericht aus fünf Konzentrationslagen*, US Information Service (in German) 1945

16 Benedict Nicolson, 'Graham Sutherland's "Crucifixion"', *Magazine of Art*, vol.40, no.7, Nov. 1947, p.280; Clark, quoted in Cooper 1961, p.34.

17 This comparison is made by John Hayes, *The Art of Graham Sutherland*, Oxford 1980, p.109.

18 Sutherland could have seen *Les Demoiselles d'Avignon* at the Institute of Contemporary Art's exhibition *40,000 Years of Modern Art* at the Academy Cinema in December 1948. The sketchbook has been dated 1947–50, Tate Archive 812.15.

19 Sutherland, letter to Curt Valentin, 24 Jan. 1946, published in *Graham Sutherland*, exh. cat. Buchholz Gallery, New York 1946.

20 Cooper 1961, pl.64c.

21 Ibid. p.42

PICASSO IN BRITAIN 1945–1960

1 For Lynda Morris, this owed largely to Picasso's political engagement with the international peace movement; see Morris, 'The Sheffield Peace Congress and Anti-Apartheid', in Morris and Grunenberg (eds.), *Picasso: Peace and Freedom*, exh. cat., Tate Liverpool 2010, pp.60–7.

2 'British art lovers will welcome the opportunity of seeing the direction taken by these two world-famous painters during the war years. In spite of war conditions the work of the Paris school has continued, and the re-opening of such exchanges between Britain and France is a living demonstration of the attitude of democratic countries towards their cultural traditions'; press release, MA/28/70 Picasso, Matisse, 1 Nov. 1945–11 Jan. 1946. In addition, a large exhibition of modern British painting from the Tate collection organised by the British Council toured Europe in 1946–7. This major exhibition introduced European audiences to the work of Graham Sutherland, John Piper and Victor Pasmore; see *Modern British Pictures from the Tate Gallery*, exh. cat., British Council, London 1946. Herbert Read also chaired a lecture by l'Abbé Morel entitled 'Picasso' at the Anglo French Art Centre, London, on 4 July 1946: Jennifer Anne Powell, 'Constructing National Identities through Exhibition Practices in Post-War London. Anglo-French Exchanges and Contemporary Sculpture on Display c. 1945 – 1966', unpublished PhD thesis, University of Birmingham, 2008, p. 73, fig. 22.

3 *Night Fishing at Antibes* was lent to the exhibition by Picasso's friend and cataloguer Christian Zervos.

4 'Some Facts about the Picasso-Matisse exhibition', British Council monthly overseas bulletin supplement, no.22, 31 Dec. 1945. In a letter from the Paris office of the British Council to Major A.A. Langden of the British Council London, plans for a publication on Picasso is discussed, 'But it must go out "hot" before Picasso has been quite forgotten by the British public, which I take it will be in about three weeks'; British Council Archives, BW31/21.

5 *Times*, 31 Dec. 1945. RPA 538/6.

6 Penrose, *Scrap Book, 1900–1981*, London 1981, p.143.

7 Plans for the exhibition were abandoned in December 1952, on the basis that funding for the exhibition would be jeopardised if communist sympathies in the area were mobilised; letter from Bryan Robertson, Director of Whitechapel Gallery, to the American Embassy in London, 30 Dec. 1952, Whitechapel Gallery Archive.

8 'Most Praised, Most Vilified Painter', *Dublin Evening Press*, 13 July 1960. Other interesting headlines included 'Picasso a Puzzle for the Prince', *Daily Herald*, 6 July 1960; 'Picasso Pulls 'em in at the Tate', *Evening Standard*, 6 July 1960; and 'The Picasso Blockbuster', *Tatler and Bystander*, 20 July 1960. TGA 955/1/13/6.

9 For Clark's account of his visit see Clark, *The Other Half: A Self-Portrait*, London 1977, pp.71–3.

10 Translation: 'He's done a Picasso.' Read's volume on Moore was the first monograph to be published on the artist; see ibid. p.71, and Herbert Read, *Henry Moore* London 1944.

11 Roger Berthoud, *The Life of Henry Moore*, London 2003, p.234. Letter from Alfred Langdon, British Council Director, to Leigh Ashton, Director, V&A, 20 Nov. 1945: 'Herbert Read and Henry Moore have seen all of the Picasso's while in Paris last week and we have very satisfactory reports about them'; MA/28/70.

12 Letter from Penrose to the Editor of the *Times*, 31 Dec. 1945; RPA 538/6.

13 Peter D. Whitney, 'Picasso Is Safe', *San Francisco Chronicle*, 3 Sept. 1944. Quoted in Steven Nash (ed.), *Picasso and the War Years: 1937–1945*, exh. cat, Fine Arts Museums of San Francisco 1998, p.13.

14 Heron, 'The Changing Jug', *Listener*, 25 Jan. 1951, p.135.

15 Vaughan, Journal 29, Jan. 1946, Tate Archive 200817/1/29.

16 Images of Picasso's Vallauris studio were published in *Picture Post* in June 1950.

17 *Picasso: Ceramics*, organised by the Arts Council of Great Britain, V&A, 1957.

18 Letter from Cooper to Trenchard Cox, Director of the V&A, 20 May 1957; MA/1/P1225, Picasso 1957–8.

19 See Jeffrey Jones, 'In Search of the Picassoettes', *Interpreting Ceramics*, Centre for Ceramics Studies, University of Wales Institute, Cardiff. Issue 1, 2000. Consulted online by the author, June 2011, http://www.uwic.ac.uk/icrc/issue001/picasso/picasso4.htm

20 Ibid.

21 Quoted in Lynda Morris, 'The Sheffield Peace Conference and Anti-Apartheid', in Morris and Grunenberg (eds.) 2010, p.63.

22 Picasso's speech was summarised by the *Manchester Guardian*, Tuesday, 14 Nov. 1950; Roland Penrose archive, Edinburgh, RPA 529/2.

23 Bernal, 'Proposed note appending to the Picasso Mural, donated by J.D. Bernal', Penrose Archive, Edinburgh, TGA 955/5/9.

24 Penrose, visit to Picasso's studio, 16 Feb. 1955, quoted in Cowling 2006, pp.103–4.

25 Richardson, 'La Californie', in *Picasso: The Mediterranean Years*, exh. cat., Gagosian Gallery, London 2010, p.27.

26 Picasso Party publicity, TGA 955/1/13/3.

27 Letter from Penrose to Rothenstein, 4 June 1959, TGA 4/2/829/2.

28 Golding, 'Picasso and the Image', *Listener*, 14 July 1960, p.52.

DAVID HOCKNEY AND PICASSO

1 See, for example, *Three Chairs with a Section of a Picasso Mural* 1970 (private collection).

2 Gregory Evans quoted in Peter Webb, *Portrait of David Hockney*, London 1988, p.190.

3 The lecture was first given at the Los Angeles County Museum of Art, 11 Jan. 1983.

4 A number of these were collected in Hockney, *Picasso*, Madras and New York 1990, pp.35–9.

5 Webb 1988, pp.244–5.

6 Marco Livingstone, *David Hockney*, London and New York 1981, 3rd edn 1996, p.187.

7 Hockney, quoted in Webb 1988, p.163.

8 In fact, Gregory Evans, the subject of the second painting, is replaced in the photographs by Peter Schlesinger; Livingstone 1996, p.190.

9 In 1966 Hockney designed *Ubu Roi* for the Royal Court Theatre, London, and, for Glyndebourne Opera House, *The Rake's Progress* (1975) and *The Magic Flute* (1978).

10 Martin Friedman and David Hockney, 'Designing Parade', in Friedman, *Hockney Paints the Stage*, exh. cat., Hayward Gallery, London 1985, p.161.

11 Ibid.

12 Webb 1988, p.189.

13 Ibid.

14 Martin Friedman, 'Painting into Theatre', in Friedman 1985, p.48.

15 Lecture by Hockney, reproduced in *David Hockney on Photography*, Emmerich Gallery, New York 1983, p.21.

16 Hockney, in conversation with the author, 1 April 2011.

17 Hockney 1990, pp.35–9.

18 Hockney, in conversation with the author, 1 April 2011.

THREE DANCERS

1 Picasso, quoted in Penrose, *Picasso: His Life and Work*, London 1981, p.472.

2 Quoted in Cowling 2006, p.271.

3 Ibid. p.276.

PICASSO AND BRITAIN
A SELECTED CHRONOLOGY OF EXHIBITIONS AND ACQUISITIONS 1900–1960

HELEN LITTLE

This chronology examines how Picasso's art was disseminated in Britain through exhibitions and acquisitions of his work. Where appropriate, it lists significant works exhibited with sale prices as provided in the gallery checklist or accompanying exhibition catalogue. Many of Picasso's exhibitions and acquisitions in Britain are undocumented and contemporary sources such as reviews and press coverage have been consulted to help fill in such gaps.

Information about public institutions' acquisitions of Picasso's work has been attained from a number of sources including Tate Library and Archive, The Arts Council Archive, Institute of Contemporary Arts Archive, The Roland Penrose Archive, Edinburgh and the V&A Archive, London. A substantial piece of work on the subject of British acquisitions of Picasso's work can be found in Madeleine Korn's doctoral thesis: 'Collecting Modern Foreign Art in Britain before the Second World War', PhD Thesis, University of Reading, 2001, aspects of which are contained in, 'Collecting paintings by Matisse and Picasso in Britain before the Second World War', *Journal of the History of Collections*, vol. 16, no. 1, 2004, pp. 111–129. The significant collections of Douglas Cooper, Roland Penrose and Hugh Willoughby have been subjects of increasing importance for a number of scholars and curators. For an overview of Cooper's collecting activity and relationship with Picasso see Dorothy M. Kosinski, *Douglas Cooper and the Masters of Cubism*, Kunstmuseum Basel and Tate Gallery London 1988. Elizabeth Cowling, *Visiting Picasso*, (London and New York 2006) has been a key source for information relating to Roland Penrose's relationship with Picasso, charting key works by the artist that entered Penrose's collection. Hugh Willoughby's connections to the Parisian avant-garde are the subject of Anne Strathie and Sophia Wilson's *Hugh Willoughby: The Man who loved Picassos*, Cheltenham Art Gallery and Museum, 2009. Another key source is Anna Gruetzner Robins, *Modern Art in Britain: 1910–14*, London 1997.

EXHIBITIONS	ACQUISITIONS
1910 **8 November – 15 January** *Manet and the Post-Impressionists*, Grafton Galleries, London. Organised by the British critic and artist Roger Fry, Picasso is represented by two paintings *Young Girl with a Basket of Flowers* 1905 and *Portrait of Clovis Sagot* 1909 (fig. 13) and seven works on paper including the etching *Salomé* 1905 (no.1) and *Les Deux Soeurs* date unknown (the remaining five drawings remain unidentified).	
1911 **December – January 1912** *Loan Exhibition of Works Organised by the CAS (Contemporary Arts Society)*, Manchester City Art Gallery.	Clive and Vanessa Bell purchase *Jars and Lemon* 1907 (no.2) for £4 during a visit to Paris, the first painting by Picasso to enter a British collection.
1912 **April – May** *Exhibition of Drawings by Pablo Picasso*, Stafford Gallery, London. Picasso's first solo exhibition in London. The twenty-six drawings exhibited including *Horse with a Youth in Blue* 1905–6 (no.4) on sale for £22 – the most expensive work on show. Almost all works date prior to 1907, mostly from Picasso's Blue and Rose periods.	Stockbroker and collector Frank Stoop acquires, *Horse with a Youth in Blue* 1905–6 (no.4) and *Girl in a Chemise* c.1905 (no.3) now in the Tate collection. *Bottle and Books* 1910–11 (no.5) is the only painting by Picasso to be sold from either of Fry's exhibitions. It is bought by H.T.J. Norton, a Cambridge mathematician and Bloomsbury figure.
October – December *Second Post-Impressionist Exhibition*, Grafton Galleries, London. For the first time Picasso's works are displayed alongside his British contemporaries, including Duncan Grant and Wyndham Lewis. It includes thirteen paintings and three drawings by Picasso, among them: *Femme assise dans un fauteuil* 1906; *Nature morte aux bananes* 1907; *Bol vert et flacon noir* 1908; *Paysage (Deux arbres)* 1908; *Tête de femme (Fernande Olivier)* 1909; *Femme et pot de moutarde* 1910; *Buffalo Bill* 1911; *Tête d'homme moustachu* ('Kou') 1912 (no.6) and *Le bouillon 'Kub'* 1912.	
1913 **June** *A Loan Exhibition of Post-Impressionist Paintings and Drawings*, Leeds Art Club, Leeds. Organised by Frank Rutter, Curator, Leeds City Art Gallery.	
October *Post Impressionist and Futurist Exhibition*, The Doré Galleries, London. Organised by Frank Rutter, Picasso's etchings *Salomé* 1905 (no.1) and *The Frugal Meal* 1904 (no.7) are exhibited. For Rutter, who had visited Picasso's Paris studio earlier in the year, the aim	Sir Michael Sadler acquires the etching *The Frugal Meal* 1904 (no.7) from the *Post Impressionist and Futurist Exhibition* at the Doré Galleries. Roger Fry acquires *Head of a Man* 1913 (no.8) in Paris, shortly after it was painted. The work was, in its

of the exhibition "is to illustrate the development of modern painting from 'Impressionism' to the vagaries of the present day."

1914 January
The Second Grafton Group Exhibition, The Alpine Club Gallery, London. Organised by Roger Fry and Vanessa Bell, reproductions of Picasso's Cubist constructions are shown alongside *Head of a Man* 1913 (no.8) owned by Fry.

1919

1920

1921 January
Exhibition of Works by Pablo Picasso, Leicester Galleries, London. Accompanying exhibition catalogue with text by Clive Bell. This was Picasso's first major exhibition in Britain and the first opportunity the British public had to see a wide-ranging survey of his work to date, including *Woman in an Armchair* 1913 (no.60), priced £780. The sixty-two works exhibited included significant examples from his Blue, Rose, Cubist and Neo-Classical period – lent by the artist, his dealers and by several of his earliest collectors in Britain, such as Roger Fry, Clive Bell and Frank Stoop.

virtual denial of representation, the most radical work by Picasso to enter a British collection before the First World War.

25 May – 3 August
Picasso spends three months in London working in a studio in Floral Street, Covent Garden, designing the décor, drop-curtain and costumes for the Russian Ballet's production of *The Three-Cornered Hat*.

The Flower-Seller, 1901 (no.49) is one of the earliest Picassos bought by a Scottish collector and the first work by the artist to enter a public museum in Scotland. It was acquired by the Glaswegian shipping magnate William McInnes sometime in the 1920s (probably from the dealer Alexander Reid).

The Offering 1908 is acquired during the inter-war period from Alex. Reid & Lefèvre, London by James Bomford, a notable collector of modern European painting who was also one of the earliest and most significant patrons of Francis Bacon. *The Offering* belonged subsequently to the distinguished physician and politician Lord Amulree – a close friend of the historian and collector of Cubism, Douglas Cooper, and through Cooper of Picasso himself – by whom it was bequeathed to the Museu Picasso, Barcelona.

Sales of Picasso's work are poor and the entire exhibition reaps only £92, reflecting the sale of one or two drawings and a few prints.

1922

1924

1926
The Tate's new modern foreign galleries open. Picasso's *Jars and Lemon* 1907 (no.2) and *Child with a Dove* 1901 (no.50) are loaned.

1927 May
A Century of French Painting, McLellan Galleries, Glasgow. Organised by Alex. Reid & Lefevre Gallery, London, this exhibition brought together work by Corot, Boudin, Renoir, Manet, Rousseau, Modigliani and Matisse. Picasso's *Femme en blanc* c. 1925 is exhibited. Photographs of the exhibition appear in the journal *Cahiers d'Art*.

1928

1929
Zwemmer's bookshop on London's Charing Cross Road branches out as an art gallery. As well as becoming instrumental in widening the availability of colour reproductions of Picasso's works in London (chiefly through sale of key reviews of modern French art *Cahiers d'Art*, *Documents* and *Minotaure*), it showcases work by Epstein and Moore and presents engravings by Picasso and Matisse.

Sir Michael Sadler presents *The Frugal Meal* 1904 (no.7) to the Whitworth Gallery, Manchester, one of the earliest works by Picasso to enter a British public gallery and the first to do so outside London. Sadler also presents the drawing *Two Dancers* 1919 (no.23) to the Whitworth this year.

Child with a Dove 1901 (no.50) is acquired by Mrs R.A. Workman, a considerable, if now rather over-looked collector of Impressionist and Post-Impressionist painting.

Child with a Dove 1901 (no.50) is sold by Mrs. Workman to Samuel Courtauld, the greatest of all British collectors of modern French art. Although Courtauld subsequently bought a handful of drawings and etchings by Picasso, this remained the only painting by the artist in his collection.

Civil engineer W. Rees Jeffreys acquires *Le Combat de taureaux* 1900 and *Tête de Femme* 1921.

Frank Stoop acquires *Seated Woman in a Chemise* 1923 (no.58), now in the Tate collection.

1930

1931

June
Thirty Years of Pablo Picasso, Alex. Reid & Levefre Gallery, London. In the preface of the accompanying exhibition catalogue, the American art critic Maud Dale writes that "Picasso is the figure of our more complex life and art today. In him alone can be found a definition for any of those many movements that go into the formation of Modern Art. He is the history of our whole artistic epoch and not of any particular group, or formula, or theory." Included in the display of thirty-seven major works are *La Vie* 1908; *La Corsage jaune* 1907; *Femme aux poires* 1909 and *Guitare et bouteille sur un guéridon* 1917. Works from the Dinard period are also revealed in Britain for the first time.

1932

The Duchess of Roxburghe acquires *Flowers* 1901.

Alex. Reid & Lefevre Gallery, London, purchase six paintings from Picasso via the art dealer Etienne Bignou, for 650,000 francs.

The Victoria and Albert Museum acquire its first Picasso print, an edition of *The Frugal Meal* 1904 (no.7).

Abstraction: Background with Blue Cloudy Sky 4 January 1930, is bought by the collector W. Rees Jeffreys.

British painter and printmaker Edward Wadsworth purchases *Fish on a Newspaper*, 1922.

Sir Michael Sadler acquires *Cubist Head (Portrait of Fernande)* 1909–10 (no.55), now in the Fitzwilliam collection. It was lent by him to the exhibition *Picasso in English Collections*, organised by Roland Penrose at the London Gallery in 1939.

A number of British collectors and artists travel to Paris to see Picasso's first major retrospective at Galerie Georges Petit, Paris. This exhibition (together with the first Picasso catalogue raisonné published by Christian Zervos), mark a distinct phase in his reputation in Britain which can be traced through the increasing rapidity with which his works are exhibited and collected in this country during the 1930s.

In June, *La Belle Hollandaise* 1905 is offered to the Tate Gallery by Alfred Gold for £5,000. The offer is declined.

1933

20 April
Exhibition of recent paintings by English, French and German artists, The Mayor Gallery, London. Organised to mark the reopening of the gallery, this exhibition includes Picasso, Georges Braque, Fernand Léger, Juan Gris, Francis Bacon, Henry Moore, Paul Nash, Ben Nicholson. Part financed by the English art collector Douglas Cooper, the gallery's policy was to promote the most progressive art and artists and quickly establishes itself for presenting artists – Picasso included – who were otherwise neglected in Britain at this time. A review of this exhibition in *The Scotsman* on 20 April features the title 'Pupils of Picasso'.

October
Twentieth Century Art, Mayor Gallery, London. Selected by Douglas Cooper, this exhibition coincides with the publication of Herbert Read's seminal book *Art Now – An Introduction to the Theory of Modern Painting and Sculpture*, published the same year. Works exhibited include Picasso's *Juan le Pins* 1924; Bacon's *Composition* 1933 and Moore's *Composition (Carving)* 1933. Ivon Hitchens, Paul Nash, Edward Wadsworth and Barbara Hepworth are also represented.

31 October – 21 November
Exhibition of works by Matisse and Picasso, Zwemmer Galleries, London.

Henry Moore, Ben Nicholson and others start a fundraising campaign to purchase one of Picasso's still-lives on show at the Mayor Gallery, London, in order to present it to the Tate Gallery. They manage to raise £9 of the £150 asking price.

After an unsuccessful campaign to purchase *Woman in an Armchair* 1927 (no.60), the Tate Gallery purchases *Flowers* 1901 (no.46) with assistance from the Contemporary Art Society for £700 "The very fact that the flower painting is scarcely recognisable as a Picasso makes it an easy acquisition!" Tate correspondence reveals, "Now that he is represented by the gallery, by name at least, it may not be so long before we come to his more representative work."

Among works by Degas, Van Gogh, Matisse, Braque, Modigliani, Cezanne, Laurenoin and Rousseau, Frank C. Stoop bequeaths Picasso's *Girl in a Chemise* c. 1905 (no.3), *Seated Woman in a Chemise* 1923 (no.58) and *Horse with a Youth in Blue* 1905–06 (no.4) to the Tate Gallery. The Stoop bequest is hung in gallery 11, and reported in the Daily Telegraph. "The importance of the existing modern foreign collection at Millbank is scarcely realised by the public," the Tate declared, "but the acquisition of 17 pictures of the first rank should go far towards encouraging a wider interest in the foreign school."

John Rothenstein, Director of Sheffield Art Galleries 1933–8, is unable to secure funds to purchase Picasso's masterpiece *La Vie*, 1903.

Douglas Cooper begins to collect major Cubist works, investing £10,000 between 1933 and 1938 to purchase 128 works of art – 36 by Picasso – in order to form a comprehensive collection of Cubism. *Les Oiseaux morts* 1912 is among the first to be acquired. "The taste of the English in modern art, until about 1939, was for Bonnard, Vuillard, Roualt, post-1918 Matisse, Derrain, Modigliani, and Utrillo," Cooper explained, "...Modern art in order to be acceptable, had to appear traditional, decorative, and easy to understand. Thus no one collected Fauve or Cubist pictures; very occasionally single pictures by Picasso, Braque or Juan Gris might be bought by a collector, but never a museum."

1934

February – March
20th Century Classics, Mayor Gallery, London. Group exhibition including Braque, Ernst, di Chirico, Gris, Klee, Léger, Picasso, Matisse. Picasso represented by *Nature Morte aux oiseaux morts*, *La Femme aux poires*, *Baigneuse aux bras levés* and *Arlequin* (dates not supplied)

15 March – 7 April
6 Maîtres modernes: Cézanne, Derain, Matisse, Picasso, Renoir, Rousseau, Arthur Tooth & Sons, London.

Autumn
Picasso Drawings, Mayor Gallery, London.

22 November
Drawings and Paintings by Picasso from the Collection of Mr. Hugh Willoughby, Tate Gallery, London. The first major display of Picasso at the Tate Gallery, comprising fourteen paintings and two drawings.

1935

31 January – 28 February
Drawings and Paintings by Picasso from the Collection of Mr. Hugh Willoughby, Cheltenham Museum and Art Gallery, Cheltenham. Of the seventeen works, *Head of a Woman* 1924 (no.52) and *Guitar Suspended on a Wall* 1927 (no.53) are shown. 4586 visitors see the first significant exhibition of Picasso's work outside London.

January – February
Paintings by Picasso, Juan Gris, Léger, Mayor Gallery, London.

1936

20 May – 20 June
Oil paintings, water-colours, pastels drawings and etchings by Pablo Picasso, Zwemmer Gallery, London.

Cooper acquires *Head of a Woman, Casket and Apple* 1909 from Arnold Haskell Gallery, London, for £8. He also purchases *The Soldier* c. 1901, from Alfred Flechtheim for £5.

Hugh Willoughby acquires *Head of a Woman* 1924 (no.52) and in the mid 1930s he purchases *Female Nude with Arms Raised* 1907 (no.51). A pioneering British collector of Picasso, by the end of the 1930s Willoughby had assembled a collection of twenty-five works in various media.

Douglas Cooper purchases *Head of a Woman* 1909 for £20.

Cooper continues to expand his collection with the purchase of *Still-life with Dead Birds* 1912 from the German dealer Alfred Flechteim for £150; *Fruit Dish with Mandolin* 1932 bought from the artist's dealer Paul Rosenberg in exchange for a Cézanne still-life; and two 1920 still lifes *Guitar on a Table* and *The Artist's Table*, bought from Galerie Percier for £10 and £12. He also bids 2,300 Francs for *Nature Morte* 1922 at a Paris auction.

In December, Jacques Seligmann & Fils, Paris, offer the Tate Gallery a work from Picasso's Blue Period for £3,000: "If I remember well, you have no Picasso in the gallery and you know how scarce pictures of that period are," the dealer wrote, "Due to the quality of the picture, its fine colours and its intense melancholic charm, I feel your board could be enraptured by it." The offer is declined.

Edward James buys *Seated Woman with a Hat* 1923 from Zwemmer Gallery, London, for £2,000. A 1930s photograph shows it hanging above the desk in the study of James's house in Wimpole Street, London.

4 June – 11 July
The International Surrealist Exhibition, New Burlington Galleries, London. Organised by Roland Penrose and Herbert Read. Eleven works by Picasso dating from 1913 to 1933 are presented, including W. Rees Jeffrey's *Abstraction: Background with Blue Cloudy Sky* 4 January 1930, Edward James's *Sleeping Woman* 17 January 1935 and *Head* 1913 (no.66), affirming the artist's relationship to the Surrealist movement. The British artists Moore, Nash, Agar and Penrose are also represented.

5 – 31 October
Masterpieces by Braque, Matisse, Picasso, Rosenberg & Helft, London.

1937

February
A collection of paintings by French and English Artists, Mayor Gallery, London. Works by Picasso, Braque and Matisse.

2 – 25 February
A Collection of Fifty Drawings by Picasso, Zwemmer Gallery, London.

1 – 30 April
Recent works of Picasso, Rosenberg & Helft, London. Twenty-five large canvases and four gouaches including *Nude Woman in Red Armchair* 1930 (no.60), *Woman Holding a Book* 1932, *Girl before a Mirror* 1932 and *Tauromachies* 1934.

May
Modern French Tapestries: Braque, Dufy, Leger, Lurcat, Matisse, Picasso, Rouault, Lefevre Gallery, London.

Blue Roofs, Paris 1901 (no.47) is bought by the textile manufacturer and collector Frank Hindley-Smith and bequeathed to the Ashmolean Museum, Oxford upon his death in 1939. Emblematic of the prevailing taste in Britain for Picasso's early, most easily legible works: of the six paintings by him that were acquired by British museums and galleries before the end of the Second World War, most date from the first years of the century, including three from the same year.

The etching *Minotauromachy* 1935 (no.63) is purchased from Zwemmer's bookshop, London by Helen M. Inman and immediately presented by her to the Fitzwilliam Museum, Cambridge.

Hugh Willoughby purchases one of the 50 copies of the etching *Minotauromachy* 1936, possibly directly from the artist.

Cooper purchases two drawings *The Guitar Player* 1912-13 for £25 and *Head of a Man* 1908 for £20, from Galerie Pierre, Paris. From Galerie Renou & Colle, Paris, he adds *Standing Woman* 1911–12.

Roland Penrose purchases *Nude on the Beach* 1932 (no.69), *Portrait of Lee Miller* 1937 (no.68), *Dream and Lies of Franco* 1937 (nos.100, 101) and *Weeping Woman* 1937 (no.107) directly from the artist following a holiday with Picasso and Dora Maar in Mougins, south of France, during which Picasso paints six portraits of Lee Miller. The trip is documented by Miller in a series of revealing photographs.

Woman in Green 1909–10 (no.64), *Girl with Mandolin* 1910, and *Guitar, Gas-Jet and Bottle* 1913 (no.65) are among a group of fourteen Picassos acquired by Roland Penrose from the Belgian collector René Gaffé. Penrose also acquires *Glass*, 1914, which he almost immediately gives to his friend, the critic, poet and curator Herbert Read.

23 April
An auction at Christies, London features 16 works by Picasso including *The Model* 1912 and *Mandolin, Palette and Brush* 1925. *Still Life: Bowls and Apples* 1924 (no.59) is bought at the auction by John Maynard Keynes, whose wife Lydia Lopokova was a close friend of Olga Picasso and the subject of several portraits by the artist.

June
Albert Hall Meeting, London. A mass rally organised by the anti-Fascist Artist International Association (AIA) takes place to raise funds for refugees of the Spanish Civil War. Picasso makes a drawing for the cover of the programme and an etching of *Weeping Woman* 1937 (no.106) is auctioned and bought by Hugh Willoughby.

June – July
Exhibition of Paintings from Ingres to Picasso, Rosenberg and Helft, London.

28 July – 1 September
Hugh Willoughby's Picassos, Cheltenham Museum and Gallery, Cheltenham. A second exhibition of Willoughby's now expanded collection with the additions of *Female Nude with Arms Raised* 1937 (no.50), *Minotauromachy* 1935 (no.63) and *Weeping Woman* 1937 (no.106).

20 November – 18 December
Contemporary Art Water Colours, Drawings, Etchings by Matisse, Picasso, Utrillo, Dobson, Maillol, Gertler, Paul Nash, and others lent by the Artists, The Oxford Arts Club, Oxford.

Date unknown
Surrealist Broadsheet, 41 Grosvenor Square, London. Organised by the Artist International Association (AIA) in support of Peace, Democracy and Cultural Development. An unidentified work by Picasso appears in the Surrealist section of a large exhibition surveying a range of styles, alongside Ernst, Man Ray, Dali and Klee.

June
Hugh Willoughby acquires the etching *Weeping Woman* 1937 (no.106) from the Albert Hall Meeting auction, London.

Douglas Cooper acquires *Still Life with Peaches and Playing Cards* 1914, from Daniel-Henry Kahnweiler, for £22. Cooper also purchases *Abstraction*, 1922, for £78 at a Christie's London auction sale. *Nude* 1909 and the papiers collé *Still Life with Bottle, Cup and Newspaper* 1912–13 are added, purchased from the American collector Earl Horter for $160 and $30.

Cooper purchases the drawings *The Card Player* 1914 and *Still Life with Table and Dish of Pears* 1912 from Galerie Renou & Colle, Paris. 1937–8 Douglas Cooper purchases a significant group of works spanning Picasso's career from the German collector G. F. Reber, including *Standing Female Nude* 1906–07; *Three Figures Under a Tree* 1907/08 [£900]; *Nude Woman in an Armchair* 1909; *Man with a Clarinet* 1911–12 (no.56); *Bottle of Bass and Guitar* 1912/13; *Two Women* 1920 [£500]; *Head of a Woman* 1921 [£100]; *Woman and Harlequin* 1915 [£30] and *Still Life on a Table* 1923/4 [£1,300].

Dying Bull 1934 is acquired by the financier and collector Oswald T. Falk from Rosenberg and Helft, London. A friend of Maynard Keynes, Falk compiled a small but significant collection of Picasso's contemporaneous work during this decade, including *Nude Woman in a Red Armchair* of 1932 (no.60), now in Tate's collection. This compelling image is exemplary of Falk's taste (unusual in Britain at this time) for the most highly-charged of Picasso's paintings of the 1930s.

Reading at a Table 1934 (no.62) is acquired from Rosenberg and Helft, London, probably by 1937 and certainly by 1939, by the patron and collector Peter Watson. As the financial backer and art editor of the cultural magazine *Horizon*, and as a co-founder (with Roland Penrose, Herbert Read and others), of the Institute of Contemporary Arts, Watson played a vital role in the wider dissemination of Picasso's work in Britain at this time.

Lee Hardy purchases *The Race Course at Auteuil* 1901 (no.48) from Arthur Tooth & Sons, London.

16 March
Realism – Surrealism Debate, Group Theatre Rooms, London. Paintings by Matisse and Picasso are exhibited as a backdrop to a debate attended by Roland Penrose, Julian Trevelyan, Humphrey Jennings, William Townshend and Herbert Read.

Group exhibition at Peggy Guggenheim's Guggenheim Jeune Gallery, London.

5 – 31 May
Picasso: Drawings and Collages, The London Gallery.

3 – 31 May
A Century of French Drawings: Prud'hon to Picasso, Mathiesen Gallery, London.

28 May – 26 June
Realism and Surrealism: an Exhibition of Several Phases of Contemporary Art, The Guildhall, Gloucester. Organised by The Gloucester Art Sub-Committee and opened by Herbert Read, among 120 works by leading European artists Picasso's *Weeping Woman* 1937 (no. 107) and Penrose's *The Last Voyage of Captain Cook*, 1936–7 are exhibited.

4 – 29 October
Picasso's 'Guernica' with 67 Preparatory Paintings, Sketches and Studies, New Burlington Galleries, London. Organised under the auspices of the National Joint Committee for Spanish Relief. During the two-week run 3,000 visitors paid the 1/3d admission charge.

November
Tour of *Guernica* to Oriel College, Oxford (due to shortage of space only the studies were shown).

December
Tour of *Guernica* to Leeds City Art Gallery. Due to shortage of space only the studies were shown, but the exhibition's organiser Roland Penrose added *Weeping Woman* 1937 (no.107) from his own collection.

January
Picasso's 'Guernica' with 67 Preparatory Paintings, Sketches and Studies, Whitechapel Art Gallery, London. The exhibition was opened by Major Clement Atlee, Leader of the opposition Labour Party and ardent supporter of the International Brigade. 12,000 visitors see the exhibition during the 2 week show.

Penrose purchases *The Death of a Monster* from his and the artist's mutual friend and Surrealist poet Paul Eluard.

Douglas Cooper purchases *Portrait of Dora Maar* April 27 1938 directly from the artist for £60, and *Still Life with Garlands* 1918 (no.57) from Galerie Pierre, Paris, for £150.

The Card Player 1913–14 is acquired in the late 1930s by Francis B. Cooke.

Blue Roofs Paris 1901 (no.47) is bequeathed by Frank Hindley Smith to the Ashmolean Museum, Oxford.

Despite the hiatus in the art market at the onset of World War Two, Cooper acquires a number of key works by Picasso outside the continent, including

1 – 15 February
Picasso's 'Guernica' with 67 Preparatory Paintings, Sketches and Studies, 32 Victoria Street, Manchester. Organised by the Manchester Foodship for Spain, the mural and studies are reunited in a car showroom.

1 March – 1 April
Picasso: Recent Works, Rosenberg & Helft, London.

16 May – 20 June
Picasso in English Collections, London Gallery, London. Catalogue edited by E. L. T. Mesens and Roland Penrose, published in *The London Bulletin* 2, no. 15–16, May 15, 1939. The last exhibition of Picasso in London before WW2, it included Picasso's *Weeping Woman* (no.107) lent by Roland Penrose.

1941

1942

4 – 21 June
An exhibition in aid of the Russian war effort is held at the architect Erno Goldfinger's Hampstead house, featuring *La Nicoise* 1937, loaned by Hugh Willoughby.

November
Hugh Willoughby organises an exhibition of his Picassos at his flat in Hove, Sussex, including the loan of *Weeping Woman* 1937 (no.107) from Roland Penrose.

1943

11 February – 6 March
Victor Pasmore, P. Picasso, P. Tchelitchew, J. Mablord: French Paintings, Redfern Gallery, London.

March – April
Exhibition of Gouaches with works by Picasso and his contemporaries, Lefevre Galleries, London.

11 – 29 May
French paintings: etchings by Picasso, Dali, Chagall: drawings by Sigmund Pollitzer, Redfern Gallery, London.

1944

The Student 1917–18 from Pierre Matisse Gallery, New York, for £600. He also acquires four works on paper from G.F Reber in Lausanne, *Bacchus* 1906; *Standing Female Nude* 1906–07; *Bottle of Bass and Guitar* 1912–13 and *Man and Woman* 1921.

Willoughby sells *Female Nude with Arms Raised* (no.51) to Sir Robert and Lady Sainsbury.

Hugh Willoughby sells his etching *Minotauromachy* 1936 (no.63) to his friend Helen Shipway for £75.

Douglas Cooper purchases *Nude* 1906, from the Mayor Gallery, London, his first Picasso acquisition since the outbreak of war.

The Flower Seller, 1904 (no.49) is bequeathed by William McInnes to Glasgow Art Gallery.

1945

23 May – 16 June
Picasso loan exhibition: Collection of Hugh Willoughby, Esq., Eugene Slatter Gallery, London. The accompanying catalogue, priced 2s 6d, is sold for the benefit of the French Red Cross.

May – June
School of Paris (Picasso and his Contemporaries), Alex. Reid & Lefevre Gallery, London.

June
Since the Impressionists, Wildenstein Gallery, London.

Date unknown
Pablo Picasso: Thirty Important Paintings from 1904 – 1943, Modern Art Gallery, London. Accompanying exhibition catalogue by Jack Bilbo.

1 November – 31 December
(extended until 15 January 1946): *Exhibition of Paintings by Picasso and Matisse*, Victoria and Albert Museum, London. Organised by the British Council and the Direction Général des Relations Culturelles, the exhibition includes 24 paintings lent by Picasso made during the Occupation, and *Night Fishing at Antibes* 1939, lent by Christian Zervos. Despite mixed reviews, the show captures popular attention and attracts 160,000 visitors.

1946

26 January – 10 February
Exhibition of Paintings by Picasso and Matisse, Glasgow Museum and Art Gallery, Glasgow. 90,000 visitors, the largest exhibition attendance in the city. Director Dr. Honeyman gives two lectures titled 'Understanding Picasso' to packed auditoriums.

February – March
Exhibition of Paintings by Picasso and Matisse, Manchester Art Gallery, Manchester. 71,613 visitors.

1947

January
Roland Penrose's translation of Picasso's surrealist play *Le Désir attrapé par la queue* (Desire Caught by the Tail), 1941, premieres at the London Gallery. A reading of the play later takes place at London's Rudolf Steiner Hall, where Picasso's stage directions were read by the Welsh poet Dylan Thomas.

Shortly after the exhibition of his collection at Eugene Slatter Gallery, Hugh Willoughby sells *Head of a Woman* 1924–5 (no.52) and the drawing *Weeping Woman* 1937 (no.106) to Helen Shipway.

Cooper purchases several drawings and etchings by Picasso from Redfern Gallery and the Leicester Galleries, London.

1947
(cont.)

4– 25 January
Picasso: 55 Lithographs, 1945–47,
Regional Exhibition Room, Cambridge.
Organised by the Arts Council of
Great Britain.

18 March – 3 May
The Cubist Spirit in its Time,
The London Gallery, London.
Accompanying exhibition catalogue
by Robert Melville and E. L. T. Mesens.

1948

6 April – 1 May
Picasso, Paul Nash, Miró, Redfern
Gallery, London.

4 – 22 May
*Robin Ironside, Fred Uhlman, Lyons
Wilson, Edward Eker, W. Barns-Graham,
Peter Grimm, Picasso, Paul Nash, Miró*,
Redfern Gallery, London.

May
Miró, Borès, Picasso, Zwemmer Gallery,
London.

20 December – 29 January 1949
*40,000 Years of Modern Art: A
Comparison of Primitive and Modern*,
Academy Cinema, Oxford Street,
London. Organised by Roland Penrose
under the auspices of the Institute
of Contemporary Arts Picasso's *Les
Demoiselles d'Avignon* 1907, is lent
by the Museum of Modern Art, New
York, the first of two appearances
in Britain.

1949

April
*Etchings by Braque for Hesiode,
La Théogonie, with other etchings by
Picasso and Dali*, Zwemmer Gallery,
London.

10 May – 4 June
*Four Exhibitions: Recent work by
Roland Penrose: first one-man
exhibition in London, Sven Blomberg:
the early Chirico: twenty original
drawings by Picasso*, The London
Gallery, London.

17 May – 16 July
Lithographs by Pablo Picasso,
Hanover Gallery, London.

1950

14 September – 21 October
*Posters: Picasso, Matisse, Léger, Braque,
Miró: Francis Bacon, Recent Paintings*,
Hanover Gallery, London.

November
Picasso in Provence, New Burlington
Galleries, London. Organised by the

August
The Tate Gallery reject an offer from
Eardley Knollys to purchase *Head* April
1909 for £2,000 owing to insufficient
funds. Later that year in October, the
Tate Gallery purchase Knolly's *Bust of
a Woman* 1909 (presumably the same
work) (no.54) for £1800.

September
The Tate Gallery purchase *Seated
Nude* 1909–10 from Galerie Pierre,
Paris, for 3,250,000 Francs.

Arts Council, this touring exhibition
introduces British audiences to
Picasso's recent work in sculpture
and ceramics.

1951

11 October – 24 November
*Drawings and watercolours since
1893: Homage to Picasso on his 70th
Birthday*, Institute of Contemporary
Arts, London. Accompanying exhibition
catalogue with introduction by
Roland Penrose and translation of
Paul Eluard's text *Picasso bon maître
de la liberté*. Picasso himself lends a
generous number of works from his
own collection, including two pen
and ink studies for *Les Demoiselles
d'Avignon*.

1952

December
The trustees of the Whitechapel
Gallery, London, abandon plans for a
Picasso exhibition – possibly with the
inclusion of *Guernica* - on the basis
that funding for the exhibition would
be jeopardised amid concerns it would
mobilise Communist sympathies in
the area.

1953

5 March – 19 April
*Wonder and Horror of the Human
Head: An Anthology*, Institute of
Contemporary Art, London. Organised
by Roland Penrose, Picasso's *Head of a
Woman (Nusch Eluard)* 1937 is included.

9 April – 31 May
*20th Century Art Form: Painting,
Sculpture and Architecture*,
Whitechapel Art Gallery, London.
Picasso's *Tête d'un Homme* 1909–10
is shown alongside work by British
and European artists including Reg
Butler, Henry Moore, F. E. McWilliam,
Juan Gris, C. R. W. Nevinson,
Wyndham Lewis, Merlyn Evans,
Giorgio de Chirico, Lurcat, de Stael
and Mondrian.

May – June
Picasso: 1898–1936, Lefevre Gallery,
London.

14 May – 4 July
The Art of Drawing: 1500–1950,
Wildenstein & Co., London.

September
Picasso: Lithographs and Aquatints,
Marlborough Fine Art, London.

1954

May
Picasso: 1938–1953, Lefevre Gallery,
London.

December
Four of Hugh Willoughby's paintings
are sold at Sotheby's on London's
Bond Street including *La Nicoise* 1937
(£1250) and the works on paper
Three Studies (£180) and
Head of a Woman 1926 (£180).

The Tate Gallery acquires *Nude
Woman in a Red Armchair* 1932 (no.60).
Tate also buys the sculpture *Cock* 1932
(cast 1952) from Galerie Kahnweiler,
for 750,000 Francs.

Douglas Cooper acquires *Still-Life
with Chocolate Pot* 1909, from
Alex. Reid and Lefevre, London.

26 November
W. Rees Jeffrey's collection goes on
sale at Christies, London

November
Christmas selection: Picasso pottery, and artists' original prints and lithographs from London and Paris, Zwemmer Gallery, London.

November – December
Collector's Choice IV, Gimpel Fils, London.

1955

May – June
Picasso: 63 Drawings, 1953–54, and 10 bronzes, 1945–53, Marlborough Fine Art, London.

21 June – 23 July
Picasso: Etchings 1930–36, St. George's Gallery, London.

1956

22 June – 5 August
Picasso: Fifty Years of Graphic Art, Arts Council Gallery, London. Organised by the Arts Council of Great Britain.

October – December
Picasso Himself: Portrait of Picasso, Institute of Contemporary Arts, London. Accompanying catalogue with text by Roland Penrose and introduction by Alfred H. Barr Jr. The following May this exhibition tours to the Museum of Modern Art, New York.

December
Christmas Exhibition: Picasso etchings, Maillol lithographs, Zwemmer Gallery, London.

1957

Date unknown
Post Picasso Paris, Hanover Gallery, London.

Date unknown
Picasso: Ceramics, Victoria and Albert Museum, London. Organised by the Arts Council of Great Britain and curated by Douglas Cooper.

1958

28 January – 22 February
Michael Wishart, Rowland Suddaby, Robert Parkinson, Picasso, Redfern Gallery, London.

April – May
Cézanne to Picasso "Oeuvres de Jeunesse", O'Hana Gallery, London.

June
Nineteenth and Twentieth Century Masters, Marlborough Gallery, London. Group exhibition featuring work by Braque, Munch, Van Gogh, Moore and Picasso.

The Tate Gallery purchase *Goat's Skull, Bottle and Candle*, 1952.

Picasso gives the small ceramic *Pitcher – Horse and Rider* c. 1951 (no.118) to the Victoria and Albert Museum, London, following his exhibition there the previous year.

July – October
Corot to Picasso, Arthur Tooth & Sons, London.

3 October – 2 November
The Moltzau Collection: from Cézanne to Picasso, Tate Gallery, London. Accompanying exhibition catalogue with introduction by David Baxandall.

1960

23 June – 28 July
Pastels and drawings of the Blue Period (1900–1905) by Pablo Picasso, O'Hana Gallery, London.

6 July – 18 September
Pablo Picasso, Tate Gallery, London. Organised by The Arts Council of Great Britain, this major retrospective attracts over 460,000 visitors, with the galleries sometimes so full they had to be closed. On the last day of the exhibition, 6,175 people had been through the doors alone. 500,000 postcards and 92,000 catalogues were sold. The term 'Picasso-mania' is coined by the British press in their coverage of the phenomenon of vast crowds queuing around Millbank for hours.

12 July – 27 August
Picasso: 45 Colour Engravings on lino, Hanover Gallery, London.

4 August
After months of complex negotiations, the loan of 10 paintings from the Soviet Union including *Nude with Drapery* (1907) arrives at the Tate Gallery, London and joins Picasso's retrospective in a special gallery set aside alongside the main exhibition.

18 July – 3 September
Delacroix to Picasso, Arthur Tooth & Sons, London.

17 November – 3 December
Exhibition of Fruit and Flowers: Alzpriri, Braque, Jawlensky, Lorjou, Picasso, Renoir, Serusier, Van Gogh, Vlaminck, Ohana Gallery, London.

21 November – 22 December
Klee & Picasso: watercolours and drawings, Brook Street Gallery, London.

29 November – 31 December
Picasso en gravures, Redfern Gallery, London.

La Belle Hollandaise 1905, is sold at Sotheby's, London, for £55,000, a record price for a work by a living artist.

LIST OF EXHIBITED WORKS

Illustrated works are indexed on p.233.
Non-illustrated works are denoted by
an asterisk (*).
Measurements of artworks are given in
centimetres, height before width.

PICASSO IN BRITAIN 1910–1914

Pablo Picasso
The Frugal Meal 1904, printed 1913
Etching with drypoint on paper
46.3 × 37.7
The Whitworth Art Gallery,
The University of Manchester

Pablo Picasso
Salomé 1905, printed 1913
Drypoint on paper
40 × 34.8
British Museum. Bequeathed by
Campbell Dodgson. 1949

Pablo Picasso
Girl in a Chemise c.1905
Oil on canvas
72.7 × 60
Tate. Bequeathed by C. Frank Stoop 1933

Pablo Picasso
Horse with a Youth in Blue 1905–6
Watercolour and gouache on paper
49.8 × 32.1
Tate. Bequeathed by C. Frank Stoop 1933

Pablo Picasso
Jars and Lemon 1907
Oil on canvas
55 × 46
Albertina, Vienna. Batliner Collection

Pablo Picasso
Bottle and Books 1910–11
Oil on canvas
38 × 46
Private collection

Pablo Picasso
Head of a Man 1912
Oil on canvas
61 × 38
Musée d'art moderne de la Ville de Paris

Pablo Picasso
Head of a Man 1913
Oil, gouache, varnish, ink, charcoal
and pencil on paper
61.6 × 46.4
The Museum of Modern Art, New York.
Richard S. Zeisler Bequest, 2010

DUNCAN GRANT AND PICASSO

Duncan Grant
Design for a Firescreen c.1912
Oil on paper
83 × 75
Private collection
Duncan Grant

Head of Eve 1913 (*)
Oil on board
75.6 × 63.5
Tate. Purchased 1984

Duncan Grant
The Tub c. 1913
Watercolour and wax on paper
laid on canvas
76.2 × 55.9
Tate. Presented by the Trustees of
the Chantrey Bequest 1965

Attributed to Duncan Grant
Abstract Design 1913–15
Bodycolour and pencil on paper
60.8 × 48.3
The Samuel Courtauld Trust,
The Courtauld Gallery, London

Duncan Grant
The Modelling Stand c.1914
Oil and collage on board
75.6 × 61
Private collection courtesy
Ivor Braka Ltd.

Duncan Grant
Interior at Gordon Square 1914–15
Papier collé on board
76 × 65
Private collection

Duncan Grant
The White Jug 1914–18
Oil on panel
106.7 × 44.5
Southampton City Art Gallery

Pablo Picasso
Vase of Flowers 1908
Oil on canvas
92.1 × 73
The Museum of Modern Art, New York.
Gift of Mr. and Mrs. Ralph F. Colin, 1962.

WYNDHAM LEWIS AND PICASSO

Wyndham Lewis
The Theatre Manager 1909
Ink and watercolour on paper
50.8 × 61
Victoria and Albert Museum, London.
Presented by the family of
Capt. Lionel Guy Baker, in accordance
with his expressed wishes

Wyndham Lewis
Smiling Woman Ascending a Staircase 1911
Charcoal and gouache on paper
96.5 × 65
Private collection

Wyndham Lewis
Self Portrait 1911
Pencil and wash on paper
30.5 × 23.5
The Courtauld Gallery, London.
Samuel Courtauld Trust. Acquired for
the collection by Daniel Katz, 2011

Wyndham Lewis
Two Mechanics c. 1912 (*)
Drawing and watercolour on paper
55.9 × 33.7
Tate. Purchased 1956

Wyndham Lewis
Composition 1913 (*)
Pen, watercolour and pencil on paper
34.3 × 26.7
Tate. Purchased 1949

Wyndham Lewis
Workshop c.1914–5
Oil on canvas
76.5 × 61
Tate. Purchased 1974

Wyndham Lewis
A Reading of Ovid (Tyros) 1920–21
Oil on canvas
165.2 × 90.2
Scottish National Gallery of Modern Art,
purchased 1977

Wyndham Lewis
Archimedes Reconnoitring the Enemy Fleet 1922
Pencil, ink, watercolour and gouache on paper
33 × 47
Private collection

Wyndham Lewis
Mrs. Workman 1923
Pencil and wash on paper
33 × 47
Private collection

PICASSO IN BRITAIN 1919

Pablo Picasso
*Design for costume for the Chinese Conjuror,
'Parade'* 1917
Watercolour on paper
28 × 19
Family Helft

Pablo Picasso
Portrait of Lydia Lopokova 1919
Pencil on paper
35.6 × 25.1
Lent by the Syndics of the Fitzwilliam Museum,
Cambridge. Acquired with assistance from the
National Art Collections Fund administered
by the V&A on behalf of the Museums and
Galleries Commission, 1989.

Pablo Picasso
Portrait of Vladamir Polunin 1919
Pencil on paper
53 × 34
Private collection

Pablo Picasso
Costume design for The Three Cornered Hat:
The Dandy 1919
26.3 × 17.9
Watercolour, gouache and pencil on paper
Musée national Picasso, Paris,
Donation Pablo Picasso, 1979, MP1683

Pablo Picasso
Costume design for The Three Cornered Hat:
The Corregidor's Wife 1919
Gouache, India ink, watercolour and
pencil on paper
26.5 × 19.6
Musée national Picasso, Paris,
Donation Pablo Picasso, 1979, MP1714

Pablo Picasso
Sketch for the stage curtain for
The Three Cornered Hat 1919
Oil on canvas
36.5 × 35.4
Private collection

Pablo Picasso
Three Seated Women: study for the drop curtain
for 'The Three Cornered Hat' 1919
Pencil on paper
31.1 × 23.8
By kind permission of the Provost and
Scholars of King's College, Cambridge, on loan
to the Fitzwilliam Museum, Cambridge

Pablo Picasso
Two Dancers 1919
Pencil on paper
30.4 × 23.2
The Whitworth Art Gallery,
The University of Manchester

Pablo Picasso
Mauve velvet waistcoat from the Costume for
the Miller, The Three Cornered Hat 1947 (*)
(Originally designed 1919)
Mauve velvet waistcoat
Dimensions variable
Victoria and Albert Museum, London

Pablo Picasso
Black wool trousers from the costume for
The Miller, The Three Cornered Hat 1947 (*)
(Originally designed 1919)
Black wool trousers
Dimensions variable
Victoria and Albert Museum, London

Pablo Picasso
Theatrical costume for the Miller's Wife in Leonide
Massine's ballet The Three Cornered Hat for the
Ballet Russes, orginally designed and produced
in 1919, remade 1937–39 1947 (*)
Pink dress with black lace trim and blue
fringed shawl, petticoat, headdress and shoes
Dimensions variable
(Lent by the) Museum of London

Pablo Picasso
The Three Cornered Hat: Set design 1919–1920
Pochoir on paper
20.3 × 26.7
Royal Opera House, Covent Garden.
Donated by Sir John Ritblat

Pablo Picasso
The Three Cornered Hat: The Miller 1919–1920
Pochoir on paper
25.3 × 19.1
Royal Opera House, Covent Garden.
Donated by Sir John Ritblat

Pablo Picasso
The Three Cornered Hat: The Miller's Wife
1919–1920
Pochoir on paper
25.8 × 19.2
Royal Opera House, Covent Garden.
Donated by Sir John Ritblat

Pablo Picasso
The Three Cornered Hat: Design for the
drop-curtain 1919–1920 (*)
Pochoir on paper after design for
The Three Cornered Hat
26.7 × 25.8
Royal Opera House, Covent Garden.
Donated by Sir John Ritblat

Pablo Picasso
The Three Cornered Hat: The Sedan Chair
belonging to the Corregidor's Wife 1919–1920 (*)
Pochoir on paper
26.7 × 20.1
Royal Opera House, Covent Garden.
Donated by Sir John Ritblat

Pablo Picasso
The Three Cornered Hat: The Corregidor
dressed in the Miller's Cloak 1919–1920 (*)
Pochoir on paper
25.3 × 18.9
Royal Opera House, Covent Garden.
Donated by Sir John Ritblat

Pablo Picasso
The Three Cornered Hat: the Picador 1919–1920
Pochoir on paper
25.9 × 19.2 (*)
Royal Opera House, Covent Garden.
Donated by Sir John Ritblat

Pablo Picasso
The Three Cornered Hat: a Neighbour
1919–1920 (*)
Pochoir on paper
25.8 × 18.9
Royal Opera House, Covent Garden.
Donated by Sir John Ritblat

Pablo Picasso
The Three Cornered Hat: two servants of
the Corregidor's Wife 1919–1920 (*)
Pochoir on paper
25.6 × 18.9
Royal Opera House, Covent Garden.
Donated by Sir John Ritblat

Pablo Picasso
The Three Cornered Hat: an old woman
1919–1920 (*)
Pochoir on paper
25.8 × 18.8
Royal Opera House, Covent Garden.
Donated by Sir John Ritblat

Pablo Picasso
The Three Cornered Hat: the Beggar 1919–1920 (*)
Pochoir on paper
25.7 × 19.3
Royal Opera House, Covent Garden.
Donated by Sir John Ritblat

Pablo Picasso
The Three Cornered Hat: an old negro
1919–1920 (*)
Pochoir on paper
26.1 × 19.1
Royal Opera House, Covent Garden.
Donated by Sir John Ritblat

Pablo Picasso
The Three Cornered Hat: one of the Fools
1919–1920 (*)
Pochoir on paper
25.3 × 18.8
Royal Opera House, Covent Garden.
Donated by Sir John Ritblat

Pablo Picasso
The Three Cornered Hat: one of the fools
1919–1920 (*)
Pochoir on paper
25.3 × 18.8
Royal Opera House, Covent Garden.
Donated by Sir John Ritblat

Pablo Picasso
The Three Cornered Hat: The Majorcan
1919–1920 (*)
Pochoir on paper
25.3 × 18.8
Royal Opera House, Covent Garden.
Donated by Sir John Ritblat

Pablo Picasso
The Three Cornered Hat: the dancers of
the Sevillana 1919–1920 (*)
Pochoir on paper
25.3 × 18.8
Royal Opera House, Covent Garden.
Donated by Sir John Ritblat

Pablo Picasso
The Three Cornered Hat: the Torero 1919–1920 (*)
Pochoir on paper
25.3 × 18.8
Royal Opera House, Covent Garden.
Donated by Sir John Ritblat

Pablo Picasso
The Three Cornered Hat: Details of the costumes
for the Torero, Aragonosos and Aragonases
1919–1920 (*)
Pochoir on paper
25.3 × 18.8
Royal Opera House, Covent Garden.
Donated by Sir John Ritblat

Pablo Picasso
The Three Cornered Hat: the shawl of
the Miller's Wife 1919–1920 (*)
Pochoir on paper
18.8 × 25.3
Royal Opera House, Covent Garden.
Donated by Sir John Ritblat

Pablo Picasso
The Three Cornered Hat: the Aragonasos
1919–1920 (*)
Pochoir on paper
25.3 × 18.8
Royal Opera House, Covent Garden.
Donated by Sir John Ritblat

Pablo Picasso
The Three Cornered Hat: the Alguazil
1919–1920 (*)
Pochoir on paper
25.3 × 18.8
Royal Opera House, Covent Garden.
Donated by Sir John Ritblat

Pablo Picasso
The Three Cornered Hat: the cape of the man
on crutches 1919–1920 (*)
Pochoir on paper
25.3 × 18.8
Royal Opera House, Covent Garden.
Donated by Sir John Ritblat

Pablo Picasso
The Three Cornered Hat: a Man's Costume
1919–1920 (*)
Pochoir on paper
25.3 × 18.8
Royal Opera House, Covent Garden.
Donated by Sir John Ritblat

BEN NICHOLSON AND PICASSO

Ben Nicholson
1924 (first abstract painting, Chelsea) c.1923–4
Oil and pencil on canvas
55.4 × 61.2
Tate. Accepted by HM Government in lieu of
tax and allocated to the Tate Gallery 1986

Ben Nicholson
1924 (painting – trout) 1924
Oil on canvas
22 × 23
Private collection

Ben Nicholson
1929 (still life with green jug) 1929
Oil and pencil on board
45.7 × 54.5
Private collection

Ben Nicholson
1932 (crowned head – the queen) 1932
Oil and pencil on canvas
91.5 × 120
Abbot Hall Art Gallery, Kendal, Cumbria

Ben Nicholson
1932 (Au Chat Botté) 1932
Oil and pencil on canvas
92.5 × 122
Manchester City Galleries

Ben Nicholson
1933 (musical instruments) 1932–3
Oil on board
104 × 90
Kettle's Yard, University of Cambridge

Ben Nicholson
1933 (coin and musical instruments) 1933
Oil on board
106.7 × 121.9
Lent by the Metropolitan Museum of Art,
Bequest of Richard S. Zeisler, 2007
(2007.247.6)

Ben Nicholson
1933 (St.Remy, Provence) 1933
Oil on board
105 × 93
Private collection

Pablo Picasso
Bowl of Fruit, Violin and Bottle 1914
Oil on canvas
92 × 73
Tate. Lent by the National Gallery 1997

Pablo Picasso
Guitar, Compote Dish and Grapes 1924
Oil on canvas
98.5 × 132
Collection Stedelijk Museum, Amsterdam

Pablo Picasso
Head of a Woman 1926
Pen and charcoal on paper
62 × 47
Staatsgalerie Stuttgart /
Graphische Sammlung

PICASSO IN BRITAIN 1920–1939

Pablo Picasso
A Child with a Dove 1901
Oil on canvas
73.3 × 54
Private collection, on long loan to
The Courtauld Gallery

Pablo Picasso
Blue Roofs, Paris 1901
Oil on board
39 × 57.7
The Ashmolean Museum, Oxford.
Bequeathed by Frank Hindley Smith, 1939.

Pablo Picasso
Flowers 1901
Oil on canvas
65.1 × 48.9
Tate. Purchased with assistance from
the Contemporary Art Society 1933

Pablo Picasso
The Flower Seller 1901
Oil on board
33.7 × 52.1
Lent by Culture and Sport Glasgow
on behalf of Glasgow City Council.
Bequeathed by William McInnes, 1944

Pablo Picasso
The Race Course at Auteuil 1901
Oil on board
47.3 × 62.2
Private collection

Pablo Picasso
Female Nude with Arms Raised 1907
Gouache on paper
63 × 46
Robert and Lisa Sainsbury Collection,
University of East Anglia

Pablo Picasso
Bust of a Woman 1909
Oil on canvas
72.7 × 60
Tate. Purchased 1949

Pablo Picasso
Cubist Head (Portrait of Fernande) 1909–10
Oil on canvas
66 × 53
Lent by the Syndics of the
Fitzwilliam Museum, Cambridge

Pablo Picasso
Woman in Green 1909–10
Oil on canvas
99 × 80
Collection Van Abbemuseum,
Eindhoven

Pablo Picasso
Man with a Clarinet 1911–12
Oil on canvas
106 × 69
Museo Thyssen Bornemisza, Madrid

Pablo Picasso
Guitar, Gas Jet and Bottle 1913
Oil, charcoal, varnish and grit on canvas
70.4 × 55.3
Scottish National Gallery of Modern Art,
Edinburgh: purchased 1982

Pablo Picasso
Head 1913
Papier collé and chalk on card
43.5 × 33
Scottish National Gallery of Modern Art,
Edinburgh: purchased with help from
the National Heritage Lottery Fund and
The Art Fund, 1995

Pablo Picasso
Still Life 1914
Painted wood and upholstery fringe
25.4 × 45.7 × 9.2
Tate. Purchased 1969

Pablo Picasso
Still Life with Garlands 1918
Oil and sand on canvas
46.4 × 46.4
J. Hutchinson

Pablo Picasso
Composition with a Blue Cigarette Packet c.1921
Oil on canvas
30 × 17
Private collection. Courtesy fundacion Almine
and Bernard Ruiz-Picasso para el Arte

Pablo Picasso
Seated Woman in a Chemise 1923
Oil on canvas
92.1 × 73
Tate. Bequeathed by C. Frank Stoop 1933

Pablo Picasso
Head of a Woman 1924
Oil on canvas
34.5 × 26.5
Tate. Accepted by HM Government in lieu of
tax and allocated to the Tate Gallery 1995

Pablo Picasso
Still Life: Bowls and Apples 1924
Oil on canvas
32 × 38
By kind permission of the Provost and
Scholars of King's College, Cambridge, on
loan to the Fitzwilliam Museum, Cambridge

Pablo Picasso
Guitar suspended on a wall 1927
Oil on canvas
81.5 × 81.5
Guggenheim Art Holdings /
W. H. Patterson Ltd.

Pablo Picasso
Nude Woman in a Red Armchair 1932
Oil on canvas
129.9 × 97.2
Tate. Purchased 1953

Pablo Picasso
Nude on the Beach 1932
Oil on canvas
33 × 40
The Penrose Collection, England

Pablo Picasso
*Nude, Green leaves and Bust (also known as
Bust Nude with Sculptor's Turntable)* 1932
Oil paint on canvas
164 × 132
Tate. Lent from a private collection 2011

Pablo Picasso
Reading at a Table 1934
Oil on canvas
162.2 × 130.5
Lent by the Metropolitan Museum of Art,
Bequest of Florene M. Schoenborn, in honor
of William S. Lieberman, 1995

Pablo Picasso
Dish of Pears 1936 (*)
Oil on canvas
38 × 61
Tate. Bequeathed by Mrs A.F. Kessler 1983

Pablo Picasso
Portrait of Lee Miller as l'Arlesienne 1937
Oil on canvas
81 × 60
The Penrose Collection, England

HENRY MOORE AND PICASSO

Henry Moore
Figure Studies 1924
From Notebook no. 3 1922–1924
Pencil on cream lightweight laid
22.4 × 17.2
The Henry Moore Foundation:
gift of the artist, 1977

Henry Moore
Two Seated Figures 1924
Pencil and pen on paper
24.8 × 34.1
Collection Art Gallery Ontario.
Gift of Henry Moore, 1974

Henry Moore
Woman with Upraised Arms 1924–5
Hopton Wood stone
48.2 × 21.0 × 15.7
The Henry Moore Foundation:
gift of the artist 1977

Henry Moore
*Sixteen Ideas for Sculpture: Standing and
Reclining Figures* 1929
Pencil, crayon, wash on cream medium
weight wove
29.5 × 23.2

Henry Moore Foundation,
gift of the artist 1977
Henry Moore
Seated Figure 1930
Alabaster
46.1 × 27.7 × 19.6
Collection Art Gallery of Ontario, Toronto.
Purchased 1976

Henry Moore
Studies of Torso Figures c. 1930–31
From no. 1 Drawing Book 1930–31
16.2 × 20.1
The Henry Moore Foundation:
gift of the artist, 1977

Henry Moore
Ideas for Composition in Green Horton Stone
c. 1930–31 (*)
Page from No.1 Drawing Book
Pencil on cream lightweight wove
16.2 × 20.1
The Henry Moore Foundation:
gift of the artist 1977

Henry Moore
Composition 1931 (*)
Cumberland alabaster
37.5 × 44 × 27
The Henry Moore Foundation:
gift of Irina Moore 1979

Henry Moore
Composition 1931
Blue Hornton stone
48.3 × 27 × 24.5
Henry Moore Family Collection

Henry Moore
Composition 1932
African wonderstone
44.5 × 45.7 × 29.8
Tate. Presented by the Friends of the
Tate Gallery 1960

Henry Moore
Reclining Figure 1931
Bronze
cast Fiorini Ltd.
25 × 53.3 × 25
The Henry Moore Foundation:
gift of the artist 1977

Henry Moore
Composition 1934
Cast concrete
20.5 × 44 × 21
The Henry Moore Foundation:
gift of the artist, 1977

Henry Moore
Four Piece Composition: Reclining Figure 1934
Cumberland alabaster
17.5 × 45.7 × 20.3
Tate. Purchased with assistance from
the Art Fund 1976

Henry Moore
Reclining Nude 1934
Pen and wash on paper
26 × 46
Victoria and Albert Museum, London

Henry Moore
Reclining Figure 1936
Elmwood
64 × 115 × 52.3
The Hepworth Wakefield

Henry Moore
Five Figures in a Setting 1937
Charcoal (rubbed), pastel (washed) and
crayon on paper
38 × 55.5
Henry Moore Family Collection

Henry Moore
Three Points 1939–40
Bronze
14 × 19 × 9.5
Tate. Presented by the artist 1978

Pablo Picasso
Nude Seated on a Rock 1921
Oil on wood
15.8 × 11.1
The Museum of Modern Art, New York.
James Thrall Soby Bequest, 1979.

Pablo Picasso
The Source 1921
Oil on canvas
64 × 90
Moderna Museet, Stockholm. Gift 1970 from
Grace and Philip Sandblom

Pablo Picasso
Female Figure Metamorphosis II 1928
Bronze
22.8 × 18.3 × 11
Private collection. Courtesy Fundación
Almine y Bernard Ruiz-Picasso para el Arte

Pablo Picasso
Standing Nude 1928
Oil and chalk on canvas
162 × 130
Private collection

FRANCIS BACON AND PICASSO

Francis Bacon
Composition (Figure) 1933
Gouache, pastel, pencil and pen on paper
53.5 × 40
Colección Abelló

Francis Bacon
Composition 1933
Gouache on paper
52.2 × 39.7
Henry Moore Grandchildren Trust

Francis Bacon
Crucifixion (the dance) 1933
Chalk, gouache and pencil on paper
64 × 48
Private collection

Francis Bacon
Crucifixion 1933
Oil on canvas
60.5 × 47
Murderme, London

Francis Bacon
Crucifixion/Figure 1933
Gouache, pastel, pencil and pen on paper
53.5 × 40
Collection Triton Foundation,
The Netherlands

Francis Bacon
Corner of the Studio 1934
Ink and wash on paper
52.5 × 40.5
Heli Investments Ltd.

Francis Bacon
Interior of a Room 1933–35
Oil on canvas
112 × 86.5
Heli Investments Ltd.

Francis Bacon
*Three Studies for Figures at the Base of
a Crucifixion* c.1944
Oil on board
each: 94 × 73.7
Tate. Presented by Eric Hall 1953

Francis Bacon
Head I 1947–1948
Oil and tempera on board
100.3 × 74.9
Lent by the Metropolitan Museum of Art,
Bequest of Richard S. Zeisler, 2007 (2007.247.1)

Pablo Picasso
Bathers at the Beach Hut 19 May 1929
Oil on canvas
33 × 41.5
Musée national Picasso, Paris,
Donation Pablo Picasso, 1979, MP114

Pablo Picasso
Head 1929
Oil on canvas
55 × 46
Moderna Museet, Stockholm

PICASSO IN BRITAIN 1938–1939

Pablo Picasso
Minotauromachy 1935
Etching on paper
57.7 × 77.5
Lent by the Syndics of the
Fitzwilliam Museum, Cambridge

Pablo Picasso
Dreams and Lie of Franco I 8 January 1937
Etching and aquatint on paper
38.1 × 57.4
Penrose Collection, England

Pablo Picasso
Dreams and Lie of Franco II 7 June 1937
Etching and aquatint on paper
38.1 × 54.7
Penrose Collection, England

Pablo Picasso
Dream and Lie of Franco 1937 (*)
Sheet 3, poetic text and facsimile of
Picasso poem
38.1 × 57.4
Penrose Collection, England

Pablo Picasso
Study for the Horse's Head II 2 May 1937
Pencil on blue paper
26.9 × 21
Museo Nacional Centro de Arte
Reina Sofia, Madrid

Pablo Picasso
Composition Study V: Sketch for 'Guernica'
2 May 1937
Oil and pencil on plywood
60 × 73
Museo Nacional Centro de Arte
Reina Sofia, Madrid

Pablo Picasso
Weeping Head VII (Postscript) 19 June 1937
Pencil, tempura and gouache on board
11.8 × 8.8
Museo Nacional Centro de Arte
Reina Sofia, Madrid

Pablo Picasso
Weeping Woman 16 June 1937
Pencil and crayon on paper
29.2 × 23.2
Tate. Accepted by HM Government in lieu of
tax and allocated to the Tate Gallery 1995

Pablo Picasso
Weeping Woman 1 July 1937
Drypoint, etching and aquatint on paper
77.2 × 56.9
Accepted by H.M Government in lieu of
Inheritance Tax on the Estate of Joanna Drew
and allocated the Scottish National Gallery
of Modern Art, 2005

Pablo Picasso
Weeping Woman 26 October 1937
Oil on canvas
60.8 × 50
Tate. Accepted by HM Government in lieu of
tax with additional payment (Grant in Aid) made
with assistance from the National Heritage
Memorial Fund, the Art Fund and the Friends
of the Tate Gallery 1987

GRAHAM SUTHERLAND
AND PICASSO

Graham Sutherland
Gorse on Sea Wall 1939
Oil on canvas
62.2 × 48.3
National Museums Northen Ireland

Graham Sutherland
Association of Oaks 1939–40
Gouache, watercolour and pencil on paper
68.6 × 48.6
Scottish National Gallery of Modern Art,
Edinburgh

Graham Sutherland
Green Tree Form 1940
Oil on canvas
60.5 × 54.5
British Council Collection

Graham Sutherland
Devastation: House in Wales 1940 (*)
Oil on canvas
64.5 × 113.4
Cheltenham Art Gallery and Museum

Graham Sutherland
Composition: Devastation 1942
Pencil, pastel and gouache on paper
23.5 × 36.5 Private collection

Graham Sutherland
Crucifixion 1946
Oil on board
90.8 × 101.6
Tate. Purchased 1947

Graham Sutherland
The Deposition 1946
Oil on millboard
152 × 121.9
Lent by the Syndics of the
Fitzwilliam Museum, Cambridge

Graham Sutherland
Thorn Head 1946
Oil on canvas
113 × 80
Private collection, London

Graham Sutherland
Homage to Picasso 1947
Oil on canvas
30 × 50
Private collection

PICASSO IN BRITAIN 1945–60

Pablo Picasso
The Enamel Saucepan 16 February 1945
Oil on canvas
82 × 106.5
Musée Nationale d'Art Moderne
Centre Georges Pompidou, Paris.
Donation Pablo Picasso 1947.

Pablo Picasso
Woman Dressing her Hair June 1940
Oil on canvas
130.1 × 97.1
The Museum of Modern Art, New York.
Louise Reinhardt Smith Bequest, 1995

Pablo Picasso
*Leaping Bulls (La Corrida), from the Institute of
Contemporary Arts Visitor's Book* 1950 (*)
Watercolour and coloured inks
25.1 × 40.2
British Museum. Donated by Roland Penrose.
1975

Pablo Picasso
Mural drawing known as Bernal's Picasso
12 November 1950
Drawing: crayon on plaster; wall:
horsehair & wooden lathes
135.1 × 226.4 × 17.8
Wellcome Collection, London

Pablo Picasso
Pitcher: Horse and Rider c.1951
Tin glazed earthenware painted in black
and brown with scratched detail
41.6 × 26.3 × 31.5
Victoria and Albert Museum, London
X36241

Pablo Picasso
The Studio 1955
Oil on canvas
80.9 × 64.9
Tate. Presented by Gustav and Elly Kahnweiler
1974, accessioned 1994

Pablo Picasso
Women of Algiers (Version O) Paris,
14 February 1955
Oil on canvas
114 × 146.4
European private collection, courtesy of
Libby Howie

Pablo Picasso
Las Meninas (Maria Agustina Sarmiento)
20 and 26 August 1957
Oil on canvas
46 × 37.5
Museu Picasso, Barcelona

Pablo Picasso
Las Meninas (group) 2 October 1957
Oil on canvas
161 × 129
Museu Picasso, Barcelona

DAVID HOCKNEY AND PICASSO

David Hockney
The Student: Homage to Picasso 1973
Printer's proof xv/xv
Etching and aquatint on paper
75.6 × 56.5
Collection of the David Hockney Foundation

David Hockney
Artist and Model 1973–4
Artist Proof xii
Etching and aquatint on paper
74.9 × 57.2
Collection of the David Hockney Foundation

David Hockney
Christopher Without His Glasses On 1984
Oil on canvas
65.1 × 46
Collection of David Hockney

David Hockney
Discord merely magnifies from The Blue Guitar
1976 –77 (*)
Etching and aquatint on paper
45.7 × 52.3
British Council Collection

David Hockney
A picture of ourselves from The Blue Guitar
1976 –77 (*)
Etching and aquatint on paper
45.7 × 52.3
British Council Collection

David Hockney
What is this Picasso? from The Blue Guitar
1976 –77
Etching and aquatint on paper
45.7 × 52.3
British Council Collection

David Hockney
The Old Guitarist from The Blue Guitar
1976 –77
Etching and aquatint on paper
52.3 × 45.7
British Council Collection

David Hockney
Chinese Conjuror, from Parade Triple Bill 1980
Ink and gouache on paper
35.6 × 43.2
Collection of the David Hockney Foundation

David Hockney
Harlequin 1980
Oil on canvas
121.9 × 91.4
Collection of the David Hockney Foundation

David Hockney
The Set for Parade 1980
Oil on canvas
152 × 152
Private collection

David Hockney
Still Life Blue Guitar 4th April 1982 1982
Composite Polaroid
62.2 × 76.2
Collection of David Hockney

David Hockney
Pembroke Studio Interior 1984 (*)
Lithograph on paper
103 × 126.3
Tate. Presented by the artist 1993

David Hockney
Paint Trolley, L.A. 1985 1985
Edition 1/2
Photographic collage
101.6 × 152.4
Collection of David Hockney

Pablo Picasso
*Portrait of Emilie Marguerite Walter
(Mémé)* 1939
Oil and pencil on canvas
41 × 33
Private collection

THE THREE DANCERS

Pablo Picasso
The Three Dancers 1925
Oil on canvas
215.3 × 142.2
Tate. Purchased with a special Grant in Aid
and the Florence Fox Bequest with assistance
from the Friends of the Tate Gallery and
the Contemporary Art Society 1965

Pablo Picasso
The Kiss 1967 (*)
Pencil on paper
50.5 × 65.5
Tate. Bequeathed by Joanna Drew 2003,
accessioned 2006

INDEX

SUPPORTING TATE

Tate relies on a large number of supporters – individuals, foundations, companies and public sector sources – to enable it to deliver its programme of activities, both on and off its gallery sites. This support is essential in order for Tate to acquire works of art for the Collection, run education, outreach and exhibition programmes, care for the Collection in storage and enable art to be displayed, both digitally and physically, inside and outside Tate. Your donation will make a real difference and enable others to enjoy Tate and its Collection both now and in the future. There are a variety of ways in which you can help support Tate and also benefit as a UK or US taxpayer. Please contact us at:

Development Office
Tate
Millbank
London SWIP 4RG
UK

American Patrons of Tate
520 West 27 Street
Unit 404
New York, NY 10001
USA

TEL 020 7887 4900
FAX 020 7887 8098

TEL 001 212 643 2818
FAX 001 212 643 1001

Donations, of whatever size, are gratefully received, either to support particular areas of interest, or to contribute to general activity costs.

Gifts of Shares

We can accept gifts of quoted share and securities. All gifts of shares to Tate are exempt from capital gains tax, and higher rate taxpayers enjoy additional tax efficiencies. For further information please contact the Development Office.

Gift Aid

Through Gift Aid you can increase the value of your donation to Tate as we are able to reclaim the tax on your gift. Gift Aid applies to gifts of any size, whether regular or a one-off gift. Higher rate taxpayers are also able to claim additional personal tax relief. Contact us for further information and to make a Gift Aid Declaration.

Legacies

A legacy to Tate may take the form of a residual share of an estate, a specific cash sum or item of property such as a work of art. Legacies to Tate are free of inheritance tax, and help to secure a strong future for the Collection and galleries. For further information please contact the Development Office.

Offers in lieu of tax

Inheritance Tax can be satisfied by transferring to the Government a work of art of outstanding importance. In this case the amount of tax is reduced, and it can be made a condition of the offer that the work of art is allocated to Tate. Please contact us for details.

Tate Members

Tate Members enjoy unlimited free admission throughout the year to all exhibitions at Tate, as well as a number of other benefits such as exclusive use of our Members' Rooms and a free annual subscription to *Tate Etc*. Whilst enjoying the exclusive privileges of membership, you are also helping secure Tate's position at the very heart of British and modern art. Your support actively contributes to new purchases of important art, ensuring that the Tate's Collection continues to be relevant and comprehensive, as well as funding projects in London, Liverpool and St Ives that increase access and understanding for everyone.

Tate Patrons

Tate Patrons share a strong enthusiasm for art and are committed to giving significant financial support to Tate on an annual basis. The Patrons support the acquisition of works across Tate's broad collecting remit, as well as other areas of Tate activity such as conservation, education and research. The scheme provides a forum for Patrons to share their interest in art and to exchange knowledge and information in an enjoyable environment. United States taxpayers who wish to receive full tax exempt status from the IRS under Section 501 (c) (3) are able to support the Patrons through the American Patrons of Tate. For more information on the scheme please contact the Patrons office.

Corporate Membership

Corporate Membership at Tate Modern, Tate Britain and Tate Liverpool offers companies opportunities for corporate entertaining and the chance for a wide variety of employee benefits. These include special private views, special access to paying exhibitions, out-of-hours visits and tours, invitations to VIP events and talks at members' offices.

Corporate Investment

Tate has developed a range of imaginative partnerships with the corporate sector, ranging from international interpretation and exhibition programmes to local outreach and staff development programmes. We are particularly known for high-profile business to business marketing initiatives and employee benefit packages. Please contact the Corporate Fundraising team for further details.

Charity Details

The Tate Gallery is an exempt charity; the Museums & Galleries Act 1992 added the Tate Gallery to the list of exempt charities defined in the 1960 Charities Act. Tate Members is a registered charity (number 313021). Tate Foundation is a registered charity (number 1085314).

American Patrons of Tate

American Patrons of Tate is an independent charity based in New York that supports the work of Tate in the United Kingdom. It receives full tax exempt status from the IRS under section 501(c)(3) allowing United States taxpayers to receive tax deductions on gifts towards annual membership programmes, exhibitions, scholarship and capital projects. For more information contact the American Patrons of Tate office.

Mark and Cathy Corbett
Cynthia Corbett
Tommaso Corvi-Mora
Mr and Mrs Bertrand Coste
Kathleen Crook and James Penturn
James Curtis
Mrs Virginia Damtsa
Daniella Luxembourg Art
Mr Theo Danjuma
Sir Howard Davies
Mrs Belinda de Gaudemar
Giles de la Mare
Maria de Madariaga
Anne Chantal Defay Sheridan
Marco di Cesaria
Simon C Dickinson Ltd
Mrs Fiona Dilger
James Diner
Liz and Simon Dingemans
Mrs Noelle Doumar
Mr Raymond Duignan
Joan Edlis
Lord and Lady Egremont
John Erle-Drax
Stuart and Margaret Evans
Eykyn Maclean LLC
Gerard Faggionato
Ms Rose Fajardo
Mrs Heather Farrar
Mrs Margy Fenwick
Mr Bryan Ferry, CBE
The Sylvie Fleming Collection
Mrs Jean Fletcher
Lt Commander Paul Fletcher
Mrs Rosamund Fokschaner
Eric and Louise Franck
Elizabeth Freeman
Stephen Friedman
Julia Fuller
Carol Galley
Daniela and Victor Gareh
Mrs Lisa Garrison
Mrs Joanna Gemes
Mr Mark Glatman
Mr and Mrs Paul Goswell
Penelope Govett
Martyn Gregory
Sir Ronald Grierson
Mrs Kate Grimond
Richard and Odile Grogan
Mr Jacques Hakimian
Louise Hallett
Jane Hay
Richard Hazlewood
Michael and Morven Heller
Miss Judith Hess
Mrs Patsy Hickman
Robert Holden
James Holland-Hibbert
Lady Hollick, OBE
John Huntingford
Mr Alex Ionides
Maxine Isaacs
Sarah Jennings
Ms Alex Joffe
Mr Haydn John
Mr Michael Johnson
Jay Jopling
Mrs Marcelle Joseph and Mr Paolo Cicchiné
Mrs Brenda Josephs
Tracey Josephs
Mr Joseph Kaempfer
Andrew Kalman
Dr Martin Kenig
Mr David Ker
Nicola Kerr
Mr and Mrs Simon Keswick
Richard and Helen Keys
Mrs Mae Khouri
David Killick
Mr and Mrs James Kirkman
Brian and Lesley Knox
Kowitz Trust
Mr and Mrs Herbert Kretzmer

Ms Jacqueline Lane
Steven Larcombe
Mrs Julie Lee
Simon Lee
Mr Gerald Levin
Leonard Lewis
Mr Gilbert Lloyd
George Loudon
Mark and Liza Loveday
Kathryn Ludlow
Anthony Mackintosh
The Mactaggart Third Fund
Mrs Jane Maitland Hudson
Mr M J Margulies
Lord and Lady Marks
Marsh Christian Trust
Ms Fiona Mellish
Mr Martin Mellish
Mrs R W P Mellish
Professor Rob Melville
Mr Michael Meynell
Mr Alfred Mignano
Victoria Miro
Ms Milica Mitrovich
Jan Mol
Mrs Bona Montagu
Mrs Valerie Gladwin Montgomery
Mr Ricardo Mora
Mrs William Morrison
Paul and Alison Myners
Ann Norman-Butler
Julian Opie
Pilar Ordovás
Sir Richard Osborn
Joseph and Chloe O'Sullivan
Desmond Page
Maureen Paley
Dominic Palfreyman
Michael Palin
Mrs Adelaida Palm
Stephen and Clare Pardy
Mrs Véronique Parke
Eve Pilkington
Ms Michina Ponzone-Pope
Mr Oliver Prenn
Susan Prevezer, QC
Mr Adam Prideaux
Mr and Mrs Ryan Prince
James Pyner
Valerie Rademacher
Mrs Phyllis Rapp
Mr and Mrs James Reed
Susan Reid
Mr and Mrs Philip Renaud
The Reuben Foundation
Sir Tim Rice
Lady Ritblat
David Rocklin
Frankie Rossi
Mr David V Rouch
Mr James Roundell
Naomi Russell
Mr Alex Sainsbury and Ms Elinor Jansz
Cherrill and Ian Scheer
Sylvia Scheuer
The Schneer Foundation
Mrs Cara Schulze
Andrew and Belinda Scott
The Hon Richard Sharp
Mr Stuart Shave
Neville Shulman, CBE
Ms Julia Simmonds
Mrs Cindy Sofer
Mrs Carol Sopher
Flora Soros
Louise Spence
Digby Squires, Esq
Mr and Mrs Nicholas Stanley
Mrs Tanya Steyn
The Swan Trust
Mrs Patricia Swannell
Mr James Swartz
The Lady Juliet Tadgell
Sir Anthony and Lady Tennant

Christopher and Sally Tennant
Mr Henry Thompson
Britt Tidelius
Mr Henry Tinsley
Karen Townshend
Melissa Ulfane
Mr Marc Vandecandelaere
Mrs Cecilia Versteegh
Gisela von Sanden
Mr David von Simson
Audrey Wallrock
Stephen and Linda Waterhouse
Offer Waterman
Terry Watkins
Mr and Mrs Mark Weiss
Miss Cheyenne Westphal
Mr David Wood
Mr Douglas Woolf
and those who wish to remain anonymous

YOUNG PATRONS
Ms Maria Allen
HRH Princess Alia Al-Senussi
Miss Sharifa Alsudairi
Sigurdur Arngrimsson
Miss Joy Asfar
Kirtland Ash
Miss Olivia Aubry
Rachael Barrett
Ms Shruti Belliappa
Mr Edouard Benveniste-Schuler
Miss Margherita Berloni
Ms Natalia Blaskovicova
Mrs Sofia Bocca
Ms Lara Bohinc
Mr Andrew Bourne
Miss Florence Brudenell-Bruce
Miss Camilla Bullus
Miss Verena Butt
Miss May Calil
Miss Sarah Calodney
Matt Carey-Williams and Donnie Roark
Dr Peter Chocian
Mrs Mona Collins
Thamara Corm
Miss Amanda C Cronin
Mrs Suzy Franczak Davis
Mr Alexander Dellal
Ms Suzana Diamond
Ms Michelle D'Souza
Ms Catriona Early
Miss Roxanna Farboud
Mr Mark Thomas Flanagan
Jane and Richard Found
Miss Rita Freitas
Mr Andreas Gegner
Ms Alexandra Ghashghai
Mrs Benedetta Ghione-Webb
Ms Emily Goldner
Mr Nick Hackworth
Alex Haidas
Mr Benji Hall
Ms Susan Harris
Sara Harrison
Mrs Samantha Heyworth
Miss Fran Hickman
Miss Eloise Isaac
Ms Melek Huma Kabakci
Mr Efe Kapanci
Ms Tanya Kazeminy Mackay
Mr Benjamin Khalili
Miss Lily King
Helena Christina Knudsen
Ms Marijana Kolak
Miss Constanze Kubern
Miss Marina Kurikhina
Mr Jimmy Lahoud
Ms Anna Lapshina
Mrs Julie Lawson
Ms Joanne Leigh
Mr Christian Levett
Mrs Siobhan Loughran
Charlotte Lucas

Alessandro Luongo
Ms Sonia Mak
Mr Jean-David Malat
Mr Kamiar Maleki
Mr Shahriar Maleki
Miss Erica Mathiesen
Ms Clémence Mauchamp
Dorian May Hasiotis
Mr John McLaughlin
Mr Fernando Moncho Lobo
Mrs Sarah Morgan
Erin Morris
Mrs Annette Nygren
Phyllis Papadavid
Ms Camilla Paul
The Piper Gallery
Lauren Prakke (Chair, Ambassador Group)
Ivetta Rabinovich
Mr Eugenio Re Rebaudengo
Mr Bruce Ritchie and Mrs Shadi Ritchie
Kimberley and Michael Robson-Ortiz
Miss Tatiana Sapegina
Mr Simon Scheuer
Count Indoo Sella di Monteluce
Preeya Seth
Miss Kimberly Sgarlata
Amir Shariat
Henrietta Shields
Ms Heather Shimizu
Ms Marie-Anya Shriro
Mr Max Silver
Tammy Smulders
Mr Saadi Soudavar
Miss Malgosia Stepnik
Mr Dominic Stolerman
Mr Edward Tang
Mr Ariel Tepperman
Miss Inge Theron
Soren S K Tholstrup
Hannah Tjaden
Mrs Padideh Trojanow
Dr George Tzircotis
Mr Rupert Van Millingen
Mr Timo Weber
Mr Neil Wenman
Ms Seda Yalcinkaya
Michelle Yue
Miss Burcu Yuksel
Miss Tiffany Zabludowicz
Mr Fabrizio Zappaterra
and those who wish to remain anonymous

NORTH AMERICAN ACQUISITIONS
COMMITTEE
Carol and David Appel
Rafael Cennamo and Amir Baradaran
Beth Rudin De Woody
Carla Emil and Richard Silverstein
Dr Kira Flanzraich
Glenn Fuhrman
Andrea and Marc Glimcher
Pamela Joyner
Monica Kalpakian
Massimo Marcucci
Lillian Mauer
Liza Mauer and Andrew Sheiner
Nancy McCain
Stavros Merjos
Gregory R. Miller
Shabin and Nadir Mohamed
Elisa Nuyten & David Dime
Amy and John Phelan
Liz Gerring Radke and Kirk Radke
Laura Rapp and Jay Smith
Robert Rennie (Chair) and Carey Fouks
Randy W Slifka
Donald R Sobey
Robert Sobey
Ira Statfeld
Marla and Larry Wasser
Christen and Derek Wilson
and those who wish to remain anonymous